FORKS

A Quest For Culture, Cuisine And Connection.

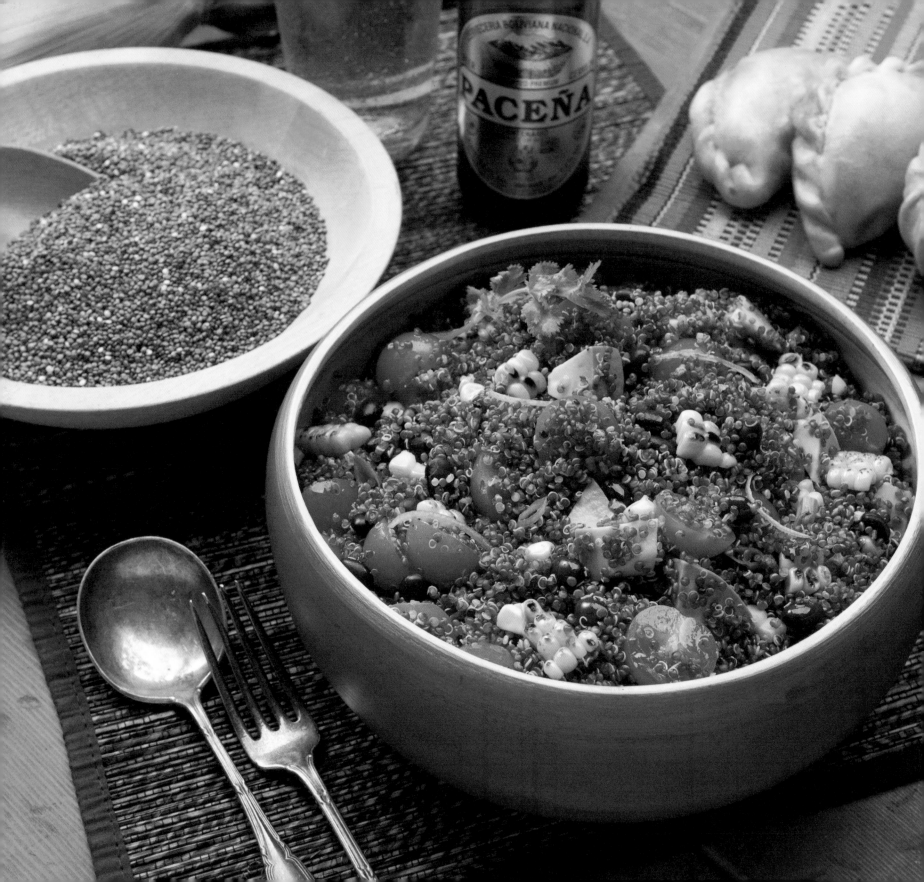

THREE YEARS | FIVE CONTINENTS | ONE MOTORCYCLE

FORKS

A Quest For Culture, Cuisine And Connection.

ALLAN KARL

WorldRider Publishing & Press
Leucadia, California

© 2014 Allan Karl

WorldRider Publishing & Press
PO Box 232356
Leucadia, California 92023
worldriderpress.com

Publisher's Cataloging-in-Publication data

Karl, Allan F.

Forks : three years , five continents , one motorcycle :
a quest for culture , cuisine , and connection / Allan Karl.

p. cm.

ISBN 978-0-9894418-1-0

1. Karl, Allan F. 2. Voyages around the world. 3. Motorcycling. 4. Voyages and travels. 5. Travel photography. 6. Dinners and dining. 7. Food habits --Anecdotes. 8. International cooking. I. Title.

G440 .K28 2014

910.4/1—dc23 2014948533

Designed by Michael Paff Design

Production coordinated by Bonnie Toth

Edited by James Powell and Dean Whitlock

Cover photo by Allan Karl

Food photography by James Porter

Food styling by Lisa Meredith

Travel photography by Allan Karl, with contributions by fellow travelers and friends, especially Jeremiah St. Ours whose photos of Allan in Mexico, Peru and Bolivia appear on pages 22, 75-77 and 81-83.

Country facts were sourced online from the CIA Fact Book and UNESCO and were the most current available at the time of printing. Some of the figures have been rounded.

Printed in China

10 9 8 7 6 5 4 3 2 1

There are no strangers, only friends you haven't met. —Irish Proverb

Contents

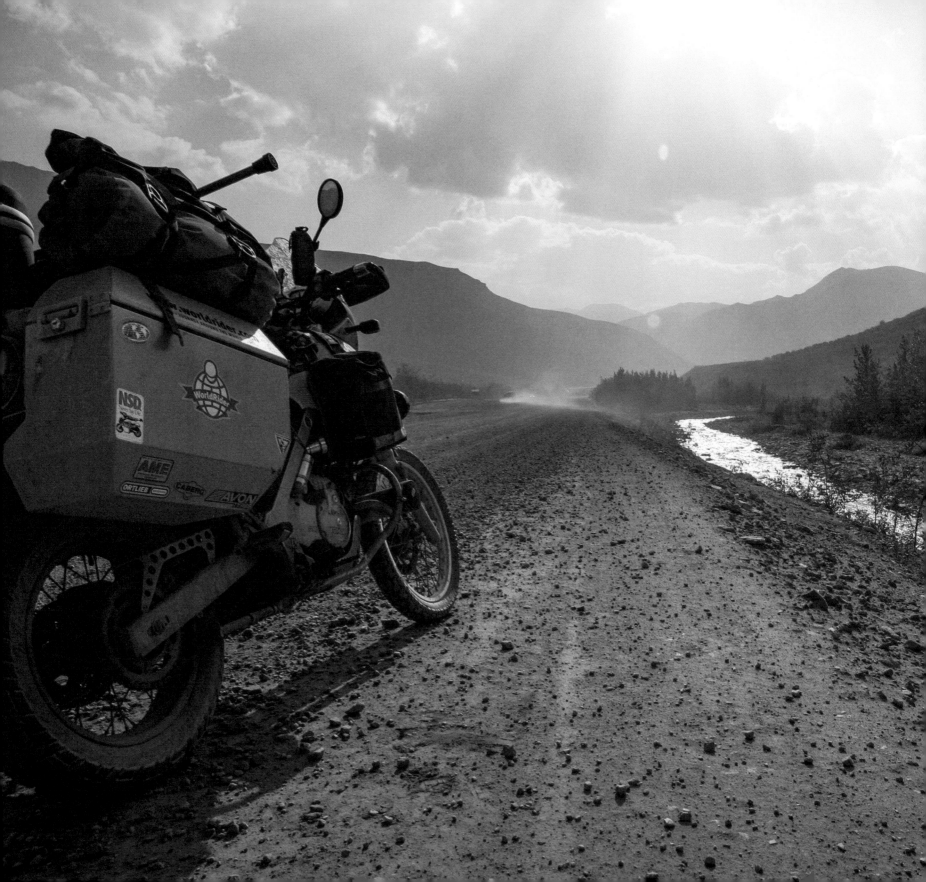

Introduction

My goal was to ride a motorcycle around the world—alone.

I had to go by motorcycle—my motorcycle—the same bike for the entire journey. Only on a motorcycle could I truly immerse myself in and taste the diverse cultures of our world.

To me, there is no better way to travel. On a bike, not only would I feel the wind in my face, I would feel the temperature change, smell the unique aromas of each place, and breathe the air freely. I would also hear the sounds of our world—changes in language and dialect, like music. And I would see the faces of people and their cultures change before me.

Most of all, on a motorcycle I could stop freely, and when I came to a fork in the road, I could choose to go with the wind—or against it. Along the way, I would be able to connect with anyone—especially those living way off the beaten track and with no history of exposure to tourists. Real people.

Still, overland travel takes time. It would take me days, even weeks to travel from one place to the next. Most tourists board airplanes and hours later they land, as though they have been beamed somewhere in a flash. But where are they really? Suddenly they find themselves in another part of the world. Do they have a true sense of where they are? Do they have any understanding of the places in between? On a motorcycle, I knew, I would have a chance to see, feel, and taste anything and everything along the way. To me, it's not where I go that is important, it's the discoveries I make, the truths I uncover, and the journey that unfolds—these are what make it rewarding.

I was filled with near insatiable curiosity. I wanted to learn, understand, and connect with everything and everyone I could: history, language, culture, local people, and their food. I wanted to visit as many UNESCO World Heritage Sites as I could get to. It would be essential to take the time to taste everything. I also needed time to learn more about myself—to discover my own truths.

This was the time. I had come to a fork in the road, and I knew what I had to do. Nobody could talk me out of it. No matter how tough the road was going to be, or how long it would take, I was committed.

This was the time. I had come to a fork in the road, and I knew what I had to do. Nobody could talk me out of it. No matter how tough the road was going to be, or how long it would take, I was committed. I imagined it would be long, that there would be many adventures and discoveries. I knew it would be hard, dangerous and often lonely. I also realized that there would be no turning back, no end to the journey or the road—even after

Introduction

In every culture, there is a place where people come together to share and enjoy a meal. Whether at a home in Buenos Aires, along a roadside in Tanzania, on a muddy floor in Ethiopia or Sudan, that's where I experienced the most precious moments of my journey. That's where I connected with people.

I returned home—only new forks and new beginnings, choices I would make that would reveal, for me, new truths about the world and about myself.

I set off on this journey alone, yet quickly realized I was never alone. Whenever I looked around, I found a caring soul. Despite the challenges and difficulties compounded by language, culture, customs, and economics, I discovered how easily the divisions inherent in diversity can be overcome. In every culture, there is a place where people come together to share and enjoy a meal. Whether at a home in Buenos Aires, along a roadside in Tanzania, on a muddy floor in Ethiopia or Sudan, that's where I experienced the most precious moments of my journey. That's where I connected with people. Together we bridged our differences and learned about each other by sharing treasured moments, joined together in tasting local flavors, telling life stories, and discovering truths.

I also discovered I never had to look too hard or too far for those truths. Even when the road was rough and the weather foul. Even when I was lost and lonely, or confused by strange road signs and languages, truth always found me. And when it did, it deepened my love, trust, and faith in humanity. That's where truth shines.

My journey spanned 62,000 miles, traversing the globe from North to South, East to West, across thirty-five countries on five continents. Along the way I shared some 2,500 meals with people of all ages and walks of life, and I came to realize that my appetite for learning, culture, and good food is uniquely satisfied in the company of strangers. Far from the white tablecloths and glistening stemware of five-star resorts, big city restaurants, and celebrity chefs, I discovered the true beauty of humanity. While sharing real food, sitting at dining tables in simple kitchens or on the floors of thatched huts, at roadside stands or in local restaurants, I connected with real people and embraced the diversity of our world through the unifying warmth of shared food and drink.

I didn't set out to write a book about food or a cookbook. I set out to discover new and different cultures that I knew I would share

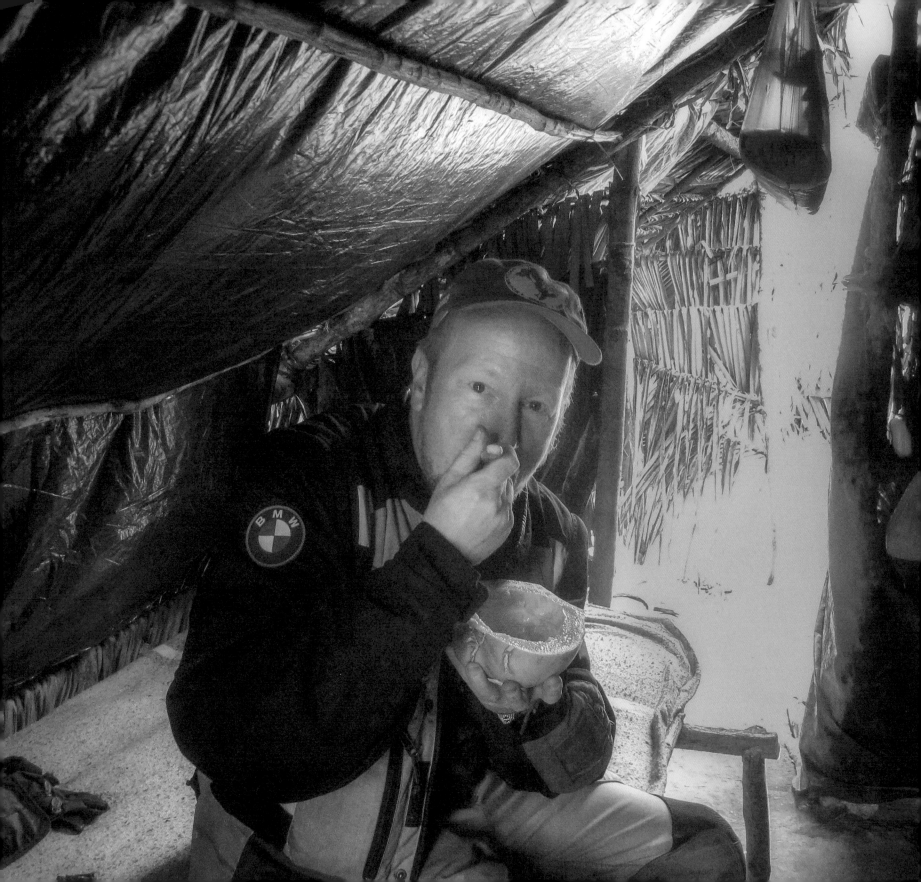

Introduction

one day in a book. Well into my journey—over dinner in a small town on an island in Bahia, Brazil, with my new friend and host Felipe—it finally hit me. That's where I tasted my first moqueca, a delicious stew made from coconut milk, fresh fish, herbs, and dendê, a remarkable aromatic oil made from the fruit of a palm tree (see page 113). While talking about the moqueca, Brazil, and Felipe's life on that island, it occurred to me how much we learn when we take the time to share a meal with strangers or good friends, and how local flavors and aromas tell as much about a place and its culture as do the customs by which it is prepared, served, and shared.

So I collected recipes from every place I visited. They are the perfect complement to the stories and photographs of my around-the-world adventure.

These recipes are the real deal. Many could be candidates for the national dish in some of the countries I traveled through. Others are dishes that have evolved over generations and are served not only in local restaurants but in the homes of local people. The more miles I logged, the more I was taken by the beauty and flavors of even the simplest dish, and the more I realized how important was the ritual of sharing food. That's what makes these recipes so special to me, and why I hope they will soon be as special to you.

Each recipe presents an opportunity to try something new. Whether to taste the flavors of a new food or to cross into an unknown and perhaps dangerous country, each and every experience is an opportunity to connect with others and overcome the barriers created by differences in experience, race, religion, or geography. This, I discovered, is true.

I invite you to travel and adventure around the world as I did. Through the stories, photographs, and recipes in these pages, discover authentic food, cross into unfamiliar territories, explore new ingredients, and taste each unique culture. Grab your forks, knives, and spoons or use your hands. Invite friends over, pick a country, and cook up your own adventures, discover your own truths, and most important, tell stories.

After all, it's in cooking and dining that we all come together, connect, and share.

The beginning at the fork in the road.

Crazy. That's what my friends call me.

"You're gonna do what?" they ask.

"Ride my motorcycle around the world," I answer. I keep my tone serious, trying to refrain from smiling, to hold back my excitement. "It's time for me to be the WorldRider," I tell them. "That's my dream; as far back as I can remember, I've always wanted to travel around the world."

"You're gonna get killed," they say, or suggest other doomsday scenarios that will befall me. Some friends make bets. I never ask the odds, but many think something terrible will happen.

My bike will be stolen,

I'll contract an incurable disease,

Bandits will rip me off, or

I'll be locked away in some foreign prison by a corrupt government with no diplomatic ties to the United States.

My friends are filled with fear—for me. They suggest safer alternatives.

"Why not go on a cruise?"

"How about spending a year in France? Italy? Spain?"

"What about traveling here, in the United States?"

"Have you thought of flying?"

Finally someone asks me the more sensible question, "Why?"

I have long been planning this trip. My living room—with a floor-to-ceiling world map on one wall; with a massive whiteboard on another; and with country maps, travel guides, history books, and traveler stories stacked everywhere—has become WorldRider headquarters. I spend long evenings poring over books and maps, researching and visualizing faraway places. Here I plan my adventure.

A number of life-changing events have pushed me to follow my dream.

I have been working for a digital-marketing agency. Another firm has invested in the company, so a dozen of our regional vice-presidents have gathered together for an offsite strategic-planning meeting. Led by our new investor partners, it is to be a typical corporate retreat—with a Vegas twist: lots of meetings and discussions, but also golf tournaments, gambling, alcohol, decadent meals, and even a late-night run, initiated by our CFO, to a local strip club.

The beginning at the fork in the road.

The two primary investors invite me, as a founder and director for the company, to a private breakfast meeting to outline their vision for the future. After what seems hours of torture, napkin scribbling, and discussions, I feel empty. I am sick to my stomach. I cannot connect with them. They think they know better; I think I do. They come from a world of numbers: high finance, banking, and fast-food outlets. I come from a world of creative, strategic marketing and branding. My wife runs a slow-food, fine-dining, catering business. I just cannot relate to these people.

The next morning terrorists attack our country; the twin towers of the World Trade Center fall.

No longer challenged, and with new investors commanding more and more control, I find myself unfulfilled, chasing a version of success that just isn't mine. In the solitude of my Las Vegas hotel room, as a stunned world gathers to make sense of the tragedy unfolding, I make the decision to quit my job.

I resign.

At home, my seven-year marriage is in trouble, though we've kept up a good front. Always entertaining and attending public events, we seem the perfect couple. We want children, but it isn't happening for us. After two years of fertility treatments and sex by appointment we find ourselves growing apart. We live more like roommates than lovers or husband and wife. After nearly a year of counseling, we both realize we will be happier living separate lives. So we mutually and amicably agree to divorce.

We have to tell our friends. Rather than risk the dangers of miscommunication through the rumor mill or friends choosing sides, we plan a party where, we tell everyone, we will make a big announcement. Alicia cooks all day, and I pull the best wines out of my cellar. Most of our friends think Alicia is finally pregnant. Others think we have won the lottery, and still others believe we are planning a trip around the world.

After we announce our divorce, Alicia breaks the uncomfortable silence.

"We still love each other," she explains. "And we both love all of you. We want to remain friends with each other and with each of you. There is no anger and there are no sides to take."

Alicia returns to school to study nutrition. I start over.

I start another company and begin doing the same thing: branding, marketing, and creative communications. I am good at this work, but though the new company earns the respect of clients and peers, I still am not fulfilled or challenged.

I've come to a fork. I need to choose a new direction, change the scenery, so I can continue to learn and grow.

I no longer want to let the pace of business and the pursuit of its success get in the way of doing what inspires and motivates me most: traveling, writing, and photography. Over the past few years, my motorcycle has accumulated more dust than miles, but it has called.

Not that I haven't had enough change already.

Crazy? Maybe. An extreme route through a midlife crisis? Possibly.

No matter what, it is time to choose a different road—to be true to myself and follow my passion.

In preparation for the trip, I sell nearly everything I own, pack most everything else, and set out to discover the world.

Despite fearful friends' concerns for my safety and the warnings of the U.S. State Department and other travel advisories, I believe the world to be a safe place, full of curious people from different cultures—all open to learning and sharing with each other. I hope to prove this. By focusing on what is good in our world and what makes us similar, we can bridge our differences, embrace our diversity, and learn and grow. We can experience true humanity by finding what it is inside each of us that is alive and ripe for connection.

Mine is a journey of exploration, adventure, and discovery—to the ends of the world—to the end of the road...on a motorcycle, wherever it takes me.

I plan to leave my home in Newport Beach, California, and travel north as far as the road goes, to the Arctic Ocean in Deadhorse, Alaska. Then I will head south through Western Canada and the United States until I find the end of the road at the tip of South America, in Tierra del Fuego. After this, I will make my way to Africa, the Middle East, Europe, and Asia.

My journey will soon begin.

3

North America

"Twenty years from now you will be more disappointed by the things you didn't do than by the ones you did do. So throw off the bowlines, sail away from the safe harbor. Catch the trade winds in your sails. Explore. Dream. Discover.

– Mark Twain

SHIPYARD • STORE

U.S.A.

Lost and Found in the Arctic Circle.

On a motorcycle you hear everything. I barely make it out the door before the new tenants arrive and I hear the loud air brakes of the moving truck turning down my street. My motorcycle feels heavy. After all, I've packed my panniers with almost everything. Panniers, another word for saddlebags, comes from Latin, derived from 'pan,' meaning bread. In Old French, pannier means breadbasket. Yet I'm carrying most everything except bread, because I'm interested in breaking bread with others—people I will connect with on the road.

No, I'm weighed down by everything else in my panniers: multiple copies of my passport and driver's license; first aid kit, complete with spare needles and syringes, malaria pills, analgesics and antibiotics; a rain suit; a dummy wallet to hand over in case of a holdup; motorcycle title, gear, tools, and parts; three cameras, a MacBook Pro computer and backup drives; a marine-grade GPS; an In Case of Emergency card (in three languages); condoms; beef jerky and nutrition bars; gas and water containers; multiple pairs of gloves, clothes, and shoes; spare inner tubes and a tire repair kit; a mosquito net; a tent, sleeping bag, and Thermarest mattress; a camp stove, pots, pans, and utensils; waterproof matches; lighters; water purification tablets; dry bags; and a Leatherman knife and multitool.

Maybe my friends are right, I am crazy. Not for going on this trip, but for thinking I can pack even more on my motorcycle. Everything I haven't had time to pack I've sent to my friend John in Garberville, a few hours north of San Francisco and my first major stop on my way to Alaska.

Besides feeling heavy, my bike feels off balance. Though I've planned for every possible detail and packed for nearly every contingency, I've never had a chance to test ride my bike loaded with all the gear I'm taking around the world. John will need to help me pack up the rest and then tweak the load into balance.

Size: 9,826,675 sq km (3rd in world)

Population: 317.6 million (3rd in world)

Capital: Washington, DC (4.4 million)

Largest city: New York-Newark (19.3 million)

Independence Day: 4 July 1776 (declared from Great Britain)

World Heritage Sites: 21

Literacy rate: 99%

Currency: United States dollar

Population below poverty line: 15.1%

Key exports: soybeans, fruit, corn

Mobile phones: 290.3 million (3rd in world)

The quiet and verdant old-growth forests of the Pacific Northwest were perfect spots to camp in after a long day of riding. Here I pitch my tent along the McKenzie River just off the Aufderheide Highway, one of the most beautiful and memorable roads I traveled.

Beyond not finishing my packing, I have yet to fit my motorcycle with the special equipment I've acquired: parts that will reinforce it, making it more resilient and better equipped to handle the rough roads of the Yukon, South America, Africa, and beyond.

My journey starts on Independence Day, July 4, 2005. I look at my situation in two ways. One, I'm free of my old life and starting fresh. Two, I'm out of time, no longer have a home, and must leave.

I hop on the freeway and head north, thinking, "I'm really doing this! I'm on the road!"

My bike looks as overloaded as it feels, and decals on my aluminum panniers read "WorldRider: Journey Around The World." It even lists the URL of my website. Barely anyone on the busy freeway notices.

My endeavor has yet to seem real to me, either. There's been no send-off party like I had envisioned, and the only goodbyes I've shared have been with my former wife, in a parking lot just off the freeway, and my girlfriend, Angie, with whom I stayed the night before.

I'd said goodbye to my close friends four months before at the trip's fund-raising event, where, in a silent auction, I'd sold most of my wine collection, along with other products and services donated by generous supporters of my journey. With Michiko, the owner of Nesai, a Newport eatery where my friends and family had gathered to partake of Asian-infused Italian fare, we all shared good wine, tall stories, heartfelt farewell toasts, and bets placed on whether or not I would make it back alive.

Now, with all the gear packed on my motorcycle and the panniers almost as wide as my handlebars, I find it awkward to navigate in tight traffic. In San Francisco, the Golden Gate Bridge traffic is backed up for miles, so I slowly ride down the narrow line between lanes. Struggling to keep balance as the gap tightens, I feel a soft bump and realize my bike has smacked the passenger-side mirror of a new Mercedes-Benz. With no room to stop, I keep moving until I get to the bridge, where I find room to pull over and wait. I never see the Mercedes, so I move on.

I've started my journey by going north for two reasons. First, I want to reach the end of the road, the top of the world, the Arctic Ocean. Second, this 4,000-mile ride to Alaska and then back south another 4,500 miles through Canada and the western states to the border of Mexico will serve as my test ride. I can iron out any bugs in my bike, packing, or mindset before heading into Mexico and Latin America.

At John's, instead of packing more on my bike, I unpack some, prioritize, and leave him with a bigger box of stuff than I'd sent earlier. A local mechanic fits the protective equipment to my bike, and then, with everything sorted, packed, and balanced, John hosts a farewell party warmed with friends and home-cooking.

U.S.A.

Some six weeks later, I arrive in Fairbanks, Alaska, just 600 miles from Deadhorse, a tiny working village sitting at the edge of the Arctic Ocean, where the Alaska Pipeline starts, where the northernmost road in North America ends, and where my journey south to the bottom of the world will soon begin.

To get to Deadhorse, I ride the dirt road known to travelers as the Dalton Highway and to truckers as the Haul Road. Originally closed to public traffic and used only by trucks hauling the heavy equipment to build the Alaska Pipeline, the road passes through the Arctic Circle, across miles of permafrost, over the North Slope, and onward to Deadhorse, at the Arctic Ocean. I'm surprised to find a road sign saying Dalton Highway, and then another that says Circle. I happily follow them.

I'd carefully researched this road and knew what to expect: it would be paved for the first fifty miles or so before changing to dirt, there would be only one gas station, and the route would carve and wind over a beautiful mountain pass.

Everything is as expected until the road gets worse, turns to sand, and then to big ruts. Even with the slightly lighter load than I'd started with, my bike is still heavy. In the sand it handles like a boat in rough seas: I can't really steer. I have to keep the throttle twisted and go forward, and standing on the pegs is the only way I can keep balance. I slow down as the road gets rougher. My front tire

squirrels through sand, making me tense and scared. Several times I lose traction and almost drop the bike.

When I finally arrive at a tiny encampment with a general store with a bushplane sitting in its parking lot, I venture inside to see just how far I am from Deadhorse.

At first, caught by the nostalgia of old advertisements, cluttered shelves, and kitschy merchandise, I don't notice a fellow sitting under a worn baseball cap that shadows his rough features and weathered skin.

"Man, that road is a bitch," I say. "I hope it gets better. How much further to Deadhorse?"

His old wooden office chair creaks as he leans forward, removes his cap, and laughs. "Deadhorse, eh? You want the good news or the bad?" he teases.

"Huh?"

"The bad news is you're lost. You're on the wrong road. The good news is the road you want is a hundred times better than the one you took."

So much for reading the signs: I'm in Circle, Alaska, not at the Arctic Circle. He tells me there's only one way out—the way in.

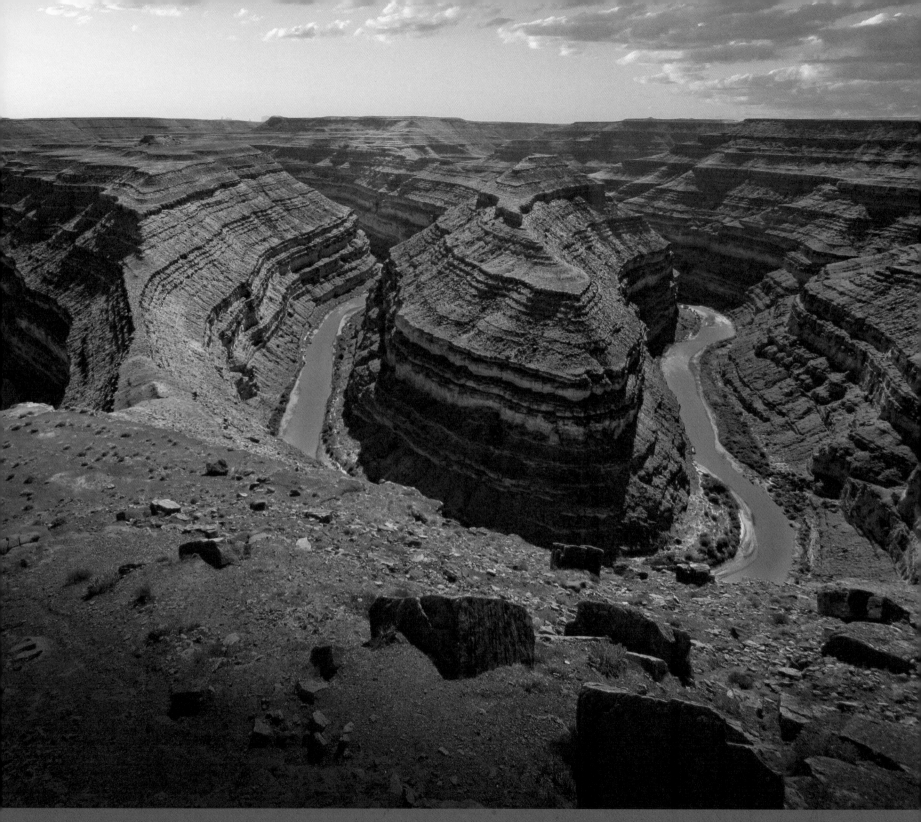

U.S.A.

I'm pissed at myself. "What an idiot I am," I think. Before I get more upset, I catch myself. After all, I realize, this is adventure.

I take off my motorcycle jacket, chug a cold bottle of water, and chat with my new friend. Turns out he's the mayor, power company, bush pilot, and owner of the general store.

He's a photographer, too, and passionately shares with me photos of aurora borealis, the northern lights.

"Come back a couple of months earlier next year. I'll show you." He then shares with me photos of baby peregrine falcons he's been tracking. "You want to go see 'em?"

I think about Deadhorse—and that road. The offer is tempting, but I want to move on.

Four hours later I'm back to the real Dalton Highway, where I try to get a room at the Chatanika Lodge, but highway construction workers have it booked. Fortunately, the owners let me sleep on the couch in the breakfast room.

"Just be aware that we'll start serving breakfast here at six sharp."

I smile and say, "Sounds good to me."

As I slide into my sleeping bag later that night, it occurs to me that before you can find yourself, you've gotta get lost.

As I slide into my sleeping bag later that night, it occurs to me that before you can find yourself, you've gotta get lost.

I finally find Deadhorse and take a quick, chilling swim in the Arctic Ocean before heading back. Wildfires are turning the forests to charcoal. At a roadside lodge, I meet some of the smoke jumpers who parachute into targeted areas with shovels, pulaskis, and tanks of water.

"We just try to protect property from the fire; there's no fighting fire here," they tell me.

There are about twenty of them at the lodge, one on crutches, having broken his leg upon landing. The lodge owner invites me to join the smoke jumpers for an outdoor BBQ: wild Yukon River salmon he'd caught just hours before. Though I'm in the land of the twenty-four-hour sun, tonight it is diffused by layers of smoke from the wildfires, turning it orange, yellow, and deep red.

The salmon—fresh and wild—is the best I've ever tasted. 🏴

There are hundreds of Native American totem poles in Sitka, Ketchikan, and the other cities and parks on the myriad of islands in the Alexander Archipelago in Southeast Alaska. The poles were carved to honor the dead, proclaim status, and tell family and clan histories.

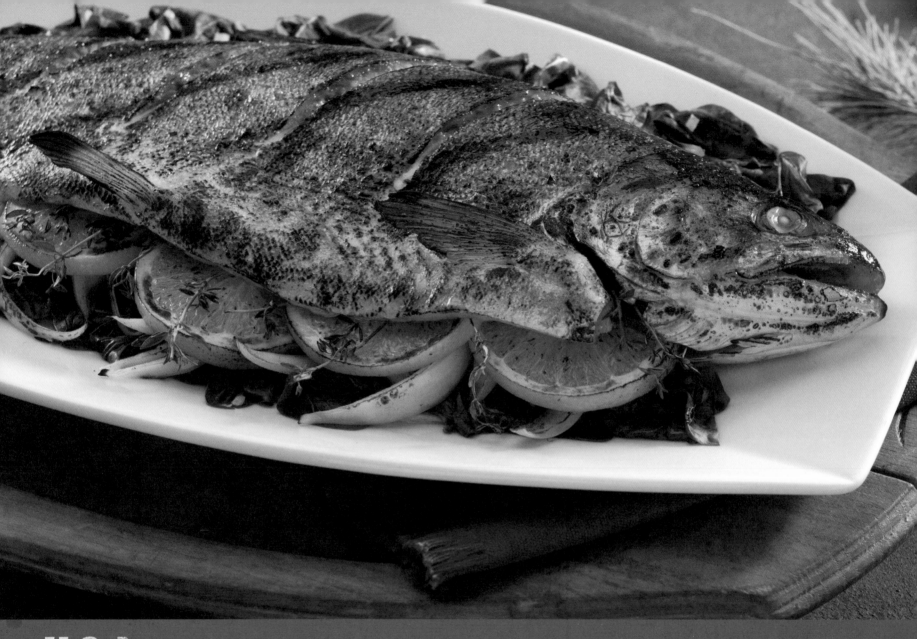

U.S.A.

I made it my mission to ride my motorcycle as far north as I could, to the end of the road, the Arctic Ocean. Along the way, I traveled through the Pacific Northwest, over the Colombia River, and into Canada and Alaska to the Yukon River. To me, nothing represents the Pacific Northwest and Alaska better than salmon. By coincidence and good fortune, I found myself sharing a small lodge in Alaska with a dozen firemen— smokejumpers who invited me to join a barbeque of fresh wild Yukon River salmon. This recipe is inspired by and in honor of firefighters all over the world, who risk their lives to save ours and our property.

Grilled Wild Alaskan Salmon with Garlic Sautéed Spinach

Ingredients

1 cup grapeseed or canola oil (for seasoning grill rack or basket)

1 whole Alaskan salmon, scaled and gutted, gills and fins removed (about 4 pounds)

Coarse sea salt and freshly ground white pepper

10 sprigs fresh thyme

1 medium yellow onion, peeled and thinly sliced

2 oranges, sliced, one reserved for garnish

½ cup dark brown sugar, loosely packed

2 tablespoons unsalted butter, at room temperature

½ cup apple cider vinegar

1 tablespoon lemon juice

½ cup honey

2 garlic cloves, minced

1 teaspoon chipotle chile powder

Sautéed spinach

1 tablespoon olive oil

1½ pounds baby spinach leaves, well rinsed and dried

3 garlic cloves, chopped

1 shallot, minced

1 tablespoon unsalted butter

Salt and freshly ground pepper, to taste

Preparation

1. Starting with a very clean grill rack or grill basket, generously coat it with all of the oil. If it's not pristine and clean, you may need more oil. (This is essential to ensure that the salmon doesn't stick to the grill. It's very important that the skin stay intact because it keeps the moisture and flavor in.)

2. Preheat grill to medium-high heat (300-350 degrees F). Rinse whole salmon inside and out in cool water and pat dry with paper towels.

3. Generously season the cavity of the fish and the skin with salt and pepper. Stuff the cavity with the thyme, onion, and half the orange slices. Make a few deep incisions with a knife on both sides of the fish, about two inches apart, almost to the spine, through the thickest part of the flesh and set aside until ready to grill.

4. Make the basting sauce in a small bowl by whisking together brown sugar, butter, vinegar, lemon juice, honey, garlic, and chipotle powder.

5. Brush one side of the salmon generously with the basting sauce, making sure to baste inside the incisions. Place the salmon on the grill, basted side down, and cover with the grill top, vents open.

6. After about 7 minutes, lift the cover and thoroughly baste the top of the fish. If using a fish basket flip over or use 2 large metal spatulas to loosen the salmon from the grate or rack and carefully turn it over. Close the lid and cook for about 8 more minutes. Open the grill lid and baste the top of the salmon with more sauce, turn over again, and cook for two more minutes. The salmon is done when the flesh is opaque and an instant read thermometer registers 135 degrees F when inserted in the thickest part of the flesh. Be sure not to overcook.

7. When the fish is done, remove it from the grill to a large platter, garnish with the remaining orange slices, and allow to cool for 5 minutes.

8. Meanwhile, prepare the spinach by heating the olive oil in a large skillet over medium heat. Add the spinach, garlic, and shallots, and sauté until wilted and tender, about 2 minutes.

9. Remove from heat and, with a slotted spoon, transfer spinach to a serving bowl. Toss with the butter and season with salt and pepper to taste. To serve, place a scoop of spinach in the center of a serving plate and top with a portion of the salmon.

Canada

YUKON
TERRITORY
Whitehorse
enzie River
Echo Bay
Great Bear
Lake
Watson
Baffin
Island
Davis Strait
★ Nuuk (Godthab

Capital Rewards. The two college students stumbling down Main Street in Bend, Oregon, clearly have been over-served by the local bartenders. Their voices and laughter echo off the stone buildings, now all closed, as is the restaurant where I've spent the evening eating and working on my laptop. They almost run into me on the sidewalk.

"Hey!" The tall, lanky guy startles me. "You."

The other man, short and stocky and swaying, has to be held up by his friend.

"What's the capital of Canada?" The alcohol on his breath nearly makes my eyes water.

"You guys from Canada? I'm heading to British Colombia and the Yukon," I say, trying to connect.

"Come on, answer. What's the capital of Canada?" The lanky guy lets go of his friend, who stumbles for balance.

"That's easy," I say. "Ottawa. Ottawa, Ontario."

Seemingly puzzled, they look at each other and then to me, somewhat sobered.

Then they slip back into character, hooting and slapping their hands in high-fives. "Yay, fuckin' ay, you win!"

"You're the only person in this w-h-o-l-e town that knows that," one says. "How'd you know?"

They've been asking that question of nearly everyone they've met while exploring the Pacific Northwest on a two-week trip from Calgary.

"You guys," he says, referring to U.S. citizens, "just don't know. I don't know what's up with all those Americans. They all think it's Toronto." He shakes his head. "Toronto!"

Size: 9,984,670 sq km (2nd in world)

Population: 34.6 million (37th in world)

Capital: Ottawa (1.2 million)

Largest city: Toronto (5.4 million)

Independence Day: 1 July 1867 (union of British North American colonies)

World Heritage Sites: 17

Literacy rate: 99%

Currency: Canadian dollar

Population below poverty line: 9.4%

Key exports: plastics, fertilizers wood pulp, timber, crude petroleum, natural gas

Mobile phones: 27.4 million (37th in world)

They're right; even though the United States shares its largest border with Canada, most Americans know little about Canadian history...or geography. Two days later I'm headed up through British Colombia and don't realize its size until I'm some 600 miles north of Vancouver. I travel another thousand miles before crossing into the Yukon, where conversations at gas pumps get interesting.

"Be sure you stop for gas anytime you see a gas station," a tall, gruff mountain man tells me. The bed of his pickup is rusted through so much I can see its rear axle. "They open late and close early."

The distance between towns and gas stations grows the further I travel north. And with each night, I have more daylight and can travel longer before settling in for the evening. The sweeping turns, wilderness vistas, and good road conditions make the vast distances tolerable.

"That's right, British Colombia is about four times bigger than the United Kingdom," another overland traveler in a massive luxury RV shares. He seems happy to find an interested traveler he can impress with his accomplishments and knowledge.

"This is my sixth trip up the Alcan," he says, referring to the road we both are traveling, the Alaska-Canadian Highway. "It's about 2,300 kilometers long (1,400 miles)."

Feeling temperatures dropping, I pull out my electric vest. He boards his climate-controlled house on wheels.

Also known as the Alaska Highway, most of this pioneer road runs through Canada. Today it's completely paved and in fairly

good shape. It wasn't until 1941 that the idea of linking the lower forty-eight states with the Alaskan territory was given serious consideration. After the attack on Pearl Harbor, the US feared the Japanese might continue its Pacific conquest. Alaska seemed a likely target. There was no way to get troops, supplies, and equipment overland into Alaska across the rugged topography of British Colombia and the Yukon. The timing was right to build a road.

In what's considered one of the most spectacular engineering feats in US history (much of it, ironically, in Canada), 1,600 soldiers and civilians carved through 1,700 miles of dense spruce forest to build a road at a rate of about ten miles per day. They completed it in just eight months.

Though I can hardly imagine the conditions the workers of this highway had to deal with more than sixty years ago, I am hypnotized by the majesty and beauty of the country the road winds through. I often find myself slowing to a crawl and then drifting into the other lane as I gaze around me, craning my neck up to take in mountain peaks, then to the right and left to gaze upon their reflections in glacial lakes.

Parts of the road follow the natural flow of mountain streams. I pass provincial parks that seem lonely and begging for attention, with vacant parking lots and pull offs.

Not only are gas stations scarce, so are other services, allowing me to experience the serenity and soul-calming beauty of these forest and raw alpine landscapes. Sometimes they're a little too raw. Although the brooding clouds hovering above the

As I traveled north on the Alaska Highway and the days grew longer, I found I had to force myself to stop and rest. The idea of camping under the sun was unappealing, so I took refuge in cabins where I could pull the shades to darken the room.

Northern Canadian Rockies create drama and invoke intrigue, the unfortunate side effect for a motorcyclist is rain. And it keeps raining, hammering me with drops heavy on my coat, beaded on my helmet, and draining into my boots. Rain, rain, wet rain.

It's a good thing I move faster than the rain. It isn't long until I'm rewarded with sun and wildlife. Near Summit Lake, I find fearless stone sheep roaming the highway. Later, hundreds of buffalo, including one of the biggest bulls I've ever seen, huddle together on both sides of the road.

I let the rain and weather in general affect me too much. Sure, it makes me wet, but it makes me tense, too. I soon learn to take a cue from the animals around me. Unfazed by climatic shifts, the wildlife—goats, elk, sheep, and buffalo—go about their business, rain or shine. So I decide to go about mine, and continue riding, open and free of tension.

For the next several hours I ride happily, so much so that it is nearly midnight when I check the time. The sky offers no clue; it seems like twilight. I've been on the road for more than fourteen hours and have logged more than 500 miles. Too tired to make camp, I stop in White River Crossing and awaken a woman so I can rent a cabin for the night.

She leads me into a small shop to register and pay for the room, then shows me the showers, laundry, and my meek cabin. It has two beds, extra blankets, a small refrigerator, but no bathroom.

"Can I buy a beer," I ask, "and do you have any food?"

It has been a ritual these past long days while riding through BC: I've eased into most evenings with a cold beer and a homemade meal. That's all you can find this far north—real food and brew.

"Nope. Sorry. We don't have a restaurant, and we don't sell beer," she says, but recognizing the disappointment in my face, she asks, "Where'd you ride from?"

"Watson Lake." I crossed into the Yukon the night before.

"Wow, that's a long ride."

Outside my cabin, I perform my nightly ritual of unpacking my bike and getting out of my riding suit into normal clothes.

The woman returns a few minutes after I'm done. In one hand she holds a plate of venison with blueberry sauce and in the other a can of Budweiser.

"Here," she says, handing me the frosty can and setting the plate on my bed, "This one's on me. Eat, drink, and get some rest."

As she walks away I ask, "Whitehorse, right?"

Confused, she asks, "What?"

"The capital of Yukon Territory, it's Whitehorse, right?"

"Yes, you're right—Whitehorse." 🇨🇦

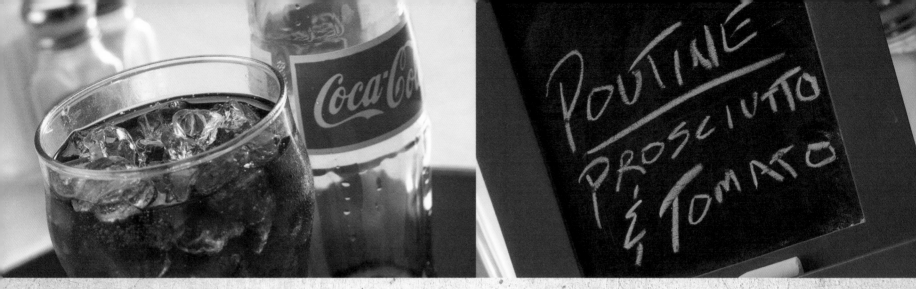

POUTINE
PROSCIUTTO
& TOMATO

Canada

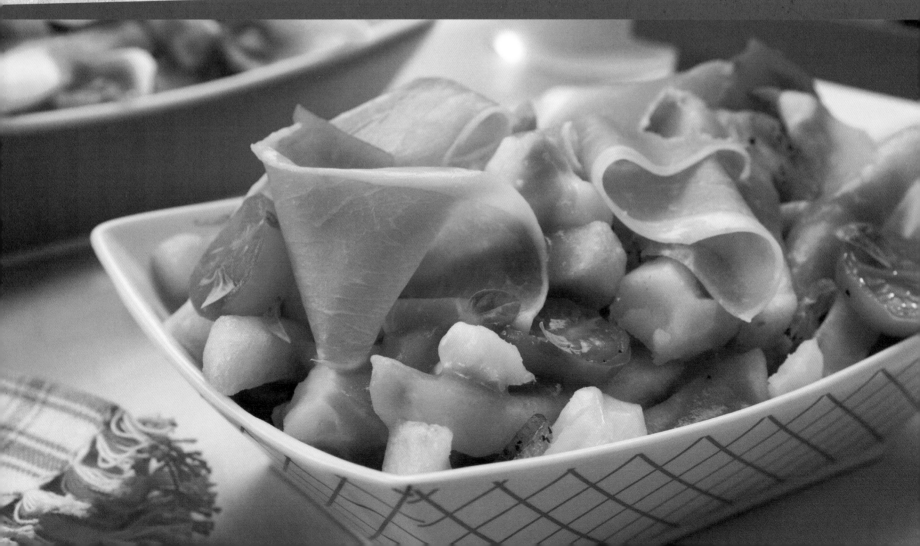

Though my travels through Canada were entirely through the western provinces and territories, it's impossible to escape this eastern Canada, Quebec-originated dish of fresh fries, cheese curds, and gravy. I imagine some Canadians may stick up their noses at poutine and shudder at the notion that it may be considered the quintessential dish. The truth is, poutine is a Canadian phenomenon, and variations of these fast-food delicacies are popping up in the United States and Europe. After many miles of cold riding, I was happy to find warmth and comfort from a deliciously prepared poutine in Whitehorse in the Yukon. This particular version of the Canadian classic is inspired by Nadia G.

Poutine
Yukon Potatoes with Cheese Curds, Cherry Tomatoes and Prosciutto

Ingredients

6 to 8 large Yukon gold potatoes

2 tablespoons granulated sugar

1 tablespoon grapeseed or canola oil

2 shallots, thinly sliced

1 garlic clove, minced

4 cups beef stock

1 tablespoon apple cider vinegar

1 tablespoon whole green peppercorns

Dash Worcestershire sauce

2 tablespoons unsalted butter

2 tablespoons all-purpose flour

Pinch fresh thyme leaves

¼ cup freshly minced parsley

1 pint cherry or grape tomatoes, halved

¼ cup roughly chopped basil leaves

2 cups cheddar cheese curds

¼ pound thinly sliced prosciutto

Salt and freshly ground black pepper, to taste

Canola or grapeseed oil, for frying

Preparation

1. Clean and peel the potatoes. Cut into fries or use a French-fry cutter. Fill a large bowl with very cold water and mix in two tablespoons of sugar. Put the potatoes in the water for at least an hour, or if possible, overnight for extra crispiness and sweeter flavor. Heat the oil in a medium saucepan over medium heat and sauté the shallots, stirring often, until golden brown, about 10 minutes. Transfer shallots with a slotted spoon to a paper-towel-lined plate. Season with pepper only and set aside to crisp for 5 to 10 minutes.

2. In the same saucepan, add the garlic, stock, cider vinegar, peppercorns, Worcestershire sauce, and the crispy shallots and bring to a boil then simmer.

3. Meanwhile, in a saucepan over medium-high heat, make a roux by melting the butter and slowly adding the flour, stirring constantly for 2 to 3 minutes or until the mixture browns slightly. Add this roux to the other saucepan with the shallot sauce, stirring well. Lower the heat and allow the sauce to reduce by half and thicken by simmering for about 30 minutes. Stir in the thyme and parsley, season with salt and pepper to taste and set aside. Keep warm.

4. Preheat the oven to 400 degrees F. In a medium bowl, toss the tomatoes with grapeseed oil and spread out on a rimmed baking sheet. Sprinkle with salt and pepper and roast in the oven for 15 minutes, until tomatoes are soft. Transfer to a bowl and sprinkle with the basil. Set aside.

5. For the fries, add oil to a Dutch oven or deep fryer and heat to 300 degrees F. Remove the potatoes from the water and pat dry with a towel. Fry the potatoes, in batches if necessary, for 2 minutes, then transfer to a wire rack on a baking sheet. As they start to cool, increase the temperature of the oil to 375 degrees F. Place the fries back into the hot oil and fry until golden brown and crisp, 1 to 2 minutes. (This double-fry method is the secret to crispy fries.) Transfer to another wire rack and baking sheet and season with salt and pepper.

6. To serve, divide the fries into four bowls and top each with cheese curds. Ladle a generous portion of the gravy over the fries and cheese. Then top each dish with roasted tomatoes and a few slices of prosciutto. Serve immediately.

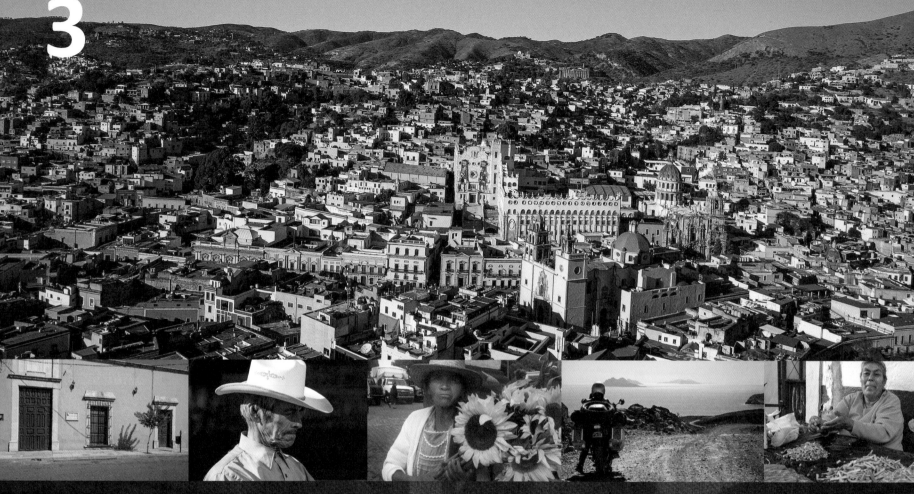

Mexico

NORTH
PACIFIC
OCEAN

ISLAS
TRES
MARIAS

Tepic

Zacatecas

Aguascalientes

Guanajuato

San Luis
Potosi

Ciudad Mante

Tampico
Ciudad Madero

Progreso

Merida

Coffee with Salt & Pepper and a Bottle of Wine. For the first

time, the reality of my endeavor comes into focus. I am about to enter Mexico—the first of what will be sixty-two international borders I'll cross during my three-year journey. Only one truck is waiting to cross the dusty track into Tecate, Baja California, Mexico. For me, Baja will be no weekend party, as it is for many Americans. It will be the end of my journey on familiar roads and my access to triple-A roadside service and friends and family with my mobile phone. It will be the true beginning of my global adventure.

 I decide to forgo the coastal route through Mexico's famous beaches, and instead take the colonial route through the Sierra Madre Mountains. To get there I tackle the harsh roads and 110-degree weather of Baja California, before hopping over to the mainland. Then, after traveling south for three weeks without a plan, itinerary, hotel reservations, or any specific route, I ride into the rich colonial city of Zacatecas. Founded in 1546 after silver was discovered in the surrounding mountains, it's about 640 kilometers (400 miles) north of Mexico City.

The city is abuzz with energy: it's the middle of the annual Festival de Teatro de Calle (International Street Theatre Festival). Clowns, mimes, dancers, musicians, and other performers act and play in the streets, in the plazas, and on stages throughout the historic district, which is marked by a series of beautiful colonial buildings, including an impressive baroque church, the Catedral de Zacatecas, and the 19th-century Fernando Calderon Theater.

I have decided to keep with my rule to remain flexible, open to sudden changes in timing or destination. So when Hector, in a quick and confident strut, crosses the street and approaches me, I have no idea that my morning's packing and departure preparations have been for naught. Dressed in a clean, single-breasted black sport coat over a white t-shirt with a faint coffee stain, Hector sports a thick,

Size: 1,964,375 sq km (14th in world)

Population: 116 million (11th in world)

Capital and largest city: Mexico City (19.3 million)

Independence Day: 16 September 1810 (from Spain)

World Heritage Sites: 32

Literacy rate: 86.1%

Currency: Mexican peso

Population below poverty line: 51.3%

Key exports: oil and oil products, fruits, vegetables, coffee, cotton

Mobile phones: 94.6 million (13th in world)

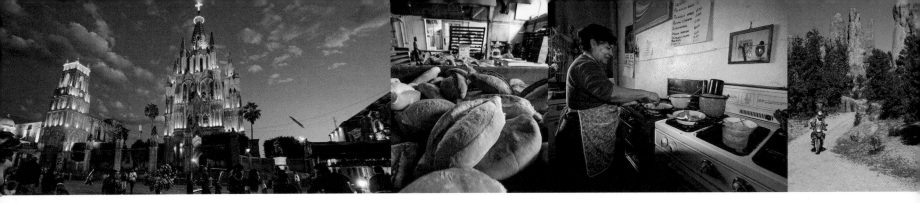

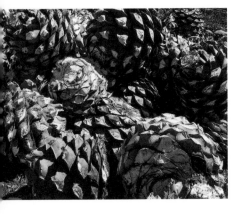

In the desert south of Oaxaca, I found artisan distillers of mezcal, made from the blue agave plant. Mezcal piñas, the sugar-rich heart of the agave, will be baked over charcoal in a conical, rock-lined pit (palenque), giving mezcal a distinct, smokey flavor.

salt-and-pepper mustache, which frames his gentle smile. That and a crisp, white fedora with a thin, black band lend him an air of casual elegance. He wears everything well, even the coffee cup he has wrapped in his well-manicured sixty-seven-year-old fingers.

"The best coffee in town. You want some?" he asks, his eyes locked onto mine.

A Mexican national who spent several years in the U.S. military, Hector speaks perfect English. The young man walking with him uses few words, but his eyes and smile speak volumes: He is in the company of a legend, a sophisticated man of means, taste, and class. In the young man's hands is a brown bag, tightly wrapped, revealing a shape all too easy for me to identify.

"Is that a bottle of wine?" I ask, pointing.

"Wine? Yes," Hector rolls down the paper bag, revealing the label. "Unique, from Fresnillo. You want a bottle?" he asks.

I falter, trying to imagine adding any more weight to my already overloaded motorcycle.

"You want a bottle, or not?" he asks again, pushing for my answer, slightly puzzled by my hesitation.

"Si! Yes, I'd love a bottle, where can I get one?" The words tumble out.

He leads us across the street through a courtyard and into a tiny shop. Wine bottles line the walls, several sitting on velvet

in glass cases. In rapid-fire Spanish, Hector speaks to the cute brunette behind the counter, too fast for me to understand. She pulls a bottle from one of the glass cases, wraps it neatly in paper, and rests it gently into my hand.

I reach for my wallet, asking, *"Cuantos?"* (How much?).

She shakes her head and points to Hector. No money is exchanged between any of us.

"Coffee?" he asks, adding, "The best coffee in town isn't easy to find. Go between the two lions. There's no sign."

He leads us to the coffee shop, where the host greets him by name and seats us at small, round table. Hector asks me if I would like salt and pepper with my coffee. I'm mystified. I wonder if this is yet another Mexican cultural tradition that I've yet uncovered or if he is as strange as the circumstance I find myself in. The waiter places two small canisters on the table. One black. One white. I'm hesitant but game to try new things, even salt and pepper in my coffee. I lift the covers and find sugar in both. He laughs as he pulls out a pack of cigarettes, flicks his wrist, and pulls out a smoke with his lips.

For the next several hours he takes me on a walking tour of Zacatecas while telling stories of his escapades in the United States, women he's conquered, and his family in Mexico. We wander around a colorful food market, where we sample the local flavors, including tuna, a slightly sour fruit from desert cactus, fresh-squeezed fruit juices, and more. From an elderly man in

Mexico

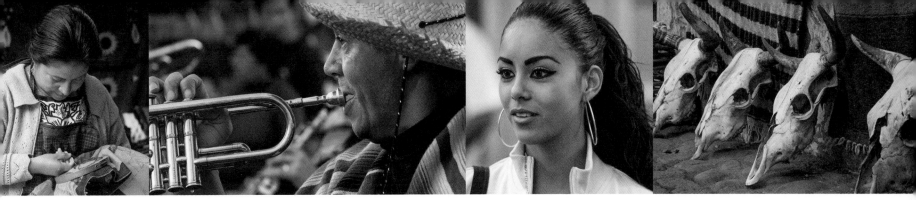

I realize, as I walk back to my hotel and motorcycle, that although I had been in Zacatecas for three days, today I have experienced a slice of life in Zacatecas that I would have missed had I not met Hector, and how important it is to remain open and available to new experiences and meeting new friends.

torn clothes sitting on a concrete stoop, he buys a taste of sweet honey carved out of freshly harvested beehives. He hands the man four times the asking price, refusing to take the change. He doesn't let me pay for anything. Most of the merchants recognize and greet him, and he stops to make jokes with school children.

We walk through several beautifully restored *haciendas* (mansions), once homes to colonial-era aristocrats and silver barons, and then into a restaurant where more than fifty chickens are slowly roasting on rotisseries above a wood-burning fire.

"It's time for lunch," he commands. He orders chicken, prepared three different ways: lemon garlic, honey glazed, and spicy. "You must try all the preparations," he says, smiling as he places the chicken and paper plates on a red picnic table surrounded by brightly painted chairs. We eat and laugh.

Our tour continues, and I realize that it's too late to get back on the road and hope the hotel I checked out of this morning will have room for me again tonight. I feel sad; I must say another goodbye. Hector doesn't use e-mail and suggests when I return to Zacatecas to simply ask around, someone will find him. He hugs me and

reminds me to share the wine with new friends. He lifts the hat off his head and places it over his heart, "Goodbye, my American friend, be safe."

I realize, as I walk back to my hotel and motorcycle, that although I had been in Zacatecas for three days, today I have experienced a slice of life in Zacatecas that I would have missed had I not met Hector, and how important it is to remain open and available to new experiences and meeting new friends.

As I nod off to sleep, I reflect on my day. I'm not sure what triggered Hector's beeline approach to me this morning. Do I look like a coffee drinker? Are all gringos looking for the best coffee? Or was there a connection? I realize most tourists move in the opposite direction when approached by a stranger, fearing a threat or just someone looking to peddle souvenirs or trying to rope people into a shop or restaurant. That's because most tourists, in Mexico and other parts of the world, hide behind a visor, constantly guarded, if not afraid. That's too bad, because the most precious travel memories come not from museums, historical artifacts, or beautiful landscapes, but when connecting and sharing with newfound friends. ▌•▌

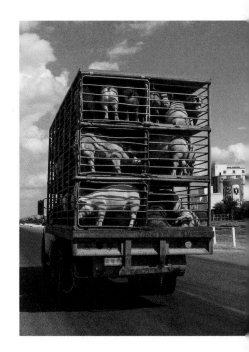

As I made my way more or less around the world, I was constantly amazed. Often the oddities I saw made me smile, cry, hesitate, and even stop to wonder or wander. I got very good at pulling out my camera to take pictures while riding, but don't tell my mom.

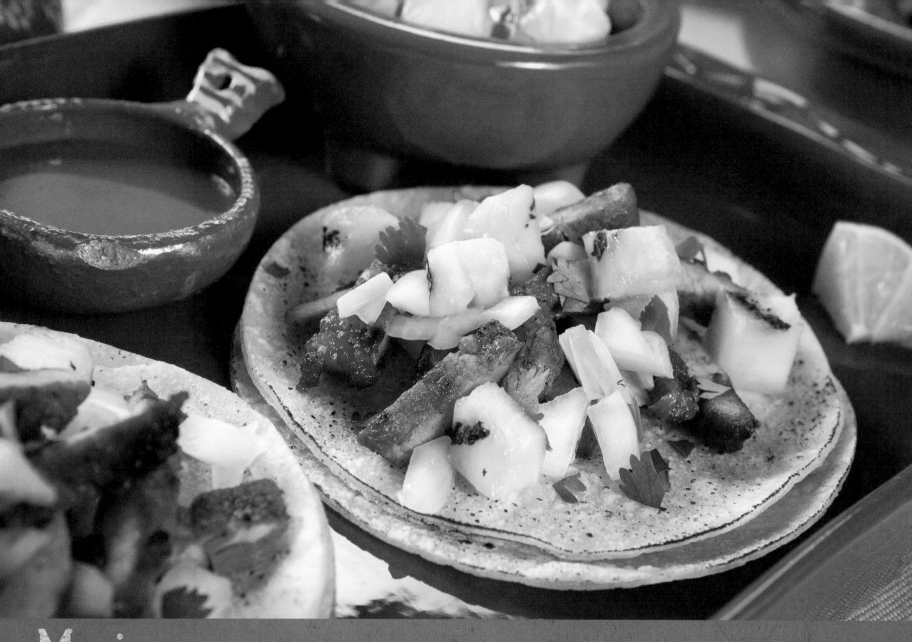

Mexico

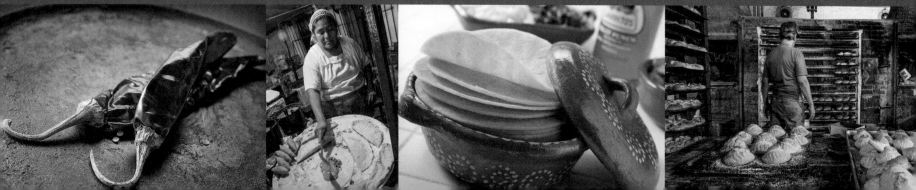

Tacos with pineapple? If you've never had tacos al pastor, you truly haven't enjoyed real Mexican street food. Literally translated as shepherd's tacos, they were inspired by Lebanese immigrants who brought vertical-spit-roasted meats to Mexico in the early 20th century. Here the pineapple is used as a marinade and makes the meat tender. I ate about a dozen of these one evening after being served too many beers by my new Mexican friends. You may want to double this batch and have friends over. Ask them to bring the beer!

Tacos al Pastor
Grilled Pork and Pineapple Street Tacos

Ingredients

1 3-pound pork roast, shoulder, or butt

Grapeseed or canola oil for frying

1 pineapple, peeled, cored, and cut into ½-inch-thick discs

Marinade

4 cups water

2 dried ancho chiles

1 dried guajillo chile

1 bay leaf

½ large yellow onion, roughly chopped

2 ½-inch slices fresh pineapple, roughly chopped

6 garlic cloves

1 tablespoon kosher salt

1 chipotle chile, in adobo sauce

1 tablespoon adobo sauce

¼ cup white vinegar

1 teaspoon cinnamon

1 teaspoon dried oregano

1 teaspoon cumin

¼ cup achiote paste

To serve

32 small and thin corn tortillas, warmed

1 bunch cilantro, finely chopped

1 yellow or sweet onion, minced

3 limes, cut into wedges

Preparation

1. Place the roast in the freezer to make it firm and easier to slice later.

2. Meanwhile make the marinade by filling a medium sauce pan half way with water and combine with ancho and guajillo chiles and bay leaf. Bring to a boil and immediately remove from heat. Set aside. When the chiles are rehydrated, stem, seed, and place into a food processor or blender with the onion, the 2 pineapple slices roughly chopped, and remaining marinade ingredients, and puree until smooth. Pour into a medium saucepan and bring to boil. Remove from heat and set aside to cool.

3. Remove the pork from the freezer and slice into ¼ to ½-inch slices. Place pork into a large ziplock bag, pour marinade over pork, and seal bag while removing excess air. Turn the bag over in your hands several times, massaging it and coating the pork with the marinade. Place bag in refrigerator and let marinate for at least 4 hours, preferably overnight.

4. In a cast iron skillet, heat about a tablespoon of oil over medium-high heat. Working in batches, cook all the pork until browned and no longer pink, about 2 minutes per side. Transfer to a plate and keep warm.

5. In the same pan over medium heat, brown the remaining pineapple slices, working in batches, and transfer to a cutting board. Cut into ½-inch cubes and place in a serving bowl.

6. Assemble the tacos by using 2 of the warmed small corn tortillas per taco. Fill with a portion of pork, then top with pineapple, onion, and fresh cilantro. Squeeze lime over the top and enjoy!

Pineapples can be found throughout Mexico at roadside stands, cut up into small chunks in a plastic cup or carved delicately like an edible sculpture and served on a stick.

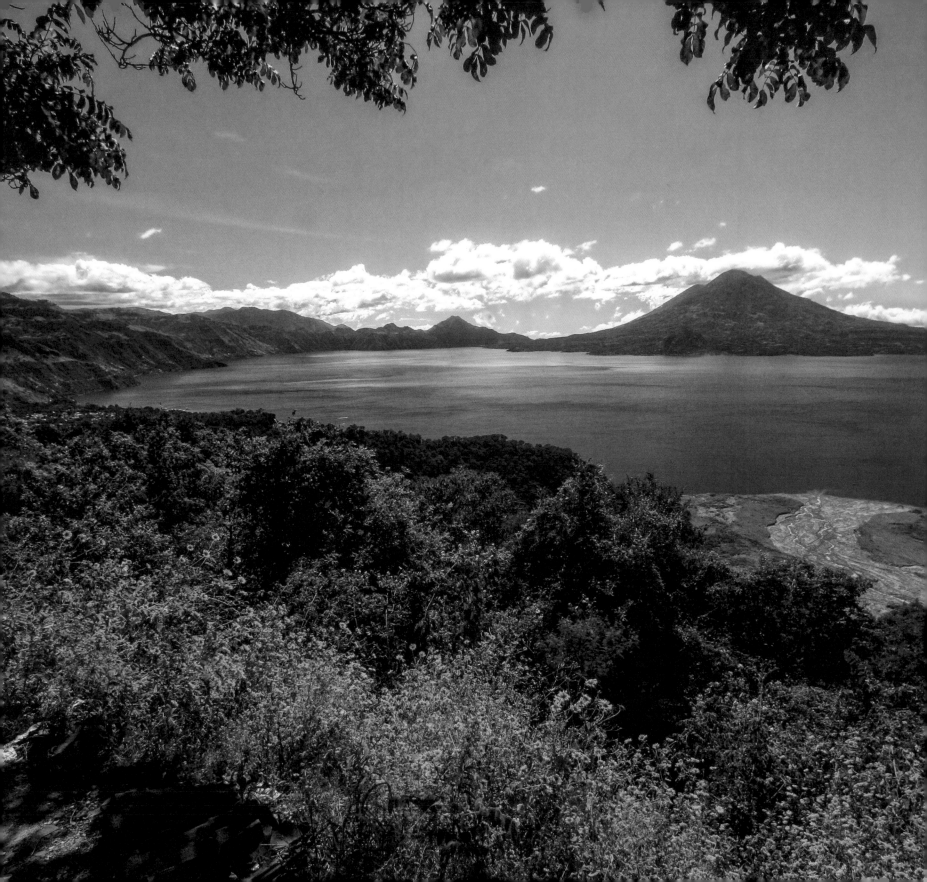

Central America

> One's destination is never a place, but a new way of seeing things.
>
> – Henry Miller

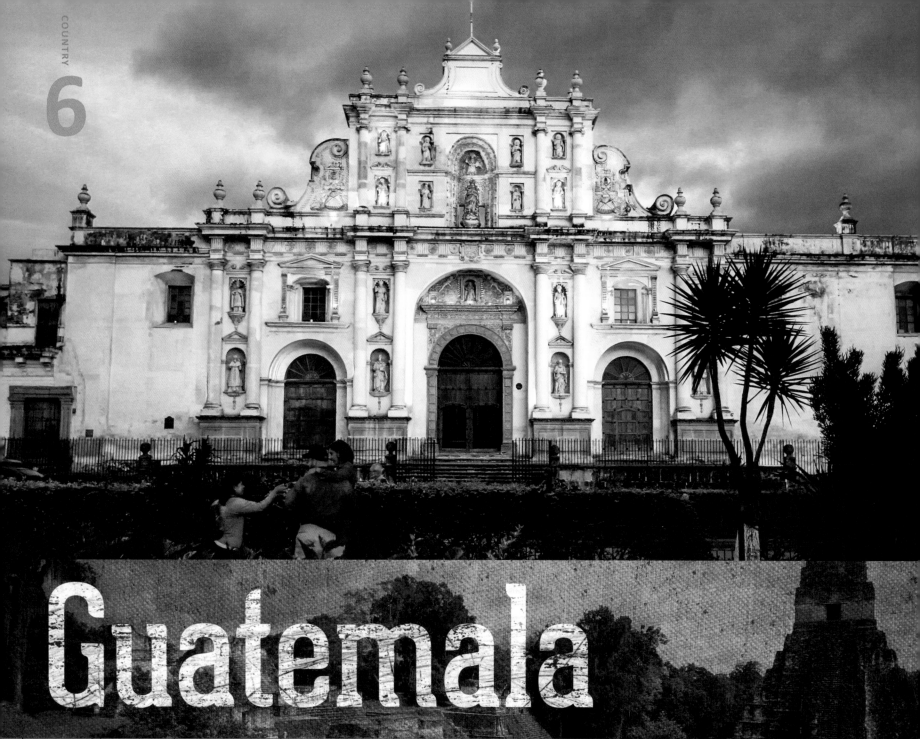

Guatemala

Coatepeque

Chimaltenango

Jalapa

Mazatenango

Antigua

Guatemala City

Retalhuleu

s

Concepcion las Minas

A Paradox.

I wish I hadn't seen the photo on the cover of the daily newspaper that rested on the worn steel desk in the customs office. The stale stench of nicotine is enough to make me nauseous, but the photo, even in black and white, of three dead bodies covered in blood, one headless, makes my stomach turn. "What am I doing here?" I wonder.

Most of the nearly two million tourists who visit Guatemala each year arrive in the small country by plane, and then are shuttled in tourist vans to Antigua, the Mayan ruins of Tikal, or any of the few popular spots on the tourist circuit. Me? Far from any airport, city, or the comfort of air-conditioned private vans, I arrive in Guatemala by land, through a tiny outpost in the northern jungle from Mexico.

"*Drogas. Drogas,*" the customs guard repeats, explaining to me that the dead bodies are the result of the drug war. I'm not sure what is more disconcerting, his wandering eye or the AK-47 draped over his shoulder. The more he tries to calm me down and tell me not to worry about dead bodies or the violence that plagues this border, the more I want to tell him, "Sure, easy for you to say, you've got the gun."

My original plan was to enter Guatemala from the east, through the country of Belize. Hurricanes have changed that. Perhaps this isn't the best time to be traveling through Central America, but who knew that the fifteen hurricanes that would cause a swath of destruction from the Pacific Coast of El Salvador to the Gulf of Mexico and the southern United States would be among the worst in recorded history? Hurricane Katrina has already devastated New Orleans, Wilma has wiped out Cancún and the Yucatán Peninsula in Mexico, and Stan has drenched Guatemala, burying complete villages under devastating mudslides.

I'm riding a motorcycle through the middle of it.

As I travel south, toward Antigua, evening is beginning to fall, yet it is not only my never-ride-in-the-dark dictum that makes me anxious. What should be an easy ride to Lago de Atitlán (Lake Atitlan), turns out to be a test of patience, riding skill, and confidence. There are no

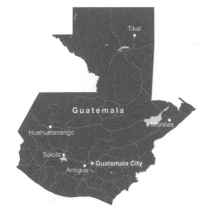

Size: 108,889 sq km (107th in world)

Population: 14.4 million (69th in world)

Capital and largest city: Guatemala City (1.1 million)

Independence Day: 15 September 1821 (from Spain)

World Heritage Sites: 3

Literacy rate: 69.1%

Currency: Guatemalan quetzal

Population below poverty line: 54%

Key exports: bananas, coffee, cardamom, fruits and vegetables, sugar

Mobile phones: 20.7 million (47th in world)

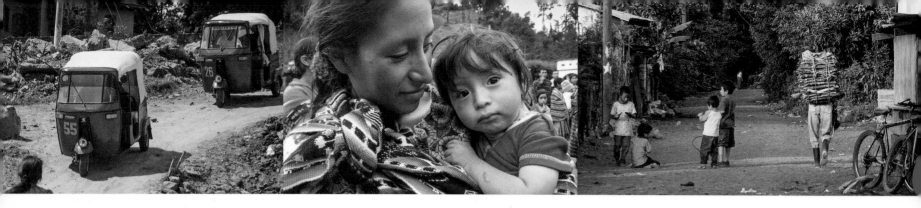

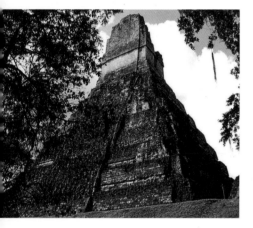

The most impressive Mayan ruins in the Americas are found in the jungles of Guatemala. The grandaddy of them all is Tikal, where ancient pyramids rise high above the jungle canopy. It's said there are even larger ruins engulfed by the jungle that will take dozens of years to discover and unearth.

signs warning that a bridge ahead has washed away in the storm. Nor do I guess that the drivers in the steady stream of oncoming traffic are all victims of the same fate—a dead end—until I find myself there. We all have to turn around on the narrow and crumbling cliff-side road and head back. This costs me time and sunlight.

With images of dead and headless bodies streaming through my mind and the thought of unmarked obstacles and animals wandering the unlit road in the dark of night, to admit I am afraid would be a gross understatement. Fortunately, the concentration required to see the road and keep my motorcycle upright helps me forget, if only temporarily, that I am indeed traveling in harm's way.

Usually the sight of my modern BMW motorcycle, high-tech textile riding suit, and space-age helmet attracts attention from locals in remote villages, but this time I am surprised. In spite of dangerous, dark roads, I've arrived here not only without incident but without anyone seeming to notice. Though I am relieved, my new surroundings are not pretty. Drivers honk their noisy horns and kick up dust from the dirt roads. And, like smoke wafting in a search beacon, dust lends headlight beams ghostly dimensions, making the village of Sololá seem like the scene of a disaster. It looks like a dump, a Mayan shanty town.

Though I couldn't then, I would see many days later that Sololá, marked by an outdoor market filled with colorful textiles, fruit, and vegetables, is the center of a charming Mayan community,

and the real disaster is on the other side of the lake, where, just a week before, a mudslide buried more than 500 people and turned an entire town into a graveyard.

As I hop on a boat to cross Lake Atitlán, gray skies threaten, and halfway across I realize the waves beneath those whitecaps are bigger than they'd looked from shore. I futilely try to keep my camera dry from the spray flying off the bow of the boat.

Once ashore, I learn that much of the fruit sold in the Sololá market comes from here, villages like Santiago de Atitlán, where the mineral-rich soil is fertile thanks to the volcano towering above. I taste that richness in the fruit, especially the freshly picked oranges squeezed into my juice. The woman who squeezes them gives me clean towels to dry my camera. Flirting while practicing my Spanish, I suck down an entire glass in under a minute. So clean, fresh, and tasty. I ask for another. At home I rarely drink orange juice, yet when I do, it is usually poured from some sort of container after spending days on a truck. Here, there are no Styrofoam cups, nothing plastic, and no cardboard cartons. It's as if I am in her kitchen, drinking from her glass. She giggles.

Most of the townspeople seem happy, smiling despite the fact that many of their friends, neighbors, and family have perished in the mudslide days before. Children play in the street. Down the alleys and in the fields, women carry fruit, bread, and infants wrapped in scarves woven from brightly colored yarn.

Guatemala

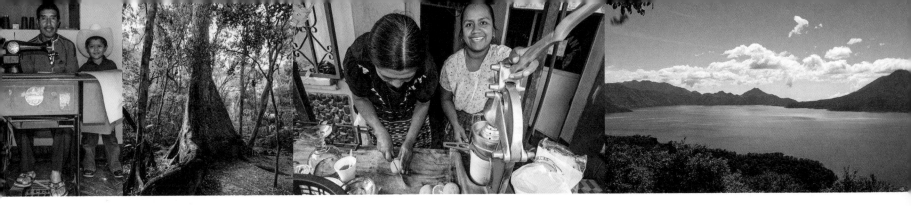

As I walk outside the city center toward Panabaj, the small, adjacent village now under about twenty feet of mud, I stumble. Looking down at my feet, I realize I nearly tripped on the roof of what was once a school. Two metal tubes protrude from the mud, the tops of goalposts. I am standing on the remains of a playground, a soccer field.

I walk up the path, now getting steeper, toward the volcano. Across a vast field of mud, dozens of crosses are planted in the ground, some surrounded by flowers, fruit, or small shrines built from corrugated metal once the roofs of homes. Nearby, I watch workers spread a white powdery substance, I guess it is lime, over the muddy terrain, while another truck follows, dousing it with water.

Once more, I look into the sky above, and then to the choppy waters of the lake, worried that more rain and storms will claim more lives. "When will it stop?" I wonder.

Days later and many miles south, I help a group unload a truck and distribute food rations to displaced locals. All of them are now without homes, many missing family and friends, and yet, despite the gravity and desperation of their situation, most smile, laughing as they patiently wait to get their share—a basic aid package of grains, canned beans, tortillas, corn, and a few packages of crackers.

The next day I wander the streets of Antigua—once the capital of Guatemala. The city is surrounded by three ominous volcanoes, and its streets are lined by colonial architecture from the 17th and 18th centuries. Here—among the restored cathedral, churches, monasteries, and grand pastel facades of municipal buildings—Europeans and Americans sip lattes, attend yoga classes, and study Spanish, when they are not dining in street-side cafés or rooftop terraces. Although I'm drawn to the history, architecture, and natural setting, something here doesn't feel right—or real. I find it hard to see the prosperity and abundance and not think about the death, poverty, and homelessness I've witnessed just days before.

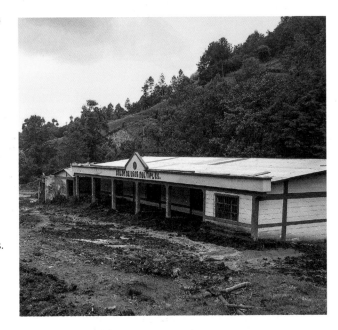

I was dismayed and saddened by the destruction caused by floods and the ensuing mudslides. This roadside eatery and market, swallowed by mud, will likely never open again.

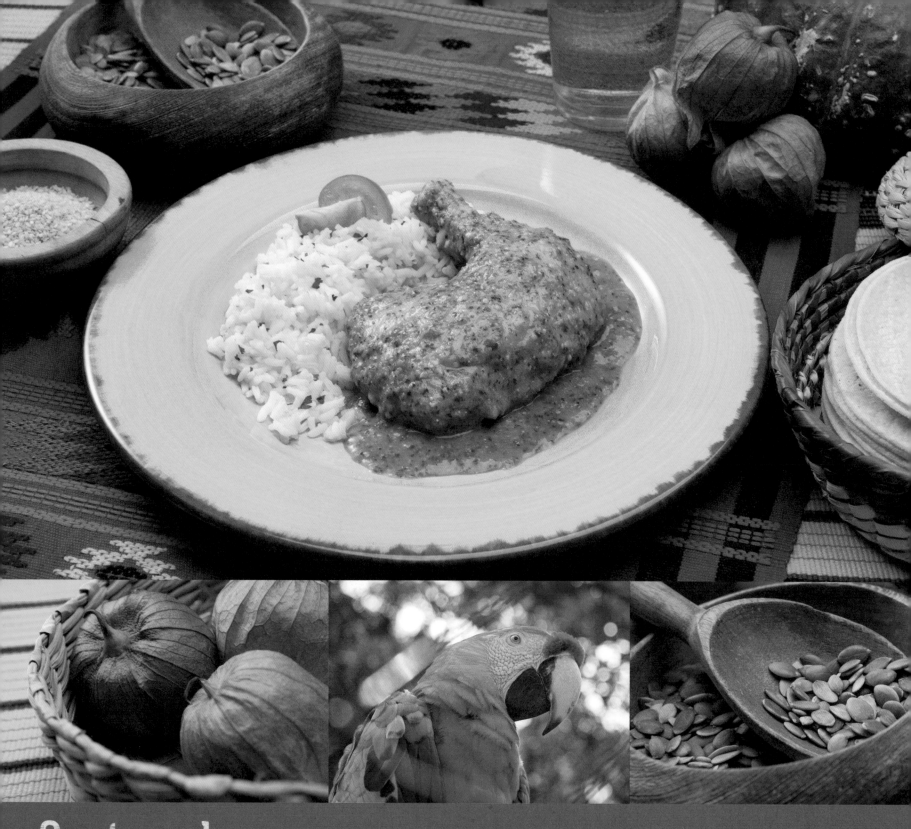

Guatemala

As in most Latin cultures in Central America, Guatemalan cuisine features corn, beans, rice, plantains, tortillas, and chiles. Yet what makes Guatemalan food unique is a flavorful blend of Mayan fare, with its use of pumpkin, sesame, and mint as well as fresh fruits grown in the rich volcanic soil throughout the country. Whether I dined at a roadside stand in a small Mayan village or in an upmarket tourist restaurant in Antigua, I could always find Jocón, tender chicken cooked and simmered in a light yet flavorful and strikingly green sauce made with cilantro and tomatillos. To me, the perfect accompaniment to this dish is a plate of fresh cut and stuffed cucumbers, also a Guatemalan staple.

Jocón
Chicken Simmered in a Tomatillo Cilantro Sauce

Ingredients

1 whole chicken (2½ to 3 pounds), cut into serving-size pieces

5 cups water

2 teaspoons salt

2 medium corn tortillas, roughly chopped

¼ cup sesame seeds

¼ cup pumpkin seeds (substitute with additional sesame seeds if unavailable)

1 cup tomatillos, hulled and chopped

1 bunch cilantro, chopped

1 bunch green onions, greens only, chopped

2 jalapeño or serrano chile peppers, seeded and chopped

2 cloves garlic, peeled

2 cups steamed white rice for serving

Preparation

1. Place the chicken, 4 cups of water, and salt into a large pot over medium-high heat. Bring to a boil, reduce heat to medium-low and simmer for 30 minutes to 1 hour, until no longer pink. Then remove the chicken to a bowl and set aside to cool. Strain and reserve the broth.

2. Soak tortillas in a bowl with a cup of water for 10 minutes, drain and set aside.

3. Heat a dry skillet over medium heat. Add the sesame and pumpkin seeds to toast, stirring occasionally to prevent burning. After 5 minutes, or when lightly browned, remove from skillet to cool.

4. When cool, remove meat from the chicken bones and shred it with your fingers. Set aside.

5. Place cooled seeds in a food processor or blender and pulse or grind for about a minute until nearly fine.

6. Add tomatillos, cilantro, green onion, chile peppers, garlic, and soaked tortillas to the food processor or blender containing the ground seeds. Add 1 cup of the reserved broth. Using the pulse button, puree or blend at high-speed until the sauce is smooth, about 1 to 2 minutes. Set aside.

7. Return the shredded chicken to the pot. Pour in the sauce and slowly add 1 to 1½ cups of the remaining broth to give it a sauce-like consistency. Simmer over medium-low heat for about 20 minutes, stirring occasionally, until tender and flavors integrate. Season with salt and pepper to taste and serve in bowls over the steamed rice.

Variations

Leave chicken on the bone (as pictured).

If you prefer, use cubed pork instead of the chicken. Don't shred the pork, but simmer it longer so it will become tender.

Honduras

Translations and Motivations.

Travelers and tourists, the difference between which is defined by motivation, come to Copán Ruinas in Honduras to visit perhaps the world's most well-restored and historically significant pre-Colombian Mayan ruins. Tourists are motivated by personal bucket lists and the desire to check things off. Travelers are inspired by the journey, and although the destination is certainly important, they are motivated by curiosity: the desire to learn, experience, and feel something about the places they visit. Tourists follow itineraries. Travelers follow their hearts and dreams.

I'm a traveler.

As twilight fades to moonlight and the sky darkens to a deep mood of indigo blue, I finally arrive at the small town of Copán Ruinas, a good thing considering the anxiety I feel when riding my motorcycle in the dark.

At first glance, Copán Ruinas appears to be no different from most Latin American towns. Home to about 8,000 Hondurans, the hub of culture and life here revolves around the *parque central,* the central park. Cobblestone streets surround and radiate a couple blocks from the park and then turn to dirt and eventually cornfields or pastures.

At the *parque central,* a group of Czech backpackers playing Hacky Sack are interrupted by the sound of my motorcycle. Fascinated by my bike and my journey, they ask for advice about travel in Guatemala and then direct me to a nearby hotel with affordable accommodations, though when I arrive I discover a busload of German tourists have beaten me to the last rooms.

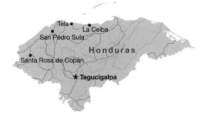

Size: 112,090 sq km (103rd in world)

Population: 8.5 million (93rd in world)

Capital and largest city: Tegucigalpa (1 million)

Independence Day: 15 September 1821 (from Spain)

World Heritage Sites: 2

Literacy rate: 80%

Currency: Honduran lempira

Population below poverty line: 60%

Key exports: coffee, shrimp, cigars, bananas, palm oil, fruit, lobster, lumber

Mobile phones: 8.1 million (88th in world)

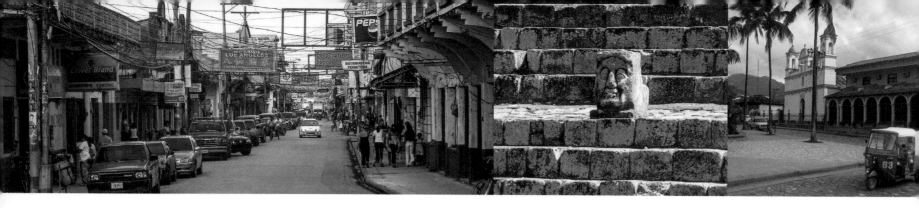

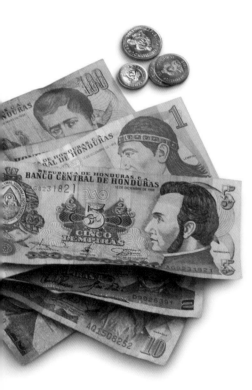

Young lovers walk hand in hand or sit on park benches, kissing passionately, while children beg their parents for balloons and toys sold by vendors pushing makeshift carts down the sidewalks that crisscross the park. Loud, and to these ears, indistinguishable Latin pop music blares from cars continuously cruising and circling. At one end of the park is a simple Catholic church, painted white with pastel yellow trim. At the other end is the Banco Occidente, a local bank with an ATM machine that accepts my card. If I'd arrived here blindfolded, at first glance it would be hard to tell exactly in which country in Latin America I was.

Clues and subtle nuances that help travelers understand more about the places they visit can be found in the dialect, facial features, and often the food. Sometimes in this game of discovery, only the local currency reveals which border has been crossed. I open my wallet and realize I still have bills from Mexico and Guatemala. Currencies in Latin America may seem like Monopoly money to some tourists: to me, the colors, faces, and images that grace the bills and coins spark my curiosity.

In the US, we have the dollar. Mexico has the peso. And Guatemala has the *quetzal.* The currency is named after the national bird, the resplendent quetzal, which—despite its neon-green plumage, fire-engine-red belly, and long, flowing tail—is difficult to spot in the dense, wooded forests where it lives. The quetzal graces not only the nation's currency, but also its flag. According to legend, the quetzal used to be all green, and its feathers adorned headdresses of Mayan leaders and warriors, including the strongest Mayan warrior of all: Tecún Umán.

Though even Tecún Umán, the last Mayan warrior to fall, couldn't fend off the Spanish conquistadors, who with their gunpowder and horses took Mayan land by force. After his final battle, as he lay dying on the ground, a quetzal flew over, then landed and rested on his bleeding body. The blood of the bravest warrior of all forever stained the chest of the bird, creating a vivid symbol for this phrase in the Guatemalan national anthem: *"Antes muerto que exclavo sera."* (Choose death rather than slavery.)

Here in Honduras, the currency is named after another warrior, Cacique (chieftain) Lempira, who persuaded previously warring and rival tribes to rally together and take on the Spaniards during the conquest. Amassing more than 30,000 troops, Lempira held off the conquistadors for more than three years, until the Spaniards lured him into the open, under the guise of peace talks and killed him.

I withdraw what I think will be enough Honduran *lempira* to cover my expenses for the next few days. With the prevalence of banks and ATM machines in Latin America, and elsewhere in the world, there is no need to carry excess cash or traveler's checks. I carry a secret, emergency stash of dollars, several Benjamin Franklins, in a small fabric envelope hidden and secured by Velcro inside one of my motorcycle riding boots, just in case.

I ride my bike to Ruinas de Copán, just a few kilometers outside of town, the only cultural UNESCO World Heritage site in Honduras. Though there are larger and more expansive Mayan ruins in Guatemala and Mexico, these are distinguished by a seventy-two-step staircase, made up of more than 2,000 stone blocks, each

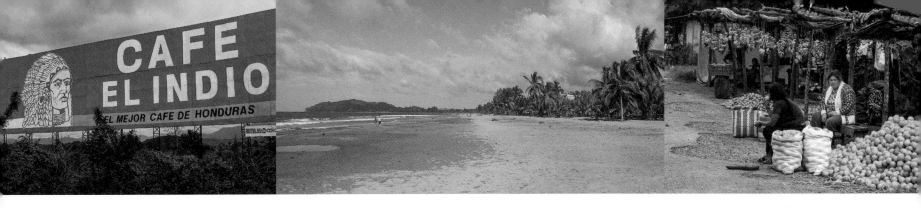

...with its percussive music of drums and shakers made of gourds rousing Garifuna women in a dance of hypnotic hip shaking that could make a Middle Eastern belly dancer jealous.

intricately carved to form the longest-known Maya hieroglyphic text. The staircase is like the Rosetta Stone of the Mayan civilization, unlocking the secret code to an intricate and complex writing system with signs or glyphs in the form of humans, animals, objects, abstract designs, and even images of supernaturals. Thanks to the code and carvings on the staircase, historians can study and travelers can learn about the life and times of hundreds of years of Mayan dynasties. It also tells the history of this town, Copán, dating back to AD 426.

By the time Christopher Columbus discovered and named Honduras, on his fourth journey, in 1502, most of the great Mayan cities had been abandoned and buried in the jungle. Searching for a strait that he thought would take him to the Indian Ocean, Columbus met a group of seafaring Mayans canoeing around what are now known as the Bay Islands, just a few miles off the Caribbean coast of Honduras.

Eager to discover the Bay Islands, indulge in beach culture, and swim and snorkel the coral reefs that attract more than a half-million tourists to coastal Honduras every year, I ride from the eastern highlands through rugged mountains and forests of thick pine. It's not until I begin to drop into the valley and flatlands outside San Pedro de Sula that I get a sense of agriculture in Honduras, passing miles of bananas, corn, pineapple, and cacao. In the distance I see the Nombre de Dios mountain range shrouded in puffy white clouds, forming a dramatic backdrop to the coastal town of Tela, where I decide to take a quick side trip.

Again my plans change. Here in Tela, I get a taste of Honduras Garifuna culture, with its percussive music of drums and gourd shakers stirring Garifuna women to a dance of hypnotic hip shaking that could make a Middle Eastern belly dancer jealous. Despite a troubled history of slavery and shipwrecks in the 1600s and the displacement of its entire population by the British in the 1800s, for now at least, the Garifuna and the freshly caught seafood served at my quiet and modest hotel are far more interesting to this traveler than snorkeling, rum drinking, and mingling with western tourists on the Bay Islands. ▦

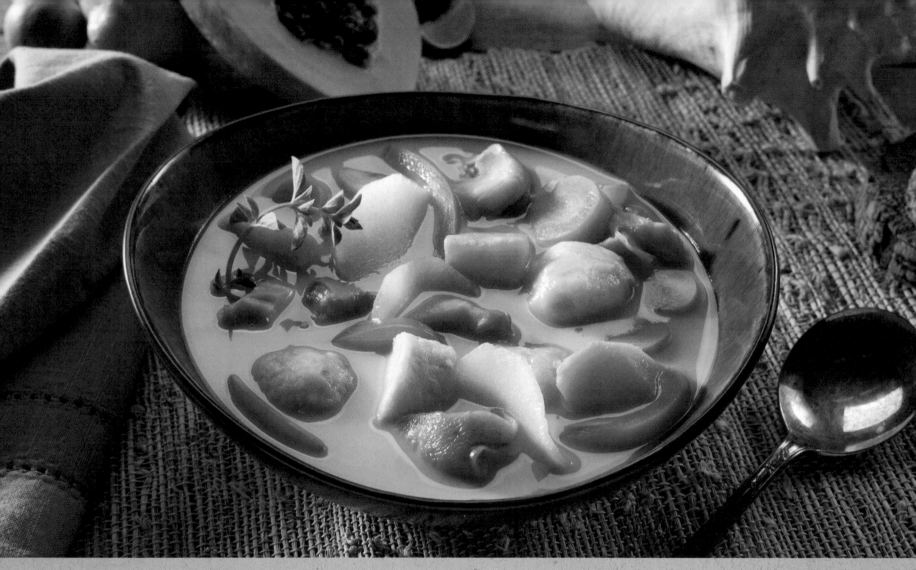

Honduras

From the beaches of the coast, to the shores of the Bay Islands and the inland jungle, travelers to Honduras will always find some preparation of conch, a wonderful Caribbean shellfish. Though I often enjoyed the typical preparation of fried conch fritters, I prefer conch soup, a richer and healthier preparation. I discovered this soup at Twisted Tanya's, a small restaurant in the remote town of Copán Ruinas, near the Guatemalan border. This recipe blends the best of Honduran coastal flavors—coconut and conch—with traditional root vegetables of the countryside, such as yucca, malanga, and yams. Because conch is seasonal or hard to find, feel free to try this Honduran specialty with scallops, clams, or other shellfish.

Conch Soup

Ingredients

2 pounds conch meat

Juice of 3 limes

1 pound yucca root, peeled and sliced into disks, about ¾-inch

1 pound malanga (or yam), peeled and sliced into disks, about ¾-inch

1 13.5-ounce can of unsweetened coconut milk

1 medium bell pepper, red or yellow, cored, seeded and chopped

1 medium yellow onion, diced

1 habanero chile pepper

⅛ teaspoon white pepper

⅛ teaspoon *each:* cilantro or coriander, fresh thyme, fresh basil, aniseed, fresh oregano and sweet paprika

1 teaspoon sea salt

1 large carrot, peeled and thinly sliced

2 yellow plantains, peeled and cut into ½-inch slices

Dumplings

2 cups all-purpose flour

⅛ teaspoon salt

1 teaspoon baking soda

½ cup coconut oil or suet, frozen if available

2 quarts water, divided

1 lime, sliced into wedges

Preparation

1. Bring 1 quart of water to boil.

2. Place conch into a large zip lock bag, pound only on one side to tenderize, then transfer to a bowl and add lime juice, tossing well to coat. Let sit for 10 minutes then rinse under cold water and drain. Add to boiling water and simmer, covered, about 15 minutes, or until foam rises to the surface. Remove the conch from the water with a slotted spoon and set aside reserving pot liquid.

3. Add yucca, malanga, and coconut milk to the conch broth and return to a boil.

4. When conch is cool enough to handle, chop into bite-sized pieces, return to the pot, and continue cooking at a boil with the vegetables for about 15 minutes. Stir in the bell pepper and onion. Pierce the habanero pepper several times with a knife and add to the soup along with the spices and herbs.

5. Prepare the dumplings by whisking together the flour, salt and baking powder. Grate the frozen coconut oil and add to the mixture. Add the water. Mix well to form a stretchy dough.

6. Roll small balls (1 to 2-inch) of dough and carefully add to the soup pot. Reduce heat, cover and simmer for 35 minutes or until they nearly double in size and are firm to the touch. (Note: dumplings will rise to the surface after about 15 minutes.) Remove the habanero pepper and discard, then carefully add plantains and carrots without disturbing dumplings and cook for 5 more minutes. Remove from heat and let sit for 20 minutes.

7. Serve with lime wedges.

Variation

Use scallops, clams, or other shellfish if you cannot find conch meat.

Though this recipe calls for malanga, a brown tuber similar to taro root that is grown throughout Central America, it can be difficult to find in other parts of the world. Feel free to use yams, not sweet potatoes, instead.

Nicaragua

Somotitte

Potosi

Rio Grande

Esteli

El Sauce

Jinotega

Matagalpa

La Cruz de Rio Grande

Rio Blanco

Nuevo Amanecer

Young Entrepreneurs and Rare Coffee.

Though I crossed into Nicaragua several days ago, my mind is still flooded with images of the young boy I met at the border: with brown, dust-covered skin, as if he'd walked out of a sepia photograph. The duct tape holding his shoes together had lost its stickiness, and the soles, worn and perforated with holes, barely held together as he followed me through the maze of border-crossing bureaucracy. He had no laces to thread through the eyelets, and often a shoddy shoe would fly off one foot.

His buddies, barely teenagers, all had better shoes, it seemed: a tall, lanky one sported brand new Crocs. "Our village got a big box of them," he told me, "with lots of t-shirts, too." He pointed to the dirty Hollister shirt he wore.

My nearly shoeless shadow must have come from another village. Hoping to make a few bucks by shuttling documents between immigration and customs offices and various inspectors, young boys like these congregate at all the border crossings in Central America. "Mister. *Señor. Señor! Necessitas tramitadores?*" they ask, hovering and annoying travelers like mosquitoes. Shooing them away only brings more offers. Pointing at my motorcycle and then their eyes was all it took to say, "Hey gringo, I'll protect your bike...or I'm gonna rip you off."

The boys compete to see who will get the job. To some travelers it may seem like petty extortion. To me it's just another opportunity to play, practice my Spanish, and engage with the locals.

I shove a few bills into the pocket of my shoeless friend, telling him, *"Para los zapatos nuevos"* (for new shoes), and as I motor into Nicaragua the other boys run after me, yelling with their hands held out, "Mister! Mister!"

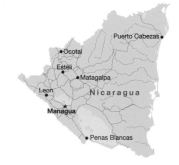

Size: 130,370 sq km (98th in world)

Population: 5.8 million (109th in world)

Capital and largest city: Managua (934,000)

Independence Day: 15 September 1821 (from Spain)

World Heritage Sites: 2

Literacy rate: 67.5 %

Currency: Nicaraguan córdoba

Population below poverty line: 42.5%

Key exports: coffee, sugar, peanuts, tobacco, cigars, beef, shrimp, lobster, cotton

Mobile phones: 4.8 million (107th in world)

The road leaving the border and dipping into the fertile valley east of Esteli, Nicaragua, is banked, curvy, and filled with boys on horseback, men riding donkey carts, and women carrying packs of firewood on their backs. I notice bus stops that actually have paved pull-offs with sheltered structures and benches. In the valley I notice rice fields and hundreds of workers laying the daily harvest out to dry. I pass through small villages and take a turn toward Matagalpa, in search

Though my heart sinks—the road and living conditions in this part of Nicaragua are depressing—I do find a glimmer of hope: Instead of the panhandlers who make home on the sidewalks of U.S. cities or loiter around the traffic lights or off-ramps of California boulevards and freeways, holding signs and offering to work for food, I am surprised to find young Nicaraguan boys working without the promise of money or food. Boys with pails of rocks and dirt at

At the bank entrance, I watch a scruffy man lift his ratty t-shirt to pull the handgun out of his pants and hand it to an armed guard. I am fascinated that the two men have behaved so casually, as if this exchange is as normal as pulling an ATM card from a wallet.

of the famed Northern Nicaragua coffee plantation, Selva Negra. Without warning, the beautiful road changes to the worst road I've seen yet.

The farther I travel, the worse the road gets. To avoid slamming into an increasing number of potholes, I navigate a complex obstacle course. Cars have it worse. With four wheels it's nearly impossible to avoid craters in the road, making the drive to Matagalpa rough, frustrating, and slow.

their feet and makeshift shovels in their hands line this steep road. Between passing cars, they run into the road with shovelfuls of rocks and dirt, fill a pothole, and then retreat to the side of the road, where they hold out their hands, hoping for tips from locals.

After I avoid my 900th pothole, I am within the city limits of Matagalpa, where I notice a very worn, hand-painted sign welcoming newcomers. It has been amended with a simple, scrawled declaration that the national government is responsible for the condition of the road.

Nicaragua

Nestled in the mountainous and forested northeastern highlands, the city claims nearly a quarter-million residents, but exudes an incredible small-town ambiance: cobblestone streets, a clean, colonial central square, and friendly people.

At the bank entrance, I watch a scruffy man lift his ratty t-shirt to pull the handgun out of his pants and hand it to an armed guard. I am fascinated that the two men have behaved so casually, as if this exchange is as normal as pulling an ATM card from a wallet. I wonder how many others routinely conceal handguns in their pantalones.

The turnoff for Selva Negra is marked by a beat-up old tank—a remnant of Nicaragua's civil war. The dense, thick, and dark forests reminded the German immigrants who settled here in the 1800s of the Black Forest, so they named it Selva Negra.

Today Selva Negra is a sustainable and organic coffee plantation and mountain resort. One can hike the old-growth forest or explore it on horseback. In addition, Mausi and Eddy Kohl, descendants of Germans who in 1891 settled near the city of Matagalpa, offer a guided tour and tell how, in the late 1800s, the Nicaraguan government offered plots of land, coffee plants, and financial incentives to Europeans who settled in the country to farm coffee.

Today, the Matagalpa region is home to more than four generations of Germans. Over the years, however, the German population has dwindled for several reasons. First, during World War II, Nicaragua declared war on Germany and confiscated many farms. German residents fled back to Germany or elsewhere. Though many returned to Nicaragua in the late 1940s and early '50s, another exodus of Germans was triggered by the Contra-Sandinista war of the 1980s, when more farms were claimed or destroyed by the Sandinistas' land redistribution efforts. In fact, for ten years during the '80s, Mausi and Eddy lived in the United States, returning in 1991 to rebuild their farm.

Despite being in the poorest country in Central America, Selva Negra is an impressive and, given the location, surprising testament to organic and sustainable farming. All the coffee harvested there is 100% shade-grown and perhaps the finest in Nicaragua.

I stay three nights on the *finca* (plantation), each day hiking the old-growth forest and learning the simple practices that Selva Negra employs for sustainability, such as converting methane gas from cows to fuel for the stoves and using chicken poop to fertilize the vegetable gardens.

Even so, would-be Nicaraguan coffee consumers in the US or Europe will be more likely to find a pothole than a pound of Nicaraguan coffee on the shelves of their local Starbucks because Nicaragua produces little coffee compared to other coffee-producing countries, including its neighbors.

I'm just happy to taste the local flavors...though I prefer a darker roast than they brew here at Selva Negra. ▭

Selva Negra is nearly 100% sustainable. From the vegetables, chickens, eggs, beef and pork to the cheeses produced from the milk of organically raised cows and sheep, most everything served in its lakeside restaurant is grown or produced on the farm.

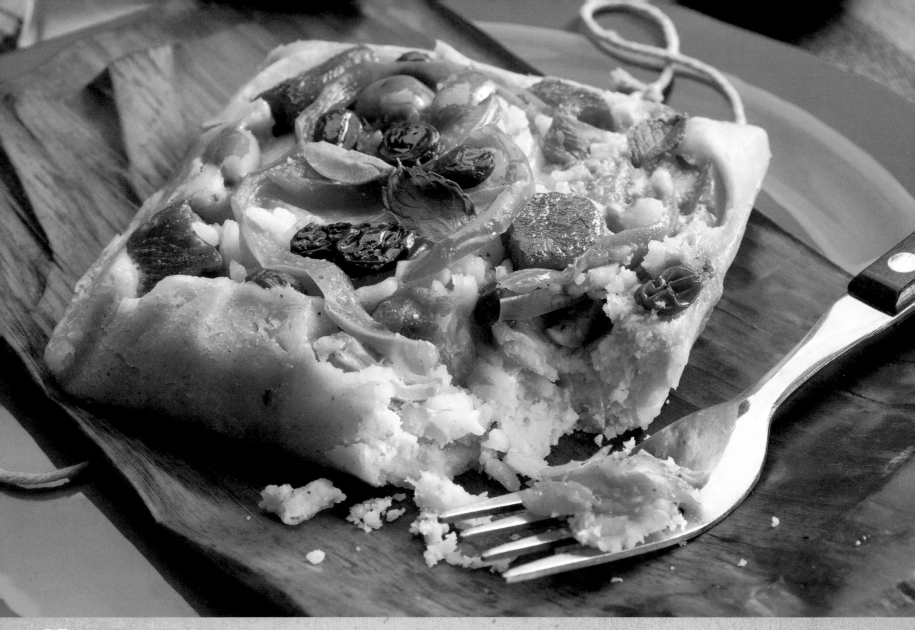

Nicaragua

To me, nothing tastes more like Nicaragua than nacatamales. The making of nacatamales usually involves family and friends, all joining together to wrap the delicious masa (cornmeal dough) with pork, rice, vegetables, and spices into banana or plantain leaves, neatly folded into bundles tied with twine. They are not available every day in Nicaragua, as the ceremonial preparation is usually reserved for Sundays or special occasions like weddings, anniversaries, and other fiestas. Gather your family and friends to create your own nacatamale prep station and enjoy your own ceremony of togetherness by both making and enjoying this traditional meal from Nicaragua.

Nacatamales
Tamales Wrapped in Banana-leaf

Ingredients

Marinade and Meat

3 cups white wine vinegar

2 tablespoons achiote powder

1 teaspoon ground pepper

1 teaspoon salt

1 teaspoon cumin

¼ teaspoon paprika

2 garlic cloves, minced

1 pound pork shoulder (butt), cut into ¾-inch cubes

¾ cup uncooked white rice

Filling

12 ¼-inch slices uncooked peeled white potato

12 ¼-inch slices onion

12 ¼-inch slices tomato

12 ¼-inch slices green bell pepper

12 green olives

12 mint leaves

⅓ cup raisins

Dough

1 pound bacon, cooked crisp and finely chopped, fat reserved

6 cups masa harina

1 cup butter, softened

¼ cup olive oil

1 medium onion, finely chopped (about ⅔ cup)

2 garlic cloves, minced

1 jalapeño pepper, finely chopped

½ cup orange juice

Juice of 2 limes (about ¼ cup)

4 cups chicken stock

1 cup whole milk

3 tablespoons mint leaves, coarsely chopped

Salt and pepper, to taste

Wrappers

Banana leaves, spines removed, cut into 12 10x10 inch squares

Twine/rope to wrap tamales

Preparation

1. Prepare a marinade by whisking together white wine vinegar with achiote powder in a large bowl. Add pepper, salt, cumin, garlic, and paprika, whisking well to combine. Add pork, toss to coat, cover, and chill overnight.

2. The next day, soak the rice in water to cover for 2 hours, drain and set aside.

3. Begin preparing the dough by sautéing the onion, garlic, and jalapeño pepper in a teaspoon of the butter in a medium pan over medium heat until soft, about 5 minutes. Set aside.

4. In a large bowl using an electric mixer on low speed, blend together the remaining butter, olive oil, and masa harina until it becomes a mealy texture. Add the orange and lime juice and milk. Slowly add chicken stock, one cup at a time, until it becomes a soft moist dough (slightly firmer than mashed potatoes). Add the sautéed onion mixture, chopped bacon, reserved fat, and chopped mint leaves. Increase the mixer speed to medium and continue to blend for 2 to 3 minutes until fluffy. Set the dough aside.

5. To compose the tamales, arrange two squared banana leaves on top of each other to make a cross, and place a handful of masa (dough) in the center. Top with a tablespoon of rice, a slice each of the potato, onion, tomato, and green pepper, and a few cubes of pork. Finish with a green olive, mint leaf, and a few raisins, then fold the banana leaves over to create a parcel, and carefully tie closed with the twine.

6. Repeat with remaining tamale ingredients to make 12 parcels. Place remaining banana leaves at the bottom of a large pot. Carefully place the banana parcels into the pot. Add enough boiling water to cover 2 to 3 inches above the parcels. Cover the pot and simmer for at least three hours. Check the water level occasionally, topping up if necessary to make sure the pot does not boil dry. The nacatamales are ready when the dough is firm and comes away from the banana leaf cleanly.

7. Before serving, drain water and let tamales sit in the pot for 30 minutes. Unwrap the leaves to enjoy the nacatamales.

Costa Rica

Garza

Puerto
Jesus

Puntarenas

Barrance

Alajuela

Heredia

Matina

Moin

Peurto Limon

Naranjo

Caldera

San Mateo

de Tarcoles

Colon

San Jose

Tres Rios

Cartago

Turrialba

Moravia

Victoria

Bomba

Santiago

Crooked Cops and Twisted Roads.

Everything I've heard and read about the Costa Rica border crossing at Peñas Blancas has been negative. Stories of long lunches, corruption, and closed and understaffed offices fill the pages of internet travelogues. But riding into Peñas Blancas on an early Saturday afternoon, I breeze through immigration and customs. After the usual paper chase and a $2.50 bike fumigation, I am admitted into Costa Rica.

Most travelers simply get rubber-stamped into a new country. Getting my motorcycle admitted is usually not so easy. This typically requires an inspection, photo copies of several documents, and securing a temporary import permit. In some cases I have to post a bond equivalent to the amount of duty or tax that would be levied on the bike if it were sold inside the country. To get the money back, the bike must be inspected again and presented with another pile of documents at the next border. This usually takes hours. Today, I'm lucky.

So, papers in order, I cruise the highway south towards Liberia, weaving through the highland province of Guanacaste, with grassy savannah flatlands gently sloping west to the Pacific Ocean and ominous mountains and volcanic peaks flanking me to the east. I lift my visor to let the wind tickle my face. I can smell the ocean and feel the moist salt air. The first day in a new country is always invigorating.

Costa Rica marks my seventh country since starting my trip. For some, seven may be a lucky number, but my first day in Costa Rica plays out like a bad game of craps. I am stopped twice and held up for bribes by Costa Rican police; first at a standard checkpoint, where the police find an omission on my temporary vehicle import document, and second when I am flagged down for speeding. I wasn't speeding, and besides, there are no speed limit signs. My best defense against the extortion is patience. I have what most travelers or locals usually don't: time. So I hang out on the side of the narrow road, obstruct traffic, and practice my Spanish. This frustrates the cops, who eventually give up, realizing I'm not an easy target.

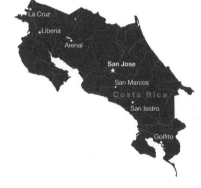

Size: 51,100 sq km (130th in world)

Population: 4.7 million (121st in world)

Capital and largest city: San José (1.5 million)

Independence Day: 15 September 1821 (from Spain)

World Heritage Sites: 3

Literacy rate: 94.9%

Currency: Costa Rican colón

Population below poverty line: 24.8%

Key exports: bananas, pineapples, coffee, melons, ornamental plants, sugar, beef, seafood

Mobile phones: 4.4 million (114th in world)

While I found other Central American countries more rich in culture than Costa Rica, the natural beauty and wildlife I experienced were impressive in both accessibility and color. Unlike its neighbors, it showed Western influence in its efforts to promote sustainable tourism and environmental protection.

If the cops don't frustrate me, the potholes do. I thought Nicaragua had bad roads; Costa Rica's potholes could swallow a bus. They multiply like rabbits as I travel closer to San Jose, the capital. I don't think the government has any intention of repairing them. Cars and trucks must make cryptic moves, often jutting into oncoming traffic in an effort to avoid getting swallowed by the craters. But these efforts are futile, and even above the drone of my motorcycle engine it sounds like a bad crash every time a truck or car slams into one.

If any country has the money to modernize infrastructure, it's Costa Rica. The country is the second-richest nation in Central America. Yet, even with a burgeoning tourist trade, an influx of retiree expat Americans and Canadians, and the highest import and export duty and taxes in all of Central America, it has, notoriously, the worst roads.

I have a theory why the government doesn't pave them. People don't drive fast through potholed stretches of primary highways. So, although speed traps might work to control speed in busy metro areas, in rural areas the practice is costly and impractical. They could install speed bumps, like Mexico, but the Costa Rican government, with its corrupt and miserly methods, would never consider it, due to the installation cost and maintenance. Perhaps Costa Rica is smarter than I think: They let the roads deteriorate and therefore keep cars traveling slower. This reduces traffic accidents, injuries, and fatalities—except for bikers.

After a week of bad roads, corrupt cops, and overpriced accommodations, I finally give in and allow myself to be seduced by Costa Rica. Nothing brings more joy to a motorcyclist than fresh air, sweeping roads, tight turns, and mesmerizing scenery—all of which Costa Rica serves up in what must be the most glorious ride of my journey. After sweltering in San Jose traffic and getting lost and then found in Cartago, I climb from sea level to over 10,000 feet by way of Cerro de la Muerte, Mountain of Death, to San Isidro de El General—a small farming community nestled in the Talamanca mountain range—and onward toward Golfito and the Osa Peninsula.

On my motorcycle I sense the elevation changes, feel the temperature shift through dozens of microclimates, and watch the shining shafts of light and shadows that dance on the road ahead of me as the sun pierces the lush tropical foliage that forms the canopy above. I feel enveloped by nature, as if I'm riding through a verdant tunnel of foliage. It's much cooler, so I pull over to take in the beauty and close the vents of my motorcycle jacket and pants. I can smell the tropical flowers, palms, ferns, and cedar as I ride higher and higher into forests of clouds. I feel I've been swallowed by the greenery. My bike, body, and soul are one and our senses thrilled as we wind, twist, and climb our way along the pothole-free road through the mountains, clouds, and jungle—all buzzing and humming in harmony with the song of the cicadas.

Soon the road drops out of the clouds into rainforest, jungle, and then tropical lowlands with miles of pineapple plantations. The air smells of sweet juice. It's hot again. I stop to open the vents on

Costa Rica

my jacket and take off my helmet to cool and breathe the muggy atmosphere. The jungle is impenetrable. I have to squeeze off the road onto a short strip of foliage under a banana tree on the bank of the Rio Térraba (the Térraba River), the largest in Costa Rica. The Pan American Highway follows this winding river through the jungle, but I haven't seen a car in hours. Though I feel alone, I know I'm surrounded. The sounds of the cicadas have given way to the songs of tropical birds. I imagine pumas, howler monkeys, yacking macaws, and the odd-looking toucan, alive and all around me. Paradise.

Paradise is threatened, and so are the ancestral homes and protected lands of the indigenous Borucan people who live here. The Borucan have been fighting the Costa Rican government over the proposed construction of what will be the largest hydroelectric dam in Central America. Like any environmentally sensitive project that involves protected lands, indigenous people, and sensitive biospheres, the issue is complicated. Having experienced the best and worst of Costa Rica, it's clear to me that the country's infrastructure has suffered from poor maintenance and negligible investment. I'm not convinced that flooding this river's basin and displacing thousands of residents will be a panacea for the country's economic woes, as government officials and big business suggest.

I suggest Costa Rica invest in its transportation infrastructure. Shortly after my blissful ride, the Costa Rican potholes make a haunting return. To make matters worse, it starts raining. I dare not complain, though. What else would I expect in a rain forest? But riding a motorcycle in any weather takes a lot of concentration, and riding

a motorcycle through the rain can be harrowing and uncomfortably dangerous. So I negotiate a good price for a room on the coast, in the sleepy yet idyllic town of Golfito, little bay.

The next morning I head south toward Panama for yet another border crossing. ▬

Costa Rica has perhaps the strongest economy in Central America next to Panama, yet its infrastructure is in horrible shape. My ride through the cloud forests and jungle is forever imprinted in my mind, but more for its beauty than its potholes. There's a good reason the expat community there is so large.

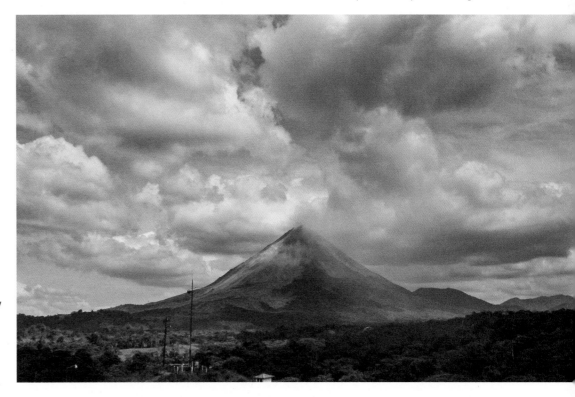

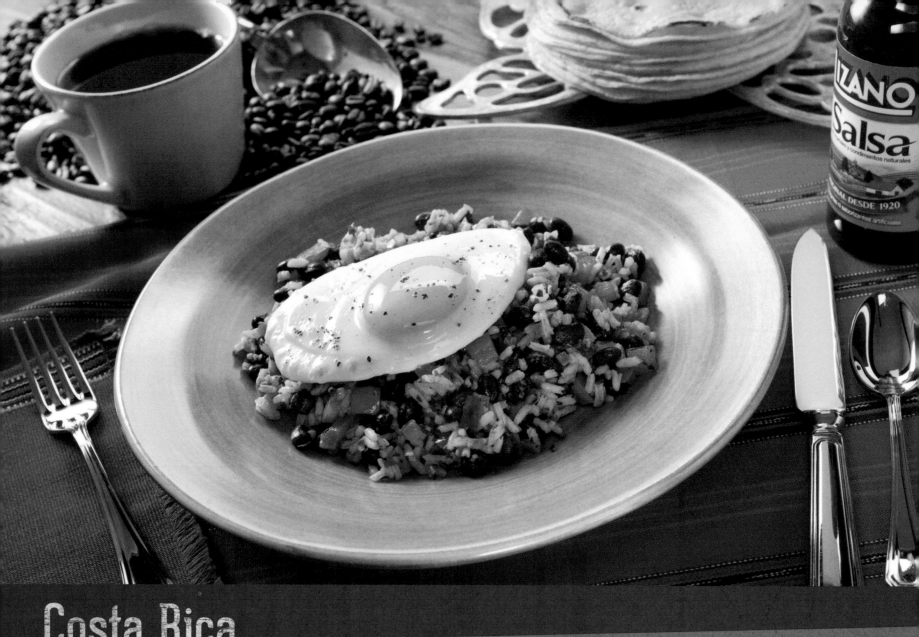

Costa Rica

It's impossible not to encounter a dish of gallo pinto when in Costa Rica. Though I had it most often for breakfast, Costa Ricans dine on this traditional dish for most any meal. By cooking the classic Latin staples of white rice and black beans together, the rice takes on some of the color of the beans, giving the dish a speckled appearance, which is how the national dish got its name: Gallo pinto means speckled rooster. With peppers, onion, and fresh cilantro, this dish is simple yet flavorful. Try toppping this dish with a fried egg, cheese or a green salad. Either way, don't forget the Lizano Salsa—a sweet and smoky condiment found on virtually every table in Costa Rica.

Gallo Pinto
Costa Rican Style Black Beans and Rice

Ingredients

2 tablespoons olive oil

2 teaspoons sesame oil

1 medium onion, finely chopped

1 medium red bell pepper, cored, seeded, and diced

2 cloves garlic, minced

1 cup cooked black beans, home-cooked or canned, rinsed and drained

¼ cup broth from cooking black beans (or use any broth or water)

1 cup cooked white rice

2 tablespoons Lizano Salsa

⅓ cup fresh cilantro, chopped

Salt and freshly ground black pepper to taste

Preparation

1. Heat olive and sesame oil together in a large sauté pan over medium heat.

2. Add onion, bell pepper, and garlic and sauté for about 5 minutes, until lightly browned and soft.

3. Add the black beans and broth and stir to combine all ingredients.

4. Add rice and simmer until rice has absorbed most of the broth, about 15 minutes.

5. Finally, stir in Lizano Salsa, cilantro, and season with salt and pepper to taste.

Variations

Lizano Salsa is essential to this dish, if you are unable to find it, you can substitute HP or Worcestershire sauce.

This dish is not your average, every day, rice and beans. No, the fresh red bell pepper, onion and garlic with a hint of sesame oil give this Costa Rican classic it's own unique character.

Panama

PANAMA

BOCAS DEL TORO

Cerro
Punta
Corredor
San
Bajo
Golfito
Andres
Boquete
El Cope
El
Valle
La Concepcion
Soloy
COCLE
David
Santa Fe
CHIRIQUI
Penonome

La Chorrera

Bay of Panama

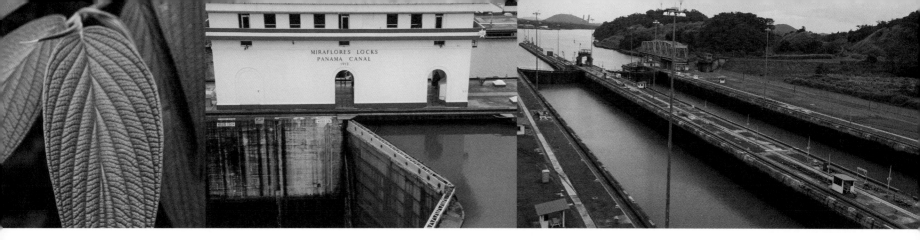

Waiting for the Sun.
If you wait until you are ready, you may never start. This truism is often offered to young couples putting off having children or to bored office workers looking to change careers. Sitting just a few miles from the border of Panama, I wonder if I should wait for the rain to stop.

I didn't choose to ride through Central America during the wet season—November and December. I had to.

To travel overland from the top of the world, the Arctic Ocean in Alaska, to Ushuaia, Argentina, at the bottom, requires planning. Due to a short window of suitable weather, I had to be in Alaska no later than August, and I must be in Ushuaia no later than early March. Otherwise I'll face extreme weather conditions that could compromise both comfort and safety—especially riding a motorcycle.

The rain pounds the pavement and my bike. I wrap my hands around a cup of Costa Rican coffee. Though it's not cold here, the solace I feel from the warmth of the mug soothes me. The ramshackle restaurant where I wait keeps me dry. I watch the rain and I wait.

I know I should get on that bike and ride into Panama. I know I'm dreaming if I think the rain will stop anytime soon. My rain suit, a big vinyl sack with places for my arms and legs, is uncomfortable and makes for difficult and clumsy maneuvering. I resist, ignoring the reality that I must put it on. Until I can wait no more.

Three days pass before I'm able get out of that rain suit.

I welcome the sun and even the humid tropical heat that comes with it. I lift my helmet's protective visor to feel the breeze cool me off as I ride from David to Boquete in northeastern Panama.

Size: 75,420 sq km (118th in world)

Population: 3.6 million (131st in world)

Capital and largest city: Panama City (1.4 million)

Independence Day: 3 November 1903 (from Colombia)

World Heritage Sites: 5

Literacy rate: 91.9%

Currency: Panamanian balboa, United States dollar

Population below poverty line: 26%

Key exports: bananas, shrimp, sugar, pineapples, watermelons

Mobile phones: 6.8 million (95th in world)

Now the road is dry and dusty. There's barely evidence that this area was drenched in rain over the past several days. And, for the first time since crossing the border, I see Panamanian people about, riding bicycles, on horses, or just walking along the roadside.

They are friendly and always make an effort to smile and wave. The drivers, though curious as they crane their necks to look at me, aren't so courteous. I tense when they speed up behind me and then slam on their brakes to slow down. They don't seem to understand the need for space between vehicles on this crowded and boring road.

The road is also narrow, rough, and has no shoulder. The banks drop off sharply, so much so that with a quick jerk of the wheel or handlebars you could find yourself crashing into a ditch. There are no guardrails. I pass a rusted old car lying on its roof. Faded photographs of the dead adorn ad hoc crosses that surround it— serving as blunt and sad reminders of just how dangerous this road can be. There is no escaping those oncoming drivers who take unnecessary risks when passing.

Though it's cooler by the time I make it to Boquete, a small village nestled in the forest and surrounded by coffee plantations, I'm drenched in sweat, a side effect of wearing a heavy and padded motorcycle suit in hot weather. The Caldera River, now rushing

through the town, seems dangerously high, running close to its banks. Looming ominously above the village is Mount Baru, Panama's tallest peak and a still-active volcano. I can smell the damp aroma of the surrounding jungle, and for the first time I welcome the drizzling rain. It cools me off.

The lush foliage, higher elevation, and cooler climate along the Caldera River makes Boquete a retreat for wealthy Panamanians and an attractive destination for North American and European expats. Eager to taste what I'm told is the best coffee in Central America, I stumble into a local coffee shop where I meet Peter, a fair-skinned American about forty years old. He buys me a coffee made to order from hot water poured over freshly roasted and ground beans. It's dark and aromatic, with rich intensity yet low in acidity, making it smooth and somewhat sweet. We talk. He's lived in Boquete for three years and tells me that the Panamanian government is offering lucrative benefits, such as property tax amnesty for life, for those who build and develop here.

I notice many construction zones, which have turned to pools of brown water and mud and make the town look dirty. Hikes through the jungle and up the volcano are cancelled due to rain and potential mud slides. The wind violently blows the foliage, kicks up thick dust bowls on the side streets, and knocks down several poles carrying

The banks drop off sharply, so much so that with a quick jerk of the wheel or handlebars you could find yourself crashing into a ditch.

Panama

RAFLORES LOCKS
PANAMA CANAL
1913

There is no sign of life other than a dozen or so wild horses running through the waves, I feel like I'm on a movie set.

power and internet cables. I settle into a simple nine-dollar motel room. With the power lines down there's no internet, and the only light in my room comes from the glow of my laptop. No longer drizzling, the rain batters my roof and everything else.

The next morning it's still raining. I want to ride into the eastern highlands, through the Fortuna Forest Reserve, and then down to the Caribbean coast, where I can catch a ferry to Bocas del Toro, a tiny archipelago of nine islands tucked close to Almirante Bay and the Chiriquí Lagoon. As I climb higher, the rain turns to fog. But my dreams of sunshine, tropical drinks, and bikinis are ditched when I must turn around after a near head-on collision with a speeding car. The fog is so thick he never saw me.

I finally escape the rain when I head west from the highlands to the Pacific coast. I have no plan. I'm happy to go anywhere the wind doesn't blow. Anywhere it's not raining. Once again I can smell the Pacific salt air, and as daylight turns to twilight, a turnoff down a dusty road at Las Lajas catches my eye. Perhaps I'll find a beach with good body surfing waves, a cold beer, and a tasty meal.

At first I think I've come to a dead end. A small, nondescript hotel, more like a collection of a dozen concrete cabañas built on the edge of a white, sandy beach seems closed, even abandoned. I circle the dirty parking lot. There is no sign of life other than a dozen or so wild horses running through the waves, I feel like I'm on a movie set.

Then a potbellied man with a grease-stained baseball cap waddles out of one of the buildings. His fingers stained from too many cigarettes, Pedro speaks no English. He offers me one of the cabañas for five dollars and hangs a new mosquito net over the thin mattress.

"Tienes hambre?" He asks me if I am hungry.

"Si, tengo hambre. Hay cerveza fria?" I tell him yes, hungry and ready for a beer. In the kitchen a large, black pot simmers over a wood-burning fire. He grabs a chicken, recently killed and hanging from the door frame, and prepares the meal. About an hour later he hands me a bowl of chicken stew.

"Soncocho," he says. *"Con pollo fresca."* Stew with fresh chicken. *"Especialidad de la casa."*

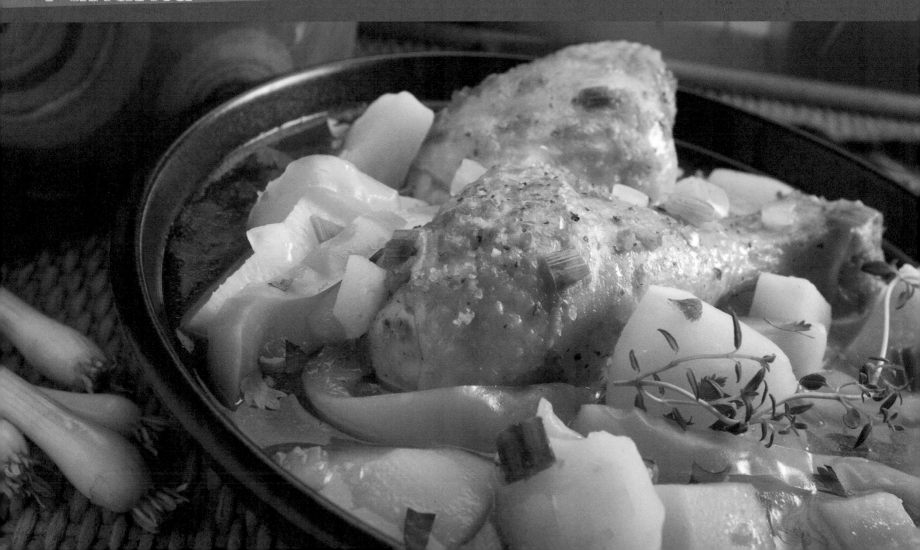

Panama

In most Latin cuisines, food adventurers will find variations on this traditional soup or stew. I found it in Mexico, Honduras, Colombia, and Ecuador. Yet it was on a beach along the Pacific Ocean in Panama where a squatty old man took a freshly killed chicken and cooked this dish for me on an open fire. In Panama, this dish is usually made with ñame, a type of yam found in tropical regions and known as the "king of tubers" because it grows to an enormous size. The yams give the stew texture, while cilantro makes this dish green and also gives it its fresh taste. Wild horses played in the surf and locals snoozed in hammocks while I enjoyed this hearty meal and a chilled Panamanian beer in the company of my personal chef.

Sancocho de Gallina Dura
Marinated Chicken Stewed with Root Vegetables

Ingredients

Guiso Marinade

1 green bell pepper, chopped (about 1 cup)

1 red bell pepper, chopped (about 1 cup)

½ teaspoon paprika

1 sprig oregano, chopped

1 sprig thyme, chopped

¼ teaspoon ground cumin

⅛ teaspoon cayenne pepper

2 tablespoons cilantro, chopped

1 medium onion, chopped (about 1 cup)

5 garlic cloves, chopped

1 tablespoon parsley, chopped

½ cup water

Salt and pepper to taste

Stew

6 chicken leg quarters

1 tablespoon salt

Freshly ground pepper to taste

Dash paprika

6 cloves garlic, crushed

1 medium yellow bell pepper, cored, seeded, and sliced

1 large onion, chopped

1 bunch of green onions, chopped

½ cup fresh cilantro leaves, chopped

2 pounds potatoes, peeled and quartered

2 cups chicken stock

2 quarts water

4 pounds fresh white yam, peeled and cut into 6 pieces

Preparation

1. Place all the guiso marinade ingredients into a blender or food processor and mix at low speed until slightly creamy. Add water if too thick.

2. Season the chicken with salt, pepper, and a dash of paprika and marinate in the guiso marinade overnight or at least 2 hours in the refrigerator.

3. Place the garlic, yellow pepper, onion, green onions, and half of the cilantro into a deep pot, add the marinated chicken, and cover. Cook over medium heat, stirring occasionally, until the vegetables soften and the chicken is no longer pink, about 30 minutes.

4. Add the chicken stock, water, potatoes, and yams, bring to boil, and cook for 30 to 40 minutes, or until the yams break apart and the potatoes and chicken are cooked.

5. Spoon the chicken stew into bowls, top with remaining fresh cilantro, and serve.

Note

The guiso marinade will keep for about 2 weeks in a well-sealed container in the fridge.

Most every Latin country has its take on sancocho. In Panama, they use the "king of tubers", a root veggie called ñame, but you may find that hard to find. So use white yams, a fine substitute found in virtually any market or grocer. These tubers serve as a starch and thicken this delicious chicken stew.

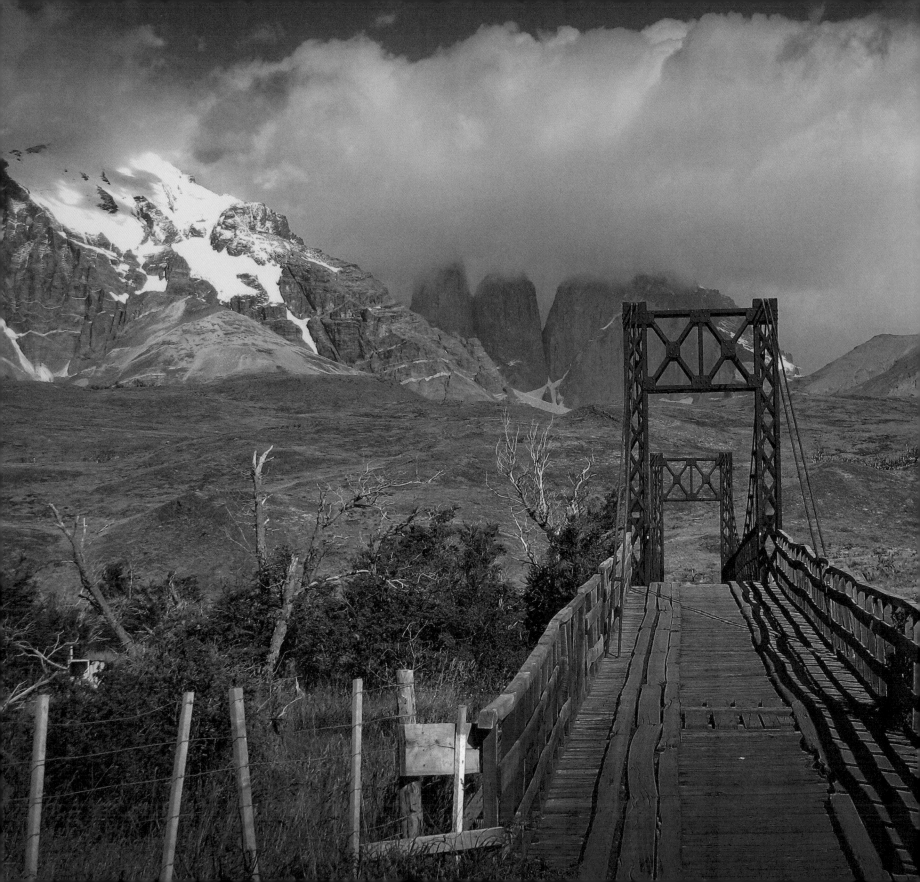

South America

> To travel hopefully is a better thing than to arrive,
> and the true success is to labour.

– Robert Louis Stevenson

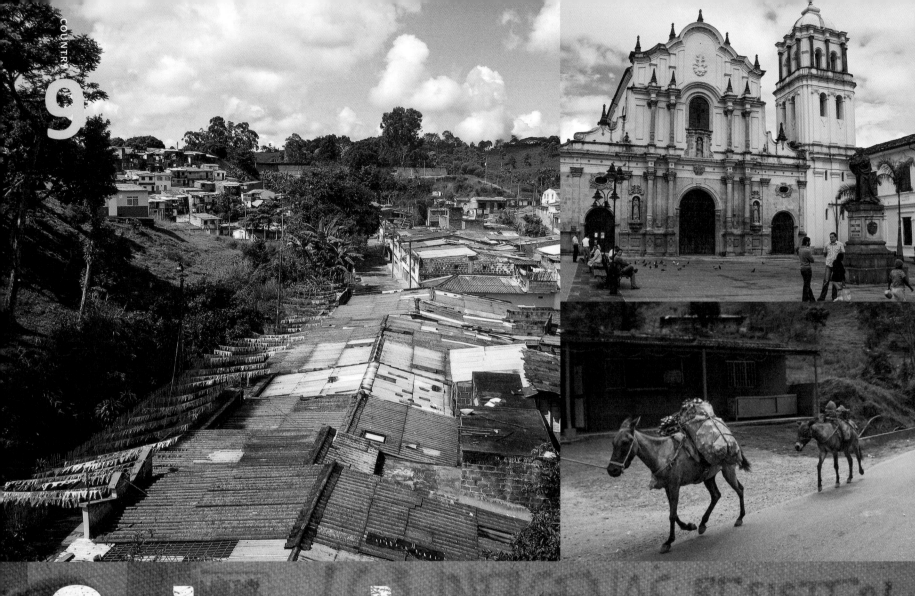

Colombia

Pacific
Ocean

Quibdó · Caldas · Salgar · Tunja · Casanare · Puerto
Ayacucho

Risaralda · Manizales · Cundinamarca · Yopal · Santa Rita · Morganito

San Andrés
y Providencia · Pereira · **Bogota** · Rio Meta · Vichada

Armenia

Guns and Waterfalls. "Colombia is one of the most dangerous countries in the world," most people told me as I planned my route. "Avoid Colombia," they said, "people get killed and kidnapped." While warning citizens against traveling to Colombia, the United States State Department advises those who must be there to avoid rural areas by staying close to major cities, and to travel within the country only by air, never by road.

By the time I get to Panama, nearly at the bottom of Central America, I begin to question my plan to avoid Colombia altogether by flying over the country to Ecuador, where I will begin my South American odyssey from Quito.

"What was I thinking?" I wonder. "Why should I let friends, family, and the U.S. Department of State tell me what I could or should not do?" I have been traveling several months in Latin America. My Spanish language skills are improving, and I feel comfortable traveling alone and connecting with the locals.

It occurs to me that I didn't sell nearly everything I owned and hop on my motorcycle to simply take the safe route. I have to go to Colombia. I know that the only way to see what's possible—and to realize the possibilities—is to be open to them, not afraid. So I change my plan. I go to Colombia.

The country is bustling with energy and seems to be prosperous; at least that's what I feel in Bogota. Cranes dot the skyline, new roads are under construction, and pedestrians wait at crosswalks. Bogota is young, modern, and eager, filled with dreams of a bright future. Yet, as much as Bogota looks forward, it is equally proud of its past.

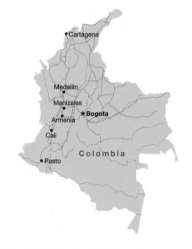

Size: 1,138,910 sq km (26th in world)

Population: 45.8 million (29th in world)

Capital and largest city: Bogotá (8.7 million)

Independence Day: 20 July 1810 (from Spain)

World Heritage Sites: 7

Literacy rate: 90.4%

Currency: Colombian peso

Population below poverty line: 34.1%

Key exports: coffee, cut flowers, bananas, emeralds

Mobile phones: 46.2 million (29th in world)

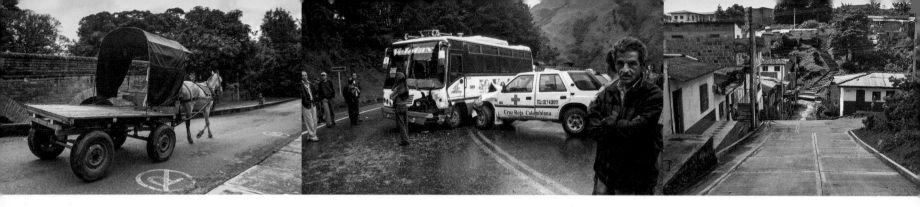

All motorcyclists in Colombia must wear a reflective vest with a license plate number on the front and back. This rider has a huge container of milk strapped to the back of his bike. He makes several deliveries each day.

High above the city, standing at more than 10,000 feet, is Cerro de Monserrate, offering panoramic views of Bogota and beyond. I see well-preserved cathedrals from the sixteenth and seventeenth centuries, nestled in old neighborhoods. From above the city, as I look southwest beyond the Bogota sprawl, I see Bogota's true beauty, its natural setting in the eastern Cordillera of the Colombian Andes. Where the megalopolis fades into a fertile plateau, rich with agriculture, I also notice the dark clouds hanging heavy, shrouding mountain peaks and volcanos. Just where I'm going.

I don't, however, feel danger or threatened, except maybe by the weather looming along my route south. It looks like I'll be battling rain and fog, rather than hostile Colombians. Here in Bogota, remarkably, even the panhandlers are courteous.

The roads are slippery as I begin to explore the rest of the country. If they were dry, the Colombian roads would be perfect for motorcycling: new tarmac with freshly painted lines and beautifully banked and cambered turns. But wet, they're dangerous, evidenced by an accident I witnessed between a speeding Red Cross truck and a passenger bus, which backed up traffic more than five miles.

After many days of rain, fog, hail, and cool weather, I find myself getting used to all the checkpoints. On nearly every road I travel, they stop cars, buses, and motorcyclists. Each time I'm stopped, the military soldiers and police, armed with guns, surround my motorcycle, gawk at the GPS, and grill me with questions about my journey and my bike before letting me pass.

Outside the busy city of Armenia, in the heart of the heart of Colombia's coffee region, down a narrow dirt road, I find a room on a working coffee plantation. I'm joined by a family from Medillen—four generations—and Pacho, a recent college graduate who is taking time before "entering the real world" to travel and explore his country.

"Too many Colombians never see other parts of our country," Pacho tells me. "I want to see both oceans, the mountains, jungle, beaches, and cities."

Two farmhands, Rosa and Marta, prepare meals for us guests. Eager to see what they're cooking, I offer to help in the kitchen. They modestly decline. Yet, at the dining table with the other guests, where I am the oddity, a foreigner, an American, Pacho and the family are all eager to hear my impressions of their country.

The passion that fills the room is as hot as the food is rich and spicy. Just like those I met in Bogota, my new friends—family—are proud of their country.

"We have the Atlantic and Pacific and the Caribbean," Pacho says ardently.

"We have the Amazon, volcanoes, and even canyons, like your Grand Canyon," Grandma speaks up. "Forests, jungles, and beautiful lakes and rivers. We have everything in Colombia."

The second-generation mother throws out the punch line: "We have the most friendly people in the world."

Colombia

I lift the helmet visor so I can look into their eyes. So they can see mine. Searching my limited Spanish vocabulary for something to say, I try to mask my fear with overly animated gestures, and colloquial expressions.

She believes this, and I do too. Even so, I believe that when anyone joins together around a kitchen table, sharing food and stories about each other's country, the whole world is friendly.

Days later I am stopped at another police checkpoint, except this time they warn me that I'm about to travel through the most dangerous part of Colombia.

"Don't stop," they warn me in Spanish. "Drive straight through."

The road is rough, potholed, and perhaps in the worst condition of any I've ridden since arriving in Colombia. With each bend in the road the mountains grow taller, the cliffs steeper, and the jungle thicker. There are no guardrails, and hardly any cars or trucks.

After two hours of riding, I wind through a series of tight turns and there it is: the most beautiful waterfall I've ever seen. It tumbles some 300 feet into the river winding far below. I want to stop, but I was warned. There is no traffic on this road, and the last car I saw had passed more than an hour before. So—I take a chance. I pull off the road.

Before I can get off my bike, I am flanked by two men carrying automatic weapons. They are dressed in jungle fatigues. As they wave the barrels of their guns at me and ask questions, I start shaking. My heart is beating so loud, I am sure they can hear it. Sweat runs down the back of my neck.

I lift my helmet visor so I can look into their eyes. So they can see mine. Searching my limited Spanish vocabulary for something to say, I try to mask my fear with overly animated gestures, and colloquial expressions.

"La cascada! Que increble!" That waterfall is incredible.

I detect a hint of a smile from one of the men. He lets me get off my motorcycle, which they inspect, looking into my bags.

"You like waterfalls, huh?" the other man asks.

Still tense and shaking, I just nod my head, perhaps a bit too vigorously.

"Si. Si, gusto," I add.

"Follow us, there's another waterfall in the jungle, just a one-kilometer hike. Come."

With pale skin, spaceman riding suit, and bike loaded for serious travel, I never fail to grab the eyes of curious locals. Filled with questions, they give me a chance to practice my Spanish. It's especially rewarding in the company of beautiful Colombian women.

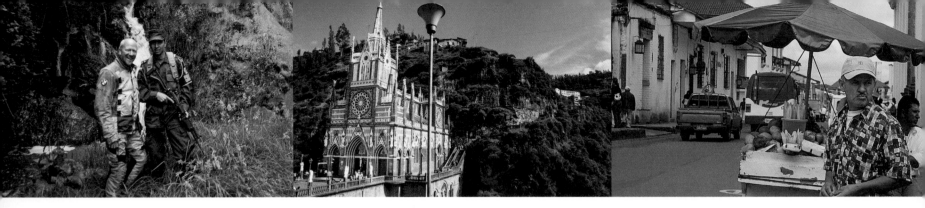

Pilgrims from all over South America come to the Las Lajas Sanctuary where in 1754 a deaf-mute girl was miraculously healed after seeing an apparition of the Virgin Mary on the canyon wall above the Guáitara River. Today a cathedral and shrine rise 100 meters (300 feet) from the bottom of the canyon.

I wonder if this is an offer or an order. Do I have a choice? Standing on the side of the road in the most dangerous part of Colombia with two men carrying guns and ordering me into the jungle, I realize nobody knows I'm here.

My mind starts playing tricks. "If I try to hop on my motorcycle, will they shoot me? If I go into the jungle with them, will I ever come out?" I wonder.

I weigh my options. I'm scared, and for the first time, I begin to think that coming to Colombia was a bad idea. Then I think of the family at the coffee plantation. At that moment, I look into the eyes of the gunmen and search for a sign, for comfort. And suddenly I am filled with a sense of calm.

So I walk into the jungle with them, single file. One man and his gun in front of me, and the other with his gun close behind. After about twenty minutes, we haven't found a waterfall. So I lift my camera and take a picture. The man in front, startled by the loud sound of the shutter, turns around and points his gun at me. The other bumps me from behind with the butt of his. I show them the photo. The man in front laughs, takes my camera, and puts it around his neck. We continue walking.

I lose track of time. Eventually we come upon a clear pool of water. Above is a beautiful waterfall, tumbling down in three tiers, cool, serene, and calming. Over the roaring of the falls, tropical birds sing and winds rustle the trees.

The man with my camera starts taking pictures. Then he asks his friend to take a picture of him and me, together. We laugh. I feel safe, comfortable, and as if I am hiking with friends.

Something comes over me, and I turn to the man next to me and ask him if I can hold his gun. To my surprise, he places his automatic weapon in my hands, warning me that it is loaded and there is no safety.

I look down at the weapon and realize that it could have been used to kill me just moments before. Then I look at my camera in the hands of the other man and realize it's probably worth more than both of these guys make in a year. And I realize something special is happening. I am in perhaps the most beautiful part of Colombia, with two strangers with guns. Though we are worlds and languages apart, we have come together like friends, to experience the beauty of a waterfall and to share the powerful gift of human connection.

This is when I realize the possibilities. Right here. In the Colombian jungle.

Colombia

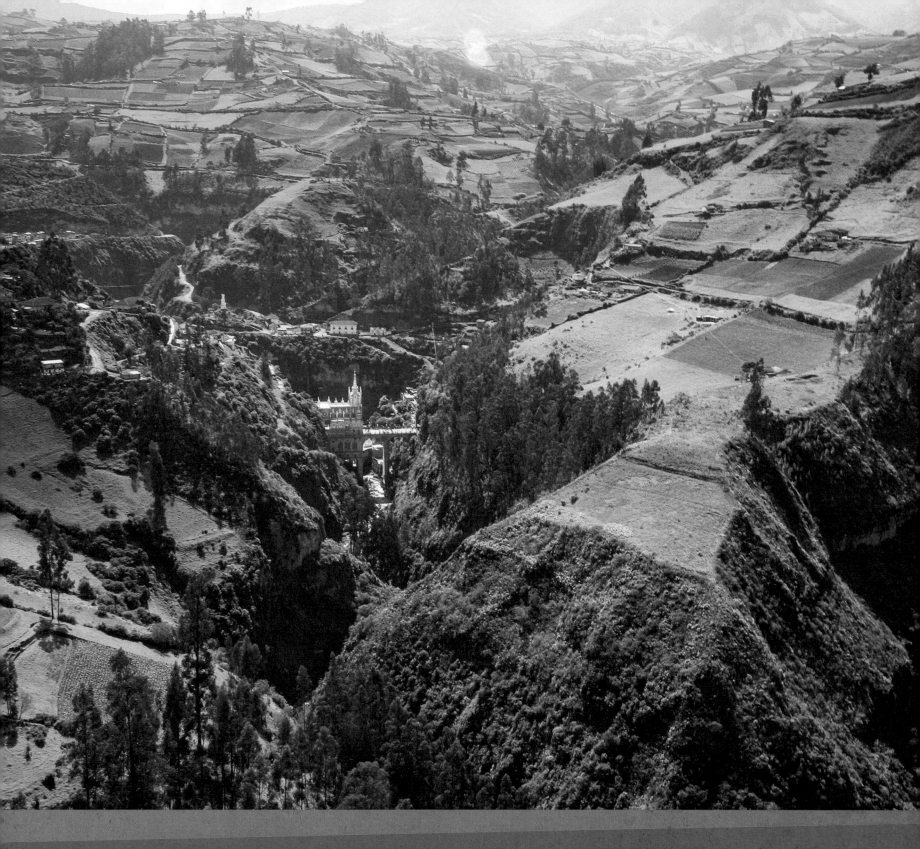

Colombia

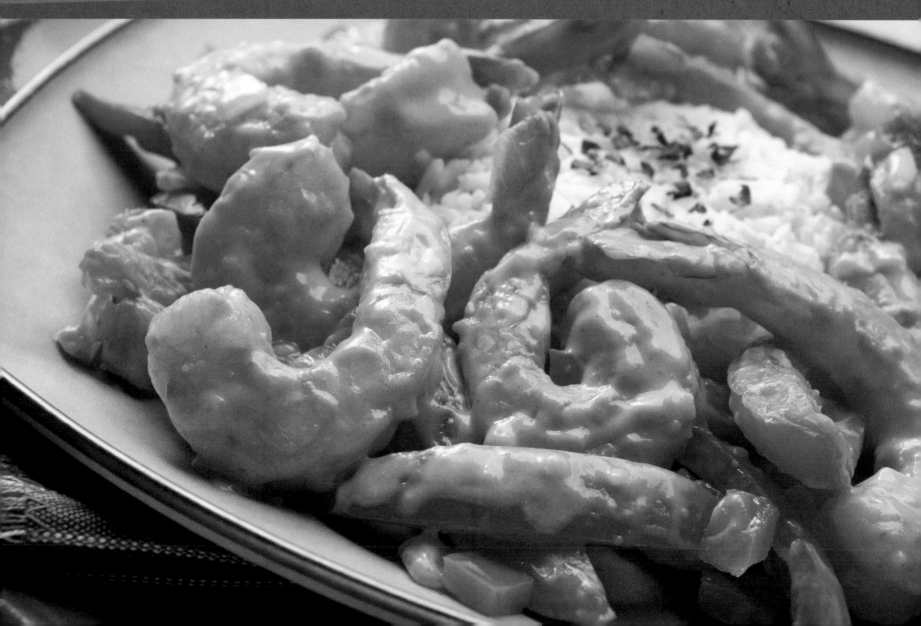

Because of Colombia's immense diversity, I struggled to find the perfect recipe to represent the country. Colombians living along the coast of either of the two oceans that border the country will appreciate a seafood dish, whereas those living in the mountains or along the tropical coffee route might prefer bandeja paisa, a platter of meats, beans, rice, eggs, and more. In my travels throughout Colombia, I learned that all Colombians are proud of their country and food. To me, this easy-to-make and delicious dish of shrimp cooked in coconut milk reminds me of the friendly Colombian people and tastes just like the Colombian coast. Serve as meal or appetizer.

Camarones a la Criolla

Sautéed Shrimp in Garlic Coconut Sauce

Ingredients

2 pounds jumbo shrimp, peeled and deveined

3 tablespoons olive oil

2 garlic cloves, minced

Salt and freshly ground pepper to taste

2 tablespoons lemon juice

1 tablespoon unsalted butter

1 large onion, chopped

½ medium red bell pepper, chopped

1 large tomato, cut into wedges

3 tablespoons all-purpose flour

2 13.5-ounce cans unsweetened coconut milk

¼ teaspoon ground cumin

1 tablespoon tomato paste

½ cup white wine

¼ cup fish stock

1 bay leaf

½ cup fresh cilantro, chopped

Cooked white rice for serving

Preparation

1. In a large bowl, marinate the shrimp for 10 minutes with 1 tablespoon of the olive oil, half the minced garlic, a pinch of salt, and the lemon juice, tossing well to coat.

2. In a large saucepan over medium-low heat, melt the butter and cook the shrimp for 2 to 3 minutes. Remove and set aside.

3. In the same pan, heat the remaining olive oil and sauté the onion, remaining garlic, bell pepper, and tomatoes, and cook, stirring often, for 2 to 3 minutes until softened.

4. Add the flour, coconut milk, cumin, tomato paste, wine, stock, and bay leaf. Season to taste and cook over medium heat for 5 minutes, until sauce is reduced and thickened.

5. Return the shrimp to the mixture and continue to cook 2 to 3 minutes.

6. Remove from the heat, discard bay leaf, and stir in the cilantro.

7. Serve immediately in a bowl with white rice.

Everything is fresh in Colombia: flowers, fish, coffee, vegetables, fruit and juices and meals. With a hint of lemon or a touch of coffee, as I discovered in many local breads, the fresh ingredients seemed to be farmed or sourced just down the road.

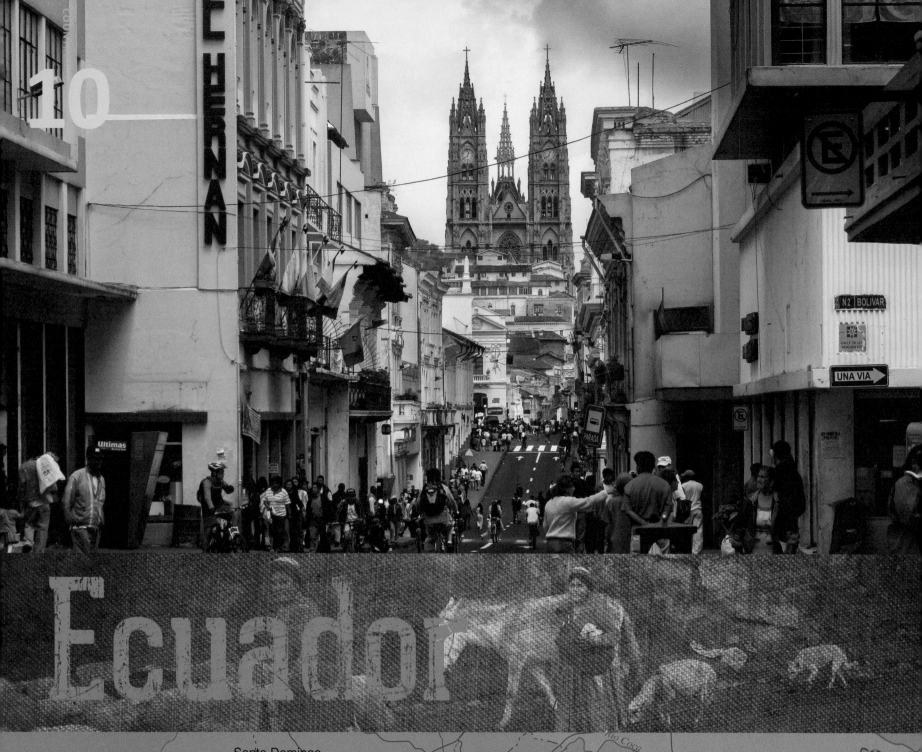

Ecuador

Santo Domingo
de los Colorados

Quito

Sucumbíos

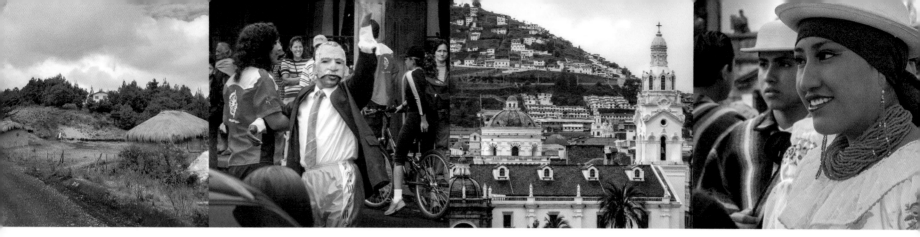

Ageless Dreams and Passion.

Crossing the equator is a landmark. I'm at the halfway point between the top of the world and the bottom. Sitting in the highlands of the eastern *cordillera* of the Andes, Quito is the highest city on earth where the equator crosses. It's also the second-highest capital in the world. The city is divided into two parts: the historic colonial center and the buzzing, modern downtown.

Ten days before Christmas, everyone in Quito is going to the celebration and festival downtown. It takes me fifteen minutes to get through just one intersection, and though traffic has me crawling, it gives me a chance to take in the Spanish colonial architecture. Ornate cathedrals, decorated for the season, resonate with holiday music from pipe organs. The district is packed with more than forty colonial churches and chapels, sixteen convents and monasteries, and numerous festive plazas. After an hour, I'm frustrated and still getting nowhere.

The colonials who conquered Quito in 1539 and the city planners who followed didn't take traffic into account. The cobblestone streets are as steep as San Francisco's but dangerously narrow. Nobody pays attention to traffic signs, and diesel-spewing buses trying to make two lanes out of one squeeze past cars. A taxi forces me up onto the sidewalk. Looking for a hotel and a reprieve from the traffic, I ride in circles.

I stop at a luxury hotel, where I persuade a receptionist to help me find lower-cost accommodations nearby. She spends fifteen minutes calling. Most are booked, but there is one modest hotel six blocks away. It takes me forty minutes to get there, thanks to one-way streets, lack of signage, and snarling traffic. The curb is nearly two feet tall. There's no room to pull off, so I park in the street, go inside, and book my room. The receptionist tells me there's no parking, but offers a suggestion: If I wait, the night-shift will help me carry my motorcycle downstairs to the laundry room.

Size: 283,561 sq km (74th in world)

Population: 15.4 million (67th in world)

Capital: Quito (1.6 million)

Largest city: Guayaquil (2.6 million)

Independence Day: 24 May 1822 (from Spain)

World Heritage Sites: 4

Literacy rate: 93.2%

Currency: United States dollar

Population below poverty line: 27.3%

Key exports: bananas, coffee, cacao, fish, shrimp; wood, cut flowers

Mobile phones: 15.3 million (54th in world)

At first I thought perhaps I'd found the only taxidermist in Ecuador, but further investigation revealed this pig would be part of my lunch feast. The dish is called *hornado de chancho*, or slow roasted pig, usually marinated in garlic, beer, cumin, and achiote.

She thinks my bike is a small Japanese or Chinese model that weighs less than 200 pounds. My bike and my gear weigh in at more than 500; it's not going downstairs.

Cars and trucks honk outside. A red-faced transit cop bursts into the hotel and speaks so fast to the receptionist that I can't understand.

"You! Ride your motorcycle inside!" he yells at me. A crowd of pedestrians gather around and watch, unfazed by the blaring horns or the traffic I've held up. He blows his whistle, yelling, "Now!"

He wedges the doors of the hotel open and waves his arm, pointing to the entrance, then rushes outside and, waving his arms again, summons two trucks to back up so I can make a running start to jump the high curb. Then I must climb the stairs and ride into the lobby. This is madness. I'm scared. If I lose my balance on the narrow steps, I will crash into the fifteen-foot-tall glass doors, shattering them.

I rev the engine, then release the clutch. The cop holds traffic back. My front wheel slams into the curb. I pull up on my handlebars, goose the throttle, zoom up the stairs, and slide into the lobby. The sound of my motorcycle reverberates off the marble and stone of the 125-year-old hotel.

Welcome to Quito.

With my bike safely nestled in the lobby, I set off to explore the city on foot.

Declared a UNESCO World Heritage Site in 1978, Colonial Quito is a large-scale museum of sculptures, paintings, and buildings, including all those colonial churches. The heart of the old town surrounds the Plaza Independencia, studded with the jewels of the city's heritage: the Presidential Palace, the Archbishop's Palace, and City Hall.

It's not long before children offering cigarettes, gum, candy, and shoe shines spot me and start following me as I walk around.

"How old are you?" I ask the youngest looking boy. "Shouldn't you be home?" He's nine and tells me there's no school tomorrow.

"It's very late," I explain. "The plaza is very dangerous at night, my hotel told me." They laugh and offer to show me the Casa del Gobierno (Presidential Palace), where the president lives.

"Can I meet the president?" They laugh, and the young boy grabs my hand, pulling me across the plaza.

There's a man in dirty, torn clothes, yelling at the Presidential Palace. The kids giggle. He's drunk. Neck craned up toward the second floor, he waves his fist and yells in Spanish. Police in the area ignore him. He's screaming, saying the president is no good because he does nothing for the poor, because there are no jobs, because people are sick, and because the president has a deaf ear to these problems.

Ecuador is South America's most densely populated country, with about 30 percent of its population below the poverty line. Armed guards flanking the palace tell me the president is away. The angry man's words are futile.

Nearby, at the La Compania de Jesus Church, regarded as perhaps the richest in the Americas with its six Salomonic columns copied

Ecuador

A week later and far south of Quito, I continue to fight cold weather and roads slippery with endless rain. Though I know there are grand, snow-capped volcanos surrounding me, I can't see them: Everything is shrouded in gray clouds and fog.

from Bernini's in the Vatican, a young bride and groom are whisked away in a vintage Mercedes-Benz. I sneak inside and see its true splendor: gold leaf walls that stretch high to a vaulted ceiling painted with Moorish designs, all overshadowing the equally gold-laden Baroque tribunes, altar, pulpit, and chapels. I feel this must be the most lavish Catholic church in the world.

A week later and far south of Quito, I continue to fight cold weather and roads slippery with endless rain. Though I know there are grand, snow-capped volcanos surrounding me, I can't see them: Everything is shrouded in gray clouds and fog.

When the sun breaks, I'm on the outskirts of the small village of Saraguro. I'm stepping out of my rain suit on the side of the road when I meet Rosalgarcia, a seventy-nine-year-old woman. She's walking up a steep hill, carrying two heavy buckets of water. She tells me she's on her way home to cook supper for her husband. She's surprised, says she has never met anyone from the Estados Unidos, and is amazed I've traveled here by motorcycle.

She tells me of her children, who have moved away, and of her husband, who is only fifty-nine years old.

"I like younger men," she says with a wink.

She then points to the only tooth in her mouth, white and shiny, sticking up like the lone cypress from the otherwise barren ridge of her lower gum. She asks how much it would cost in the US to get new teeth. When I tell her I don't know, but that I wish I could give her teeth, right there and right then, she tells me not to worry.

"I soon will have new teeth," she declares, explaining that she's saving money so she can visit a dentist in nearby Saraguro.

As I scribble in my Moleskine notebook, she asks if she can have it, or any book, so she can learn to read. All I have is the owner's manual for my helmet. With drawings on how to remove the face-shield and sun screen, it is written in five languages. Her eyes widen, and she grins a bigger smile when I place the tiny book, along with a handful of change, into her worn and weathered hand. We hug and say goodbye.

I cannot stop thinking about Rosalgarcia, her nearly toothless smile, spirit, and curiosity. And at nearly eighty years of age she still has passion and wants to learn to read. She also still has a dream—new teeth. ▬

It's efficiency over safety in most countries I visited. I've seen as many as six people (infants included) on a motorcycle. In the bustling, crazy traffic of Quito, Ecuador, this family whizzes about the city wearing the ultimate protective gear—their street clothes. Credit to the girl for sporting a helmet.

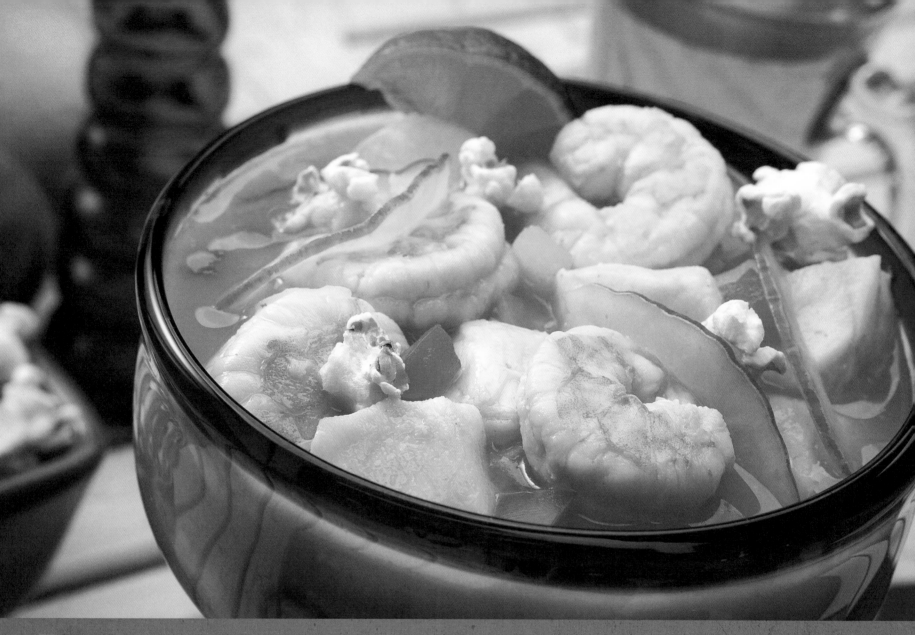

Ecuador

From the coast of the Pacific to Quito, the highest capital in the world, Ecuador is teeming with cebicherias, small cafés specializing in a fresh seafood dish known throughout Latin America as cebiche (also ceviche). Both Peru and Ecuador may lay claim to the origin of cebiche, but I found this Ecuadorian dish to have the most unique twist, with the added texture of popcorn, corn nuts (tostado), and plantain chips. Since the fish is cooked briefly, only the freshest seafood is used. Often served in late morning or lunch when the fisherman bring their fresh catch, cebiche is the ideal appetizer to share—anytime!

Ecuadorian Cebiche
Fish and Shrimp in Citrus Marinade

Ingredients

1 medium red onion, thinly sliced

1 cup plus 2 tablespoons fresh lime juice

1 pound shrimp, peeled and deveined

1 pound white fish, such as sea bass or halibut

1 cup orange juice

⅛ cup tomato sauce or ketchup

1 tablespoon Dijon mustard

1 tablespoon granulated sugar

⅛ teaspoon cayenne pepper

½ medium orange bell pepper, diced

½ medium yellow bell pepper, diced

4 Roma tomatoes, seeded and diced

2 garlic cloves, minced

Salt and pepper to taste

2 tablespoons olive oil

3 tablespoons chopped fresh cilantro leaves

Popcorn, tostado (similar to corn nuts),and chifles (fried plantain chips), to serve

Preparation

1. In a shallow bowl, soak the onion slices in 2 tablespoons of the lime juice for 30 minutes, or until they become soft and pliable.

2. Bring 2 pots of salted water to a boil. Blanch shrimp in one pot and the fish in the other, both for 2 to 3 minutes.

3. Combine 1 cup of the cooking liquid from the fish with the remaining lime juice and orange juice, tomato sauce or ketchup, mustard, sugar, and cayenne pepper. Mix well to combine, and add the shrimp, fish, peppers, tomato, garlic, and marinated onions. Toss to coat, season with salt and pepper to taste, and refrigerate for about 1 hour.

4. Before serving, drizzle with the olive oil and top with the cilantro.

5. Serve with popcorn, tostado, and chifles (fried plantain chips) on the side.

Note

Do not overcook the seafood as it will become tough and rubbery and some of the flavor will be lost.

Variation

Lime juice is best for a really tangy cebiche, but lemon juice or any combination of lime and lemon juice can be substituted.

Any seafood can be substituted for this recipe. The most common are conch, mussels, squid, and tuna.

I love the flavors of fresh citrus, especially when the juice of the fruit is used to marinate and cook the fish. In the Ecuadorian version of this Latin classic, the fish is blanched in water that is then combined with lime and orange juices to create the marinade. Feel free to experiment with your favorite fish.

Peru

JUNIN

Lima Huancayo MADRE DE DIOS

Callao LIMA Rio Madre de D

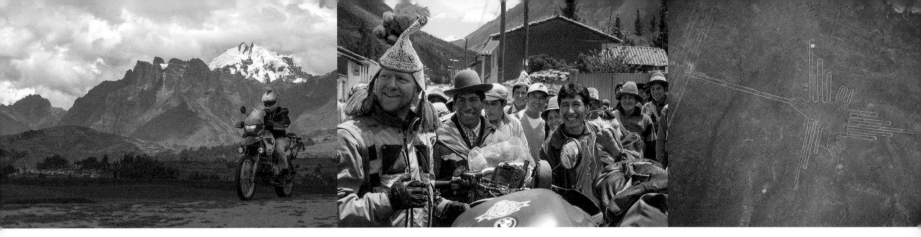

Riding Between the Lines.

The rickety tower seems to sway, and the rusty, corrugated-metal roof rattles noisily as the powerful coastal desert winds kick up dust from the parking lot below. I am about halfway up the fifty or so stairs to the observation deck when I see the first hint of the lines. A feeling comes over me. I don't know if I am going to cry or cheer. I have no expectation. They are just lines carved into a vast expanse of arid desert. But I am here, in Peru, looking down at the Nazca Lines.

I can't remember if I learned about them in school or in a Discovery Channel documentary. But I know I've been fascinated with them for years. And now here I am, twenty miles north of the town of Nazca, in a tower atop a small hill overlooking the Nazca Lines.

The Nazca Lines have mystified anthropologists and mathematicians for decades. Only truly appreciated from the air, they form a 300-square-mile anomaly in this rock-strewn desert in southern Peru. Ancient geoglyphs consisting of over 800 lines, they depict some 300 geometric shapes and about seventy animal and plant figures. "Etched" into the earth by removing sun-darkened stones from the desert surface to expose lighter stones and soil below, some are more than 600 feet wide. The lines and shapes have remained for thousands of years because they are set in one of the driest places on the planet. Since the early 1900s they've been protected by historians, scientists, and the Peruvian government.

Visitors are warned to stay off, and there are land mines rumored to be protecting this UNESCO World Heritage Site. I wonder who carved and connected the lines and how they did so with an accuracy and precision that can be appreciated only from hundreds of feet above.

Size: 1,285,216 sq km (20th in world)

Population: 29.9 million (42nd in world)

Capital and largest city: Lima (8.8 million)

Independence Day: 28 July 1821 (from Spain)

World Heritage Sites: 11

Literacy rate: 92.9%

Currency: Peruvian nuevo sol

Population below poverty line: 27.8%
Key exports: asparagus and other vegetables, coffee, fruit, fishmeal, fish

Mobile phones: 32.5 million (33rd in world)

While Machu Pichu captures most of the glory of the Inca's masonry skills, the real beauty and technical acumen of this lost civilization can be seen above the city of Cuzco. At Sacsahuaman massive stones were cut so perfectly they fit together like jigsaw pieces to create towering walls around this ancient fortress.

German mathematician and leading researcher of the lines, Ms. Maria Reiche, theorizes that ancient cultures created the lines from 900 BC to AD 700. She believes the lines served as an astronomical calendar and were mapped by sophisticated mathematicians with long strings and a lot of patience. Others argue they were landing strips for aliens, created for fertility rites, or—in hopes for rain—made to please the gods. My favorite is that they are expressions of Amazonian shamans' drug-induced hallucinations.

Some visitors should not take the airplane tour of the lines, like the other four passengers who share the tiny plane with me. We are like clothes in a dryer as the plane bounces, tosses, and shakes. Their faces are sullen and jaws sunken. They clutch their barf bags. I can hardly hear the pilot as he points out the major figures. Everyone clings to the windows in a vain effort to snap photos. I can see it coming: the woman across the aisle squeezes her eyes closed, lifts her chin high, then plants her face around the bag, gagging and teary eyed. Her husband holds her tight. She wants off the plane.

I look out the other window. The observation tower is barely a dot below, dwarfed by the shapes and figures of the Nazca Lines. It's obvious to me now that viewing them from that tower is pointless. From the plane, the scale and clarity of the figures is astonishing. We fly over a monkey; a condor with a huge, 400-foot wingspan; a hummingbird; a spider; and a unique figure with what appears to be a fishbowl over his head. They call him the Astronaut.

Eager to continue my journey onward to Machu Picchu, I leave Nazca at about four in the afternoon. Locals tell me that I can make the 100-mile ride to Puquio, a tiny town in the Andean highlands, in just over two hours. I will arrive well before sunset, they say. I don't have many rules or conditions, but I avoid riding at night for a good reason: It's dangerous. South American roads are famously free of reflectors, painted lines, guardrails, and warning signs. Road hazards or construction zones are rarely marked. Many cars and trucks travel without lights, and animals wander onto the road, making accidents inevitable.

South American roads are famously free of reflectors, painted lines, guardrails, and warning signs. Many cars and trucks travel without lights, and animals wander onto the road, making accidents inevitable.

The road climbs quickly out of the desolate, arid, and dry desert of Nazca. I find myself racing against looming dark clouds. Rockslides spill onto the road around every corner, making the riding slower than I'd expected. I am startled by a pack of animals that dance across the road in front of me, gracefully jumping up a high embankment, then stopping to watch me pass. They look like deer but seem smaller, and their fur looks too smooth, ears more pointed, and they have longer necks. I stop to take a closer look, but they flee elegantly, light-footing it across the pampas. I learn later they are vicuña, a rare and protected species known for its soft and warm fur.

Peru

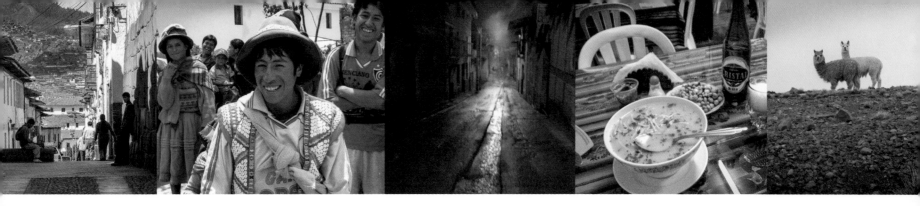

I keep riding. Endless switchbacks and loose rock and gravel challenge my skills as I dodge trucks barreling down the mountain.

I keep riding. Endless switchbacks and loose rock and gravel challenge my skills as I dodge trucks barreling down the mountain. Soon I'm riding into clouds, then fog. My visibility sinks to only several feet. And then it starts raining, pouring. I can't keep my face-shield clear. It's useless, I can hardly see. The sun dips behind a mountain peak, fog thickens. I can't see a thing. I watch the altimeter on my GPS. It reads 8,000 feet, then 9,000, and soon I've reached 10,000 feet and am still climbing. At every curve the cliffs drop off hundreds of feet. It's freezing.

Frustrated and frightened, I fear I'll slip on oil, rocks, and into oncoming traffic, but staying alert and concentrating on the road is exhausting. At 13,000 feet, I brave a short section of chilling sleet. I battle with the notion of stopping and putting on heavier gloves, but I don't want to waste time. I keep rounding darkening curve after darkening curve. No sign of lights. No sign of cars. I'm climbing higher into the Andes—but still no Puquio.

After more than three hours, without a hint of daylight remaining, I spot a far swath of lights. Puquio! Thank God! For another forty-five minutes that vision plays tricks with me, appearing then disappearing. When finally I roll into Puquio, the pavement ends. I bounce in and out of potholes and through mud. I watch the

beam of my headlight dance on the faces of locals walking down the road, huddled together and layered with colorful blankets.

The hotel clerk suggests La Estancia on the other side of town for a hot, home-cooked meal. I walk there but am not prepared for the biting cold and stinging rain.

"Frio (cold), no?" asks a squatty woman with round face. She and her son huddle around me. Wondering why I didn't dress warmer, they bring heavy blankets and drape them around me at the table. They bring a bowl of food before I ever see a menu. "Sopa gallena," she says. "Deliciosa" (delicious). A fragrant and warm bowl of chicken soup served with a bowl of large corn kernels. I grasp the edges of the bowl to warm my numb fingers. It's the best soup I've ever eaten.

They sit with me as I eat. I tell them I'm from the United States and came on a motorcycle, but that I think the ride from Nazca to here is longer. They laugh.

Locking the door of the restaurant behind me, the boy escorts me through a maze of dark alleys back to my hotel.

"Suerte," he says. "Disfrute Machu Picchu." Good luck. Enjoy Machu Picchu. ▮•▮

In the US we take public restrooms for granted. In many Latin American countries, access to bathrooms will cost you. In Peru, I offered to work as cashier at a local pay-for-pee restroom but was fired. I had to pay the boy my one *nuevo sol* (about 30 cents) and give him back his chair to take a piss.

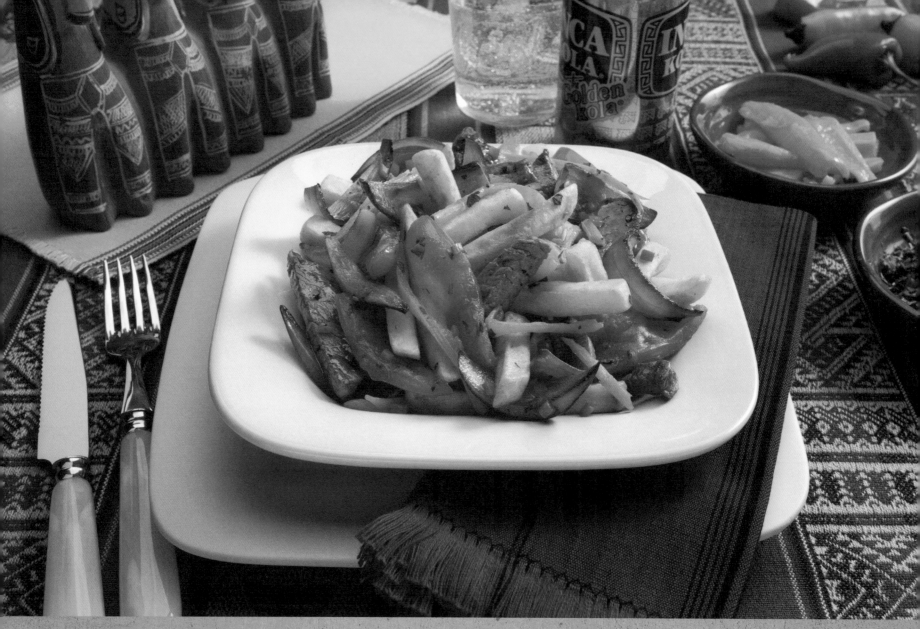

Peru

No matter where I traveled in Peru, there was one dish I always could find, Lomo Saltado. Some may argue that cebiche is the ultimate Peruvian dish, but to me nothing is more uniquely Peruvian nor expresses the cultural diversity and flavors of Peru better than this dish. In the mid-nineteenth century, thousands of Asians settled in Peru, working as contract laborers in the mines, on plantations, and building the railroad. Evidence of Asian influence is found in both the faces of the Peruvian people and their cuisine. Cooked in a deep fry pan or wok, Lomo Saltado fuses Asian ingredients and cooking techniques with fried potatoes, traditional Latin staples and uniquely Peruvian ingredients like ají amarillo hot peppers

Lomo Saltado
Beef Tenderloin Stir Fry Fusion

Ingredients

Potato Fries

2 pounds russet potatoes

Salt

Vegetable oil for deep frying (about 1 quart)

Beef Stir Fry

2 pounds beef tenderloin, cut into ¼-inch-thick slices and then into ½-inch-wide strips

2 teaspoons ground cumin

Pinch ground cinnamon

1 teaspoon freshly ground pepper

⅓ cup and 1 tablespoon soy sauce

1 to 2 quarts grapeseed or vegetable oil for stir frying

3 garlic cloves, minced

1 to 2 Thai red chiles, stemmed, seeded, and finely minced (for milder flavor use red Fresno chile)

Salt to taste

2 medium red onions, halved and cut into ½-inch thick half circles

1 teaspoon red wine vinegar

10 Roma tomatoes halved, seeded, and roughly chopped

3 Ají amarillo chiles (Peruvian yellow pepper), seeded and thinly sliced (reserve 1 for garnish)

¼ cup fresh cilantro leaves, chopped

Cooked white rice

Preparation

1. Peel potatoes and place in a bowl of cold water until ready to cut, to prevent darkening.

2. In a large bowl, toss the beef strips with the cumin, cinnamon, pepper, and 1 tablespoon of the soy sauce.

3. Heat enough oil to cover the base of a large pan or wok and sauté garlic and Thai chile over medium heat for 2 minutes until brown.

4. Raise the heat to high and, working in batches, add beef strips and stir fry until browned, about 2 minutes per batch. Season with salt and transfer the beef along with pan juices, garlic ,and chile to a clean bowl. Set aside.

5. Add a little more oil to the pan or wok if necessary and stir fry onion until barely soft, about 1 minute. Add vinegar, salt, and pepper. Continue stir-frying for about another minute, until all liquid has been cooked off.

6. Remove onion from the pan, set aside, and repeat procedure with tomatoes.

7. Preheat the oven to 300 degrees F. In a heavy, deep pot, heat oil to 375 degrees F. Cut potatoes into ½-inch fries. To prevent splattering, pat potatoes dry. Using a spoon, carefully add potato strips, a few at a time, to hot oil. Fry for 5 to 6 minutes or until crisp and golden brown, turning once.

8. Using a slotted spoon, carefully remove potatoes from hot oil. Drain on paper towels and sprinkle with salt. Place potatoes on a baking tray or in a bowl and place in oven to keep warm while frying remaining potatoes.

9. Return beef mixture, onion, and tomato to the pan or wok.

10. Add 2 of the Peruvian ají amarillo peppers, reserving 1 for garnish, and remaining ⅓ cup soy sauce. Cook for 1 minute over medium-low heat, stirring often. Add 2 tablespoons of the chopped cilantro and the potato fries, tossing gently to combine.

11. Transfer contents of pan to a warmed platter, garnish with the rest of the cilantro, the reserved Ají Amarillo chile and serve immediately, accompanied by white rice.

There's no question that the *pisco* sour is Peru's national (alcoholic) beverage. If you can't find Peruvian *pisco*, you can make it with brandy.

Pisco Sour

Ingredients

1½ ounces *pisco* or brandy

¾ ounce fresh squeezed lime juice (about 1½ tablespoons)

1 tablespoon rich simple syrup (equal amounts of granulated sugar and water heated until sugar dissolves)

1 small egg white

Ice

Several drops of angostura bitters

Preparation

In a cocktail shaker with ice, shake all the ingredients and strain into a small cocktail glass. Garnish with several drops of angostura bitters on top of the foam.

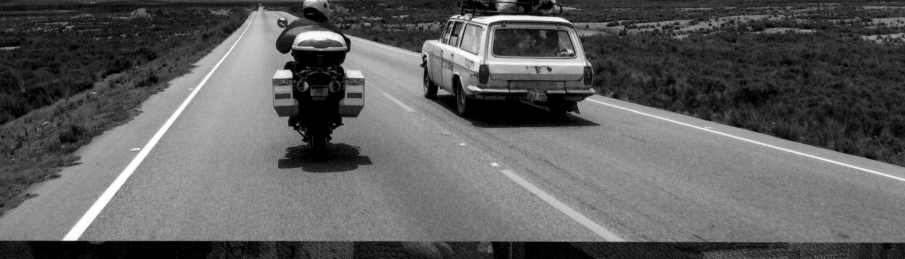

Bolivia

Pablo Lagerenza
Camiri
CHUQUISACA
POTOSI Uyuni General
 Eugenio A. Garay

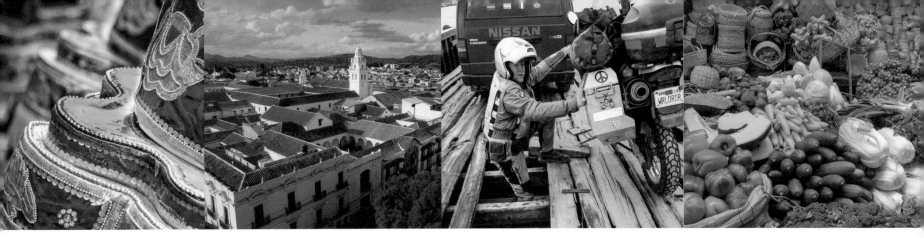

An Amazing Ride and an Unexpected Fork. Crossing Lake Titicaca

should be easier. I was expecting a ferry, one with a dock and a ramp. Instead I find a dozen ramshackle boats that look like miniature barges.

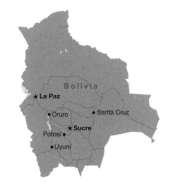

There is neither dock nor ramp, just rotten planks thrown over the stern of the boat to the shore. The boat has no deck or floor. More rotten planks are loosely laid on crossbeams over the hull. They are positioned so a car can drive on them, but a wheel will drop off if not lined up perfectly. They are barely wide enough for my motorcycle when it's on the kickstand.

Another traveler joins me for my journey into Bolivia; one more adventurer on a motorcycle. Roughly my age and riding the same BMW model as me, Jeremiah has traveled from Colorado. We'd met in Mexico months earlier and reconnected in Cuzco, outside Machu Picchu. We share a common dream: to see and ride our motorcycles on the Salar de Uyuni, the largest salt flat in the world. The Salar, as we have come to refer to it, stretches for hundreds of miles high in the Andean Altiplano in southwestern Bolivia. It's huge, nearly twice the size of the State of Delaware. In fact, it's so big that it's visible from space and is used as a target to calibrate satellites. We've agreed to ride together and explore this amazing wonder.

I push my bike up the dilapidated planks. Standing in the bilge, I have to brace my bike for the whole trip across the lake. Jeremiah's bike falls over. No problem, just a little gas leaks out of the tank. At once, the captain smells the gas. He's not worried about fire; he jealously desires the fuel. *"Ah, petrol Peruana, no? Muy bueno!"* He can distinguish between the odors of Peruvian and Bolivian gas, the latter of which has poorest fuel quality and measliest octane in South America. Impressed by the Bolivian's sense of smell, I wonder if he can distinguish a French malbec from an Argentinian.

Size: 1,098,581 sq km (28th in world)

Population: 10.5 million (82nd in world)

Capital and largest city: La Paz (1.7 million)

Independence Day: 6 August 1825 (from Spain)

World Heritage Sites: 6

Literacy rate: 86.7%

Currency: Bolivian boliviano

Population below poverty line: 49.6%

Key exports: natural gas, soybeans and soy product

Mobile phones: 8.4 million (85th in world)

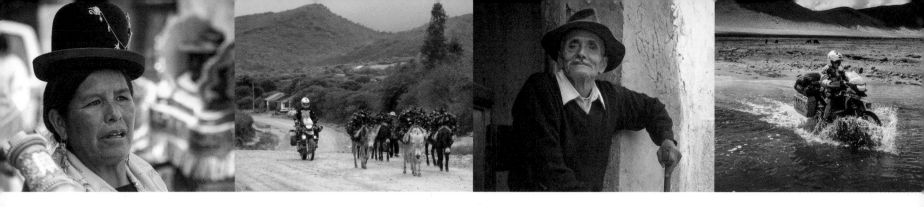

As we travel to the high plains of Bolivia, Jeremiah and I keep a close watch on the weather. During the rainy season the Salar floods with water—pure, organic saltwater. Riding our motorcycles through saltwater will destroy them. By the time we arrive at Potosí, Bolivia, the highest city in the world, we are drenched. It seems the rains have beaten us. With only 200 miles of dirt roads separating us from realizing our dream of riding on the Salar de Uyuni, we wonder if it is still dry.

We prepare for the worst weather, layer our clothing, step into our rain gear, and pull out our heaviest gloves. The chilling air of the highest city of the world at six-thirty in the morning is one reason. Rain is the other. Despite the blue skies littered with a few puffy white clouds, we know the chance of rain is 100 percent.

As we follow a river and climb hills of limestone and sandstone, the scenery brings back memories of southeastern California and western Arizona deserts. The weather is holding up. This is one of my best days of riding in months. It packs everything that defines great adventure motorcycling: dirt roads, desolate wilderness, water crossings, canyons, gorges, and the wonderful feeling of solitude and nature. We have the road to ourselves as we carve and curve along the edges of cliffs, then drop into small valleys. Even at 13,000 feet, the altitude doesn't affect me. Riding bliss.

We've been on the road for nearly five hours before we come to the first sign of civilization. The tiny settlement of Ticatica is marked by just one narrow street, which is lined with reddish-brown adobe

buildings with thatched roofs. A beautiful Bolivian girl wearing a brightly colored dress and a short-brimmed bowler hat smiles and waves as we pass.

In just minutes, the dirt road deteriorates. In the center of the town, the entire middle of the road is a pool of deep water and mud.

Jeremiah pulls to the right to avoid it, I ride to the left. My tires slither like a slippery snake, with barely any traction. I tighten my grip around the handlebars and, tense with apprehension, continue moving slowly. In just seconds my front tire sinks into the mud and my bike slides out from under me. As I fall into the mud, I watch in slow motion as my bike and my hard aluminum panniers crash on top of me. My leg is caught under the panniers and I can't move it. I feel dizzy, disoriented, as the blazing high-altitude sun blinds me. My senses are reeling, something feels funny. I know it immediately. My leg is broken, crushed.

My trip is over. My dream to see and ride the Salar, unfulfilled. I want to cry. But I don't.

I yell at Jeremiah, "My leg is broken!" In shock, giddy, I yell, "Hey, get your camera!"

The locals gather around and hover above me as I lie in the mud. The sun is baking. Unexpectedly, a boy breaks through the crowd, opens an umbrella, and holds it above me. Moments later another boy opens a second umbrella. Suddenly shaded, I feel that these

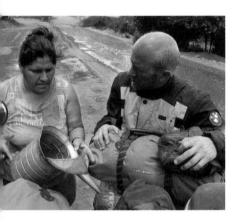

Finding fuel in Bolivia could be challenging. Gas stations were not marked so often I had to ask. Locals would direct me to a small shack selling snacks and fruit, or even to a home where enterprising Bolivians lived in close proximity to a 55-gallon drum of gasoline. This woman poured fuel from a 1-liter jug, which helped her calculate my cost. (photo courtesy of Miah)

Bolivia

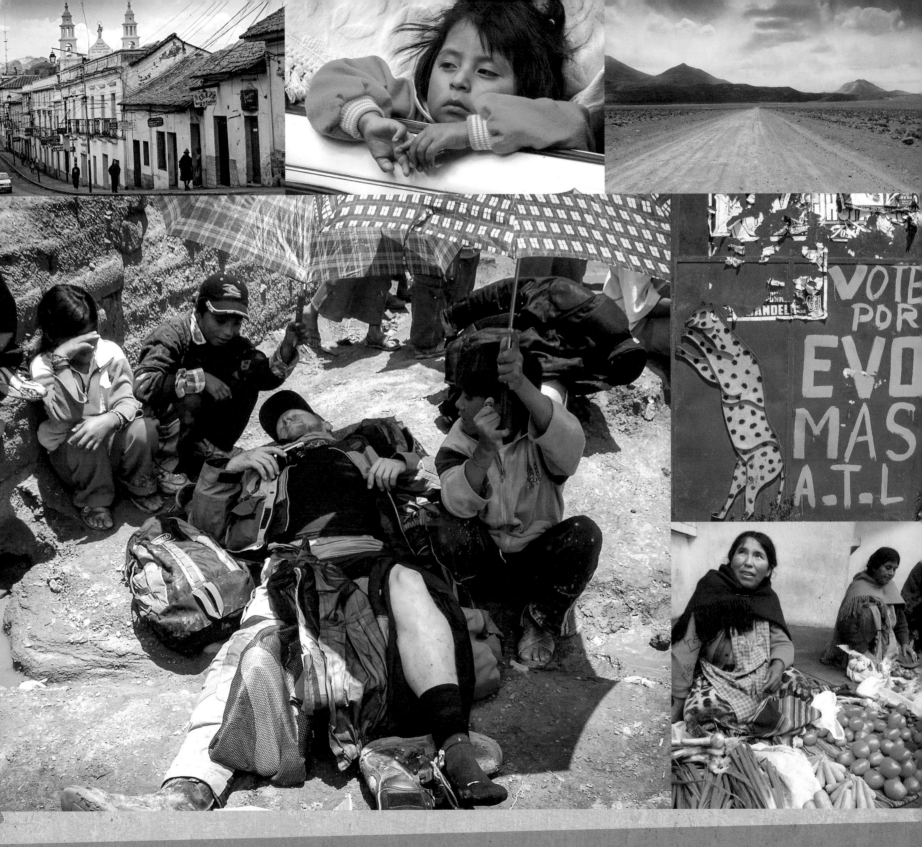

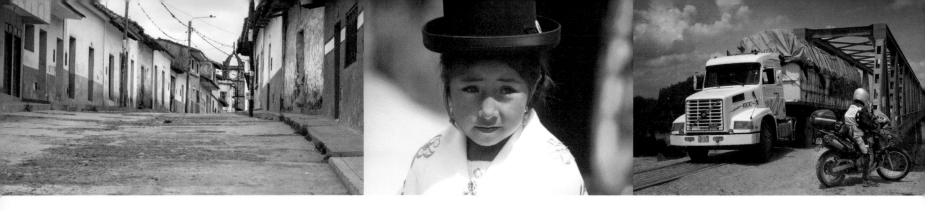

I am stuck in the middle of nowhere with a broken leg and a motorcycle

Even on the dustiest, most remote track I found smiling, curious people, often living in harsh conditions without the convenience of running water or electricity. I learned that, despite this, the people with less usually seemed happier than those with more and were always willing to share what little they had with strangers.

two young boys are angels of mercy, come to protect me from the brutal Altiplano midday sun.

Even so, I am stuck in the middle of nowhere with a broken leg and a motorcycle.

There is no cellphone service and only one phone in town, a radio telephone. In bad weather it operates sporadically. So before we can confirm that an ambulance will come, the phone cuts out. As the storm brews, Jeremiah and the locals move me to a modest medical clinic.

After twelve hours of waiting and wondering and a painful and dangerous five-hour ride in a faux ambulance through pouring rain, crashing thunder, and blinding lightning, I finally get to a hospital in Potosí. Doctors confirm that my leg is broken—in three places. They give me pills for my pain, the strongest they have, I'm told. It's a high dose of ibuprofen. "Great," I think. "Here I am in Bolivia, one of the world's largest producers of cocaine, I've got a severely broken leg, and all they can give me for pain is Advil. There is no justice."

I never thought I'd have to use it, but before I set out on this adventure I purchased medical assistance and evacuation

insurance. Now, even with it, in a public hospital in Bolivia, in the highest city of the world, it takes three days to coordinate and then three flights and more than twenty hours to get me back to the United States. My bike remains in Bolivia.

In California, surgeons put the pieces of my leg back together with the help of rods, screws, and plates. In Bolivia, a local retrieves my motorcycle and secures it in his home in Potosí.

Rehab and recovery are difficult. It takes many months before I can walk without a limp. Family and friends ask if they can help and support me.

"What are you going to do now?"

"Are you looking for a job?"

They think I have given up.

I haven't. I work hard to get strong, and many months later I return to Bolivia, retrieve my bike, and continue my journey. Yes—I finally make it to the Salar de Uyuni—and far beyond.

Bolivia

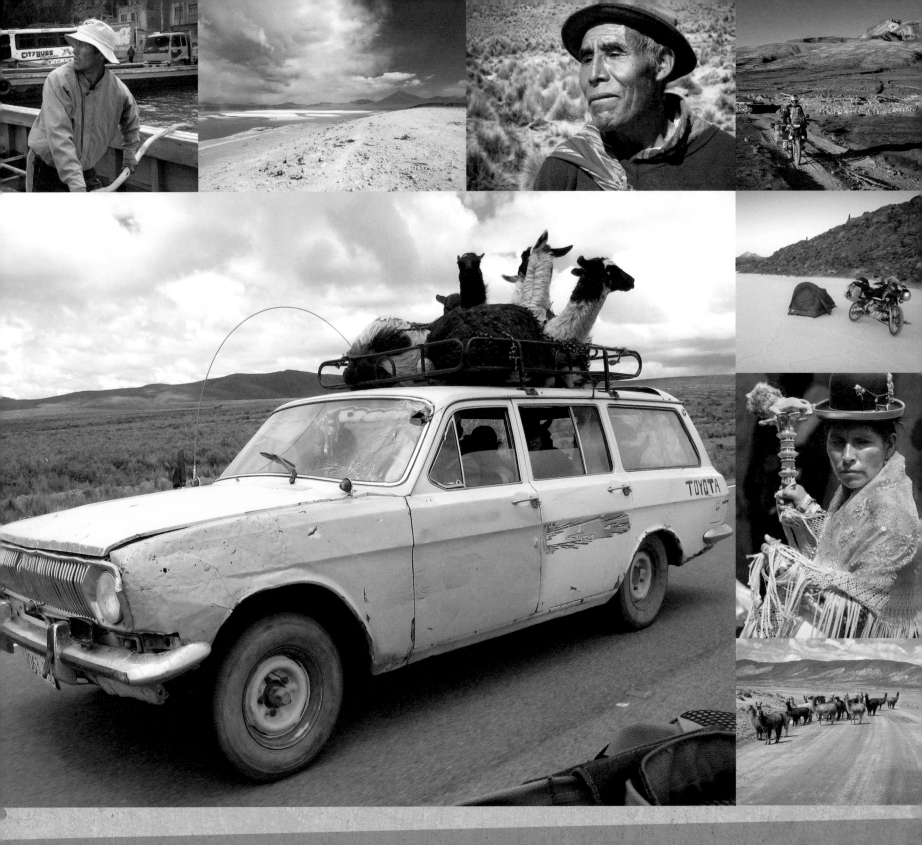

Bolivia

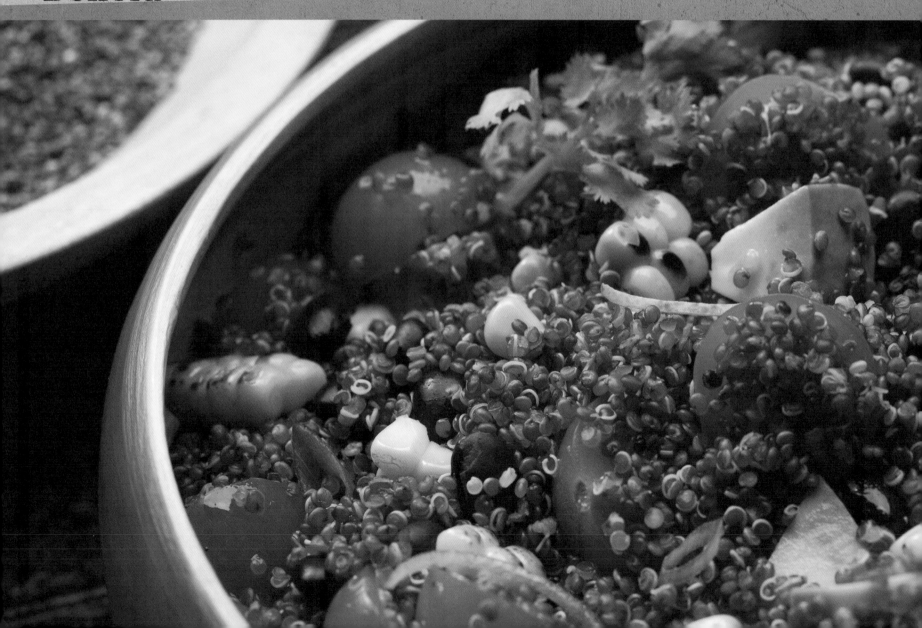

The flavors, climate, and cultural heritage of Bolivia are uniquely expressed in this Andean-inspired dish. The climate and terrain of Bolivia range from verdant tropical lowlands and jungle to the remote, cold, and arid highlands of the Andes Mountains. Quinoa, the grain-like superfood that is increasingly popular in the United States and Europe, originated in the Andes, around Lake Titicaca in Bolivia and Peru, more than 5,000 years ago. Small wild tomatoes also originated in Bolivia and Peru in the high plains. And avocados are immensely abundant in markets throughout the lowlands. Taste the splendor of all that is Bolivia with this healthy and flavorful salad.

Quinoa and Black Bean Salad with Grilled Corn, Cherry Tomato, and Avocado

Ingredients

Dressing

2 teaspoons grated lime zest

2 tablespoons fresh lime juice

1 teaspoon white wine vinegar

1 teaspoon ground cumin

⅛ teaspoon cayenne pepper

2 tablespoons unsalted butter, melted and cooled

1 tablespoon olive oil

1 teaspoon brown sugar

½ teaspoon salt

¼ teaspoon freshly ground black pepper

Salad

1 cup quinoa, red or white, rinsed

1 15-ounce can black beans, drained and rinsed

2 medium ears corn, grilled and kernels cut from cob

2 cups cherry tomatoes, halved

6 green onions, finely chopped

¼ cup fresh cilantro, chopped

1 avocado, pitted, peeled and sliced

Preparation

1. In a large bowl, whisk together the dressing ingredients and set aside.

2. Meanwhile, cook quinoa in a pot or rice cooker according to package directions, allow to cool for 5 to 10 minutes, and fluff with a fork.

3. Add quinoa to bowl with dressing and toss until liquid is absorbed. Stir in black beans, corn, cherry tomatoes, green onions, and chopped cilantro. Add sliced avocado and season with salt and pepper to taste.

In most every Latin country travelers will find stuffed pastries. They're usually called empanadas, but in Bolivia they are *salteñas,* sold at roadside shacks, bus stops, and even the best restaurants. The best are stuffed with spiced and savory chicken, peas, and potatoes. Buy them early though; these fresh delectables sell out early in the day.

Chile

San Felipe

Valparaiso

Santiago

San Antonio

Buenos Aires

Urug

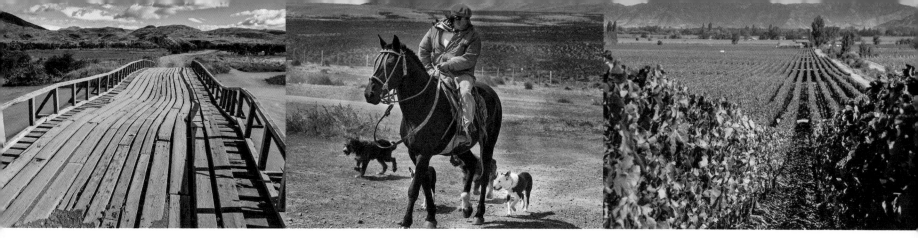

Riding The Borderline.
I've zigzagged across the border of Chile ten times while traveling through South America. With each crossing the diversity of this nation is slowly revealed. It's the longest country in the world. From the immense Atacama desert in the north to the ice fields of the Andes in the south, and the beaches, lakes, and vineyards in between, most anyone will find Chile exciting. If not, the closest border is usually less than 100 miles away; Chile is one of narrowest countries in the world.

My first crossing into Chile is perhaps the most memorable. I finally have enough confidence and strength in my leg to move on—and out of Bolivia. I'm ready, too. After two accidents in Bolivia, including the trip-interrupting broken leg many months before and an ankle-twisting crash on railroad tracks that kept me on crutches for two weeks, I think I'll never escape Bolivia.

I have a choice of just three exit routes out of Bolivia. Two lead to Chile and the other to northern Argentina—all of them over rough dirt and sandy roads. Though my foot feels stronger, I have difficulty and much pain getting on and off my motorcycle, because doing so requires placing a lot of weight on that left ankle. Riding the bike is easy, changing gears is not. Up-shifting is problematic and painful; with each shift, stinging pain shoots through my ankle.

I am told the road to Chile through San Cristobal towards Calama is good, though the distance is long, and I will need to pack additional fuel because there are no gas stations, no services.

As I throttle down the dirt road toward Chile, I realize that the notion of a good road is rather subjective. Perhaps if you are riding in a heavy, 100-ton mining truck, the kind of vehicle that usually travels this road, it may seem good enough. But it's those trucks that hammer and destroy the road, turning it into a rutted washboard of a nightmare for a motorcyclist with a bad ankle. At times, I try sticking my

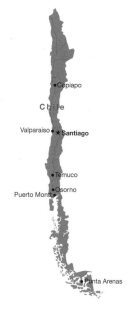

Size: 756,102 sq km (38th in world)

Population: 17.2 million (62nd in world)

Capital and largest city: Santiago (6 million)

Independence Day: 18 September 1810 (from Spain)

World Heritage Sites: 5

Literacy rate: 95.7%

Currency: Chilean peso

Population below poverty line: 15.1%

Key exports: copper, fruit, fish products, wine

Mobile phones: 22.4 million (45th in world)

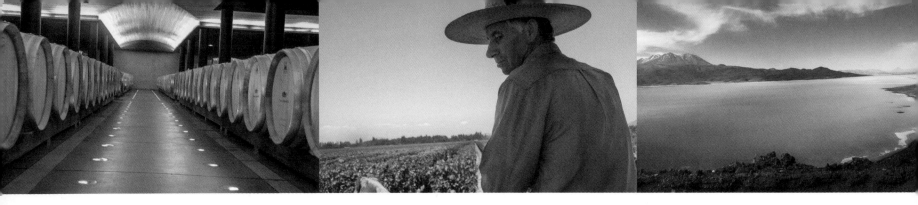

leg out—off the peg—to relieve the pressure and pain from the incessant pounding and vibration. Even this is tiring and painful.

Three hours later I finally escape Bolivia and cross into Chile. There are no services at the border. The tiny town of Ollagüe exists simply for border business and provides a tiny outpost for people who work in the handful of mines that pepper the surrounding mountains. There are two roads and two blocks. No gas. No food. No store. No hotel. And as I quickly learn, no bathroom. When I ask, the customs officer laughs, and in Spanish tells me that the entire Chilean desert is one big bathroom. With a wave of his arm he says, *"Disfrute!"* (enjoy).

The roads are supposed to be better in Chile. Not here, as I have to endure the relentless pounding of washboard again. Though my ankle is throbbing, my eyes are treated to the most surreal landscapes I've ever seen. I climb over rock-studded mountains and buttes and descend into dry lake beds, past vibrantly colored lakes, and through miles of bright-white and shimmering-pink salt flats, including the Salar de Carcote, with its turquoise lagoon, and the Salar de Ascotán, each sandwiched between towering volcanoes in all directions.

The wind blows fiercely. When I stop I have to fight and use the bad ankle to keep the bike from blowing over. I feel small, minuscule compared to the mountains and volcanoes soaring above. I climb higher, over a peak and then along a narrow ridge high above

another green lake. I am looking down into the crater of an ancient volcano. A flattened hill deep in the distance, charred and black as carbon, looks to be the remains of a cinder cone.

The roads are supposed to be better in Chile. Not here, as I have to endure the relentless pounding of washboard again. Though my ankle is throbbing, my eyes are treated to the most surreal landscapes I've ever seen.

I shield my eyes from the high sun to gaze in awe. The road stretches and winds through layers and layers of haze-tinted mountains, seemingly endless to the horizon. "Am I on the moon? Mars?" I wonder. There are no other vehicles, just infinite landscapes and more mountains that stretch higher into the sky. The road evolves and devolves from sand to ball-bearing gravel to chunky, plum-sized rocks that ping and plunk like a gamelan orchestra as they hit the underside of my bike. This gives me something to focus on when not battling the wind or taming the squirreling of my front tire over loose rocks and sand.

What is supposed to be the faster way into Chile is actually the toughest and longest. After twelve solid hours of nonstop riding, I find pavement. I want to get off my bike and kiss the tarmac. Cars zoom past, but these aren't just cars, they are new cars. Modern,

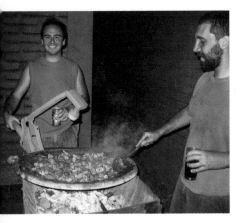

Locals in Santiago invited me to their home for an asado (BBQ party). In tribute to motorcycling they showed *Easy Rider,* but I was more impressed by the resourcefulness of these Chileans, who cooked a tasty stir-fry in an outsized outdoor wok—a satellite dish.

Chile

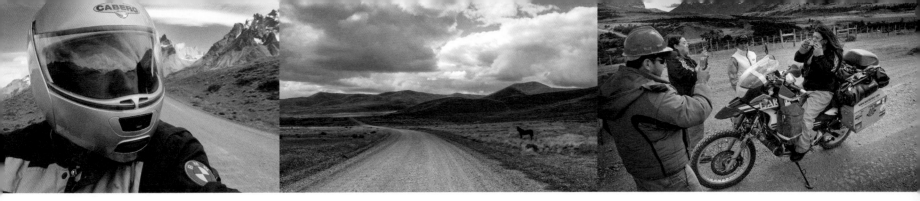

late-model cars and trucks: Toyota, Peugeot—all spanking clean.

I am no longer in Bolivia. Calama, Chile is prosperous. I pass a massive shopping mall with parking for hundreds of cars. Walkways are clearly marked, streets are brightly lit, and traffic lights are programmed. Drivers actually stop for pedestrians. Although the dreamlike desert landscapes, complete with 20,000-foot volcanoes, that I just emerged from seem out of this world, Calama itself is a world apart from economically challenged Bolivia.

Another border crossing, this time from Argentina into Chile, takes me into yet another world: the frozen topography of the Southern Andes and its Patagonian Ice Fields. With towers of granite, aquamarine lakes, rushing rivers, and glaciers, the landscapes are equally stunning. Even better, my ankle is stronger. I settle into a *refugio* in the *Parque Nacional Torres del Paine* (Torres del Paine National Park) and brave the all-day hike to the three granite monoliths of the park's namesake, Towers of Paine.

Still another crossing, and perhaps the easiest and most comfortable, is from Argentina to Santiago, where Cristian, a Chilean motorcyclist, invites me into his home. An executive for one of Chile's leading wineries, Cristian cooks traditional meals and shares with me some of the best Chilean wines. We pore over maps of Chile and Argentina and share stories from our travels.

Later I will tour and taste the wines from the Valle de Casablanca, just north of Santiago, a cooler climate region known for quality chardonnay and pinot noir. This newfound knowledge serves me well as I make my way to the Chilean coastal enclave of Viña del Mar, where local fisherman supply oceanfront restaurants with freshly caught fish, crabs, clams, and shrimp, daily. Fresh dishes crafted from the fruits of the sea perfectly complement the local wines.

After many months of rough riding, bad weather, and exposure to the harsh living conditions of many local people, for me Chile is at once a well-deserved reprieve and yet a tougher reality perhaps than the impoverished places I've been. Its prosperity comes largely from the mines nestled in the mountainous dreamscapes I've experienced and from the growing tourism of its coastal wine regions and mountain resorts. Yet, with all its abundance, diversity, and wealth, I feel something is missing.

I guess I'll just have to go back and see if I can find it.

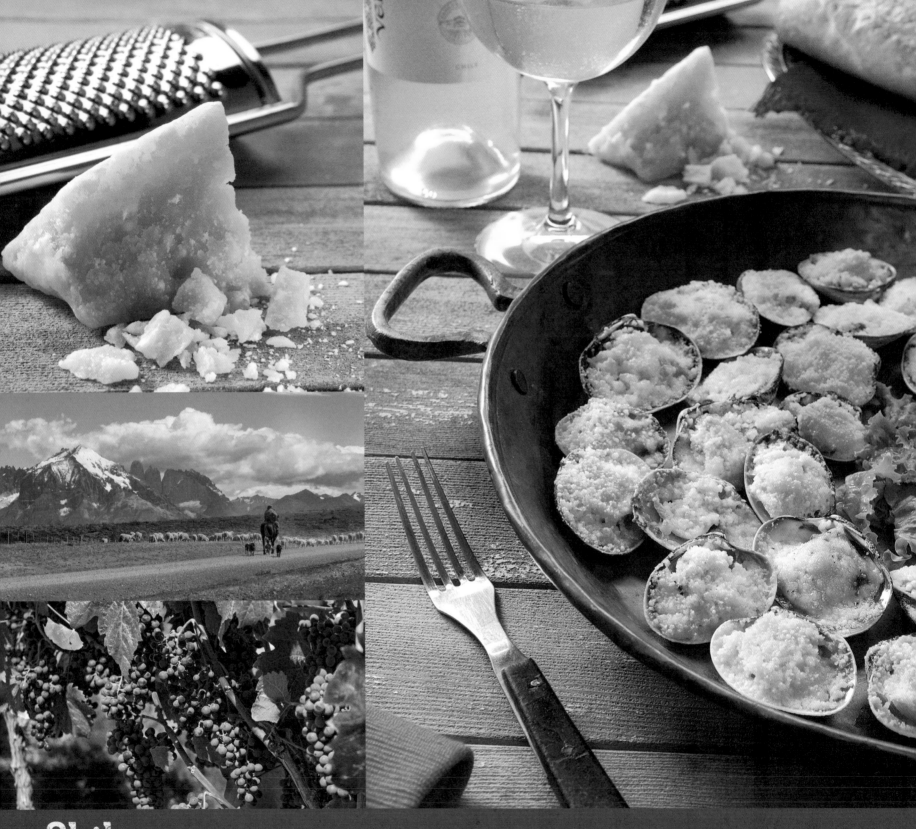

Chile

Chile offers its own versions of classic Latin American dishes, including empanadas, humitos, cazuelas, and more. But with such a long coastline, Chile's variety of fresh seafood gives the cuisine its uniqueness. I first discovered Machas a la Parmesana at a cafe near Mercado Central, Santiago's famous seafood market, and again at a small restaurant in Viña del Mar. It is best when made with surf or razor clams, though if unavailable, it's just as tasty when made with Manila or similar clams: the minimalist preparation lets the sweet flavor of the clams shine. This dish reminds me of the long coast of Chile. It's easy to prepare and a perfect appetizer for sharing.

Machas a la Parmesana
Clams with White Wine and Parmesan

Ingredients

¼ cup dry white Chilean wine

¼ cup fresh squeezed lemon juice

24 fresh pink razor clams (use Manila clams if not available)

Freshly ground black pepper

1½ tablespoons unsalted butter

¾ cup grated Parmesan cheese

1 lemon, sliced into wedges

Preparation

1. Preheat oven to 350 degrees F.

2. In a small bowl, mix together the wine and lemon juice and set aside.

3. Carefully clean the clams by scrubbing the shells under running water to remove any sand.

4. Shuck the clams by holding one at a time in your hand with a thick towel, and working a small knife between the two shells at the exact point of the hinge. Twist the knife, pry open, and scrape out the clam into a small bowl. Reserve the shells.

5. Put the shucked clams in a strainer and rinse again under cold running water to remove all traces of sand. Drain, and set aside in a clean bowl.

6. Take 24 of the deepest shells, rinse, pat dry, and arrange on a rimmed baking pan.

7. Divide the clam meat among the shells and top each with a teaspoon of the lemon-wine mixture and a grinding of freshly ground black pepper. Put a small dab of butter on top of each and sprinkle with Parmesan.

8. Bake 4 to 5 minutes or until the cheese is melted and the clams are just cooked through. Take care not to overcook.

9. Serve immediately with fresh lemon wedges.

From the fog-shrouded vineyards in Casablanca Valley northwest of Santiago to the warm and dry Colchagua Valley 100 miles south to the historic vineyards of the Alto Maipo in the Andean foothills—throughout the country, good wine was never too far.

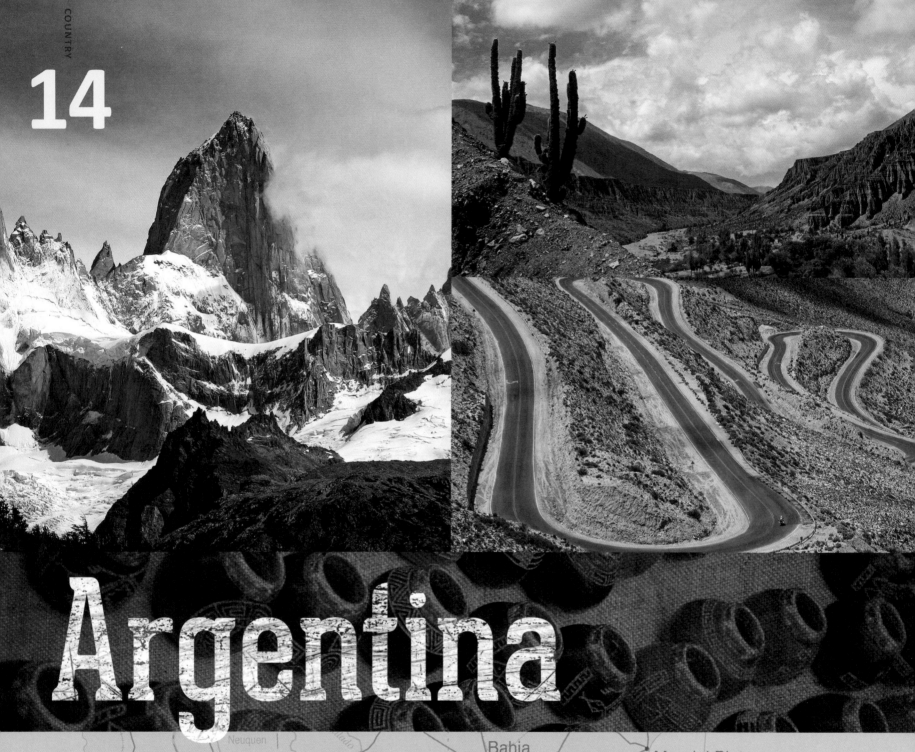

14

Argentina

Neuquen

Bahia
Blanca

Mar del Plata

Neuquen

Necochea

Riding with the Patagonia Wind.

Even though the five layers of clothing I wear are no match for the biting cold and gusting winds of the region, I feel a warm rush inside me. Thrilled, I am in Patagonia, at nearly the bottom of the world.

Many think of clothing when they hear the word Patagonia, but the true Patagonia is a vast region of mountains and desert plateau shared by Argentina and Chile and taking up nearly all of southern South America.

With the glacier-studded Andes mountains to the West, the vast, arid, and scrubby Patagonian steppe stretches east for hundreds of miles—all desert—to the Atlantic. The winds are notorious. Frigid air descends from the mountains, building speed as it races across the plateau to the ocean. There's nothing to stop it, though it seems intent on stopping me.

Powerful gusts toss me about the road, temporarily taking control of my motorcycle. Though cars and trucks are scarce, the gusts push me into the oncoming traffic. On the side of the road I spot a tent, fabric undulating violently in the wind, flapping like a determined flag. On the barren ground next to it sits a bicycle. No sign of the rider, who must have given up on the wind and built a shelter. To keep the bike from blowing away, a large rock is set atop its saddlebags.

I find warmth and reprieve from the wind in a *hosteria* in El Chaltén, a tiny village that is Argentina's youngest, settled in the mid-1980s. There is no bank, ATM, supermarket, police, traffic light, or gas station. People come for the mountains, particularly for Mount Fitz Roy, the iconic peak considered by mountaineers to be one of the most technically challenging in the world. It's also the inspiration for the Patagonia apparel company's logo. I'm here to hike—a trek to the base of Fitz Roy. Tomás, a former mountaineering guide and the owner of the *hosteria,* the first in El Chaltén, offers me coffee and shares stories and advice.

Mount Fitz Roy, I learn, is often not a welcoming host. When the weather seems clear in town, it's usually cold, rainy, and slippery along the trek. It's also rare to get a glimpse of the mountain's distinct, jagged peaks, because they usually hide behind thick clouds.

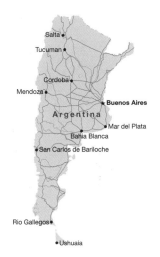

Size: 2,780,400 sq km (8th in world)

Population: 42.6 million (32nd in world)

Capital and largest city: Buenos Aires (13.5 million)

Independence Day: 9 July 1816 (from Spain)

World Heritage Sites: 8

Literacy rate: 98.1%

Currency: Argentine peso

Population below poverty line: 30%

Key exports: soybeans, petroleum and gas, corn, wheat

Mobile phones: 55 million (24th in world)

A lonely, rugged dirt road took me to the southernmost point in Argentina, Monte Dinero and Cabo Virgenes, where I spent the better part of an afternoon with a quarter-million Magellanic penguins. Here they breed, nest, congregate, and play in the surf.

Mountains are like that though. They require patience and understanding. One cannot sense the grandeur of the setting unless the mountains and skies choose to act in concert and reveal their naked glory, bathed in light and shadow, illuminated by that big ball of fire, our sun. Today I am lucky, but my words and photos fail to capture the awe or the soaring feeling I experience in my soul while trekking toward Fitz Roy.

Though the weather cooperates while I trek, the winds in El Chaltén aren't as amicable. At first I cannot believe it. But the sight of my bike lying on its side is evidence enough. The gusting winds have blown my 500-pound motorcycle over. It's so heavy it takes both Tómas and me to lift it back up.

As I continue south the Patagonian terrain gets rougher and more desolate: infinite emptiness and frozen landscapes. The winds continue to fight, gusts tossing me like a tumbleweed across a California desert. I fight back with a firm twist on the throttle and a tuck behind my puny windscreen. Wind pockets from the occasional truck passing in the other direction make my bike squirm like a fish.

The expansiveness of Patagonia makes traveling difficult and distances long. Days are shorter because the afternoon sun disappears behind the mountains, causing quick, drastic temperature drops. There are few gas stations. I carry extra fuel and stop at any gas station I find.

With my fingers numb from the cold and face bitten by wind, I pull into the first gas station I've seen in days. The motorcycle parked against the building is familiar. Inside the meager building, an atmosphere thick with cigarette smoke and the smell of freshly brewed espresso welcomes me. I love Argentina's passion for good coffee; even in the most desolate part of the country, in a dirty gas station, I can find a real espresso machine and a *barista* who knows how to use it.

"How's it going, Allan?"

It's Adrian, the artist and ceramic teacher I'd met on the road a week or so earlier. A native Argentinian, he's exploring his country on a small Honda 250cc street bike. With a pointed goatee, narrow face, a cigarette in one hand and a bottle of Quilmes, the national beer, in his other, he greets me like an old friend.

"You look famished, Allan. Here, eat." He pushes a tray of warm *empanadas* in front of me and brings me an espresso. This is the second time in two weeks we have shared coffee, snacks, and stories. We are now headed in opposite directions, but by chance have met again here in Patagonia.

We have more stories to tell than time. The waning sun and prospect of a long ride on dark dirt roads is looming for both of us. Adrian bundles up with several layers under his tattered-canvas military jacket while I layer up in my high-performance, Patagonia-branded long underwear and high-tech BMW motorcycle suit. I feel awkward, overblown, and extreme.

Argentina

I'm humbled by his tenacity, commitment, and simple gear. His bike has no GPS, no waterproof luggage, no high-design accessories. It's just Adrian, jeans, and simple hiking boots—riding his dream.

El Calafate, with its paved streets, luxury hotels, coffee shops, souvenir stores, and modest runway, is a striking contrast to El Chaltén. Even so, it's in Patagonia and is not immune to the cold, wet, and windy weather. To most, Patagonia is the middle of nowhere, but people come to see the Perito Moreno glacier, a 100-square-mile ice formation and the largest of nearly fifty glaciers that make up the Southern Patagonia Ice Field. It's the most popular tourist destination in Argentinian Patagonia. I'm reminded that the glacier is alive and moving when large chunks of ice the size of city busses creak and break off, calving, then fall in slow motion and disappear, sinking into the lake below, until they slowly re-emerge, rising in the water in splendor, like breaching whales, then crashing back into the lake and bobbing up and down as they float away in their own wakes. Tourists alert enough to see the spectacle gasp and, like crowds watching fireworks, simply utter in unison, "Oooohhh...ahhhh."

Two weeks later, after having crossed the Straits of Magellan and ridden through Tierra del Fuego, I finally make it to the end of the road, the bottom of the world, Ushauia, Argentina. Foggy skies and misting rain make it challenging to see through the visor of my helmet. I'm looking for a bed and a place to park my motorcycle, a simple hostel, when I'm startled by a careening car that comes around the corner. It slides to a stop just ahead of me. A man jumps out. "WorldRider! Is that you?"

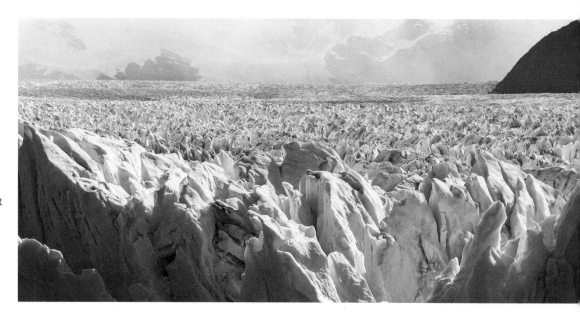

Unbelievable. It's Pepe. He lives here in Ushuaia. I haven't seen him in over a year, since we first met at the other end of this road, by the Arctic Ocean at the top of the world, in Deadhorse, Alaska. I stop my search for a hostel. In honor of our reunion, he hosts a traditional Argentinian *asado* (barbecue) with friends and family.

It's no wonder I'm seduced by travel. The people I meet, the food we share, and the coincidences and chance encounters that happen often on this journey hit me even stronger than the winds of Patagonia—only this wind makes me smile.

As the massive Perito Moreno glacier basked in dappled sunlight filtered by low, constantly moving clouds, the ice glowed and changed colors, and massive chunks fell in slow motion into the icy waters below.

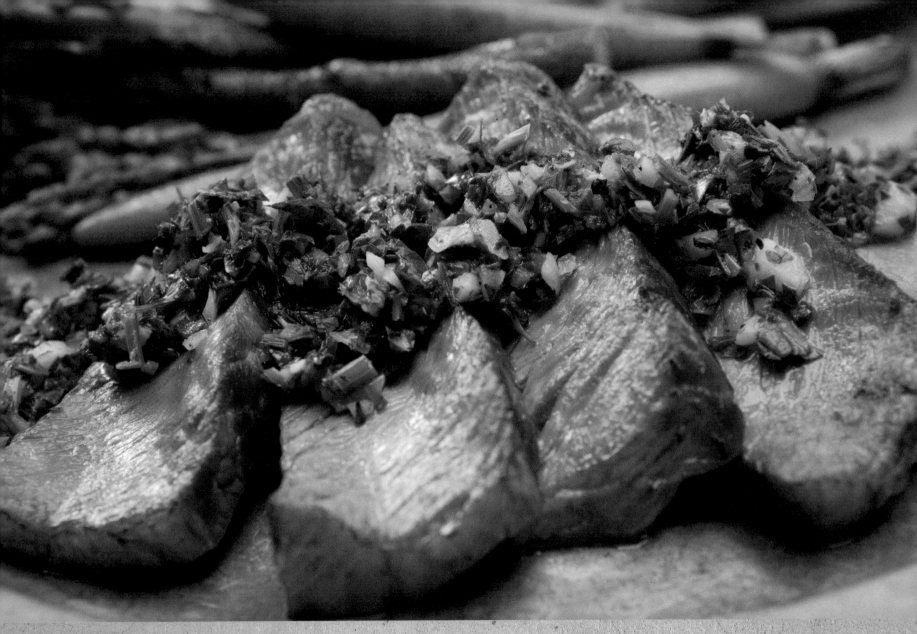

Argentina

In Argentina, asado not only means barbeque but stands for a social event—a party among friends and family. Over the many months I traveled through Argentina, I was invited to dozens of asados. They are so much a part of the Argentine culture that many homes have built-in asado pits, where fresh meats are grilled over an open fire. Though Argentine grass-fed beef is something of legend outside the country, I found while traveling within the country that it's the chimichurri sauce that defines Argentinian cuisine and makes the Argentine beef legendary. Make a big batch and have it with empanadas or even scrambled eggs!

Argentina Asado
Grilled Rib Eye Steaks With Chimichurri Sauce

Ingredients

Chimichurri Sauce

1½ cups chopped fresh Italian flat-leaf parsley

1 shallot, coarsely chopped

4 garlic cloves, chopped (about 1½ tablespoons)

¼ teaspoon red pepper flakes

2 tablespoons fresh oregano

3 tablespoons red wine vinegar

¾ cup extra virgin olive oil

2 tablespoons fresh lemon juice

½ teaspoon salt

½ teaspoon freshly ground black pepper

Steaks

4 rib eye steaks (8 to 12-ounces each)

¼ cup olive oil

Sea salt to taste

Freshly ground black pepper

Fresh baguette for serving

Preparation

1. Make the chimichurri sauce by combining all the sauce ingredients in a food processor and pulsing until well combined. Transfer to a bowl, cover and refrigerate for 30 minutes. Taste for additional salt, pepper, and vinegar, and adjust as necessary.

2. Preheat grill to high.

3. Rub steaks with the oil and season generously with salt and pepper. Grill 3 to 5 minutes per side for medium rare or more for desired doneness.

4. Remove steaks from grill, place on a clean platter, loosely wrap with foil, and let sit for 5 minutes before cutting into ½-inch slices. Serve with generous dollops of chimichurri sauce and slices of the fresh baguette.

After months traveling through the sweltering tropics of Central America and the chilling winds and rain of the Andes, in a sleepy town in the Argentinian province of Jujuy, I had the first of what would be many glasses of Malbec— a reward I felt well deserved.

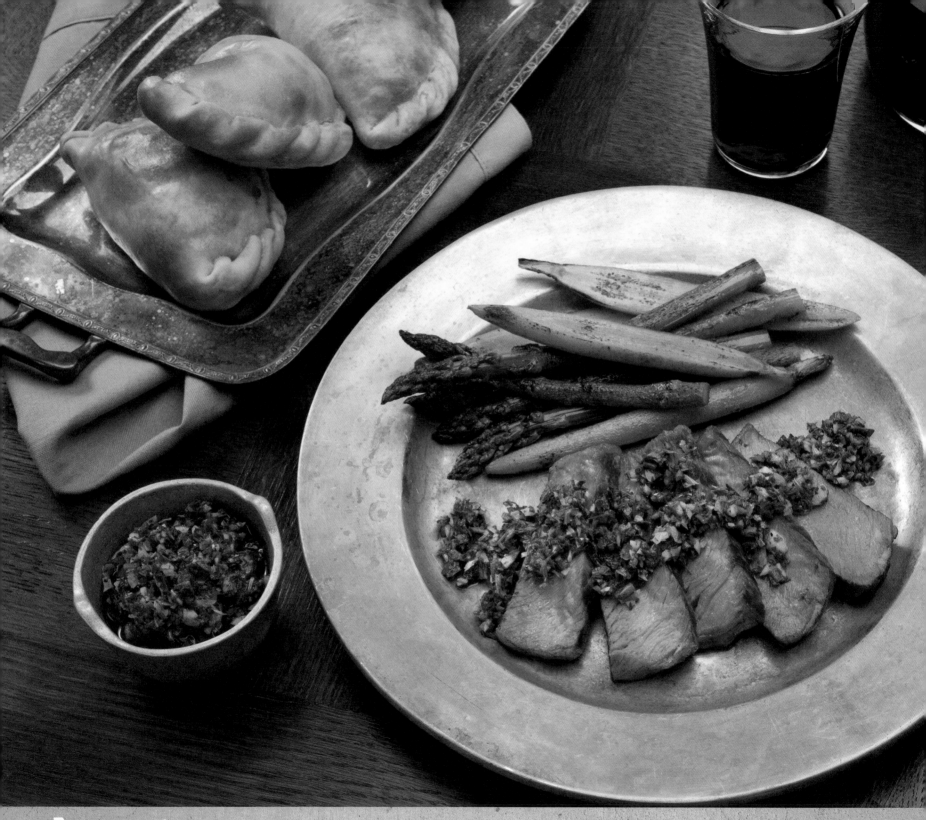

Argentina

Empanadas can be found in nearly every Latin American country. From the salteñas of Bolivia to the pastelitos of Honduras and everywhere in between, these pastries are stuffed with everything from savory meat and vegetables to fruit sweetened with sugar and cinnamon. You can be sure I tried them all. However, it was Argentina, I discovered, that makes the world's best empanadas. This recipe is inspired by those I tried in Purmamarca, a tiny town in the Jujuy province in northern Argentina, where I discovered the "holy grail" of empanadas. These are easy to make and are great for breakfast, lunch, or dinner.

Empanadas de Carne
Savory Pastries Stuffed with Beef

Ingredients

Dough

1 large egg

1 tablespoon milk

3 cups all-purpose flour

¼ teaspoon salt

1½ sticks unsalted butter, cold and cut into 12 pieces

½ cup ice water

Filling

1 tablespoon olive oil

1 medium yellow onion, chopped

2 to 3 garlic cloves, chopped

1 pound ground beef

½ teaspoon ground cloves

1 tablespoon freshly chopped oregano

1 teaspoon paprika

1 teaspoon ground cumin

Pinch granulated sugar

Salt and white pepper to taste

4 green onions, white part only, sliced

½ cup pitted and chopped green olives

½ cup raisins (optional)

1 hard-boiled egg, chopped

1 large egg

½ cup water

Preparation

1. Make the dough by beating together the egg and milk in a small bowl. In a food processor, pulse together the flour, salt, butter, and egg mixture until just combined. Slowly add the water until a clumpy dough forms.

2. Remove the dough and form into a ball. Chill in the refrigerator for at least 1 hour but no more than 24 hours.

3. Roll out the dough on a flat work surface into about an ⅛-inch thickness. Using a 6-inch wide cutter or a plate as a guide, cut out round disc shapes and transfer to a plate. Combine and roll out any remaining scraps of dough to make additional discs.

4. Preheat oven to 400 degrees F.

5. Prepare the filling by heating the oil in a skillet over medium heat. Add yellow onions and cook, stirring, until golden, about 5 minutes. Add the garlic and sauté for about 2 more minutes. Add the ground beef and brown, breaking up any clumps with a wooden spoon. Drain off the fat and return the skillet to the stove.

6. Stir in the ground cloves, oregano, paprika, cumin, sugar, and salt and pepper to taste. Cover and simmer until the meat is well cooked and the flavors have married, about 10-15 minutes more.

7. Remove from the heat and fold in the green onions, olives, raisins and chopped hard-boiled egg. Set aside to cool.

8. To make the empanadas, place one dough disc on your work surface and lightly dampen the edges with water. Add a heaping tablespoon or two of meat mixture to the center and fold one side of the disc over, pinching the edges together to form a half-circle. Seal the empanada with a fork by pushing down and crimping its edges. Place on a baking sheet lined with parchment paper. Repeat until you've used all dough and meat filling.

9. Beat together the egg and water and use to brush the tops of the empanadas. Bake in the oven for 15 minutes or until golden.

10. Serve hot or cold.

Note

To save time and effort it is very easy to find empanada discs, usually frozen, in Latin grocery markets. Be sure to thaw at least 1 hour before assembling.

Uruguay

Goodbyes and Hellos. The lights of Buenos Aires fade from view. I feel alone.

Though still and calm, the Rio del Plata, the river separating Uruguay from Argentina, is dark and empty. The only lights reflecting off the water are from the windows of the ferry that is transporting me and my motorcycle to Uruguay. There are no other boats under the moonless sky. I can't believe I've been on the road for a year, the last two months in Buenos Aires.

I have made many friends there, and before I boarded the ferry we bade farewell over a meal of prime Argentinian beef and many bottles of Malbec. They shared travel tips and stories. I snapped pictures. We laughed.

Though we all agreed we would meet again, and I know that intention is honest and true, I also know I may never see them again. That's disheartening, even though I know I will make new friends again, and certainly will share more goodbyes.

The next day, after exploring the UNESCO-designated colonial city of Colonia del Sacramento, I ride to Montevideo, Uruguay's capital, home to more than half its population. Unlike Buenos Aires, Montevideo is quiet. I enter Ciudad Vieja (the Old City) through a colonial-era arch, Puerta de la Ciudadela (Gateway of the Citadel), one of the few remaining sections of the *citadel* (wall) that once surrounded the city and protected it from invaders.

Much of the old city has devolved into ill-kempt barrios, though recent efforts to transform it into a cultural center seem to be working. At night, live music spills onto the cobblestoned streets. Lovers walk arm-in-arm through a maze of narrow alleys and plazas surrounding 100-year-old fountains. During the day, doors are open to museums and art galleries, all surrounded by well-preserved colonial architecture.

Many travelers, however, barely pass through Montevideo. And after spending several days here, I wonder why. The city, due to its small size, is easily digested. There's a commanding view of the ocean and the river. There's world-class theatre, museums, and historical sites, and the Mercado del Puerto, a lively food market on the riverside, features colorful and tasty expressions of Uruguay's cuisine. I feel it isn't time to

Size: 176,215 sq km (91st in world)

Population: 3.3 million (134th in world)

Capital and largest city: Montevideo (1.6 million)

Independence Day: 25 August 1825 (from Brazil)

World Heritage Sites: 1

Literacy rate: 98%

Currency: Uruguayan peso

Population below poverty line: 18.6%

Key exports: soybeans, rice, wheat, beef, dairy products, lumber, wool

Mobile phones: 4.8 million (109th in world)

Until 1829, Ciudad Vieja (Old City) in Montevideo, Uruguay's capital, was completely surrounded by a tall wall to keep out intruders. Today it's like an outdoor architectural museum with an eclectic mix of colonial-era buildings as diverse as the Spanish, Portuguese, Italian, and other immigrants who settled here.

leave. Even after several days exploring the city and surroundings, I decide to spend one more day.

I wander the busy commerce district during the day and explore the Old City at night. My mission is simply to feel the vibe, sense the rhythm, and move with the people while exploring some night photography. Without any direction, recommendation, or predisposition, I wander toward the Old City, looking for something different in dining. I pass the usual *parillas* (outdoor grills), *chivitos* (sandwich) stands, and pubs, but keep moving on. As I wander farther from the popular spots, just outside the financial district, I find myself in a barrio perhaps considered unsafe to walk in alone at night.

Lost in my thoughts and the eeriness of a vacant city at night, I've ignored the warning signs: no pedestrian traffic, courtyard fences secured with three or more padlocks, no streetlights. A dog violently barking and clawing at the door of a shabby apartment startles me. I jump and quicken my pace.

Suddenly, a waif of a woman with pale lips and empty eyes walks out of the shadows and crosses the street toward me. The hood of her cold-weather jacket hangs over her head, and strands of deteriorating fake fur dangle over her face. Her hands, beet red and scarred from cuts, and her fingernails, blotchy with bumps, signal she's ill. At first, I think she's a prostitute, but she simply wants a smoke, and is curious. She asks me where I'm from, then disappears into another shadow.

I hadn't planned it this way, but I'm in Uruguay during the off-season; that is, the quiet season. Most Uruguayans complain

that during the high season their country is hijacked by affluent Argentinians. Vacationing *porteños* and *porteñas* (from the port city of Buenos Aires) all flock to the popular resorts in Punta del Este, a coastal city famous for its beaches and nightlife.

In Punta del Este, I get hijacked by an Uruguayan restaurant worker who takes me, with five coworkers crammed in the back of a four-passenger car, through the labyrinth of the city's after-hours clubs. I'm treated as a celebrity, and the locals won't let me pay for my drinks. I return to my hotel as the sun crests the horizon over the Atlantic, bathing everything in a warm, golden light, and spend most of the day in bed with a bottle of water and a headache.

The next day I ride the Atlantic coast. Many coastal properties are boarded up for the winter, and there is no traffic. I stop in the small village of Punta José Ignacio to watch fisherman bring in the daily catch. With sandy streets and understated shops and restaurants, José Ignacio is dominated by a 105-foot-tall lighthouse. Hovering on the beach, several locals await the fisherman. One of them, Victor, is here to buy fresh fish for the *cioppino* he's cooking tonight.

"Would you like to join me and my family?" he asks. I want to, but feel pressured to move on. I decline the offer.

"Next time?" he asks.

"Of course!"

Victor finds a stick and draws a map of Uruguay in the sand, giving me a virtual tour of the country, pointing out the highlights and the places I must visit.

Uruguay

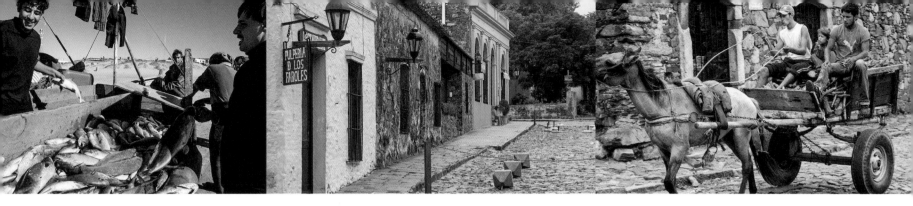

"Too many people come here thinking Punta del Este is Uruguay," Victor shares in a disappointed tone. "Vacation for these people is a place to go and spend money. Spend, spend, spend." His forehead wrinkles and eyes squint as he jabs the stick into the map on the sand, moving it along as he talks. "To see the trees, the dunes, fishing villages, the old forts, and meet the people," Victor continues, "is to know the real Uruguay."

I take his advice and make plans to visit Cabo Polonio, a town of a few hundred and home to a National Park where the wind continuously shifts and shapes massive sand dunes. En route I stop in a small town, only to discover that all the restaurants are closed for the season. Hungry, resorting to salty snacks from a convenience store, I regret not having joined Victor and his family.

There are no roads to Cabo Polonio, which sits on a point about seven kilometers (five miles) from the main road. The park ranger at Cabo Polonio is more interested in chatting about my motorcycle and sharing war stories and scars than about letting me into the park. Only residents or licensed tour operators with 4x4 vehicles can enter. Most of the tour operators are closed for the season. Of the two operators open today, one does not have a driver. "Come back on the weekend," he suggests.

The other operator, Mario, is charismatic, vocal, and slightly buzzed from cheap wine. He tells me he'll take me in if two other passengers show up. As charming and amiable as he is, he tells me he needs more to make it worth the trip.

"Let's eat, then!" Mario tells me, and he fixes me a plate of freshly caught fish, grilled and served with lemon garlic sauce and herbs. He pulls a bottle of *tinto* (red wine) from under his desk and pours me a glass. I opt for a bottle of water sold by his mother, who runs a small store from the kitchen of her home next door.

I never get to see the dunes, but the conversations in Spanish are priceless. From the quality of gas in Uruguay, compared to its neighbors, to the price of electricity, meat, and industrial goods, he blames everything on Argentina. "They buy our electricity," he tells me, "so it costs more for us."

I do get to see Fortaleza de Santa Teresa, a massive fortress built by the Portuguese in 1762 and added on to by the Spaniards in 1792. Shaped like a cockeyed pentagon, the fortress features double walls some two meters (six feet) thick and eleven meters (thirty-three feet) high. There are five pulpits, or lookouts, on each angle of the pentagon. From these I look west to see where I've traveled and south to the Atlantic.

And when I turn to the north, I can see miles of farmland stretching to the border of Brazil, my next country. With all the many miles and goodbyes behind me, I still feel the burning curiosity that stoked this journey, the drive to ride onward through the next set of miles, to discover new lands and share new hellos.

Onward.

Built in 1856, the restored neo-classical Teatro Solís (Solis Theatre) stands in the Plaza Independencia on the edge of Montevideo's Ciudad Vieja. With an annual schedule of ballet, opera, orchestra, modern dance, and comedy, it's the oldest theatre in Uruguay.

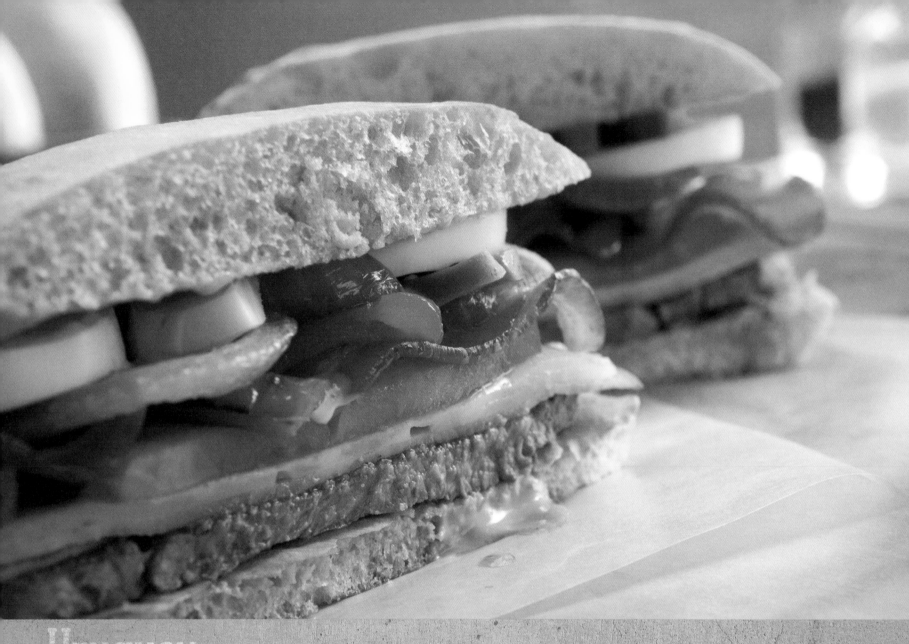

Uruguay

I tried my first chivito, the world's ultimate sandwich, while wandering the cobblestone streets of historic Colonia del Sacramento. This sandwich is to Uruguay what the cheesesteak is to Philadelphia, but better! Looking at the ingredients you might think it's a bit of an overkill, but when you taste—rather, devour—this masterpiece, you'll become a convert. Many years ago, a woman from Argentina walked into a restaurant and asked for a goat sandwich. With no goat in his kitchen, the chef-owner grilled a thin piece of churrasco (steak) and layered it with bacon, ham, and just about everything else, hoping she wouldn't notice the absence of goat meat. She loved it. Thus, the chivito, now legend, was born.

Chivito
The Ultimate Steak Sandwich

Ingredients

Salsa Golf Sauce

½ cup mayonnaise

¼ cup ketchup

¼ teaspoon lime juice

½ teaspoon salt

Freshly ground pepper

¼ teaspoon Worcestershire sauce (optional)

Chivito

2 6-ounce beef steaks such as tenderloin or sirloin, ½ to ¾ inch thick

1 tablespoon chile powder

2 teaspoons garlic powder

2 teaspoons smoked paprika

Salt and pepper to taste

8 slices bacon or pancetta

1 large sweet onion, thinly sliced

1 large red bell pepper, seeded and sliced

4 large crusty sandwich, ciabatta, or other rolls

4 slices ham, about 2 ounces

4 slices mozzarella cheese, about 2 ounces

1 to 2 tablespoons unsalted butter

4 to 6 green or black olives, pitted and sliced

Lettuce, at least 8 leaves

8 tomato slices, about ¼-inch thick

2 hard boiled eggs, peeled and quartered

Pickles, sweet or dill, sliced

Preparation

1. Make the sauce by mixing all the ingredients in a small bowl. Set in fridge until ready to use.

2. Trim any excess fat from steaks, if necessary, and slice each in half horizontally to make 4 thin steaks total. Place steaks between plastic wrap or parchment paper and gently pound from the center of the meat working towards the outer edges to a thickness of about ¼ inch.

3. In a small bowl, combine chile powder, garlic powder and smoked paprika. Rub mixture over steaks and season with salt and pepper.

4. In a large skillet over medium-high heat, cook the bacon or pancetta until crispy. Transfer to paper towels to drain and cool. Drain any excess fat and place steaks in the skillet. Cook over high heat for about 2 minutes per side for medium rare or to desired doneness. Transfer to a plate to cool. Add onions and pepper to skillet and sauté until golden, transfer to a dish and set aside.

5. Preheat oven broiler.

6. Slice the rolls in half. Heat a buttered skillet over low heat. In batches, place the rolls face down and toast until golden brown, then generously spread salsa golf sauce on all 8 halves.

7. Take four of the roll halves, layer each with steak, bacon, ham, peppers, onions, and a slice of mozzarella, place on a baking pan and quickly broil until the cheese begins to melt, about 2 minutes.

8. Top each with the olives, 2 slices of lettuce, 2 slices of tomato, 2 egg slices, and pickles. Place the remaining roll halves on top and enjoy the best steak sandwich ever!

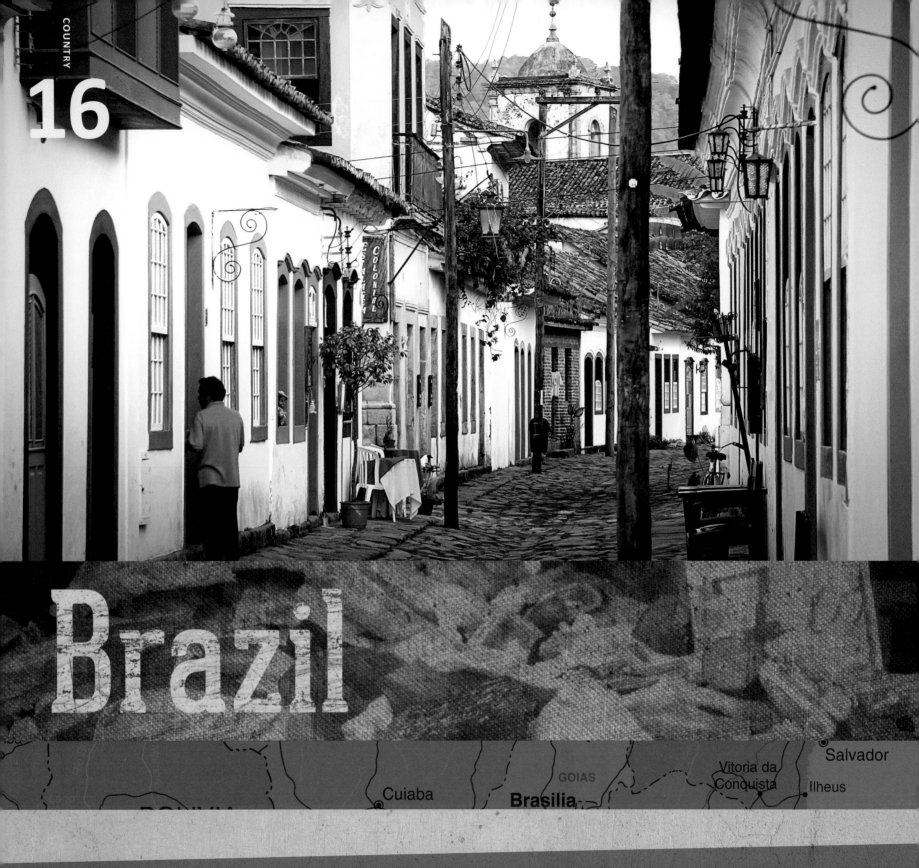

Brazil

Cuiaba GOIAS Brasilia Vitoria da Conquista Ilheus Salvador

The Priceless Papaya.

Crossing the border from Uruguay into Brazil sets me back. I suddenly feel like a child. I can hear, but not understand. I can speak, but am not understood. The language skills I've painstakingly acquired after a year in Central and South America filled me with confidence and the power of conversation few tourists ever gain. Now in Brazil, I have to start all over again.

Though Portuguese challenges me as I travel through the largest country in South America, it doesn't take long to learn the language of Brazilian food. In the south, in Porto Alegre, I seek out a true *churrascaria*, where generous portions of meat are served tableside in what's called *espeto corrido*—continuous service—or perhaps more appropriately, endless meat eating. Whenever I stab the last piece of meat with my fork, waiters, like predators circling prey, swoop over my table, carrying in each arm a long skewer of fresh meat still sizzling from the fiery barbecue just a few steps away. They offer a new cut of meat with each swoop. Never-ending meat—lamb, pork, steak, chicken, even goat—generous, tender slices fall on my plate as they are carved off the skewer. Juice explodes in my mouth as I chew. And then more and more. I discover that the only way to stop the endless barrage is to leave a slab of meat on the plate.

For six months I ride Brazil's *littoral norte,* the northern route, along the Atlantic coast. While the memory of endless meat never fades, I discover new dialects as I travel—the smell of fresh salt air permeates my helmet and spurs my imagination.

Just off the coast of subtropical Brazil, some 700 miles south of Rio, Santa Catarina Island offers sun and sea worshippers everything they desire: first-class resorts, trendy restaurants, big waves, white-sand beaches, and all-night parties where big bouncers stand behind crushed red-velvet ropes. But behind this aura of beach, Brazilian tans, and nightlife are tiny fishing villages where, before sunrise, fisherman take to the sea and bring to shore fresh fish well before the rest of the island wakes.

Size: 8,514,877 sq km (5th in world)

Population: 201 million (5th in world)

Capital: Brasília (3.8 million)

Largest city: São Paulo (20 million)

Independence Day: 7 September 1822 (from Portugal)

World Heritage Sites: 19

Literacy rate: 88.6%

Currency: Brazilian real

Population below poverty line: 21.4%

Key exports: iron ore, soybeans, coffee

Mobile Phones: 244.358 million (5th in world)

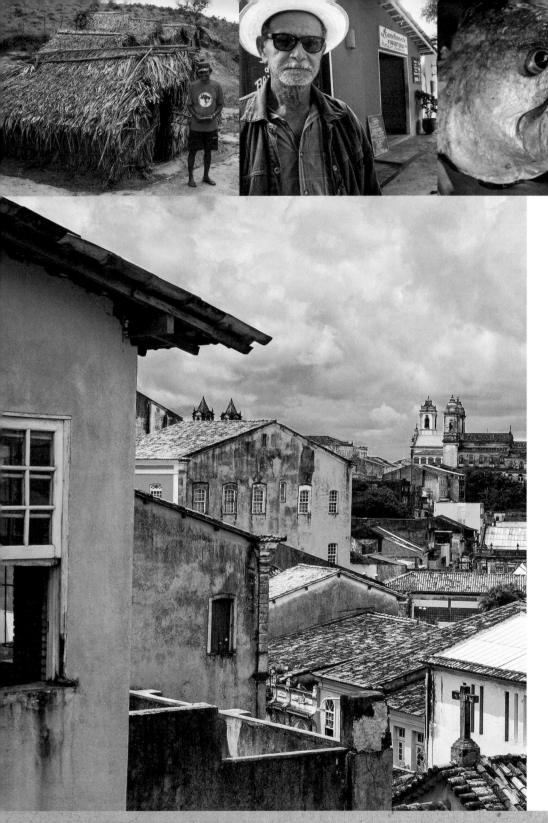

I never would have found the casual restaurant on the north side of the island without the guidance of Laura and Cezarinha, a couple I'd befriended at an all-night party a few days prior. Tucked down a narrow alley and wedged between homes and a gazebo, the restaurant features a small patio with plastic resin chairs and tables shaded by umbrellas touting the local beer. Shuffling my chair closer to the table, I have to take care not to let a leg fall off the patio, potentially sending me into the water a few feet below. That's when I notice, just a few yards away, restaurant workers harvesting the oysters we'll devour for our first and second courses. The fresh smell of seawater delights me as an oyster falls sensually on my lips; I feel like I'm kissing the sea. The euphoria lingers as she returns the kiss. There's nothing fresher nor cleaner than newly shucked oysters served under the Brazilian sun.

My journey along the coast will take me more than 5,000 miles and six months, including a diversion to the thundering Iguaçu Falls, where my motorcycle rain gear will fail to protect me from the mist, fog, and rain created by the force of two-million gallons of water per minute tumbling into the river below. But it isn't the power of waterfalls that threatens to soak me as I cruise through the Brazilian state of Bahia. Dark clouds hang low and billow like tapestries draped from a ceiling, a blatant clue it is time to change into my foul-weather gear.

As I don my rain gear roadside, I attract the attention of a man in a bright-red shirt and baseball cap, standing in front of a cluster of primitive, thatched huts made of cane and palm. I wonder how

Brazil

the huts, feeble and cockeyed, will survive the imminent rains and wind. The man, Bruno, barely thirty years old, has the hands of fifty-year-old. He invites me into the small hut he calls home. Inside the dirt-floored shack, two cots stuffed with newspaper serve as bedding. Above, torn plastic sheeting loosely tacked to the ceiling tries to block the sunlight and the rain from falling between the brittle palm fronds that make the roof. Just outside a doorless opening in back, wet black coals smolder in a small hole adjacent to the charred, perforated tin can that serves as a cooking grate. There are about 140 families in this community, Bruno tells me. He's lived here all his life.

Noticing the beads of sweat on my brow, Sancha, Bruno's wife, asks me to sit down and take off my jacket. She hands me a glass of water. She and her husband, in a ceremonious presentation, hold out a papaya about the size of a small football. Nodding their heads in unison, they slowly cut the fruit, certainly a luxury and prized piece likely set aside for a special meal. They present me a slice large enough to satisfy both of them and their two children. The sweet fruit tingles my parched lips and soothes my throat. The family watches me eat the fruit of their labor. What I don't finish, Sancha stuffs into a plastic bag with the other slices, to be saved for another time.

A crowd gathers outside their hut, and Bruno proudly parades me around the camp, introducing me to the leaders and children, who follow along as we walk. Now almost black, the hostile clouds brood, and sprinkles of rain dance on my head. Bruno and Sancha

ask if I'll stay the evening. Tempting, but I point to the sky and hug everyone farewell.

Several hours later, waterlogged and cold, I finally make it to *Ilha de Itaparica* (Itaparica Island), a small community just outside Salvador. Once I am relaxed and dry, my host, Filipe, insists we grab dinner and a beer. We walk into the sleepy town and stop at a simple, nondescript storefront with huge glass windows, bright fluorescent lights, and plastic tables and chairs. It's not surprising that I don't understand what Felipe orders, but my Portuguese is improving. Behind the counter a short, squatty woman wearing a stained apron and torn shoes pulls fresh fish from her refrigerator and makes for me the meal that inspired this book—my first, and certainly not my last, Brazilian *moqueca*.

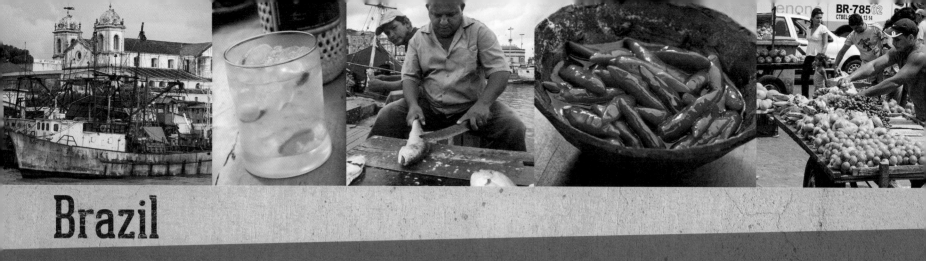

Brazil

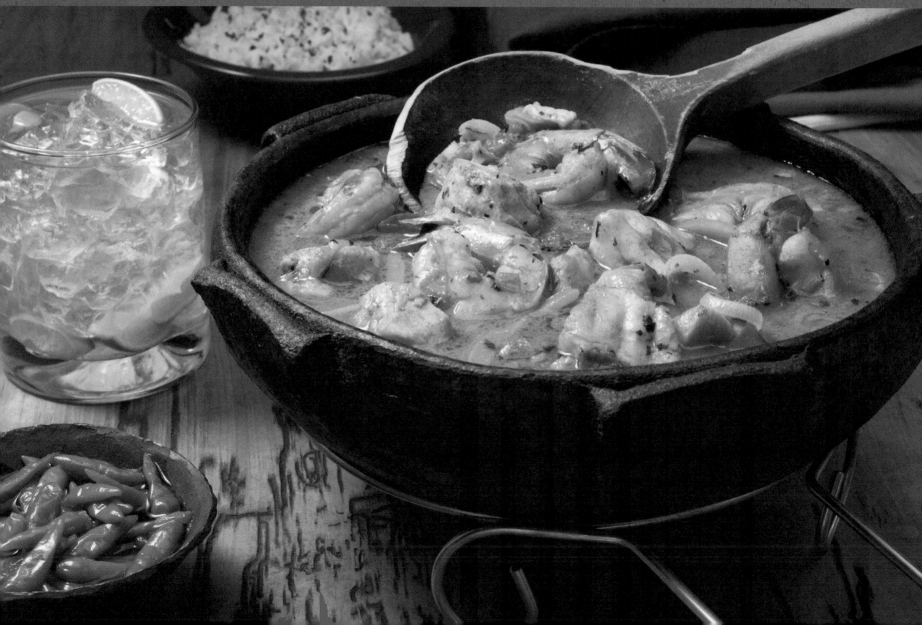

Brazil surprised me with every mile I traveled. In the northern region of Bahia, I was seduced by the complex rhythms of samba music and the graceful moves of capoeira, a mix of martial arts and dance. It was here, where the flavors of the sea are accentuated by the colors of the tropics, that I tasted true love. My mistress: the moqueca, a unique blend of fresh fish and herbs combined with flavors of the coconut palms that line the beaches. The key ingredient to moqueca is dendê, a unique red palm oil, which adds both color and flavor to this fisherman's stew. I will never forget my first moqueca—neither will you.

Moqueca
Brazilian Coconut Fish Stew with Fresh Herbs

Ingredients

4 to 6 garlic cloves

2 tablespoons extra virgin olive oil

2 medium red onions, finely chopped

3 spring onions, white part only, thinly sliced

1 cup finely chopped Italian parsley

1 cup finely chopped cilantro

1 large yellow or orange bell pepper, cored, seeded, and sliced into thin strips

2 to 3 Malagueta peppers (hot red chiles), seeded and minced

4 medium tomatoes, cored, peeled, seeded, and roughly chopped

2 pounds of fish such as monkfish, kingfish, grouper, salmon, or mahi mahi, cut into 2-inch chunks

1 pound fresh shrimp or scallops, shelled and deveined

Juice of 3 lemons

1 13.5-ounce can unsweetened coconut milk

½ cup chicken broth

4 tablespoons dendê oil (Brazilian red palm oil)

Kosher salt and freshly ground pepper to taste

Cooked white rice, to serve

Freshly prepared caipirinhas (recipe on the right)

Preparation

1. Smash the garlic, remove the skin, and add a little kosher salt while chopping to form a paste.

2. Heat a large clay pot or Dutch oven over a medium-low flame, add a tablespoon of olive oil, garlic paste, red and spring onions, and cook until the onions are translucent, 3 to 5 minutes.

3. Add parsley, cilantro, bell peppers, chiles, and tomatoes, and when the herb aromas fill the air, after about 5 minutes, add another splash of olive oil and ground pepper.

4. Squeeze fresh lemon juice over the fish and shrimp, season with salt, and carefully place the chunks on top of the herbs.

5. Slowly add the coconut milk, chicken broth, and dendê oil, without stirring.

6. Cover the pot and simmer for 15 to 20 minutes until fish is cooked completely and flavors have married.

7. Serve directly at the table with white rice and fresh caipirinhas, and open the lid to let everyone indulge in the aromas of the moqueca as it is served.

Note

To peel tomatoes for this dish, remove core and dip into a pot of boiling water for 30 seconds, then immediately into ice water. Skin will peel away easily.

Variation

If dendê oil is unavailable, you can use olive oil mixed with 2 teaspoons of achiote powder.

The *caipirinha* is the national cocktail of Brazil, made with cachaça—a liquor like rum, made with fermented and distilled sugar cane—mixed with crushed lime and sugar.

Caipirinha
Makes 1 drink

Ingredients

2 ounces *cachaça*

1 lime

1 tablespoon superfine sugar

Ice

Preparation

Cut off the ends off the lime and discard. Cut the lime into 8 wedges and place into a low-ball or rocks glass. Add sugar. Use a muddler or pestle to muddle the limes and sugar together carefully until all lime juices have been released—be careful not to break the skin of the lime. Fill the glass with ice. Add *cachaça*. Cover with a larger glass or cocktail shaker and shake very well for at least 15 seconds. Garnish with a wedge or slice of lime.

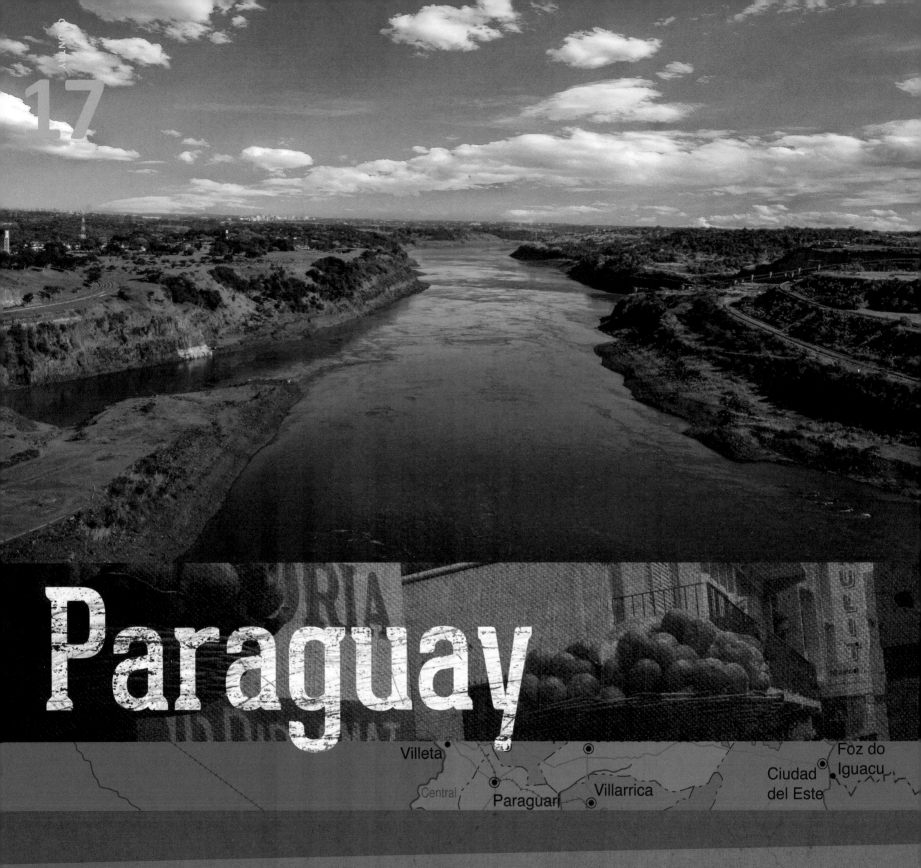

Paraguay

Villeta

Central Paraguarí Villarrica

Ciudad del Este Foz do Iguacu

Ride Across the River.

Just a few miles from perhaps the most popular tourist attraction in South America, Iguazú Falls, is the second-largest power station in the world. The Itaipu Dam and hydroelectric plant harness energy from the same raging river that's responsible for those beautiful waterfalls. Just around the corner is Ciudad del Este, a maddening city of commerce and deception that is considered the third-largest tax-free zone in the world. Welcome to Paraguay.

Sitting at the confluence of Brazil and Argentina, two of South America's largest economies, Ciudad del Este in Paraguay has emerged as the largest commerce center on the continent due to tax reform that lowered import taxes on everything from electronics to cigarettes to luxury goods. Brazilians, who have notoriously high import tax rates, flock to Ciudad del Este to stock up on these goods, and just about everything else, including an array of contraband: counterfeit goods, bootlegged movies and music, drugs, weapons, and, quite possibly, people. The city has earned the moniker, "where anything goes."

I was warned before coming here. "People get robbed, ripped off, raped, and killed." Although the border may be a tax-free zone, I quickly learn it seems to be a law-free zone, too. The madness starts at Ponte da Amizade (Friendship Bridge), where 40,000 people and 20,000 vehicles cross the Paraná River every day. Rusted and dilapidated, the pedestrian walkway is missing guardrails, and the wire grates on the foot path have large holes, making the prospect of falling several hundred feet into the Paraná below a distinct possibility. Fortunately, I will be riding my motorcycle across the the 550-meter (1,600-foot) bridge.

Size: 406,752 sq km (60th in world)

Population: 6.6 million (103rd in world)

Capital and largest city: Asunción (2 million)

Independence Day: 14 May 1811 (from Spain)

World Heritage Sites: 1

Literacy rate: 94%

Currency: Paraguayan guaraní

Population below poverty line: 34.7%

Key exports: soybeans, feed, cotton, meat, edible oils, wood, leather

Mobile phones: 6.53 million (96th in world)

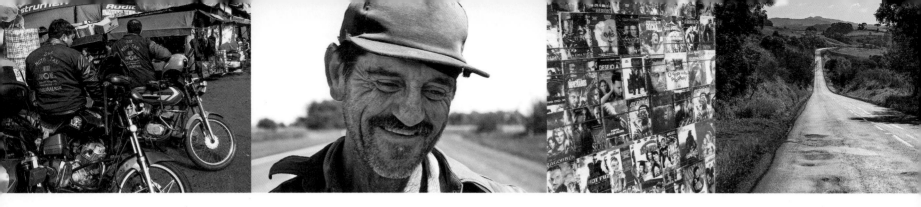

> The unknown heroes and maniacs of this odd bridge and border are these motorcycles and their riders. They hover like a cloud of gnats, roping in customers who'd rather ride than walk. For a dollar or two these motorcyclists usher people across the border—and back.

To begin to understand what it took to build the 65-story-high Itaipu Dam, I had to visit its cavernous powerhouse, 112 meters (367 feet) at its peak. The entire plant took enough iron and steel to build 300 Eiffel Towers and concrete for five Hoover Dams.

There are border offices for customs and immigration, but it seems few actually use them. This makes crossing the bridge a free-for-all, facilitating smuggling illicit goods into Brazil—and far beyond. Though the Brazilian government imposes a spending cap on purchases brought into the country, it seems that nobody is checking. Many Brazilians purchase goods in Paraguay to sell in Brazil. These socialeros either smuggle the goods past officials or pay bribes.

The pedestrian walkway is bottlenecked; people argue and push each other as they cross. The vehicle entrance to the bridge is clogged with cars and diesel-spewing trucks—all waiting and all honking. The line of vehicles stretches for a kilometer (half mile) or more. That's why so many people choose to walk, run, or hire motorcycle-taxis.

The unknown heroes and maniacs of this odd bridge and border are these motorcycles and their riders. They hover like a cloud of gnats, roping in customers who'd rather ride than walk, charging a dollar or two to usher people across the border—and back. Before they can cross, they huddle together in a designated holding area, like horses at a starting gate. When an official waves his arm, signaling it's okay to go, they swarm across the bridge through a narrow concrete-bordered lane designated just for them. They bump into each other while balancing passengers and their cargo, sometimes carrying two or three on a bike—without helmets.

Navigating the narrow motorcycle lane with my bike is challenging. My aluminum panniers add width to my bike, and the long line of motorcycles moves slowly, requiring extra effort to maintain balance and not swerve into the median.

I am visiting Paraguay for two reasons. First, I'm curious. Ciudad del Este is something of a mystery, a legend that I want to see. Second, I come at the invitation of Angelo, a local man I met while visiting the Iguazú Falls just a few days ago. He insisted I make the trip to taste the food and meet his family at the *churascarria* they own on the outskirts of town.

In his early forties, with a round face, warm smile, and friendly eyes, Angelo sports a little extra weight around his waist, proving that he enjoys eating his dishes as much as he enjoys cooking them. The Brazilian fare he serves is not much different than that of other *churascarrias* in Brazil: lots of meat. They are the carnivore's dream

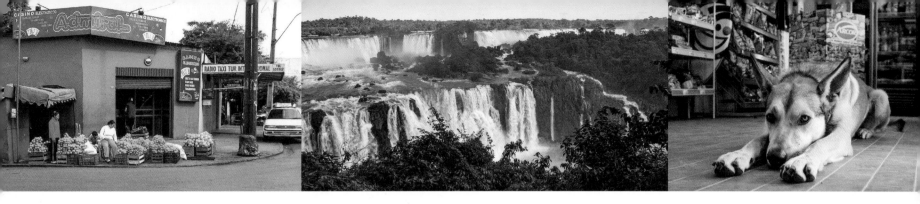

and the vegetarian's nightmare. Yet between the endless barrage of perfectly cooked beef, pork, goat, and chicken is good conversation and cold beer. Angelo and his wife have another child on the way, and he hopes to open another restaurant in the near future.

I take time to explore the shops of Cuidad del Este. For the largest free-trade zone in South America, it fails to serve me. I am looking for a backup battery for my Canon video camera. After three hours of looking and being ushered from a stall to a store to a mall and back again by no less than four helpful "runners," nobody has my battery. Though I can't fault them for the effort and tenacity in trying.

Ten miles upriver, north of the bridge, stands the Itaipu Dam, considered one of the Seven Wonders of the Modern World. The tour of the dam is much better than I'd anticipated. Two young and darling Paraguayan women fit me with protective goggles and a hard hat and spend a couple of hours walking with me above, below, and inside the dam. Its scale and size, though not as impressive as the waterfalls with which it shares its source, is mind-boggling. At a cost of about $20 billion, it's one of the most expensive structures ever built—anywhere. It took nearly ten years to complete construction, which included rerouting the powerful river in order to dry a section of the riverbed. Construction teams poured enough concrete to build a twenty-story building every hour.

Though most of the dam was financed by Brazil and international banks, Paraguay technically owns half because the dam straddles the border between the two countries. Each is allocated 50 percent of the electricity. If one country uses less, the other country must buy the surplus. The dam generates 92 percent of Paraguay's total energy use and more than 20 percent of Brazil's.

I take one more ride across the Paraná River to return to Brazil, where I'll likely learn what the people of Brazil do with all that electricity. 🇵🇾

Traveling between Brazil and Paraguay I saw more accidents and boneyards of badly wrecked vehicles. While the roads there are better than many elsewhere in South America, the drivers surely are not.

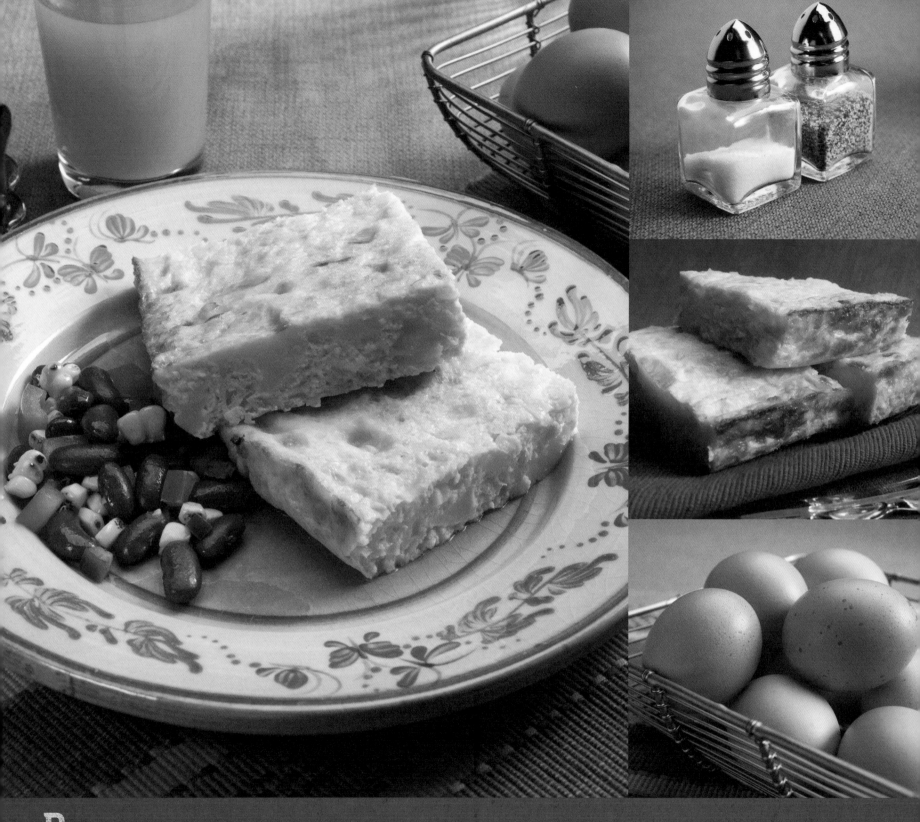

Paraguay

There are dozens of chipa dishes in Paraguay, so many I want to call it chipa cuisine. Yet chipa, a cake usually made with corn and other ingredients, is quintessentially a Paraguayan phenomena. The first time I tasted chipa guazú, I was at an asado (barbecue party). Made with eggs, cream cheese, and butter, I first thought it was a breakfast food, but seeing those around me enjoy it with grilled meats, I had to try it. The creamy corn texture paired nicely with the barbecue. Serve it for breakfast or with a roast at your next barbecue.

Chipa Guazú
Paraguayan Corn Cake

Ingredients

4 ears fresh corn (frozen corn if unavailable)

¼ cup grapeseed or canola oil

1 tablespoon unsalted butter

2 medium yellow onions, roughly chopped

1½ cups whole milk

1 pound cream cheese, softened

6 large eggs, beaten

½ teaspoon salt

¼ teaspoon freshly ground pepper

Preparation

1. Preheat oven to 375 degrees F. Grease a medium sized baking dish.

2. Remove kernels from the corn cobs with a sharp knife and place in a food processor. Pulse until creamy but still textured, and transfer to a medium bowl.

3. In a small skillet, heat the oil and butter together over medium heat, add onions, and sauté for 3 to 5 minutes, until translucent and softened. Reduce heat to low, add milk, and simmer for 10 minutes while stirring. Remove from heat.

4. In another bowl, beat together cream cheese, eggs, and processed corn. Add the onion and milk mixture, and the salt and pepper.

5. Pour into the prepared baking dish and bake until the cake is golden brown and crusty on top, about 40 to 45 minutes.

6. Let stand for 5 minutes, then cut into pieces and serve.

Many of the hostels and guest houses included breakfast, usually with sliced meats, bread, coffee, and assorted fresh-squeezed juices. Back home I never take time for breakfast. On the road I learned to slow down and enjoy it—and how much I love fresh guava juice.

119

Africa

Not until we are lost do we begin to understand ourselves.

"

– Henry David Thoreau

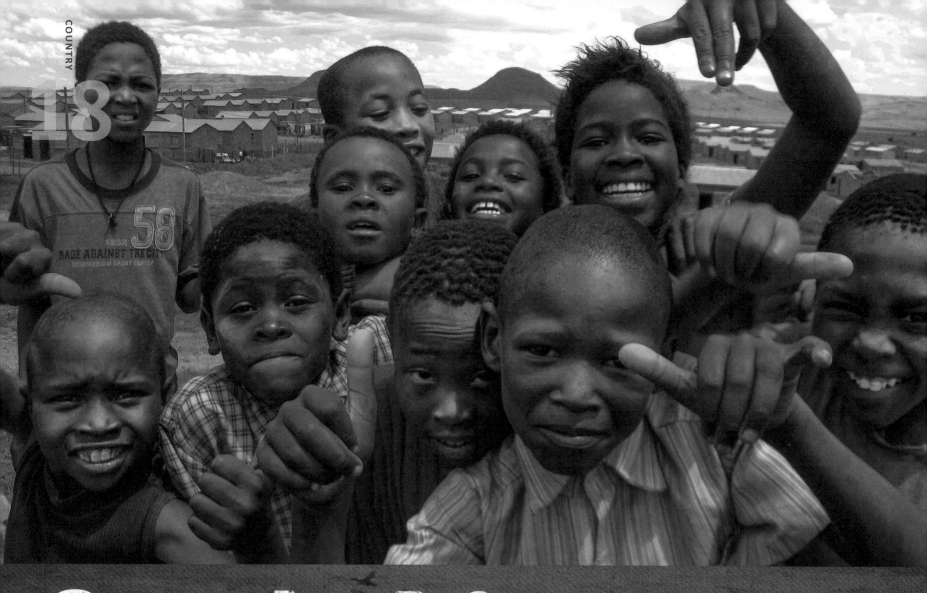

South Africa

Cape Town

Worcester

Swellendam

CAPE

Port Elizabeth

In Search of Africa.

Even though I'm in a coach-class seat at the back of a Malaysian Airlines 747 carrying me and my motorcycle to Cape Town, I feel as if I'm traveling first class. Immune to both weather and road conditions, with a glass of fine wine in hand, I am overwhelmed with guilt. To get over it, I play the justification game, thinking I deserve this after more than a year of rough and harsh travel in Latin America. Also, I remind myself, it's only a ten-hour flight to Cape Town, and then I'll be braving the Wild Continent—full of lions, leopards, and elephants.

In Cape Town the first tough thing I must brave is riding my motorcycle on what seems the wrong side of the road. South Africa, once a British colony and member of the Commonwealth, still adheres to the medieval custom of driving on the left side of the road. It's harder and more dangerous than one would expect. More than a few times I am greeted with blaring horns and blinking lights when making a turn down the wrong lane.

Though I know I'm here, it just doesn't feel like I'm in Africa. Cape Town and the Western Cape—with the dramatic backdrop of flat-topped Table Mountain and its winsome beaches, rocky coastline, bustling waterfront and harbor, and rolling hills of vineyards and wineries— feels like Provence or California, not Africa. That is, until I leave the touristed areas and enter Bo-Kaap, once known as the Malay Quarter. Sitting above the city center, on the slope of Signal Hill, this neighborhood was originally settled by former slaves brought to the area from Indonesia by the Dutch in the seventeenth and eighteenth centuries. Today it is home to most of the Muslim population of Cape Town.

I wander the Bo-Kaap on foot, taking in its cobblestone streets, traditional buildings painted in bright colors—greens, blues, and yellows—and the architecture of Cape Dutch buildings and the eighteenth- and nineteenth-century mosques dotting the neighborhood. Men and women in traditional dress walk the streets and work at street-side markets and simple cafés while young children of mixed races play cricket in the street. One hands me a bat and giggles at the way I hold it, like a baseball player, not a cricket batsman.

Size: 1,219,090 sq km (25th in world)

Population: 48.6 million (26th in world)

Capital: Pretoria (1.4 million)

Largest city: Johannesburg (3.6 million)

Independence Day: 27 April 1994 (majority rule)

World Heritage Sites: 8

Literacy rate: 86.4 %

Currency: South African rand

Population below poverty line: 31.3%

Key exports: gold, platinum, diamonds, other metals and minerals

Mobile phones: 64 million (20th in world)

The first time I saw penguins was nearly at the bottom of South America. At the bottom of Africa, I found them again. These African, or Black-footed, Penguins are found only here. Curious yet well dressed characters, they turned their heads to look at me first with one eye, then with the other. They communicate by bobbing and bowing their heads too.

Until 1994, Bo-Kaap and the nearby Sixth District neighborhood were townships and the only places near the city center where blacks and coloreds were allowed. Though it existed informally since the turn of the century, apartheid was established in 1948, in the wake of World War II. The National Party created mandatory classification of individuals by race, along with laws that legalized racial discrimination and forced the physical separation of residential areas. One of the laws, the Group Areas Act of 1950, banished all black Africans not living in townships from the Western Cape province. Cape coloreds—mixed-race, Afrikaans-speaking descendants of Dutch settlers, their slaves, and local indigenous people—were classified as second-class citizens. As such, they could be evicted from their homes and arrested if they even set foot on any of Cape Town's segregated beaches.

As Cape Town attracted more whites, demand for housing grew. So between 1968 and 1982, the government forcibly moved 60,000 coloreds from the Sixth District to Cape Flats, another township some five miles away. It then razed the entire area, including all the homes and businesses, so it could build a whites-only development. Resistance flared, however, and the project died. Walking through the area today, arguably some of the most prime real estate in the city, the only reminder of what was once a colorful multicultural community is tucked neatly inside the Sixth District museum. Outside, all that's left is an encampment of feeble tents and slums.

In contrast, Bo-Kaap still has color, and the streets, buildings, and people hint at what the Sixth District might have become. Being prime real estate, this area is threatened by ongoing gentrification as developers and entrepreneurs slowly replace the historic with the trendy. I fear the neighborhood may someday lose its charm and cultural heritage.

Still wondering when I'll spot my first elephant or giraffe, I am amused at how many signs along the roads leaving the city warn against feeding baboons. *Sure,* I think, convincing myself I need to get deeper into Africa if I'm ever going see even a warthog, let alone a wild primate. Yet just around a tight corner I spot three baboons. I stop. They look at me, and then at a tall, electrified, chain-link fence with a sign that not only cautions potential intruders in two languages, but includes a crude illustration of a man being electrocuted, making no mistake of what will happen if one chooses to scale the fence. Before I can get my camera out of my jacket, the baboons climb the fence and jump to the other side. *Hmmmm. Electric fence?* I think.

After I wind my way around the rocky headlands of the Cape of Good Hope, which I learn is not the southernmost tip of Africa, I laugh at yet another South African warning: A sign in a parking lot along the coast advises motorists to look for penguins under their cars before backing up. I don't have to worry; there is no reverse gear on my motorcycle. So I climb some rocks by the shore and sneak up on a waddle of these curious birds. I can get much closer to them than to those I'd encountered in Argentina. Here they seem happy to pose for my camera, cocking their heads and raising wings in time to the sound of my shutter.

Here in South Africa, at another "end of the Earth," I am taken aback by another startling small-world coincidence. By chance, I come

across two Australians, Grant and Julie, also on a motorcycle, whom I first met while traveling in Mexico more than a year ago.

We connect with another motorcyclist, Wes, who I met in Cape Town at the local BMW motorcycle dealer. He tours us through the Western Cape, from the coast to the Cape Winelands, over gravel and dirt roads and then over the verdant and rocky Franschhoek Pass into the Franschoek Valley, with stunning views of the winelands and wineries. We must be careful, as baboons loiter on the side of the road and often wander into the path of our motorcycles.

At the Boekenhautskloof winery I meet Marc Kent, South African winemaker of the year, who lets us taste several of the award-winning wines that helped earn him that title. He pours me a taste of a Rhone-style blend called the Chocolate Bloc, but teases and refuses to disclose why it is so named. "Let the wine speak and tell the story," he advises.

I can understand the language of wine better perhaps than most of what is spoken in South Africa, where there are eleven official languages; that is, since the abolishment of apartheid laws in 1994, before which English and Afrikaans were the only official languages.

I travel east to the Transkei, where most of the people speak Xhosa, a bizarre, percussive, and tonal language made of sounds created by clicking one's tongue on the teeth, roof, and sides of the mouth. Once an independent and controversial legal homeland granted by the South African government for those Xhosa blacks who had lost their citizenship under apartheid, today the Transkei is the least-developed part of South Africa.

I continue toward the Indian Ocean, through gentle, rolling hills dotted with brightly colored *rondavels* (a single-room, round home with a thatched roof), most without electricity. I see children in school uniforms walking the roads, and women in colorful dresses, sometimes with their black faces chalked white and wearing colorful headdresses holding their hair. People travel by donkey cart, on horses, or crammed into minivan buses. And yet, despite the primitive living conditions, people smile and seem happy.

Now I'm beginning to feel like I'm in Africa.

I pull over to the side of the road to rest. I'm tired from the intense concentration required to navigate a never-ending minefield of potholes and from constantly braking hard to avoid hitting sheep, goats, and cattle crossing the road. I chat with an elderly gentleman, a cattle herder carrying a large stick that he uses to keep his cattle in line and, hopefully, off the road. Though we speak different languages, we manage to have a conversation as he points in the distance to his round home, sitting in the bright green valley, beautiful and primitive.

In Coffee Bay, on the Wild Coast, I find a backpackers' hostel where I pause for several days, to contemplate my African plans while tasting stews, curries, and bread, all prepared in a three-legged cast iron pot, a *potjie*, over an open fire.

Yes. I'm in Africa. And to celebrate I open a bottle of South African wine and make a toast to the continent. 🇿🇦

The Xhosa tribe from the Transkei often use clay to protect their faces from the strong sun. Sometimes it is used to indicate when a woman is pregnant or menstruating. Boys will wear heavy white clay on their faces for weeks leading up to a traditional circumcision ceremony.

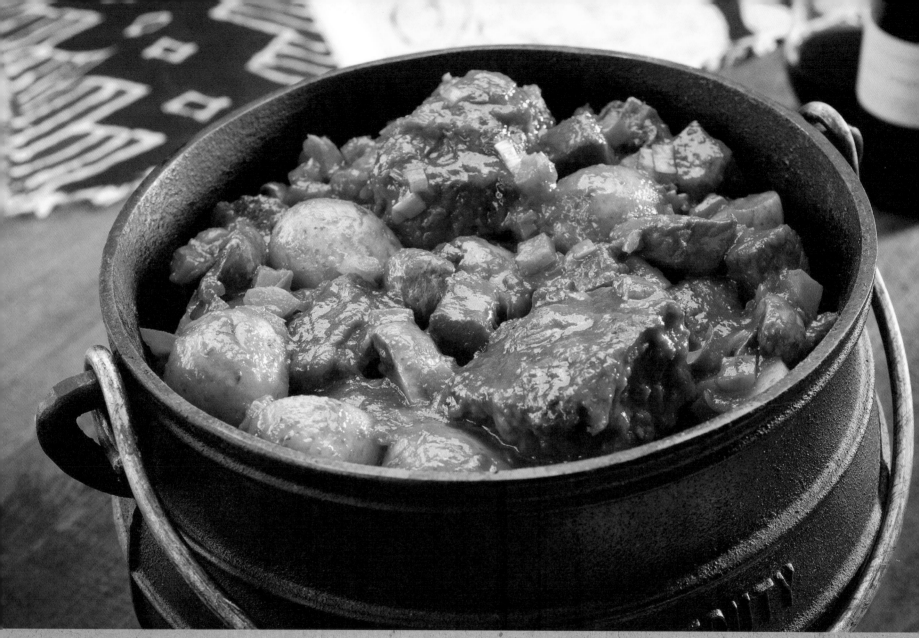

South Africa

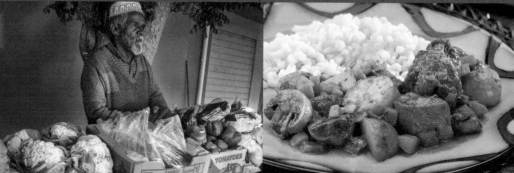

South Africans love their braais (barbeque), but it's their passion for *potjiekos* (pronounced poi-kee-koss) that, for me, defines South African traditional cooking. Just about anything can be cooked in a *potjie* (poi-kee), a round, three-legged cast iron pot. Dutch settlers introduced the pots to Africa, and explorers carried them into the bush to cook game. Over time, South African indigenous tribes such as the Zulus traded their clay pots in for the more durable cast iron and called them *phutu* pots. They come in a variety of sizes, and most South Africans have several—cooking with them in backyards, at sporting events, and on camping trips. This meal cooks slowly and is best prepared with a few beers or a good bottle of wine and friends to help pass the time.

Oxtail Potjie
Slow Roasted Oxtail Stew

Ingredients

1 to 1½ pounds oxtails, cut into 2-inch pieces

½ cup all-purpose flour

Salt and pepper to taste

1 teaspoon paprika

1 teaspoon ground coriander

¼ cup olive oil

¼ cup unsalted butter

2 boneless pork chops, about ½ pound, cut into 1-inch cubes

2 large yellow onions, roughly chopped

6 garlic cloves, crushed

5 large leeks, roughly chopped

4 large carrots, peeled and finely diced

1 large green bell pepper, cored, seeded, and roughly chopped

1 cup dry red wine

½ cup dry sherry

4 cups beef stock

2 bay leaves

1 14-ounce can crushed tomatoes

8 black peppercorns

Bouquet garni (use your favorite fresh herbs, or what you have on hand, such as thyme, parsley, oregano, and/or others, tied together with a string)

½ teaspoon Worcestershire sauce

10-15 baby potatoes

1 cup white button mushrooms

1 teaspoon freshly ground black pepper

2 tablespoons chopped flat leaf parsley

1 tablespoon chopped chives

Cooked white rice

Preparation

1. Heat your potjie over a fire of hot coals. If a potjie is unavailable, cook this on a stove in an extra large dutch oven or stockpot. Pat dry oxtails with a paper towel. Season flour with salt and pepper and place in a large zip lock bag with the paprika and coriander, shaking to combine. Add the oxtails, shake well to coat, remove and set aside. Reserve the remaining seasoned flour.

2. Heat together 3 to 4 tablespoons of olive oil and the butter in the pot and sauté onion and garlic for a few minutes until they begin to brown. Add the pork and cook for about 5 minutes, then add the oxtail and continue to cook until well well browned, about 10 minutes more. Use tongs to transfer the pork and oxtail to a clean bowl and set aside.

3. Add half the carrots, leeks, and bell pepper, and sauté until softened, about 5 minutes.

Return the pork and oxtail to the pot and add the red wine, sherry, 3/4 of the stock, bay leaves, tomatoes, bouquet garni, peppercorns, and a couple dashes of Worcestershire sauce, stirring well to combine.

4. Cover the pot and cook slowly at a simmer on very low heat for 3 hours. Every so often, check to see that there is enough liquid and add stock as necessary to prevent drying out. The meat should be barely covered but not drowned. Add the remaining carrots, mushrooms, and baby potatoes, and cook for another hour, or until tender and integrated into the sauce.

5. Sauce should be the consistency of a medium gravy, so thin with additional stock or add some of the reserved flour mixture to thicken, if necessary.

6. When ready, sprinkle chopped parsley and chives over the stew and serve on a bed of rice.

The most important rule I learned about potjie recipes is that there are no rules for potjie recipes. Though the best get passed on through generations of family and friends, it's important to experiment too. If you want to use a little more or less garlic or substitute venison, ostrich or lamb, go right ahead.

Lesotho

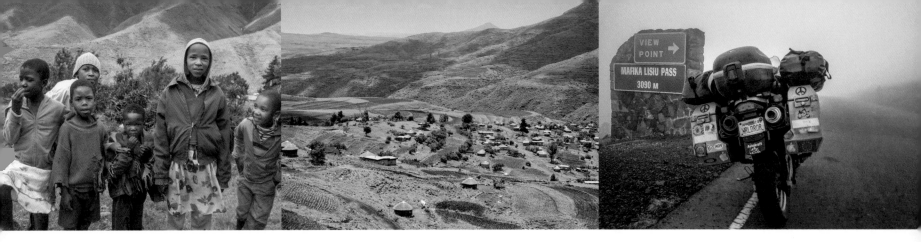

More Than 100 Years in a Lifetime. By the time I stop, I've counted five

or six waterfalls. To get here, I've braved nearly two weeks of steady rain. It's worth it. The ride
through this majestic valley of tiny villages of traditional round huts is wet, but peaceful and
relaxing. The rains have brought these cascades to life, most tumbling down cliffs for more than
a hundred meters. Gentle, rolling hills of fertile and verdant green pastures give rise to these
cliffs and to the Maloti Mountains towering above.

The *rondavel* (traditional roundhouse) I park near is perhaps the most primitive I've seen. The tall branches forming the
circular wall of the hut are tied together with twine made from long stalks of dried grass reinforced with caked mud.
I do not notice him at first, but as I pull out my camera to frame a photo of the hut with a raging waterfall as its
backdrop, he stands up out of the grass where he has been lying. Wrapped in a dark-wool blanket and with a woolen
cap pulled tightly over his head, the elderly man slowly moves toward me, steadying himself with a simple wooden
stick as he walks.

His cataract-laden eyes, a pale and cloudy blue, are at once piercing and yet warm and inviting. I introduce myself and, patting my chest
over my heart, point at the waterfalls tumbling down the cliffs beyond his hut. He speaks to me in a tribal dialect I cannot understand.
I think it's Sosotho, or South Sotho, the language of the tiny country I find myself now exploring, the Kingdom of Lesotho.

Once known as Basutoland and now The Kingdom of the Sky, Lesotho sits in the highlands of the tallest mountains in Southern Africa.
A landlocked enclave, Lesotho is completely surrounded by South Africa. This former British protectorate—despite hundreds of years
of turbulence and blood, including many kings, wars, mutinies, and coups—is today a fairly stable and independent democracy.

Size: 30,355 sq km (142nd in world)

Population: 1.9 million (148th in world)

Capital and largest city: Maseru (220,000)

Independence Day: 4 October 1966
(from the UK)

World Heritage Sites: 1

Literacy rate: 89.6%

Currency: Lesotho maloti

Population below poverty line: 49%

Key exports: wool, mohair, livestock, water

Mobile phones: 1.2 million (152nd in world)

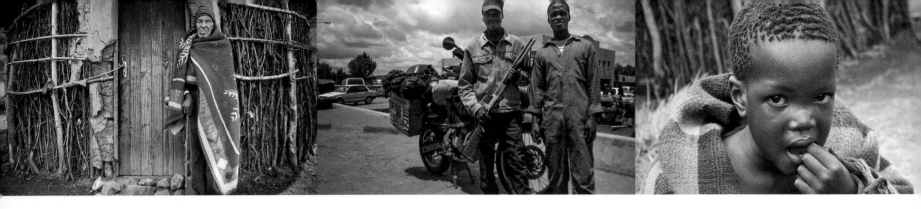

The elderly man is Mokhali Khanore. He has lived in the same village in this captivating area for 105 years. He is the oldest person I've ever met. He waves his stick—which he uses not only to steady his step but also to tend livestock—and continues speaking.

Two young girls are the first of many children and villagers to join me roadside as I communicate with Mokhali. The older girl—with thick glasses, golden hoop earrings, and a short haircut—doesn't look the part of the other villagers I've seen. She speaks English and translates as I continue to learn from my new, elderly friend.

"Are you hungry?" I ask, handing him a small chocolate candy. He laughs, his giggle more like a staccato grunt, and accepts my gesture, showing the smile of someone who seems set on living much longer. As he puts the wrapped candy in his mouth, the girl takes it from his hand and unwraps it for him, then tosses the wrapper on the ground. Before the wind can take it for a sail down the valley, I pick it up and stuff it into my pocket.

"You live in this beautiful place. We should keep it this way," I suggest.

We walk around the roundhouse, where he lives alone. There is no water, electricity, or toilet. Resting in a hole dug in the dirt outside the doorway is a large tin can with a charred screen covering the top: the stove where he cooks his own meals. He tells me that just five years ago, with the help of his grandchildren and villagers, he rebuilt the hut. He needs to rebuild it again this year. It's made out of mud, sticks, and dung.

By now a crowd is gathering; nearly two-dozen children, a scattering of adults, a couple dogs, and a sheep or two all stand around me and my elderly friend, their patriarch. A car speeds by, and I realize that most travelers zoom past villages and homes such as Mokhali's as they head into the Maluti Mountains; to the Katse Dam, the highest in Africa; or to the Bokong Nature Reserve. I'm intrigued by both the man-made and natural wonders, but it's hard to imagine that I would get as much joy visiting them as I am now, spending time with Mokhali and these children. I pass out my remaining treats and snacks. The children walk me down the hill, through the village, and show me their homes.

Before I leave, some children want to play with my motorcycle. They push buttons, sit on the seat, and stare curiously at the GPS. With his large, calloused, and dry hand, Mokhali gently squeezes mine, holds it still for several seconds and smiles. Everyone gathers around the bike to pose for a farewell photo. They surround Mokhali, who raises his hand the highest, it seems, to say goodbye.

I climb the road into Northern Lesotho and into the Maluti Mountains, where I pass more waterfalls and see more livestock herders wrapped in blankets along the roadside. Before long, I notice the elevation is more than 3,000 meters (10,000 feet), and it starts raining. The fog sets in, at first light and wispy, then thick and opaque. Soon I cannot see; my visor is soaking wet. The road winds and twists. The air chills in an instant.

In western Lesotho I saw dozens of corrugated shacks serving as store fronts for everything from shoe repair to restaurants serving classic fish and chips—yes, even here in the highlands. While they might look a little scary to the average tourist, I assure you that Lesotho street food will cure a rumbling stomach.

Lesotho

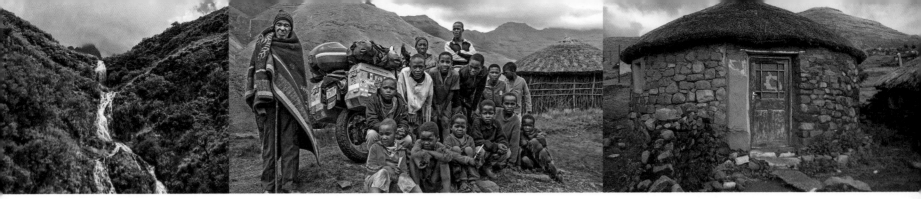

Rain is uncomfortable and dangerous, and I'd prefer milder weather when riding my motorcycle. But for Lesotho, water from these rains is extremely important. Not only does it provide for extraordinary landscapes of waterfalls and rivers, the sale and royalties from water exports contribute more than anything else to the country's GDP. This is largely due to the Lesotho Highlands Water Project (LHWP), the largest water transfer project in Africa, which includes the Ketse and Polihali dams. They deliver both water and electricity to industrial South Africa and provide most of the energy for Lesotho.

Because of the controversy and corruption that infect almost any government-related project in Africa, even though LHWP has contributed to significant infrastructure improvements for Lesotho, about half of the population of the country still lives below the poverty line, on less than $1.25 USD per day.

I think about Mokhali, who has lived such a long life. He seems unfazed by the changes in his own country and our world. He's experienced more than 100 harsh winters, with winds whipping down from the mountains and sleeting rain and snow. His only defenses from the cold have been woolen blankets and a cap. I wonder if he or his family and fellow villagers will ever experience running water, let alone heat or electricity.

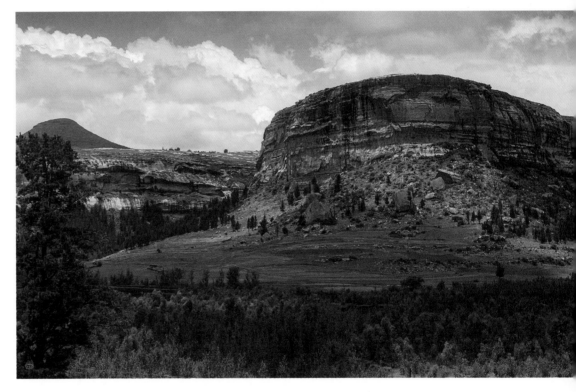

From the *rondavels* (round houses) of traditional Basotho villages of Lesotho, the valleys and grasslands give rise to the Maluti Mountains.

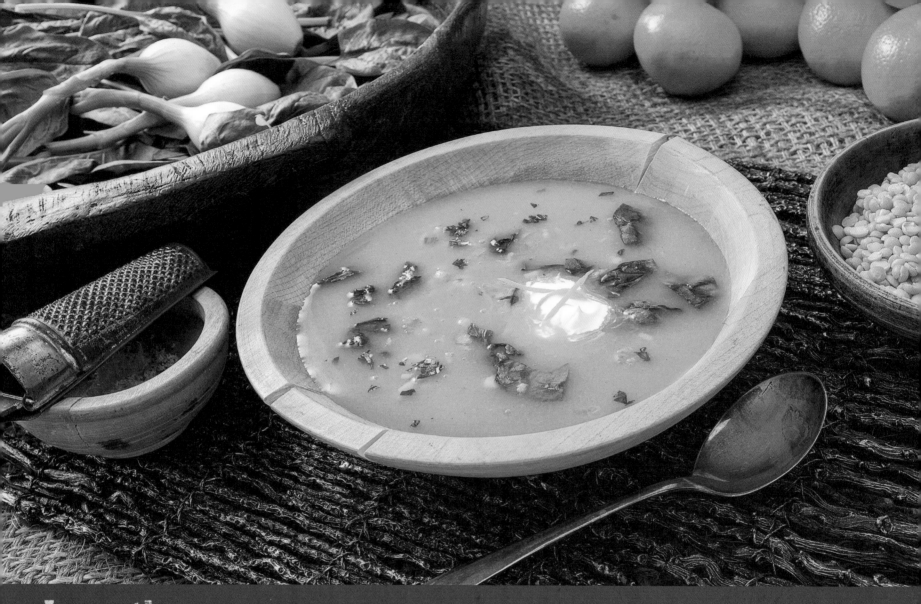

Lesotho

In the highlands of "the kingdom in the sky," and despite the chilling rain, I found warmth and hospitality with a 105-year old man and his extended family. Living in primitive round huts with equally primitive kitchens, many prepare their meals over simple stoves made of tin cans and heated by a wood burning fire. This easy to prepare soup has the added touch of citrus—a reminder that the sun does shine here—which, like the people I met while traveling through Lesotho, warms the soul.

Spinach and Tangerine Soup

Ingredients

⅔ cup uncooked yellow split peas

2 tablespoons unsalted butter

6 spring onions, thinly sliced

1 teaspoon ground turmeric

2 tablespoons rice flour

1 cup cold water

6 cups vegetable broth

½ cup freshly chopped Italian parsley

1 teaspoon salt

Grated zest of 1 orange

Grated zest of 3 tangerines

Juice of 4 tangerines

1½ cups fresh spinach, finely chopped

3 tablespoons freshly chopped cilantro, to serve

8 ounces creme fraîche, to serve

Preparation

1. Soak the split peas overnight in enough cold water to cover.

2. In a skillet, heat the butter over medium heat. Add the spring onions and sauté for about 5 minutes until softened. Add the turmeric and cook for another minute. Turn off heat, add rice flour and mix well. Stir in cold water until mixture is smooth and thickened. Transfer mixture to a bowl and set aside.

3. In a large pot, heat the vegetable broth until boiling. Drain the split peas, add to the broth, cover and reduce heat to low. Simmer for 25 to 30 minutes, or until the peas are tender.

4. Slowly stir the spring onion mixture into the pea and broth mixture. Once incorporated, stir in the parsley, salt, orange zest, tangerine zest and juice, and simmer for about 15 minutes, until flavors are well integrated.

5. Just before serving, add the spinach and cook until bright green and wilted, about 5 minutes.

6. Serve in bowls with the cilantro and a dollop of creme fraîche to garnish.

So much of the food in Lesotho seems to have a South African or Dutch influence, but with the spinach greens used in this recipe and the added twist of tangy and tart citrus, the flavor of Lesotho comes through.

Namibia

Walvis Bay

Windhoek
★

BOTSWANA

Limpopo R.

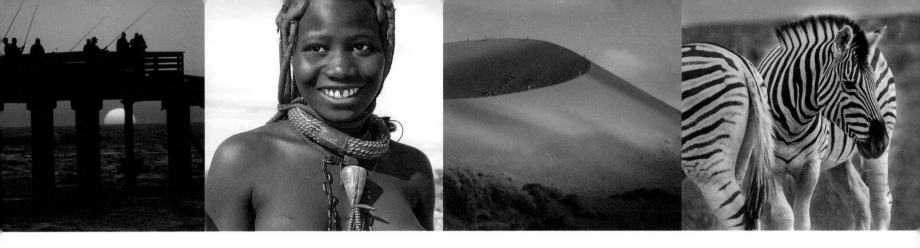

The Living Desert and Water of Life.

The signature image of Namibia must be the glorious orange-colored dunes of the Namib Desert. They stretch along nearly the entire coastline. The most famous and densely concentrated, and perhaps Namibia's largest attraction, are around Sossusvlei in the Namib-Naukluft Park, about 400 kilometers (240 miles) north of the South African border. Surrounded by vast, arid plains dotted with acacia and quiver trees, succulent shrubs, and sage, Sossusvlei is an area where strong coastal winds move and shift the gold and red sands, whipping them into a sea of massive dunes and an endless array of geometric patterns and rippling textures.

For years I'd dreamed of traveling to the Namibian coast to view these dunes. Now in Africa, I'm closer to realizing my dream, even if I must ride the toughest roads to get there. They must be tough, because the last group of motorcyclists headed there, the owner of the lodge tells me, chickened out and turned around.

I plan my adventure ride from the tiny settlement of Aus, once a World War I prisoner camp for German soldiers. About 120 kilometers (seventy-two miles) from the Atlantic coast, Aus is a small town with a few shops, a gas station, and the Klein-Aus-Vista Lodge. The lodge is perched atop a hill outside of town, providing panoramas of the southernmost part of the desert. The landscape seems painted—gold, yellow, and ocher—and, as the sun sets, the horizon looks as if it's on fire—deep red and orange. Finally the sky turns black, perforated with tiny holes of light, a mind-numbing array of stars. High above, shining so bright it commands attention, reigns a constellation I never can see at home, the Southern Cross.

Only a handful of paved roads stretch across Namibia, none leading to Sossusvlei. Most travelers here must use 4x4 vehicles or fear getting stuck or crashing. Because the roads vary in quality from deep sand to rocks to well-graded, smooth gravel, it is common for drivers who have driven a few miles on the smooth, graded portions to confidently accelerate, only to unknowingly speed into a gravel, rocky, or

Size: 824,292 sq km (34th in world)

Population: 2.2 million (142nd in world)

Capital and largest city: Windhoek (342,000)

Independence Day: 21 March 1990
(from South African mandate)

World Heritage Sites: 2

Literacy rate: 88.8%

Currency: Namibian dollar

Population below poverty line: 55.8%

Key exports: cattle, fish, karakul skins

Mobile phones: 2.24 million (136th in world)

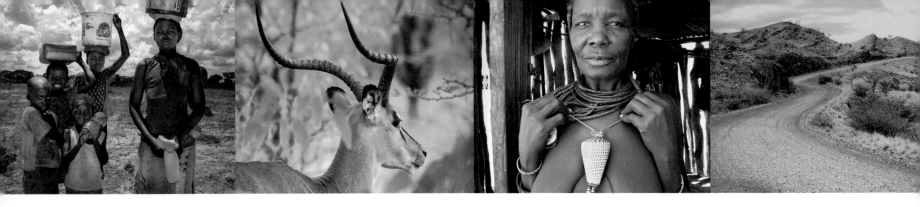

The Himba people who roam the pastoral lands of Northwestern Namibia and Southern Angola wear few clothes. The women go topless, and both men and women wear loin clothes made of animal skins. Women color their hair and skin with *otjize,* a blend of ochre and butter fat that gives them a warm red glow.

loose-sand section. Every day in Namibia, at least one car loses control, crashes, and flips on its side.

Leaving Aus, I realize the desert winds not only create the lovely and constantly changing dunes of the Namib Desert but also contribute to the constantly changing road conditions. My first thirty kilometers (eighteen miles) is in deep sand, which always makes me tense. My front tire squirrels, and my rear wheel slides as I try to find the perfect speed. This plays tricks with my mind, tensing me so much I can't enjoy the ride or the beautiful scenery.

Through one valley, I must ride across a wash or dry riverbed every 1,500 meters and deal with dangerously deep cavities of large rocks and loose sand. When the road isn't a river of rocks and sand, it's severely washboarded. The endless pounding gives me a headache, rattling my nerves.

I travel through savannah, deserts, and over mountain passes. It's scenic overdose. Shapely acacias wisp elegantly over golden-yellow brush, red clay, and washes of ivory-white sand. Turning west, the road deteriorates. I am startled when the only vehicle I've seen in two hours blows past me as if I'm standing still, leaving me in a cloud of dust. The fine, silty sand and loose rocks tax my patience and tenacity. I keep moving, but stop often for breaks.

The dunes of Sossusvlei are accessible from the small settlement of Sesriem and are best viewed at dawn. As the sun rises, the dunes glow and the shadows shift in the changing light, revealing textures of waves and patterns of stars. The massive formations rise

above the desert floor and twist into towering, serpentine walls of luminescent orange and red.

Arriving in Sesriem after battling my last wash and its patch of deep, marble-sized gravel, I learn the public campground is full. The five-star resort just outside the park is out of my price range, but the resort manager offers me a special traveler rate at his other property, about six kilometers (four miles) outside of town. They are small tented structures built on solid foundations, with functioning bathrooms and comfortable beds. With no restaurants or food markets in town, the manager invites me to dine at the resort and offers to drive me so I don't have to ride the sandy roads at night.

Dinner is served on an outdoor patio with all the amenities you would expect from a first-class resort: polite chefs in uniform, hand-carved game, fresh salads, grilled vegetables, homemade breads, and sweet desserts. I watch antelope drink from a distant water hole while I dine on exotic meats such as zebra, impala, oryx, eland, crocodile, and ostrich. Trying each, I find the oryx to be the tastiest to my palate: lean, tender, and flavorful. I feel lucky and happy, but realize this is a special occasion and justify the decadence as reward for the long day on harsh roads.

My good fortune continues. After spending the morning wandering amidst the dunes, photographing them as the rising sun bathed the dunes in changing light, I meet a wealthy businessman from Belgium who invites me explore the dunes by air in a plane he has chartered. If the dunes are best viewed on foot during sunrise, they are best viewed by air at sunset, where I'm able to take in

Namibia

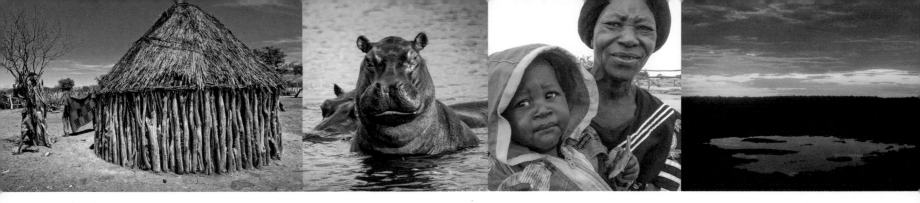

their vastness and see how changes in wind sculpt the dunes into geometric shapes, stunning curves, and sharp lines that zigzag for miles. It's the modern art of Mother Nature, mixing the surreal with geometric contours; images and colors I'm sure inspired artists such as Miro, Escher, Klee, and Dali.

As much as I am moved by the art of Sossusvlei, I am still on a quest to discover African wildlife and traditional African culture. Riding north, I see giraffes and rhinos for the first time since arriving in Africa. I camp three nights and explore Namibia's largest salt pan and wildlife sanctuary, Etosha National Park, before making my way to Opuwo, a small town in Northern Namibia Kaokoland (also known as Kunene).

Close to the border of Angola and Namibia, Kaokoland is a wild, rocky and arid desert sandwiched between two rivers that at first approach feels like I am walking into a *National Geographic* special or a movie set for a precolonial African story. It's real, and it's home to the Himba, a seminomadic tribe of tall, indigenous pastoral people with striking features who live traditional lives in huts, wear traditional clothes, and breed goats and cattle as they have for centuries.

The women, to protect their skin from the harsh desert conditions, use ochre mixed with butter or animal fat, giving their skin a reddish glow. Men use dusty, brown dirt. They all dress in loincloths or short skirts with adornments of shells, beads, bone, and iron. The women weave animal hair into their headdresses and twist them into braids caked with ochre clay. They never bathe, using instead more lotions made of animal fat and ochre. They clean their clothing and blankets with smoke from small fires built inside their huts, which are made of sticks and mud. The fragrance is unmistakable.

The first village I visit is a semipermanent settlement of a half-dozen structures with neither electricity nor running water. Each day, morning and evening, women walk eight kilometers (five miles) to a communal water source to fill their water jugs.

I bring several gallons of water to another village that is further from a water source and without huts. I huddle with twenty children and women under the cover of a mesh of dried sticks and plastic sheeting to keep out of the blazing, midday sun. Under a tree I spot what looks like an anorexic goat, moaning in pain and too weak to stand. With no water and all the pasture lands parched from four years of drought, I am sure it will be dead by morning.

I know the water I give these people will last only a few days, yet in Opuwo, just fifty kilometers (thirty miles) away, there is running water, electricity, and a supermarket. Most of the Himba will never visit Opuwo, though they are aware of a life vastly different from theirs. This makes me sad, but they seem happy. They choose their traditional life and prefer to trade crops, animals, and artisan crafts rather than use hard currency. Perhaps they are sad for me. Perhaps they have learned from the mutable dunes how to recognize what lasts; that their way of life works with nature and is thus ecologically sustainable, whereas the machinery of what we call civilization—with all its running water, electricity, and supermarkets—works against the laws of nature and is compromising, if not destroying, the planet. ◪

The Himba herd goats and cattle, but during years of drought the livestock die quickly and food is scarce. To dry the carcasses, they hang them in trees around their settlement. I saw dozens of goats, dehydrated and scrawny, perhaps just hours before being hung to dry.

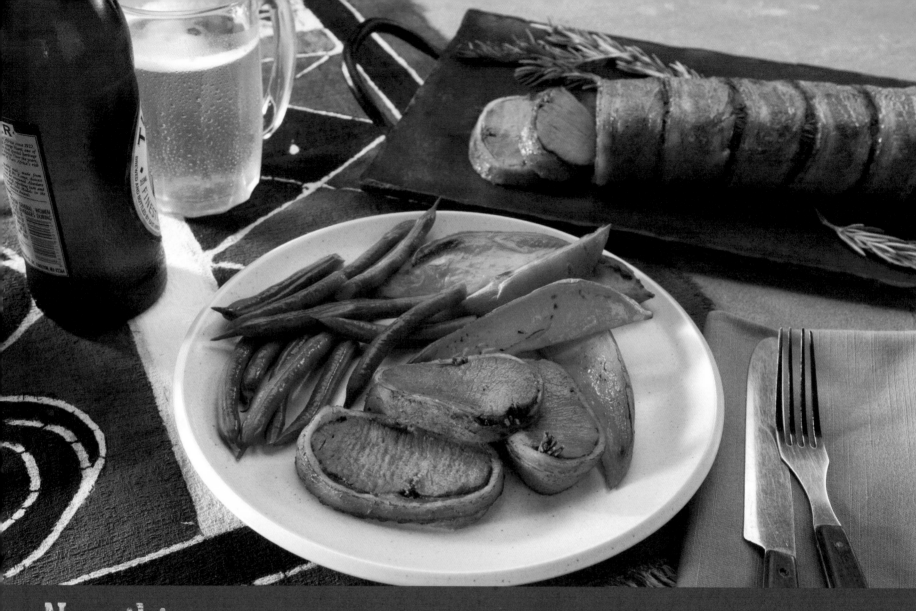

Namibia

The deeper I traveled into Africa, the more curious I became about the flavors of the various wild antelope that roam the bush. In South Africa, venison, or meat from antelopes such as kudu and springbok, is often slow cooked in a potjie pot. After roaming the golden dunes of Sossusvlei, I was invited to a buffet dinner that included grilled game, including ostrich, crocodile, zebra, and venison meat from several species of antelope. I admit I was apprehensive at first, but this venison, because it's wrapped in bacon and cooked barely medium rare, is tender and moist.

Bacon-Wrapped Venison on the Braai (BBQ)

Ingredients

Marinade

2 tablespoons olive oil

1 shallot, finely chopped

4 cloves garlic, minced

1 cup dry red wine

2 tablespoons Worcestershire sauce

2 tablespoons soy sauce

2 tablespoons fresh lemon juice

1 tablespoon fresh minced ginger

1 teaspoon wholegrain mustard

1 teaspoon dried rosemary

1 teaspoon brown sugar

1 teaspoon freshly ground pepper, or to taste

Venison

1 2-pound venison loin, trimmed of connective tissue, silver skin and fat

6 sprigs fresh rosemary

¾ pound of thick sliced bacon (about 10 slices)

Toothpicks to secure

Preparation

1. In a sauté pan, heat olive oil over medium heat and cook the shallot and garlic about 1 to 2 minutes, until the shallots soften. Remove from heat, stir in all the other marinade ingredients and mix well. Let cool. Place the trimmed loin and marinade in a large zip-lock bag. Marinate overnight in the fridge.

2. Remove the loin from the bag and marinade and pat dry. Place sprigs of rosemary on top of the meat and wrap bacon strips around the loin and rosemary. Use toothpicks to secure.

3. Prepare your gas or charcoal grill for indirect cooking with a drip pan. When the coals are ready (when the inside temperature of the covered grill reaches about 400 degrees F) place the bacon-wrapped meat over the drip pan and cover the grill.

4. Cook for 10 to 15 minutes undisturbed, then use a meat thermometer to cook the loin to 120 degrees F for rare, or to desired doneness.

5. Remove from the grill, tent with aluminum foil, and let stand for 15 minutes.

6. Remove the toothpicks and slice.

Fresh herbs are used in much of the cuisine of southern Africa. They are an essential ingredient in the *boquet de garni* used to flavor stews made outdoors in cast iron *potjie* pots in South Africa, Namibia, and Botswana. Plus, their strong aroma and flavor are ideally matched to the rich flavors of game.

Botswana

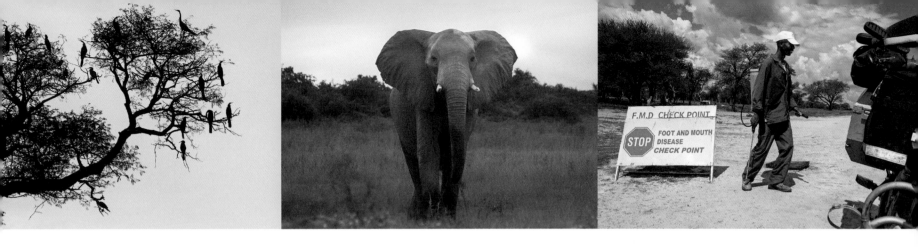

Dodging Donkeys, Eluding Elephants.

There are no roads leading into the Okavango Delta, a maze of lagoons, islands, and channels that spans the 1,600 square kilometers of one of the Seven Natural Wonders of Africa and is home to possibly the most diverse collection of wildlife on the continent. Formed by the Okavango River, which starts in Angola, it flows nearly 1,500 kilometers (900 miles) through Namibia's Caprivi strip and into Botswana, where it fans out through the open plains before being swallowed by the Kalahari Desert.

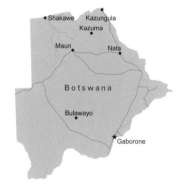

The only way to truly experience the delta is by small boat or canoe—or by air. Most fly in to exclusive safari lodges. Located on several of the delta's islands, these lodges are serviced only by air: supplies, guests, workers, and food. Without the time or budget for an extensive fly-in safari, I must explore Botswana's water channels, islands, and wildlife by other means.

The closest roads to the Okavango are near Maun, a small town at the southeast corner of the massive delta, and that's where I head after crossing the border. It's not long before I realize that Botswana's low human population density just makes more room for donkeys. I see the first few at the border post. Then, with each kilometer I ride toward Maun, the donkey population explodes. By the time I'm a hundred kilometers into the country, I've seen a thousand.

Riding a motorcycle through Botswana one quickly learns that donkeys just don't move. Honking my horn, revving the engine, and driving directly at them gets no response. They budge only to walk from the shoulder into the middle of the road.

At a police checkpoint, an officer unleashes a pressurized spray mist on my tires, wheels, and skid plate, a fumigation process for controlling hoof-and-mouth disease. The police seem to do their jobs, but the donkeys loitering about aren't helping.

Size: 581,730 sq km (48th in world)

Population: 2.1 million (144th in world)

Capital and largest city: Gaborone (202,000)

Independence Day: 30 September 1966 (from the UK)

World Heritage Sites: 1

Literacy rate: 84.5%

Currency: Botswana pula

Population below poverty line: 30.3%

Key exports: diamonds, copper, nickel, soda ash, meat

Mobile phones: 2.9 million (130th in world)

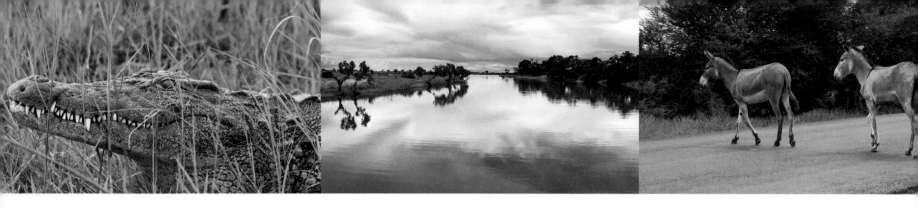

Both donkeys and elephants can be a nuisance in Botswana. I traveled hundreds of miles through vast fields that were once dense forests, until the elephants knocked down and dined on all of the trees.

"Whose donkey is that?" I ask, pointing to one urinating on the side of the road. At first I'm ignored, but then catch the ear of one of the officers. "Who owns that donkey?" I repeat.

"Sir?" He looks at me with serious eyes. Then he smiles, but he's missing several teeth, and his uniform is disheveled and missing several buttons, hardly exuding the image of a law enforcement professional.

"This dawnkee we no know who owns."

I explain the hazards these donkeys pose when allowed to wander on the highway.

"Maybe no has owner, dis dawnkee." I get nowhere; he doesn't seem to care.

After about 400 kilometers (360 miles) and more than 2,000 donkeys, I ride into Maun. Its location has made it a gateway to the delta, a large town with a busy airport, several banks, ATMs, internet cafés, shops, restaurants—and about 200 donkeys.

I'm becoming increasingly obsessed with the donkeys. Curiously, the police officer has been vindicated: They don't seem to belong to anyone.

A customer service representative at Mascom tells me her uncle was killed the past weekend when he crashed his car into a group of donkeys.

"Yes sir, dawnkees. Yes sir, no I don't know who own doze dawnkees," a local gas station attendant confides.

"Okay, big man, okay," another driver fills me in. "Yes we have much dawnkee problem here."

"The government must do it," a parking lot security guard tells me. "They must move all the dawnkees somewhere."

The owner of a repair shop tells me that every day a car or truck is smashed by hitting a donkey.

At the auto parts store, the clerk agrees that the donkey situation causes many problems for people in Maun. "Dee gubbermint must fix problem," he surmises. "They must take zee dawnkees somewhere and make zee who owns dem come git dem."

"There too many donkeys," the clerk at a hardware store agrees. "I don't know what to do."

A bartender tells me that, over several years of drought in the early 1980s, nearly the entire cattle population of Botswana was destroyed. This crippled the economy, especially in rural areas where farmers rely on cattle to plow their fields and pull their carts. So farmers turned to donkeys, which are more resilient to drought. But because donkeys can't pull as much weight as cattle, more donkeys were needed.

We cross a dozen rivers, plow through deep sand, and swerve and sliver through dozens of muddy trenches until we come upon a small pond surrounded by tall reeds, most towering four meters (twelve feet) high.

Another local speculates that the donkey population is out of hand because, during the early 1990s, a deadly outbreak of the highly contagious hoof-and-mouth disease infected nearly the entire cattle population of the country. To keep the disease from spreading and to protect the cattle industry, thousands of cows were exterminated. He tells me that the government provided donkeys to those who lost their cattle.

Today, most of the farmers are poor and cannot afford to buy feed for the donkeys, so they let them roam.

The owner of the camp where I'm staying tells me the easiest way to find a donkey's owner is to run into one on the road. When a donkey is killed, several farmers fight, each claiming to be its rightful owner.

"The value of a dead donkey is about four times than that of a live one," he explains.

I decide to look for hippos, giraffes, elephants, or any wildlife other than donkeys, so I arrange an all-day trip in a *makoro*, a shallow dugout canoe piloted by a poler.

To get to the delta waterways, I take a 4x4 to the Moremi Game Reserve. We cross a dozen rivers, plow through deep sand, and swerve and slither through dozens of muddy trenches until we come upon a small pond surrounded by tall reeds towering four meters (twelve feet) high. A dozen canoes sit in the water, most filled with rainwater, sinking.

Tall, dark, and slender, with easy-going, wide-set, eyes, my poler, Daniel, kicks and scoops the water rapidly with his foot to empty one of the canoes. Another local uses a machete to chop several reeds, which he weaves into a soft-cushioned seat for me in the front of the *makoro*.

The dugout is fashioned from a local tree, barely two feet deep, with a semi-flat bottom. It doesn't look stable, and I wonder if we'll capsize.

Daniel pilots the *makoro* by sinking a fifteen-foot, two-inch-diameter bamboo pole into the shallow water and pushing off the bottom. We float into the delta through a jungle of narrow channels cut through the tall reeds. The whisper of the hull pushing

Everywhere in Africa the bugs wreaked havoc on the windscreen of my helmet. Using a squeegee usually reserved for windshields, I would scrub my helmet so I could see. This amused and amazed the locals, who laughed and took pictures of me.

Some might think of them as river horses, but hippos (hippopotamus) are most comfortable in water by day. Though they sometimes get out, they risk cracking their skin from overexposure to the sun, so they wait until night to come out of the water to feed and graze on grass.

through the green water is muted by dozens of birds that flutter and take flight as we pass.

Sitting in the *makoro*, I am at water level and skim my hand over the surface as we whisk along. I gaze through the reeds, into the water, and up to the sky, watching herons, egrets, kingfishers, eagles, ducks, yellow- and red-billed storks, and dozens of others nameless to me.

After nearly two hours of poling through the maze of waterways, we come upon a landing. Daniel leads me on a bush walk past the reeds, through tall grass and forested glades and around large pools, where we see dozens of hippos.

With more time I would take a two- or three-day *makoro* journey and camp in the bush. Alas, I'm booked to view the delta from above so we must head back to camp. The next morning I take a one-hour flight and watch elephants, hippos, eland, and other wildlife from above. The delta stretches to the horizon in every direction. It's now that I truly appreciate the expanse of this complex network of waterways, islands, and bush.

Soon I am riding toward the borders of Zambia and Zimbabwe, passing through Botswana's green belt, and for the first time riding through this country I notice more than donkeys. Hundreds of

plantations grow maize, tomatoes, other vegetables, and seeds. As I get closer to the borders, the agriculture fades and wild vegetation grows thicker.

It becomes dense jungle. Trees tower above me on both sides of the narrow road as I pass through the Kazuma and Kasane Forest Reserves. I'm mystified. There are no donkeys, the road is in good condition, and there are no other cars in sight. Just as I speed up to 100 kph (60 mph) a huge elephant charges out of the forest and into the road ahead. I grab a handful of brake and screech to a stop.

Elephants are the largest land mammals on the planet, and they're afraid of nothing. That's why I was warned to stay close to trucks and large cars. Elephants will charge at motorcycles and people, but vehicles with large profiles seem to appear more impressive to elephants so they avoid them.

For the rest of the day I see more than a dozen herds of elephants, often startling and scaring me.

When I first set out on this trip I was told to worry about bandits, looters, robbers, and kidnappers, not elephants—or donkeys. Yet here in Botswana, I've got my hands full of both.

I wonder what dangers Zambia will offer up! ▬

Botswana

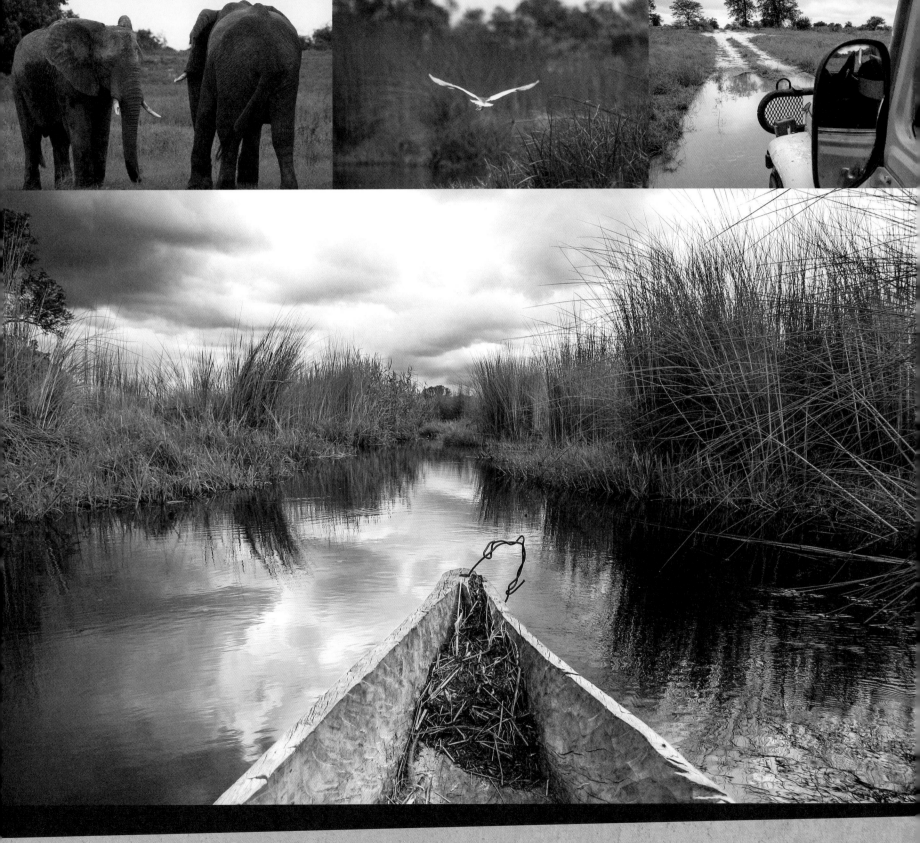

Botswana

In just about every southern Africa market, I found women selling these round, puffy fritters. At first I passed them by. Then I'd see women selling them at bus stops or on the sides of the roads. Dozens of them stacked in small shops in every town in Botswana were sold out by afternoon. In Botswana, I finally bought a bag of magwinyas, fat cakes, or sometimes mandasi. Other countries serve them with a sweet or savory filling or dusted with powdered sugar or cinnamon. I liked the plain and simple versions from Botswana the best. You might think of them as African donuts. I think they're the ideal accompaniment to tea or coffee, morning or afternoon. Cook up a bunch and give it a try.

Magwinya
Fat Cakes

Ingredients

2 teaspoons grapeseed or canola oil, plus more for deep frying

2 teaspoons white vinegar

1 quart warm water

8 cups all-purpose flour

1 cup granulated sugar

1 teaspoon salt

1 (¾ oz) packet active dry yeast

Preparation

1. In a large bowl mix together the 2 teaspoons of oil with the vinegar and warm water.

2. In another large bowl mix flour, sugar, salt, and yeast together. Slowly mix in the combined liquids to the flour mixture to form a dough. Transfer to a lightly floured work surface and knead the dough until smooth, about 5 minutes.

3. Cover the bowl with plastic wrap and set aside in a warm, dark place to rise, about 30 to 45 minutes or until it has doubled in size.

4. Heat enough oil in a heavy duty pot for deep frying to 375 degrees F. Test temperature by dropping a small pea-sized ball of dough into the oil which should brown in 1 minute if oil is ready.

5. Set some parchment paper on your counter or work surface. Rinse your hands with warm water and take a handful of dough, roll and form into a shape just smaller than a tennis ball and set on the parchment paper. Repeat, using all the dough. Slowly drop each ball into the oil, frying only six fat cakes at a time so as not to crowd the pot.

6. Frequently turn the cakes with kitchen tongs to evenly brown and fry until golden 2 to 3 minutes. Cakes will increase in size, float, and likely make a hissing sound.

7. Remove from oil and drain on racks with paper towels. Serve warm or cooled.

Create a mixture of cinnamon and sugar and sprinkle it over your magwinyas for a delicious variation of these scrumptious fat cakes.

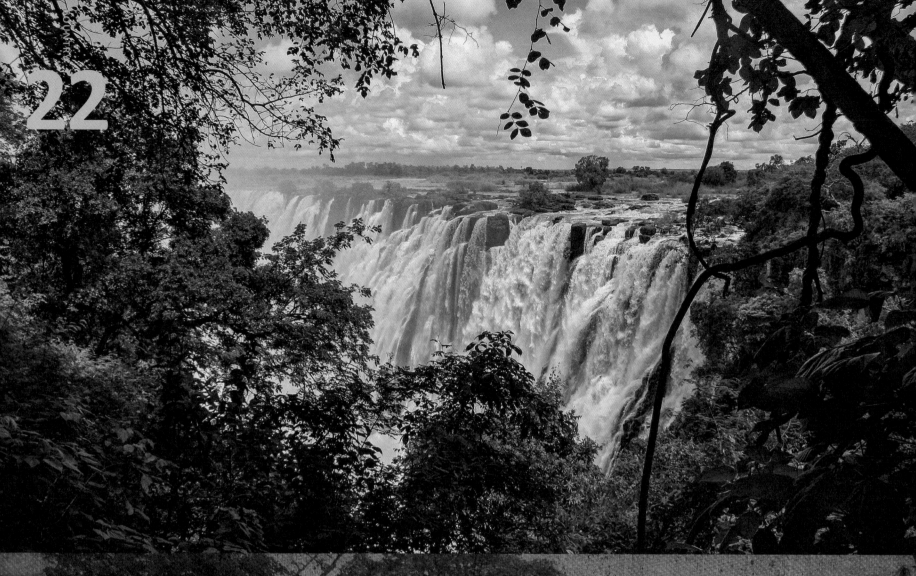

22

Zambia

ZAMBIA

Lusaka Lilongwe

Mongu • Nampula •

Wetter Than Victoria Falls.
The warning signs are everywhere. More than 50,000 people have been evacuated from Mozambique and another 10,000 from Zambia. The Zambezi River is on a course of destruction. Weeks of torrential rain have caused Africa's fourth-largest river to burst its banks and flood surrounding valleys. For me to cross the mighty Zambezi—which winds its way from Central Africa to the Indian Ocean, flowing some 1,700 miles through six countries—is a questionable proposition. Surprisingly, only five bridges span the river, one accessible only by foot.

Holed up in Botswana, I watch dark-brown mud ooze down the driveway of my guesthouse. The same brute force that has washed out roads and bridges and flooded essential agricultural areas created the mesmerizing Victoria Falls and Batoka Gorge more than 100,000 years ago. Now, at the confluence of the borders of Botswana, Namibia, Zimbabwe, and Zambia, I am stuck. Trapped.

I've accepted the reality that it will be a wet ride. Now I wonder if I'll ever cross into Zambia.

The only way across the river is through high water. I have to give it a try. I pass a lineup of more than thirty cargo trucks before I come to where the muddy road meets the Zambezi. At the riverside, local people huddle under a patchwork of colorful umbrellas. With two motorized pontoons and, when lowered, ramps that screech louder than elephants, the Kazungula ferry can carry one truck, maybe four cars, and as many people as can fill the spaces between. With the ear-splitting noise of truck horns compounded by drivers and frustrated pedestrians shouting in Swahili, the scene sounds more like a congested city street than a tiny, remote, and primitive border between two third-world countries.

I slither my motorcycle into a narrow gap between a truck and the ramp, then wait in the rain while the unlikely captain pilots the feeble vessel through the painfully slow and white-knuckled quarter-mile ride across the river.

Size: 752,618 sq km (39th in world)

Population: 14.2 million (70th in world)

Capital and largest city: Lusaka (1.4 million)

Independence Day: 24 October 1964 (from the UK)

World Heritage Sites: 1

Literacy rate: 80.6%

Currency: Zambian kwacha

Population below poverty line: 64%

Key exports: flowers, tobacco, cotton

Mobile phones: 8.2 million (87th in world)

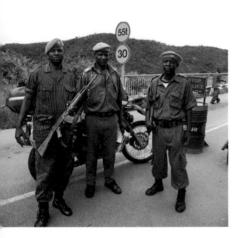

In Zambia, I somehow managed to lose the tire I had strapped to my bike, and wandered everywhere hoping to find it. The local military were not only curious about my search, they were also eager to share their firearms. When I asked if they ever lost a gun, they just laughed and said it would be impossible.

Endless rain can take its toll on the mental state of anyone. For me, it is physical. After hours of riding in the cold, pouring rain, my teeth chatter and my fingers wrinkle like prunes, even through my gloves. Seeking shelter, I stop at the kind of tiny roadside stand that would scare most travelers accustomed to valets, porters, luxury resorts, and westernized versions of ethnic foods.

I think I've scared Martha, the short woman with mocha-colored skin and a bright yellow scarf holding down her wet hair. She attentively serves lunch to a couple of locals crammed under the shelter of the shack. Not only am I the first *muzungu* (white man) to stop here, but my protective motorcycle gear (jacket, pants, gloves, and helmet) make me look like an alien from a distant planet.

The rain sounds its own African rhythm as it pounds loudly on the corrugated metal roof, while the steady stream of water cascading from the roof gargles as it drains down a nearby ditch. Despite the gray and wet surroundings, the sunshine from Martha's dark-brown eyes and easy smile warm me more than the warm water she pours from a bucket over my hands. She catches the excess in a plastic basin. This hand-washing ritual is practiced in homes, restaurants, and even these roadside stands, before serving a meal with *nshima*—a Zambian staple made from cornmeal and water, served and eaten with one's hands. As I grab a handful of *nshima* and scoop the steaming hot *ndiwo*, a stew-like dish with greens and tender goat meat, into my mouth, I feel I'm tasting more of the real Africa.

The rain continues to pour, masking the thousands of water-filled potholes along the road to Lusaka, perhaps the most frustrating stretch of tarmac I'd traveled since starting this trip. Each time my front tire slams into a pothole, my forearms sting with pain, and the jolt vibrates through my arms and down my back through each vertebrae. In Lusaka I learn that not only had the rainy ride beaten my body, but one of my forks was badly bleeding—a blown seal.

It is destiny that I find George, a sturdy black man with arms thicker than my legs, who helps me muscle my forks off and replace the seal. In the corner of his shop, I find, hiding behind an oil drum, perhaps the only set of tires in all of sub-Saharan Africa that will fit my motorcycle. With enough tread on my rear tire, I figure I can make Kenya before I have to change it, so I replace only the front tire and strap the other to my bike.

Along yet another potholed Zambian road, I pass thatched huts, poor communities, co-ops, and hundreds of people walking and riding bicycles. Everywhere I travel, I notice people carrying large white sacks tightly tied with twine. Somewhat lumpy and always bulging and overflowing, they are stacked on the sides of the road, in the backs of trucks, strapped to feeble bicycles with missing spokes, and slung over the shoulders of pedestrians, hunkered and barefoot. I stop and meet Peter, a thin-framed village Head Man with an inviting smile. He explains that the huge bags are filled with carbonized wood—charcoal—which serves the energy needs of nearly half the population of Zambia. Charcoal is their fuel. It heats their huts. Cooks their food.

Zambia

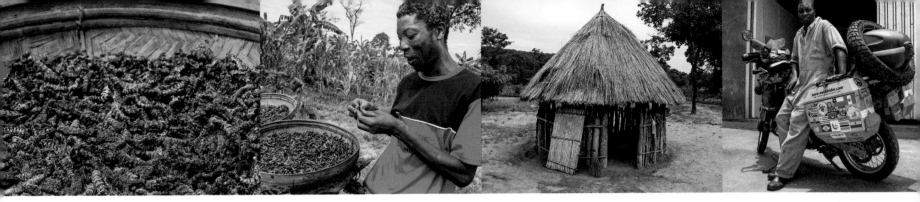

But charcoal is controversial. The transformation process from wood to charcoal causes considerable energy loss and requires more and more forest resources to meet the demands of Zambia's, and other African countries', growing populations. Walking down a dusty path, Peter leads me to his home, a simple compound in a small clearing surrounded by cassava. There are two thatched huts, one for sleeping and the other for cooking and eating. He explains that charcoal isn't necessary for everything. Lifting a large, tan woven basket filled with somewhat fuzzy peanut-sized caterpillars, he points at the sky and flashes a huge grin sporting blazing-red gums and white teeth. "We soak with salt"—he takes a handful and stuffs them in his mouth— "and the sun cook for food." He cups his hands together and presents me with a few dried, fuzzy caterpillars. "For you Mr. Allan." I chew. Very crunchy. Salty all right. Not bad. Before I leave, he hands me a small bag for the road.

Thirty minutes after my inspiring afternoon with Head Man Peter, I notice that the only tire in all of sub-Saharan Africa that fits my bike is no longer strapped to the back. Destiny? The strap broke and it flew off and bounced somewhere, or nowhere, into the Zambian bush. I retrace every inch of that road for hours, asking locals, military, and charcoal entrepreneurs if they've seen my tire.

No luck. So I head northeast toward Malawi just as the skies open and pelt me again.

Despite often horrific living conditions, questionable food choices, and chronically bad weather for raising crops and livestock, the Zambian people are incredibly happy and full of spirit. This man invited me to his village to meet his community and see the crops they tended.

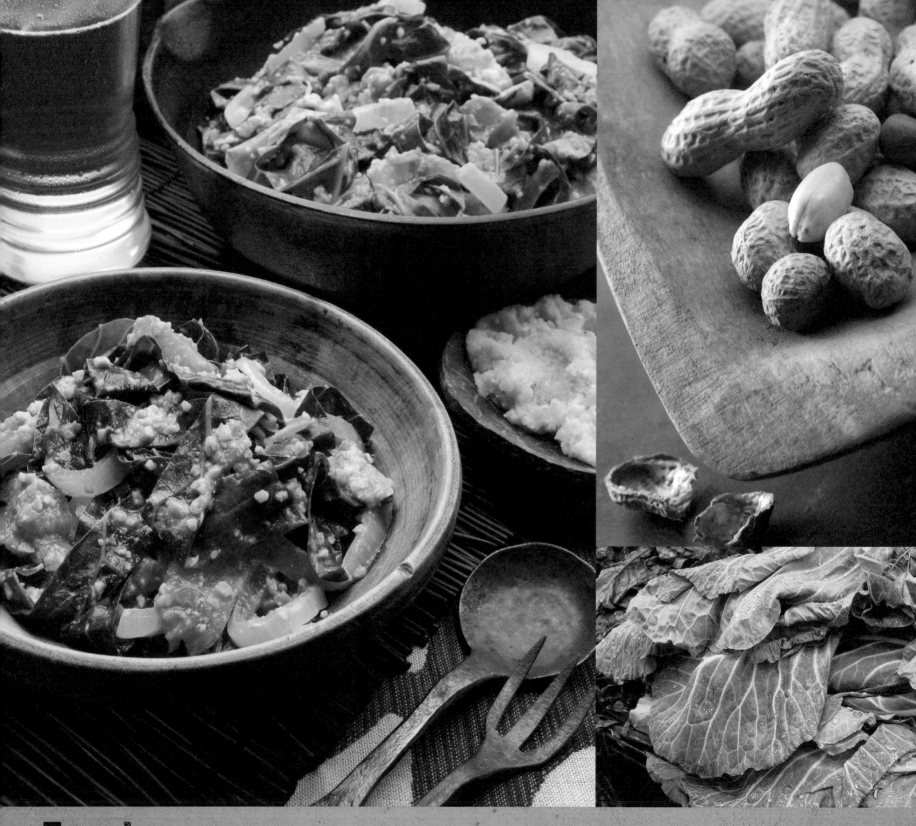

Zambia

Zambia shares borders with six countries, but is perhaps most famous for the once-tiny encampment of Livingstone, named after the Scottish explorer who was the first European to witness the mighty Victoria Falls. Most travelers never make it beyond those falls, but deep in the bush I discovered people eager to share their culture and their food. Although its bordering countries all cook variations of these greens with peanut sauce, often with cassava (manioc) leaves and sometimes with meat, my first taste of this simple yet rich and healthy vegetable dish was roadside somewhere deep in Zambia.

Ifisashi with Nshima
Greens with Peanut Sauce and East African Corn Meal

Ingredients

Ifisashi

1 cup unsalted peanuts, washed and chopped

1 tablespoon natural creamy-style peanut butter

1 medium onion, halved and thinly sliced

2 medium tomatoes, roughly chopped

1 cup water

2 medium to large bunches fresh collards, kale, or spinach, (stems and inner ribs removed) chopped

Salt to taste

Steamed white rice or nshima

Nshima

4 cups water

2 cups plain corn meal, preferably white

Preparation

Ifisashi

1. In a large saucepan, heat half the water water over low heat, add the peanuts, peanut butter, onions, and tomatoes, stir well, and bring to a boil.

2. After a few minutes, add the chopped greens and salt to taste. Reduce heat and continue cooking, stirring occasionally, until the peanuts are soft and the mixture has become thick and buttery sauce 15 to 20 minutes. (Cooking time varies by type of greens used.) Add more water if mixture dries and starts to stick.

3. Serve hot with steamed rice or nshima

Nshima

1. Heat the water in a medium sized pot over medium-low heat until lukewarm but not boiling.

2. One tablespoon at a time, slowly sprinkle 3/4 cup of the corn meal into the pot, stirring continuously with a wooden spoon. Keep stirring slowly until the mixture begins to thicken and boil.

3. Increase heat slightly, cover the pot, and let simmer for 3 to 5 minutes.

4. Remove the lid and slowly add remaining spoonfuls of corn meal while briskly stirring until the mixture is smooth and thick. Stir in more corn meal for a thicker nshima, if desired.

5. Cover the pot, remove from heat, and let stand for 2 to 3 minutes before serving.

I was thrilled and amazed how much I enjoyed ifisashi. Not only is it flavorful and rich, thanks to the peanuts and sauce, it's healthy—perfect for a vegetarian or vegan taste of Africa. You can use most any leafy greens, such as collards, kale, or even spinach.

Malawi

Huambo •

A N G O L A

Z A M B I A

Chipata MALAWI

MOZAMBIQUE

Lusaka

★ Lilongwe

Nampula

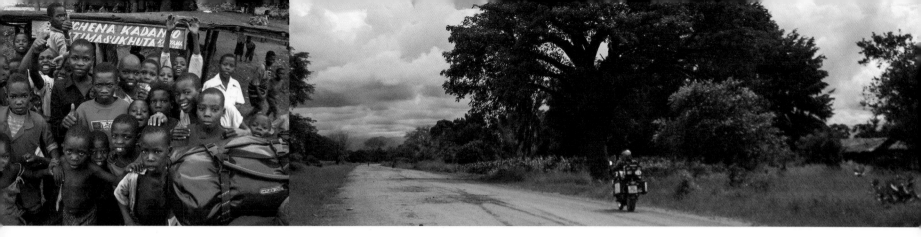

Breaking Bread Under the Baobab.

The rain that pounded all night on the corrugated roof of my Zambian motel room has washed red clay all over the road, making it slippery and dangerous. I must be careful and ride slowly to the Malawi border through many small villages of round huts. At the border, Zambian officials will let me out of the country only after I show them a paper, soggy from the rain, that proves I paid my carbon tax. With more papers, rubber stamping, and pats on my back, I wave goodbye to Zambia and roll into Malawi. Here I rendezvous with a fellow motorcyclist from South Africa, Ronnie Bee. He's riding to Tanzania, then back to South Africa.

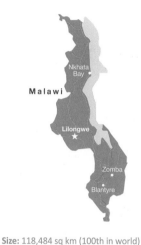

I met Ronnie a month ago in Namibia, where we spent some time riding together until he moved on to join his friends who live here in Malawi. Motorcycling is new to Ronnie. He bought the bike so he could take this trip and have time to think about his life. He admits he's angry and bitter that his wife is divorcing him and taking their two children to England.

My self-deprecating sense of humor, openness to people, well-practiced patience, and curiosity present quite the contrast to Ronnie's often frustrated, impatient, and indifferent demeanor. Born and raised in Africa, I find Ronnie to be jaded and with a cynical view of the continent. That's why he enjoys my company. He tells me that I need to rub off on him. I agree, and I remind him—often. Ronnie says I ride too slow, I tell him he rides too fast, that he misses the world he passes by. He complains that I talk to too many people.

We'd agreed earlier to meet here so he could escort me to the home of his friends, Peter and Carol, and their sixteen-year-old son, Paul, who live about an hour's drive from the border, in Lilongwe, the capital of Malawi.

On the way there, it starts pouring.

Size: 118,484 sq km (100th in world)

Population: 16.8 million (65th in world)

Capital: Lilongwe (821,000)

Largest city: Blantyre (856,000)

Independence Day: 6 July 1964 (from the UK)

World Heritage Sites: 2

Literacy rate: 74.8%

Currency: Malawian kwacha

Population below poverty line: 53%

Key exports: tobacco, tea, sugar, cotton, coffee, peanuts, wood products

Mobile phones: 3.95 million (116th in world)

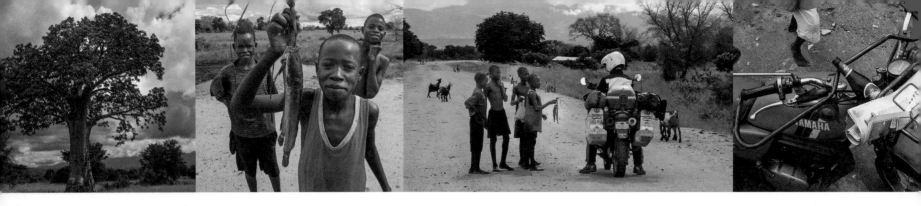

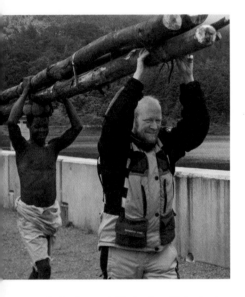

Seeing the sweat dripping down his forehead and stinging his eyes, I decided to help this young man carry these 20-foot trees across the street and over a dam. The Malawian people, like most in Africa, are resourceful and hard working. This timber is for a house under construction.

Hastily I stuff my phone into the waterproof dry bag I use to protect it and the small Moleskine notebook where I record my travel notes, expenses, contacts, and e-mail addresses. Then I shove the dry bag into the front pocket of my riding jacket.

For Peter and his family, transplants from South Africa, Malawi represents a slower and easier pace of life than the hectic, chaotic, and dangerous mess of Johannesburg. Not that living here is without challenge: there are scarcities of basic food staples and common household items.

When Ronnie and I arrive at Peter's residence, I can't find my phone or my dry bag and notebook. I'm livid. I stomp around the house, unleash a barrage of profanity, and create a scene by tearing everything off my motorcycle. I still can't find them. Maybe Ronnie is rubbing off on me.

"Relax," Peter tells me. "We'll get you another phone. Here, have a 'green,'" he adds, referring to the color of the bottle of cold Carlsbad beer he hands me. He's right, I need an attitude adjustment. My lost phone and even my irreplaceable notebook are barely inconveniences compared to the conditions most must live with in Malawi. I buy a Hungarian-manufactured Nokia phone for $15 and put the experience behind me.

Leaving the city, Ronnie and I set out to discover Malawi; its mountains to the south, the beaches and villages on the southern part of the lake, and the peaceful serenity of the remote northern lake district. As I ride through the villages closer to Lake Malawi,

the third largest in Africa, I begin to notice just how densely populated Malawi is. The red clay road is teeming with pedestrians and people on bicycles. Men and boys, some carrying freshly caught fish, lead cattle and goats up and down the crowded track. Even cars and trucks are packed dangerously with people.

There are few gas stations and no electricity, but lining the roads of every village are dozens of shacks stocked with fruit, snacks, and salty goods. Every shack sells cellular service top-off cards, used to replenish airtime. I find it amazing that most of the country is devoid of infrastructure, yet I can buy airtime for my new Nokia phone in even the most poor and remote villages.

Ronnie is riding more slowly, a sign that I'm rubbing off on him. Later he admits that he is getting the best gas mileage of his journey. With a bigger bike, it's easy to forget how fast you're going. I ride at a reasonable pace, not only for better gas mileage, but also to see. I try to look into the eyes of pedestrians, villagers, bicycle riders. Children wave and men flash high-fives as they sit roadside. I return the waves and sometimes toot the horn. No matter how hard life is here, they always smile. That's what gives me the energy and strength to focus on what is good here rather than on what's not. And that's why sometimes I just stop riding.

I see several men and children with dark black faces and friendly smiles with bright white teeth standing on the side of the road next to a baobab, a short, squatty tree with a massive trunk. They wave as I ride by. I can't resist. Burning with curiosity, I stop to visit with them.

Malawi

I see several men and children with dark black faces and friendly smiles with bright white teeth standing on the side of the road next to a baobab tree, a short, squatty tree with a massive trunk. They wave as I ride by. I can't resist. Burning with curiosity, I stop to visit with them.

"I love these trees," I say, which gets a giggle from the young boys. Because of the British history, many people speak English.

"May I sit down?" They look at each other, but remain quiet. I know they are surprised, if not confused, as it's odd that a white man would simply stop and ask to sit down. I introduce myself and shake each of their hands, then sit under the tree.

Ronnie sits on his bike, engine still running.

"Are you just going to stand there and stare?" I ask the men. "Would you like to sit down? Join me?" I pat my hand on the ground next to me. Ronnie rolls his eyes and finally turns his engine off, realizing that this is one of those instances when he's going to wish I wouldn't talk so much. I think he's practicing his patience.

Several of the men sit down under the tree next to me. Ronnie says, "You trying to drum up a posse or something?"

I pull out some bread and biscuits, offering them to the men as they sit. "What are you doing today?" I quiz the posse.

"We do nothing," one man says.

"I go now to buy cake of soap," another tells me.

I turn to the young boys, "No school?" I ask.

"No. Today is holiday. No school. We just be with friends."

"Can I be your friend?" We sit and talk under the baobab tree. The older men tell me Hastings Banda, their former president, wasn't so bad. They express disdain for Muluzi, another former president. The children don't understand.

I marvel at these people, humbled by their knowledge and that they have so little and yet are incredibly happy, friendly, and eager to learn.

A month later I'm in Tanzania and receive an e-mail from Malawi. Martha, a woman working in an Internet café, tells me two men found my Moleskine notebook. Nobody found a phone, but that's okay. She mails the book to me in Tanzania.

I've never met Martha, but today we're Facebook friends, and I've watched her get married and have her first child. I promise her that I'll return to Malawi, meet her, and thank her in person.

While I often saw three, four, or more people on a single motorcycle, the sight of this proud father and his two children on a bicycle made me smile. Malawi is one of the more densely populated East African countries, though there seemed to me to be more bicycles than cars.

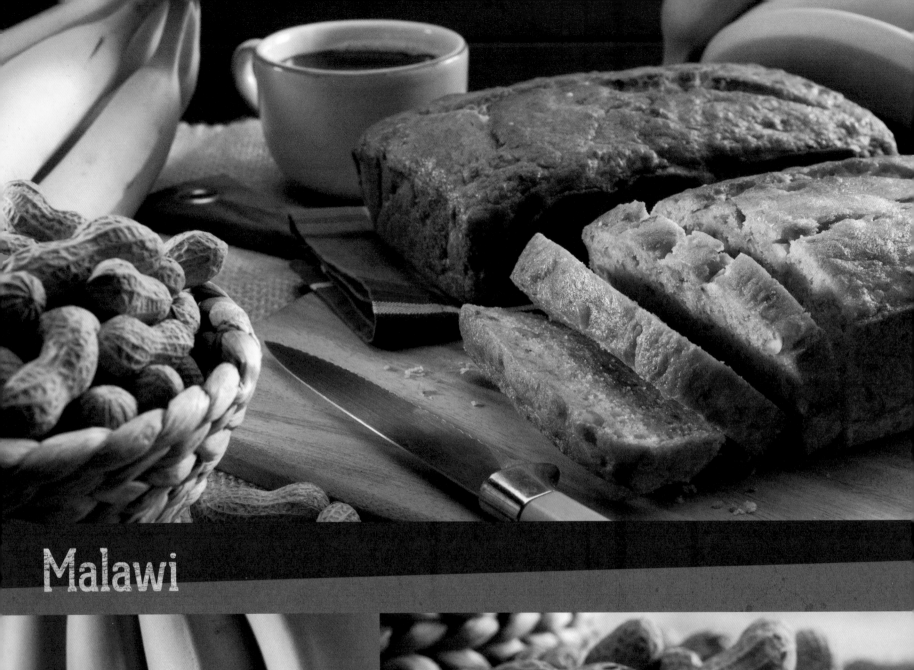

Malawi

Bananas are important to Malawi. Not only did I find bananas hanging for sale at nearly every roadside stand I passed, they provided the main ingredient for much of the country's favorite desserts. Most Malawian people have a sweet tooth. From banana fritters, to cookies, to this classic banana bread, to taste Malawi is to taste these sweet desserts. The Malawian people are incredibly respectful to their guests, refusing to take or eat any food until all the guests are fed and happy. Who doesn't like a banana bread or cake? Peanuts give the Malawian nthochi banana and nut cake a welcome texture.

Malawian Nthochi
Banana and Nut Cake

Ingredients

¾ cup butter, unsalted and softened

¾ cup sugar

2 eggs, lightly beaten

4 bananas, ripe

2 teaspoons lemon juice

1½ cups self-rising flour

¼ teaspoon salt

⅓ cup unsalted peanuts, chopped

Small quantity of milk (enough to combine)

Preparation

1. Preheat oven to 350 degrees F. Grease and line the bottom of a 9-inch cake pan with parchment paper.

2. In a mixing bowl, beat together the butter and sugar until light and fluffy. Add the eggs, and beat until smooth, about 1 minute. Set aside.

3. In another bowl, use the back of a fork or a beater to mash the bananas together with the lemon juice to form a fine paste. Add banana mixture to the egg mix and beat to combine.

4. Add half the flour and beat just to combine. Add remaining flour and salt and and beat briefly until batter is smooth. Do not over beat. Fold in peanuts and slowly stir in enough milk to combine and maintain smooth texture.

5. Pour the batter into the cake pan and bake in the oven on the center rack for about 90 minutes, or until lightly browned and a skewer inserted into the center of the cake comes out clean.

6. Allow to cool in the pan for 10 minutes, then remove and place on a wire rack to cool completely.

Peanuts, also called groundnuts, are used in many recipes in Malawi and are also made into flour. I love the texture the chopped nuts add to this banana bread.

Tanzania

Sneaking Through the Serengeti.

My first week in Tanzania is marked by incessant rain. I think back to my days in Northern Namibia with the Himba people, whose thirst was not only for water, but also for any empty plastic water bottle to carry it—when they found some. Here in Eastern Africa there is so much water that the levels on the Zambezi River are dangerously high. The Mozambique government is threatening to open the Kariba Dam, which will cause flooding and force thousands of locals to evacuate their homes. Yet even with so much hydro-power generated by dams along the raging rivers, in Dar es Salaam, the capital of Tanzania, I have no electricity. The government is randomly shutting off city sectors without notice.

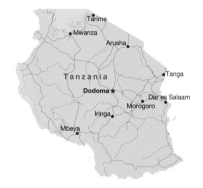

Size: 947,300 sq km (31st in world)

Population: 48.3 million (27th in world)

Capital and largest city: Dar es Salaam (3.207 million)

Independence Day: 26 April 1964 (Tanganyika united with Zanzibar; previously, the two countries gained independence from the UK)

World Heritage Sites: 7

Literacy rate: 69.4%

Currency: Tanzanian shilling

Population below poverty line: 36%

Key exports: coffee, cotton, cashew nuts

Mobile phones: 25.7 million (39th in world)

Africa is perhaps the richest continent in terms of minerals, oil, and agricultural potential, yet most of its nations seem more than a century behind the rest of the world. Tanzania has the lowest English literacy rate of any country I've visited. There is, however, one English word all the children know: "money." When they see a *mzungu* (white person), most children expect money, food, or shelter. I can't blame them. I cringe when children thrust their open palms toward me while motioning with the other hand toward their mouth, indicating they want money for food.

More than 30 percent of the Tanzanian government's budget comes from foreign aid, and 95 percent of local government budgets come from the national government or directly from donors. It's no wonder kids think all mzungus have money to spare. Yet I wonder how much this aid money impacts these kids. As in many African countries, the government here is laden with corrupt and self-interested ministers.

My plans change when, on a dusty dirt road just south of the Kenyan border, a *dala dala* (minibus) crammed with passengers forces me off the road. I crash into a ditch, injuring my arm and damaging my motorcycle. I return to Tanga, where Rashid, the owner of a truck repair facility, works on my bike while one of his coworkers takes me to the hospital.

Outside the larger cities it's difficult to find running water. Often, villagers have to walk or ride bicycles for several kilometers to a well, where they fill any containers they can find with precious drinking water.

One doesn't have to look far to understand why Tanzania faces an ongoing struggle over power and electricity. Several high-level politicians have been caught funneling funds to bogus companies—more than a hundred million dollars intended for electric and power projects—and awarding questionable contracts to family and friends. The guilty include a former prime minister and the managing director of the state-run power company.

Unfortunately, this is what Africans have come to expect. When I question what happens to the aid for education, health care, and infrastructure that's pumped into Africa, I'm answered with shrugs and the expression, "It's Africa." Most of the money ends up in the pockets of politicians and businessmen.

Despite governmental corruption, most Tanzanians are happy and always smiling. On the road north my clutch cable snaps in the countryside. Fortunately, I carry spare parts and can make basic roadside repairs. It's not long before I have an audience of dozens surrounding me and my bike. I know I'm an oddity here, but I'm hardly entertaining as I work, so I verbalize and explain, step by step, what I'm doing. As I speak to the group, I hold up

and announce the tools and parts I use. The crowd laughs. I feel like I'm doing stand-up with a live audience.

It's humid, and the sun blazes down. My pale skin reddens. I'm having problems connecting the cable. It's tight and won't adjust. My roadside performance turns to frustration and profanity.

"Mister, mister. Not you worry, now. I help," a young man in an oil-stained t-shirt says, making his way through the crowd. Another joins him. Soon everyone wants to help, also hoping I will reward them with money.

Foreigners visiting Tanzania are usually destined for Mt. Kilimanjaro or Serengeti National Park. Nearly all of them miss roadside stops like this because they choose to avoid the 800-kilometer (480 mile) drive by flying from Dar es Salaam to Arusha. I decide to take the long way.

My plans change when, on a dusty dirt road just south of the Kenyan border, a *dala dala* (minibus) crammed with passengers forces me off the road. I crash into a ditch, injuring my arm and damaging my motorcycle. I return to Tanga, where Rashid, the

Tanzania

owner of a truck repair facility, works on my bike while one of his coworkers takes me to the hospital.

In just over an hour I'm back in Rashid's shop with a fist full of x-rays (cost: $7) that show nothing broken, just a bad sprain. My bike is repaired, with no sign of damage.

"How did you fix it so fast?" I ask him.

"Easy," he says, speaking with an African-Indian accent, "but a good magic man never tells his secret."

"Maybe it's a good thing you crashed, Mr. Allan," he adds, offering some condolence and advice. "I don't think you should go to Kenya anyway. Many problems right now." Violence, riots, and brutal massacres have plagued the former model African nation since disputed election results ignited the turmoil a few weeks ago.

Rashid refuses to take any money from me, even for the parts.

"You've had a tough time enough today, Mr. Allan, don't worry about it."

I go to Arusha, passing Mt. Kilimanjaro along the way.

Motorcycles are not allowed in Serengeti National Park, Tanzania's largest and oldest. It spans nearly 15,000 square kilometers (5,700 square miles), making for a very long and difficult journey to try to go around. Besides, I don't want to miss it. Along with the Ngorogoro Conservation area, Serengeti National Park is a

UNESCO World Heritage Site. Between them, they are home to more than one million wildebeests, famous for their annual migration, and hundreds of thousands of zebras, gazelles, lions, leopards, cheetahs, rhinoceroses, and enough flora and other fauna to fill this book several times over. I must figure out a way to experience this part of Tanzania and get my motorcycle to Lake Victoria, more than 300 miles away, through the park.

Fortunately, Chris of Bush2Beach Safaris is happy to help me out. He restores an old trailer and welds a hitch onto a Toyota Land Cruiser safari vehicle.

"Your motorcycle will make it through the Serengeti," he says, proudly unveiling his work.

We secure the bike to the trailer, wrap it tightly in tarps, and I head to the Serengeti by way of Lake Manyara, the Ngorogoro Crater, and the Olduvai Gorge, where Mary and Louis Leaky unearthed prehistoric tools and evidence of human evolution in Africa.

With my driver, Simon, and a guide and chef, Ben, I spend several nights crossing the Serengeti, motorcycle in tow, camping and tracking the wild animals of these endless plains.

Just outside the western border of the park, Simon and Ben drop off me and my motorcycle and head back.

I continue my quest—to see and understand Africa.

I was surprised to learn of then President George W. Bush's visit to Tanzania while I was staying in Dar es Salaam. To greet the leader of the largest democracy in the world, local people performed traditional Swahili music and dance, in custom designed wardrobes featuring prints of President Bush.

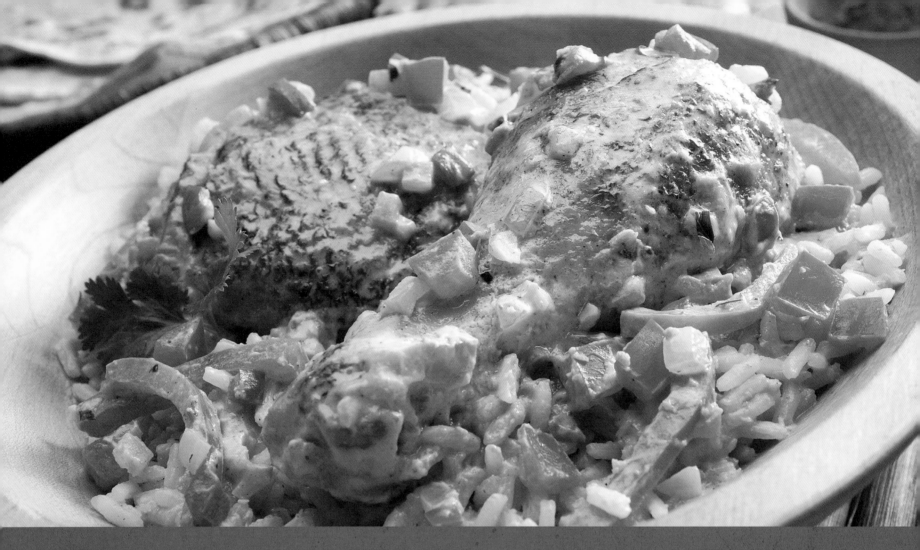

Tanzania

As I made my way toward the Indian Ocean and the coast of Tanzania, I began to feel the influence of the cultures that have merged there. From Indian-inspired curries to the spices of Arabia and Africa, studying the cuisine of Tanzania and Kenya is like taking a class in African history. Simple and easy to prepare with its rich coconut curry sauce topped with fresh lemon and cilantro, kuku paka (also kuku na nazi) is the ideal first lesson. Serve with rice or make your own chapati flatbread.

Kuku Paka and Chapati Flatbread
Coconut Chicken Curry and Chapati Flatbread

Ingredients

Marinade

⅛ cup olive oil

2 tablespoons fresh lemon juice

3 garlic cloves, minced

1 tablespoon minced fresh ginger

1 teaspoon ground turmeric

Chicken

1 3-pound chicken, cut into serving pieces

¼ cup grapeseed or canola oil

1 large onion, finely chopped

1 large green bell pepper, cored, seeded and julienned

2 red chile peppers (Thai or Fresno), chopped

2 cups chopped tomatoes

2 tablespoons minced fresh ginger

6 garlic cloves, minced

1 tablespoon curry powder

Pinch of ground cloves

1 teaspoon ground cumin

1 13.5-ounce can unsweetened coconut milk

Salt and pepper to taste

1 tablespoon fresh lemon juice

½ cup chopped cilantro

Steamed rice, to serve

Chapati flatbread, to serve (see recipe to right)

Preparation

1. In a large bowl, prepare the marinade by whisking together all the ingredients. Add the chicken, toss well to coat, and refrigerate for at least one hour.

2. In a Dutch oven or heavy sauce pan, heat the oil over medium heat. Add the chicken and marinade and brown the chicken pieces on all sides, about 10 minutes. Remove from pan and set aside.

3. Add the onion, bell pepper, chiles, tomato, ginger, garlic, and curry powder to the pan and cook, stirring occasionally, until the vegetables are softened, 5 to 7 minutes. Stir in the tomatoes and simmer for 2 to 3 minutes more.

4. Stir in the ground cloves, cumin, coconut milk, salt, and pepper, and return the chicken to the pan. Cover, reduce heat to low, and simmer until the chicken is tender and no longer pink, about 30 minutes.

5. Stir in lemon juice and fresh cilantro, and serve with the steamed rice and chapati bread.

Variations

Instead of browning chicken, simply grill the chicken pieces before adding to the simmering sauce. Boneless, skinless chicken breasts or thighs can also be used.

Chapati Flatbread (serves 8)

Ingredients

2½ cups all purpose flour

3 tablespoons, vegetable or canola oil

1/2 teaspoon salt

¾ – 1 cup warm water

Preparation

1. Mix the all purpose flour with 1¾ cups of the whole wheat flour (reserving remaining ¼ cup) in bowl and work in the oil using your hands until smooth. Alternatively, use a food processor, pulsing just to combine.

2. Stir the salt into the warm water until dissolved. Add the salt water mix to the flour mixture, a little at a time, until dough forms a soft ball. Knead for about 10 minutes or until the dough is elastic. Once a smooth ball is created, place in a bowl and rub a few drops of oil on dough to prevent drying. Cover with plastic and set aside for 20 to 30 minutes to rest.

3. Sprinkle enough flour to cover a solid work surface. Remove the dough from the bowl and roll on the floured surface into a log. Cut into 10 equal-size pieces. Sprinkle flour on top of each piece and, in the palm of your hands, roll each one into a small ball. Using a rolling pin, flatten each piece into an even, very thin round about 6 inches in diameter and place on a lightly floured baking sheet or platter.

4. Heat an ungreased cast iron or heavy non-stick skillet over medium heat. Add one round of dough and gently press down the entire surface with a spatula—this will help make your chapati puff up. Drizzle ¼ teaspoon of oil over the chapati. Flip and, as dough puffs or bubbles, continue to flip every 5 seconds until puffed golden patches emerge and dough is cooked, about 1 to 2 minutes total. Set aside to keep warm and repeat with remaining rounds.

Zanzibar

TANZANIA

Kalemi

Kananga

L. Tanganyika

Zanzibar Island

★ Dar es Salaam

Where Avocados and Coconuts Shall Fall.

Who isn't lured by the notion of palm-lined, sandy white beaches, turquoise-blue waters, coral reefs teeming with fish, and postcard-perfect sunsets? Toss in traditional fisherman, who deliver their daily catch by boat to thatched-roofed beachside restaurants where bikini-clad beauties sip colorful drinks adorned with bamboo mini-umbrellas. This could be Bali, Búzios, Barbados, or the Bahamas, but it's not. This is Tanzania, and I'm in Zanzibar.

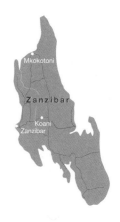

Just the name conjures up images of a tropical paradise. Zanzibar, where East meets West, where world adventurers and voyagers once traded exotic spices and textiles. Sitting somewhat in the middle of the eastern coast of Africa and just a few miles off the Swahili coast of Tanzania, Zanzibar is part of a small archipelago that includes Pemba and several smaller islands that stretch out to the Indian Ocean.

Though Zanzibar's history spans more than a thousand years, over which time it served as a trade link between East Africa, Persia, and Asia, its most colorful period probably spanned the 12th to the 15th centuries. During this time, it was a rich city-state where traders sold slaves, gold, wood, and ivory to India and Asia, and where Arab, Indian, and Asian trading partners brought textiles, spices, and glassware to Africa. This infused a mix of cultures into Zanzibar that can still be seen today in its architecture, artwork, and the faces of its nearly 500,000 residents.

Sadly, some who come to this historic island choose to cocoon themselves away from the local flavor and color by keeping to one of the five-star resorts that dot the pristine beaches of the island. Yes, visitors to Zanzibar Island can enjoy the same western amenities found at most any beach resort in the world. Although these visitors may get a Tanzania stamp in their passports, they'd hardly get a true Tanzanian Zanzibar experience.

Though technically Zanzibar is part of Tanzania, because of its rich history, its semi-autonomous status and cultural diversity, it seems like a different country.

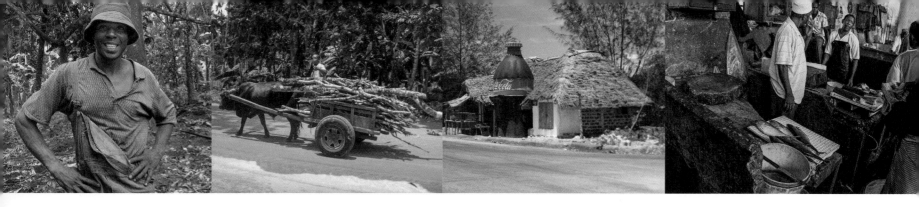

Zanzibar's Stone Town is a World Heritage Site, but the doors in this small pocket on the once island nation fascinated me most. Some grace palatial estates; others, battered and worn, have seen better days. All created a mystique that sparked my sense of wonder and imagination at history and stories never told.

With my motorcycle safely stored on the mainland, I make my way on foot to the heart of Zanzibar, the historic city of Stone Town, a UNESCO World Heritage Site and the only continuously inhabited ancient city in East Africa. The colorful textiles hanging in the markets along the narrow streets and alleys are a striking contrast to the surrounding monochromatic coral stone buildings. Women in colorful dresses with matching hijabs, or veils, some covering their entire bodies except their eyes under burqas, illustrate the diversity of the Islamic population of Zanzibar, where groups of four sects of Muslims live together among Christians, Hindus, Buddhists, and others.

With my beaming white face and sunburned red nose, I attract attention in Stone Town.

"Karibu (welcome)," I'm greeted in Swahili by many.

"Asante sana (thank you very much)," I reply with a nod of my head, using a few Swahili words I've learned.

In Zanzibar and throughout Tanzania, people don't speak much English outside the major cities. In Eastern Africa, despite the many dialects of Bantu and other tribal languages, Swahili is king, and I'm doing my best to learn more each day. When locals hear me spout out some Swahili, they show a huge smile followed by a mouthful of words I wish I could understand.

One friendly Zanzibar native, Omar, dressed in a traditional Muslim taqiyah and thwab (white robe and cap) offers to guide me through the maze of alleys of Stone Town. Zanzibar, I learn, is actually Unguja, the Swahili name for the island, which distinguishes it from

the name of the archipelago, also Zanzibar, which is derived from the Arabic appellation Zinj el Barr, meaning "land of the blacks."

In the mid-1800s more than 500,000 black African slaves passed through here on their way to Arabia, Persia, and islands in the Indian Ocean where demand grew due to expanding plantations and the fact that Islamic law prevented the enslavement of Muslims. Here, more than a half-million Africans, chained and tied together, were sold and shipped abroad. Buyers would crowd the floor of the market while the auctioneer beat on the shoulders and backs of the slaves with a heavy stick. Those who broke and fell to their knees were sold for less, while those standing commanded more.

Today, the Anglican cathedral, Church of Christ, stands on the site of the old slave market. It was constructed in 1873, the same year slavery was abolished. Built by former slaves in need of work and in celebration of the closing of the slave market, the historic church features a blend of Gothic and Islamic architectural features.

Further evidence of the blend of cultures here is found in the elegantly carved and appointed doors to residences, shops, and museums. Featuring different shapes, adornments, and symbols, most all of the old doors have sharply pointed and protruding brass handles. These were not only incorporated as a design element, at the time they were also functionally important because they prevented elephants from knocking down the doors.

After my history lesson and exploration of the dirty, colorful, sometimes smelly and always interesting alleys and corridors of

Zanzibar

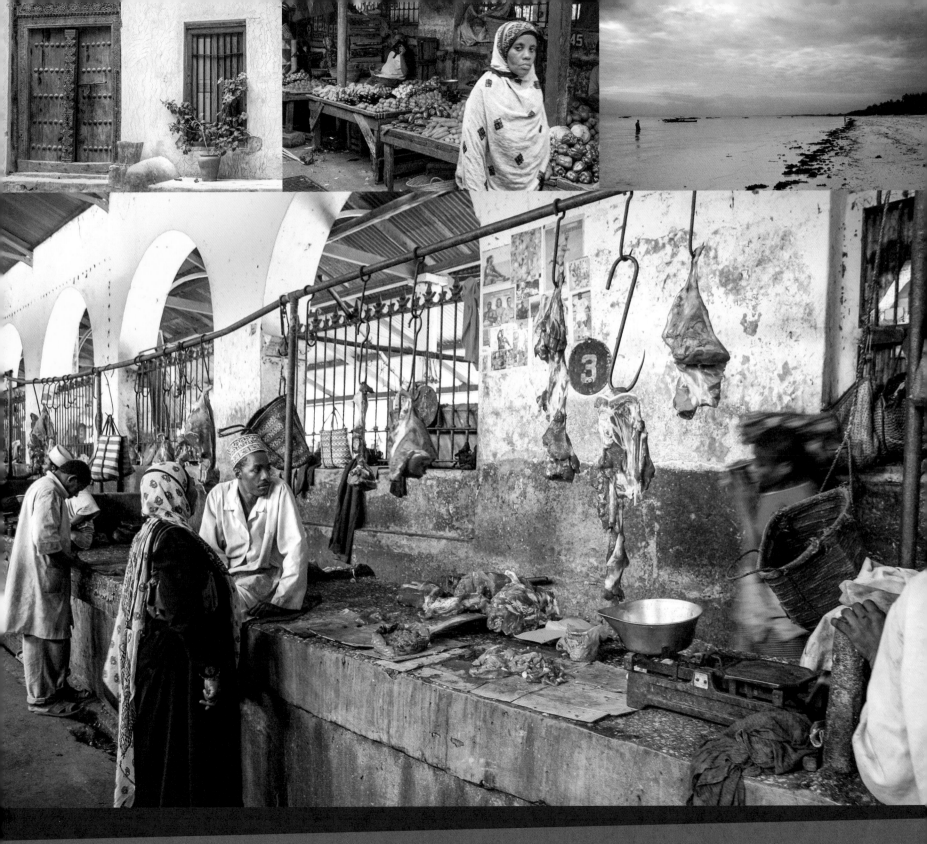

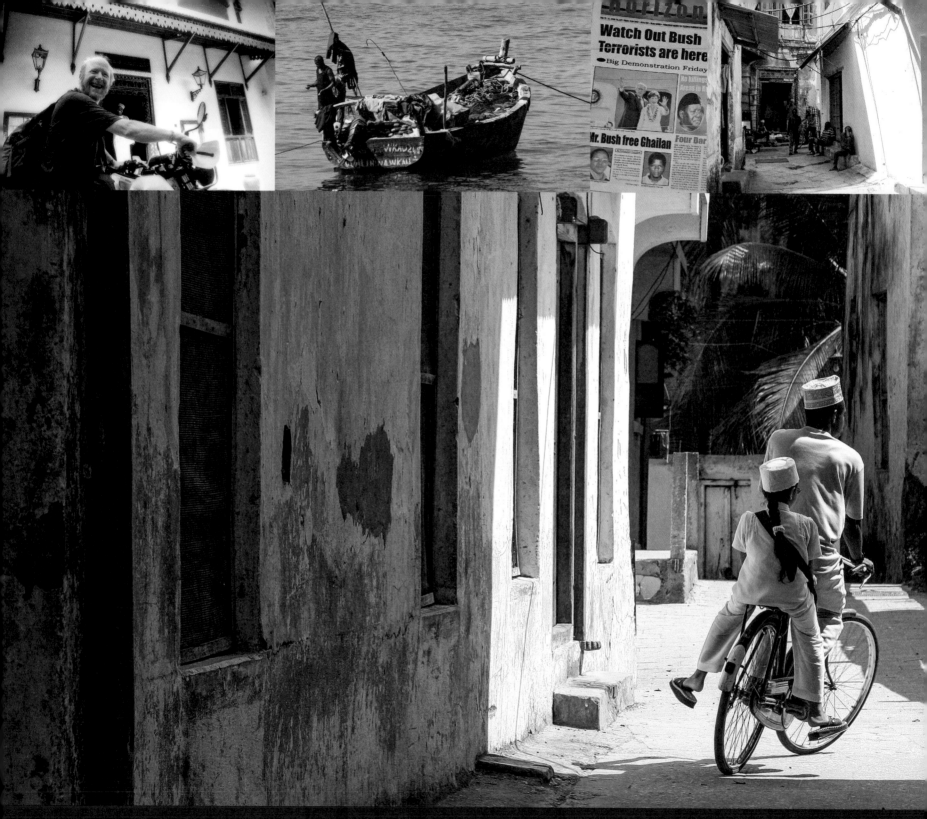

Watch Out Bush
Terrorists are here
●Big Demonstration Friday

Mr. Bush free Ghailan Four Dar

Zanzibar

Zanzibar's Stone Town, I rent a motorcycle so I can explore the rest of the island. Strapping only a backpack stuffed with a toothbrush, change of clothes, and a camera to the back of a small Honda XLR 250, I head north.

It takes only a few hours to ride from one end of the island to the other. I look for Nungwi, a small village at the very northern tip of the island, popular for young tourists looking to swim, snorkel, dive, drink, and party. As I get closer to town, I pass several dirt tracks heading west, identified only by crudely handwritten signposts in need of repair. The road ends and turns into a dirt-and-sand track. The town is dusty and sleepy. Local women with baskets, bananas, and buckets balanced precariously but confidently atop their heads crisscross the track while men ride on bicycles or pull handcarts filled with white sacks of corn, flour, and charcoal. Shacks of wood, bamboo, and corrugated metal serve as storefronts for soft drinks, snacks, and vouchers for airtime. I wonder where the tourists are.

I find them away from town, down those ill-marked sandy lanes, on the beach. After a few days of swimming, beach-combing, parties, and fresh seafood, I head southeast to the quieter side of Zanzibar. The coastal route takes me through coffee, maize, spice, and vegetable farms, through tiny villages and along dirt tracks.

I pass hundreds of young girls dressed in the traditional Muslim headscarves and boys tending cattle and goats. A boy high in a tree shakes the branches while several other boys under the tree catch avocados as they fall.

Suddenly, I hear what sounds like a gunshot from across the road. One of the boys darts faster than a cheetah into the forest, only to emerge a few moments later with a massive coconut that has just fallen. He clutches it proudly. It means money and food and more for the young twelve-year-old.

Near the southern tip of Zanzibar, while I am combing the beach of this small fishing village, a fisherman returning from the sea sells me his freshest catch. That night the owner of the hotel prepares it for me, basting it in coconut milk and grilling it to perfection. We share it with an avocado shrimp salad.

I will return to the mainland soon, but for now, I'm content to stay just a little longer, to taste and experience more of the real Zanzibar. ▬

I wandered the bazaars of Zanzibar for days. Though the scents and sights of the freshly butchered are best avoided by those with a weak stomach, for me these open-air markets, full of exotic fruits, fish, and meats, inspired not only my culinary imagination but also the lens of my camera.

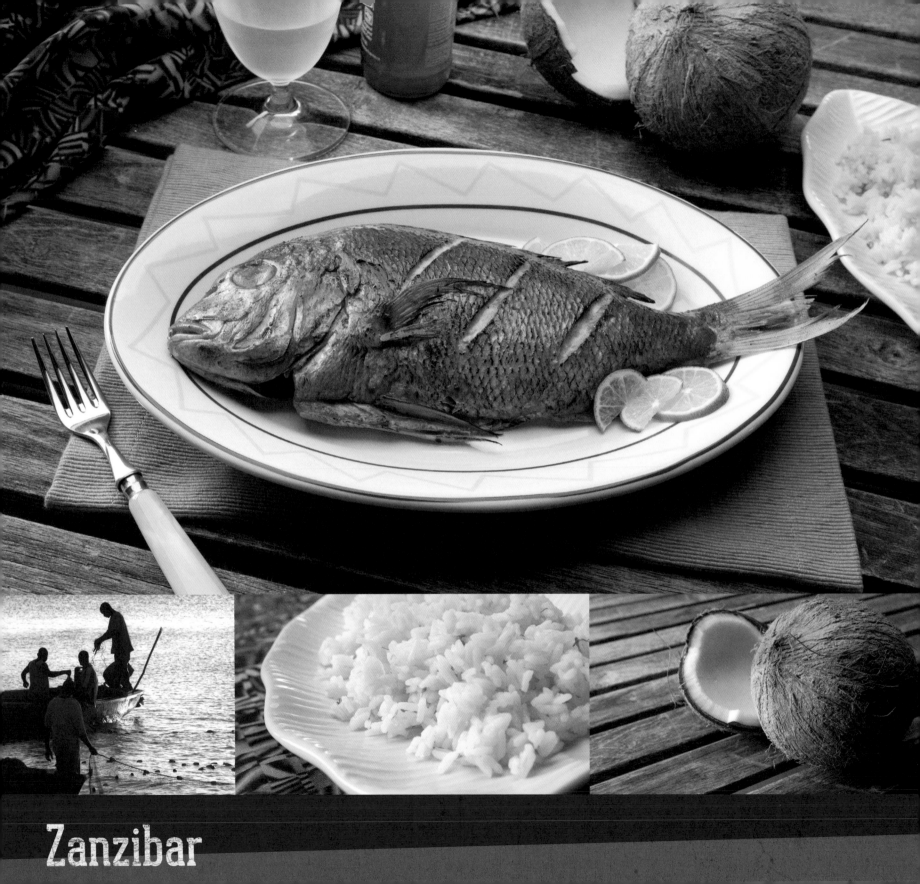

Zanzibar

Though Zanzibar is part of Tanzania today, the tiny island has been a hotbed of cultural invasion for hundreds of years. Sitting about fifty kilometers (thirty miles) off the mainland, for centuries Zanzibar was used as a trading base by Persians, Indians, Arabs, and Portuguese. The influence this left can be found in its people, architecture, and cuisine. The Indians brought curries and breads, the Arabs spices, and the Portuguese the practice of marinating meats and fish prior to cooking, all of which are represented in this classic Swahili dish from this small island.

Samaki Wa Kupaka

Grilled Whole Fish with Tamarind and Coconut Curry Sauce

Ingredients

1 whole fish such as red snapper, sea bass
or other firm white variety (2 to 3 pounds)

Coarse salt and freshly ground black pepper, to taste

2 tablespoons olive oil

8 garlic cloves, minced

2 jalapeño or green chile peppers, stemmed,
seeded, and minced

1 2-inch piece fresh ginger, peeled and minced

Juice of 2 limes

1 13.5-ounce can unsweetened coconut milk

¼ cup tamarind paste
(or 2 tablespoons tamarind concentrate)

½ teaspoon turmeric

½ teaspoon curry powder

½ teaspoon ground coriander

¼ teaspoon cayenne pepper

Grapeseed or olive oil, for brushing

Preparation

1. Place fish into a rectangular baking dish and cut 3 or 4 evenly spaced slits, about ¼" deep crosswise into each side of the fish. Season fish, skin and crevices with salt and pepper.

2. In a small bowl, combine olive oil, garlic, chiles, ginger, and lime juice and generously rub the mixture into the skin and crevices of the fish. Cover the dish with plastic wrap and refrigerate for at least one hour.

3. In a medium saucepan, heat the coconut milk over low heat and stir in the tamarind, turmeric, curry powder, coriander, and cayenne. Cook, stirring often, until tamarind is dissolved and the sauce slightly thickens. Remove pan from heat and set aside. Heat a charcoal or gas grill and brush a fish or grilling basket with oil.

4. Remove fish from refrigerator, place securely in basket, and brush with some of the tamarind coconut sauce. Cook fish, flipping every few minutes, basting each time with the tamarind coconut sauce until cooked through, about 15 minutes total. Transfer fish to a serving platter and serve immediately.

Whether you fresh-grind cumin and coriander seeds or grate newly harvested ginger root, the freshest ingredients are key to the true expression of flavor and culture in all the recipes on these pages. Search out and use the freshest, most authentic ingredients when you can; experiment when you can't.

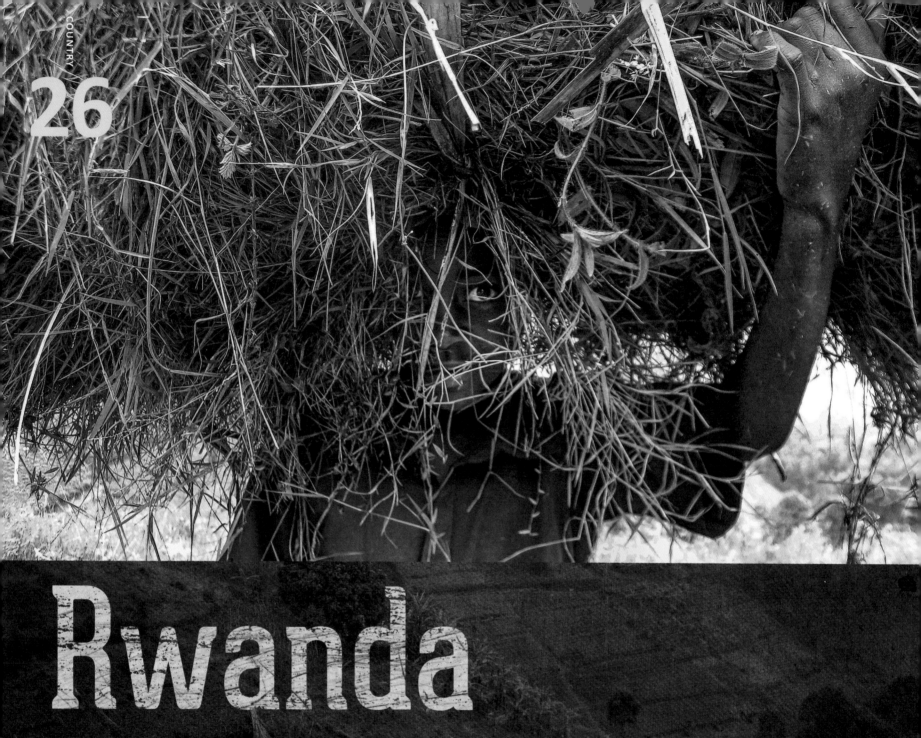

Rwanda

São Tomé Port Gentil CONGO

GABON DEM. REP. **Kigali** Lake Kisumu Chisim

OF CONGO Bukavu Victoria **Nairobi**

Brazzaville RWANDA Mwanza

BURUNDI

Bujumbura

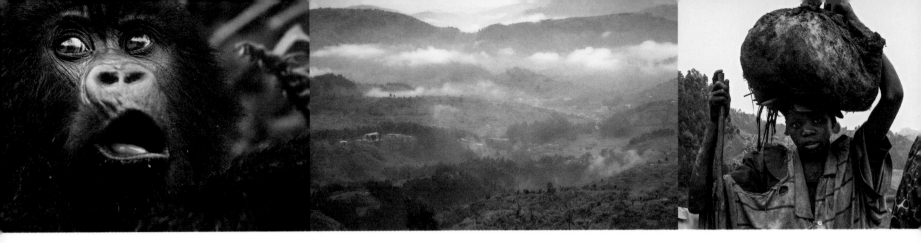

The Cleanest Country in Africa.

I cross the border into Rwanda with trepidation, but not because of the warnings of dangerous Congolese refugees hiding in the jungle or because I'd soon be forced to communicate in French, a language I continue to mutilate. Sure, I am pleased to once again ride on what we North Americans consider to be correct: the right side of the road. Even so, I can't escape thoughts of Rwanda's recent history. My shoulders tense, and I shift uneasily as I ride through the verdant, gently rolling hills of its southeastern border, toward the capital of Rwanda.

Still haunted by testimony from both victims and perpetrators of the brutal butchering of more than 800,000 innocent lives in just 100 days, I know murderers walk the streets. Cruising around Kigali, I probe people's eyes for guilt. Who is a Tutsi? A Hutu? Can I distinguish between them? Can anyone? I wonder what keeps the Tutsi from erupting in some primitive rage for revenge. And the Hutu, I wonder if they live with one eye looking over their shoulder.

Although the International Criminal Tribunal for Rwanda (ICTR) continues to pursue prosecution of the military leaders responsible for leading and inciting the genocide, the process has been slow and frustrating. For the more than 100,000 still imprisoned for war crimes and genocide, the Rwandan people draw on tradition to deal with the backlog clogging its courts and prisons. Throughout Rwanda, local villages are empowered to use precolonial methods to expedite process and bring justice. It's called *Gacaca*, which means "grass" in the local indigenous language, Kinyarwanda.

Size: 26,338 sq km (149th in world)

Population: 12 million (73rd in world)

Capital and largest city: Kigali (909,000)

Independence Day: 1 July 1962
(from Belgium-administered UN trusteeship)

World Heritage Sites: 0

Literacy rate: 71.1%

Currency: Rwandan franc

Population below poverty line: 44.9%

Key exports: coffee, tea, hides

Mobile phones: 4.4 million (112th in world)

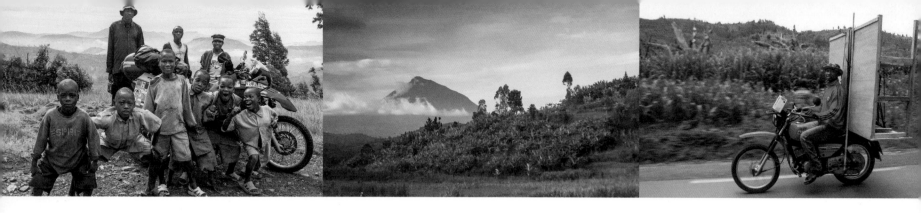

As I ride through small villages and settlements, it's not what I see that impresses me, it's what I don't: garbage. Landscaped yards, fresh paint on simple homes, and roadsides free of litter—Rwanda appears to be the cleanest country I've visited in Africa.

Opened on the tenth anniversary of the Rwandan Genocide, the Kigali Memorial Center was built on the site where more than a quarter million victims are buried. It serves as a memorial to the lives lost in April 2004 and as a permanent reminder of the ignorance that led to the senseless killings.

For hundreds of years the locals have settled disputes by simply sitting together on the grass. Today, the tradition continues as Rwandans sit outdoors under trees, the accused and the families of the victims facing each other as the *Gacaca* judge deliberates. The entire community takes part in the judicial process. The spirit of a *Gacaca* trial is to foster truth, reconciliation, and healing between victims and those perpetrators who confess and describe truthfully the crimes they committed. They then must ask the victims' families for forgiveness. Always emotional, often the process is surprising.

In one trial, a man explains in horrific detail how he killed a three-year-old girl and where he hid the body. He erupts in tears as the victim's mother bawls, shouting her daughter's name. The deafening screams last for more than ten minutes while neighbors console her, until she finally looks at the man and offers forgiveness. I'm stirred and uneasy and feel betrayed.

"Is this justice?" I think. As witness to these acts of forgiveness, I look inside myself and wonder, could I do the same?

Enok, the young man I met at a local restaurant, tells me his parents put him and his younger brother on a bus to a Ugandan refugee camp a few months before the genocide. They promised to meet them some months later. Enok never saw his mother and father again.

"You are the strongest person I've ever met, Mr. Allan," he tells me, referring to my solo motorcycle trip around the world. "You are so strong, Mr. Allan," he says, meaning "brave." In his eyes and gentle voice I sense hope and dreams. "I'm going to get my driving license next year," he tells me, proudly pumping his chest.

To be sure, I'm neither as strong nor as brave as Enok. Every day, he walks side by side with those who locked his parents in their home and burned them alive. Yet today he simply dreams of driving. Me? I imagine I'd be filled only with rage and bent on vengeance. Enok is the brave and strong man. And I've got a lot to learn.

From the grassland farms in the southeast, following gently rolling hills, I make my way northwest to where the jungle thickens, mountains loom, and cloud-shrouded volcanoes form a natural border to Rwanda's neighbor, the Democratic Republic of the Congo. As I ride through small villages and settlements, it's not what I see that impresses me, it's what I don't: garbage. Landscaped yards, fresh paint on simple homes, and roadsides free of litter— Rwanda appears to be the cleanest country I've visited in Africa.

It's no wonder Rwanda is so clean. There are no nasty plastic shopping bags clogging drains or stuck in tree branches. They're outlawed. And the cleanliness and order is the result of another

Rwanda

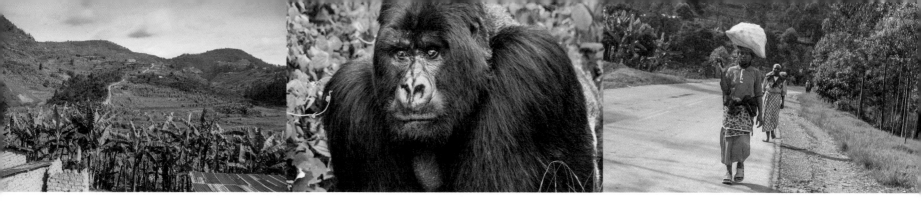

precolonial tradition now mandated by law. Called *Umuganda*, it is translated as "contributor." Every citizen over eighteen years of age is required on the last Saturday of each month to contribute to the local community. Those without specific skills usually help by cleaning streets, clearing bushes on roads, planting trees, cutting grass, and cleaning up trash. Businessmen offer free classes on entrepreneurism, accounting, or financial management, while doctors and lawyers offer free medical care and legal advice.

Maybe this is helping a post-genocide Rwanda prosper. Dozens of large cranes dot the skyline of the capital, and truckloads of electronics, agricultural supplies, and construction materials cram the crowded streets. At lunchtime the aromas of roadside vendors barbecuing goat meat are stronger than the pungent fumes of the diesel trucks. Rwandans of all ages, Hutu and Tutsi alike, gather side by side, slipping skewer after skewer of the tender meat into their mouths.

However, it isn't until I retreat to the quiet mist of the jungle—in the shadows of smoking volcanoes—that I observe a feast among altogether different beasts. Intense rays of the sun shine on their dew-matted fur, making it glisten, if not glow. I can hear breaking branches, followed by a persistent gnawing and gnashing on bamboo shoots. I'm just a few feet away from a family of beautiful, massive mountain gorillas. I stare in awe as our eyes meet. They pause, look deep into mine, and then, unbothered, continue to eat. Breakfast in the jungle. How wonderful it is to watch and hear their enjoyment of food. ▮R▮

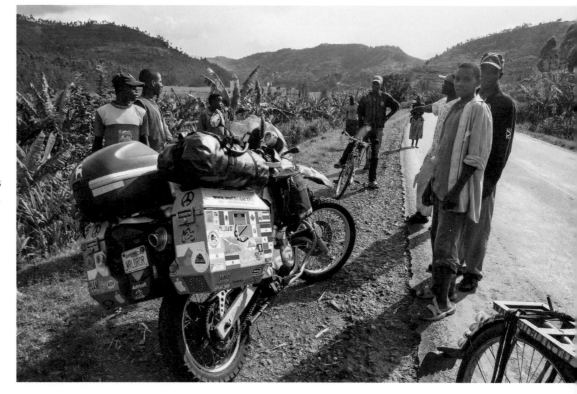

While I appreciated finally having the freedom to drive on the right side of the road, even this familiarity didn't prepare me for Rwanda's common language: French. Crowds gathered anytime I stopped to take a photo or break, but, while I yearned to communicate, my French needed polishing.

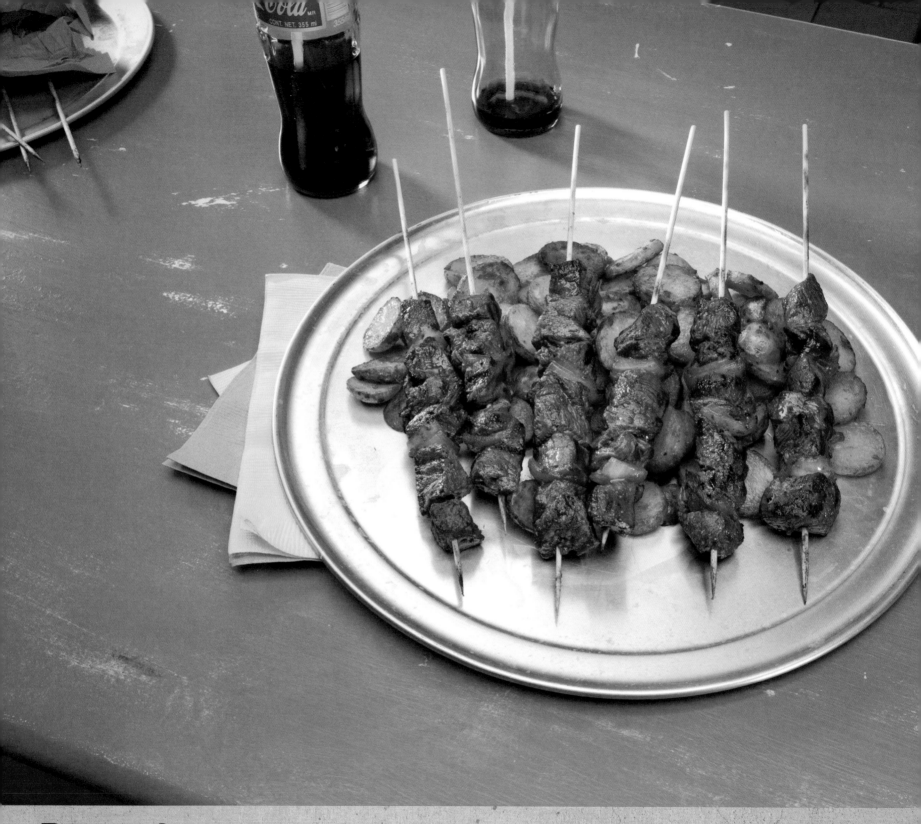

Rwanda

Wandering the streets of Kigali, Rwanda's capital city, in its mayhem and madness of noisy traffic, crowded streets, and hawking vendors, it's easy to find refuge under a faded and torn umbrella in a plastic chair just a few steps from a red-hot grill where dozens of these brochettes sizzle. Perhaps it's not the culinary hotbed of Africa, but Rwandans proudly devour their brochettes. The ad hoc street restaurants throughout the city are famous for grilling: potatoes, plantains, carrots, meat, and almost everything else. The hustle and bustle of the city fades as, with growling stomach, I stuff myself from a fresh plateful of these simple and slightly spicy yet delicious brochettes and potatoes. And yes, the beer is mandatory.

Street Grilled Brochettes with Sautéed Potatoes

Ingredients

Grilling Sauce

4 fresh Roma tomatoes, finely chopped

¼ cup onion, finely chopped

½ cup tomato puree

2 teaspoons salt

1 tablespoon white wine vinegar

4 cloves garlic, minced

¼ teaspoon cayenne pepper

1 tablespoon fresh lemon juice

2 fresh red hot chile peppers, seeded and finely chopped (traditionally *pili-pili* in Rwanda)

1 tablespoon olive oil

¼ cup grapeseed or canola oil

Water for thinning

Brochettes

1 pound beef, poultry, or fish, cut into ½-inch cubes (traditionally goat is used, but beef, pork, chicken, or even tilapia fish is fine here)

1 large onion, cut into large chunks

6 long wooden skewers, soaked in water for 20 minutes

10 to 12 baby white or red new potatoes, cut into ½-inch slices

Preparation

1. Make the grilling sauce by combining all the ingredients except the oil and water in a bowl or food processor and mix or pulse to combine. Add 1 tablespoon of the olive oil and slowly add enough water until the ingredients form a medium-thick sauce.

2. To make the brochettes, alternate threading a piece of meat and 2 or 3 pieces of the onion onto the skewer until filled.

3. Place the brochettes on the grill over medium heat and brush them liberally with some of the oil while they cook and continuously slather the brochettes with the grilling sauce while they cook for about 2 minutes. Turn them over and continue to brush with the sauce for another 2 minutes. Coat the brochettes with some of the remaining oil and grill for 1 more minute before transferring to a clean platter.

4. Make the potatoes by heating the grapeseed or canola oil in a sauté pan over medium-high heat. Fry the potatoes on both sides until light brown and crispy, about 15 minutes. Drain oil from pan, sprinkle potatoes with salt, and brush with some of the grilling sauce. Reduce heat and allow to simmer for 3 to 5 minutes until fork tender.

5. Serve hot on a plate with the brochettes piled on top and the extra grilling sauce on the side.

Rwandans also love potatoes which were first introduced to Rwanda by the Germans in the late 1800's. They are served with most meals in Rwanda. Sometimes fried, boiled or roasted, my favorites were sautéed with the same grilling sauce used on the brochettes.

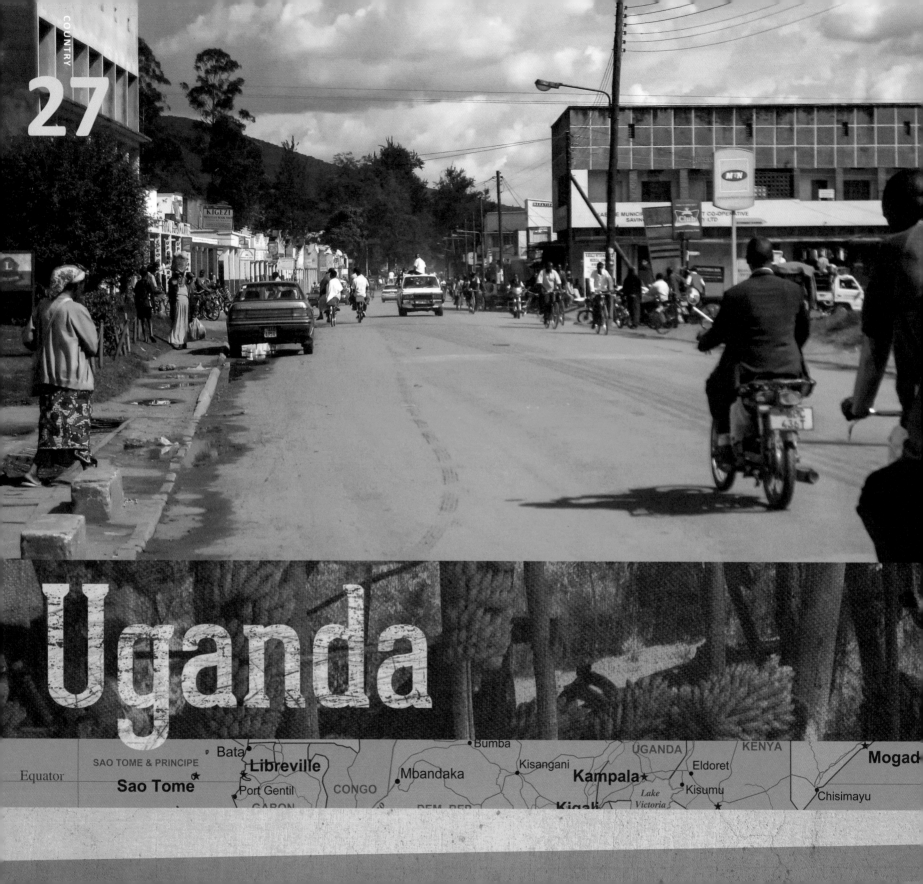

Uganda

Equator

SAO TOME & PRINCIPE

Sao Tome

Bata

Libreville

Port Gentil

CONGO

GABON

Mbandaka

Bumba

Kisangani

DEM. REP.

UGANDA

Kampala

Kigali

Lake
Victoria

KENYA

Eldoret

Kisumu

Mogad

Chisimayu

Where Hope Kindles in the Hearts of the Young. The border

post between Rwanda and Uganda consists of a few brick buildings with corrugated metal roofs. Several women in long, brightly colored skirts sit on the curb outside the immigration building, while a long line of men, many wearing soccer jerseys and carrying worn backpacks, wait by a small window. A huge dust cloud from departing buses obscures the fading paint on the informational signs, making them difficult to read.

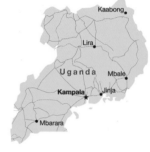

There are no questions as to the business of several large cargo trucks waiting at the border—huge stenciled letters on the cargo doors read UN. The drivers huddle together, creating chaos and upsetting the line. Waving papers in the air and pushing the line forward, they yell so loudly in Swahili that it sounds like they are arguing. Like me, however, they simply want to be cleared by customs and get back on the road.

When it's my turn, I think at first that the inquisitive customs officers are eager to inspect my motorcycle, but to the frustration of others waiting, they just want to sit on it and ask questions.

"How fast you go?" asks the youngest as he hobbles on his knees to get a good look at the engine. "I think you have problem," he says, pointing to oil stains on my rear wheel. I had just lubed the chain some 50 miles back. Not only does the oil fly off, but I always seem to overspray onto the rear wheel. Just maintaining the motorcycle on my journey keeps me busy enough. Cleaning, shining, or polishing my bike would be a waste of time. The next muddy road, rain storm, or dusty byway is surely just a few miles up the road. Besides, a clean and sparkling bike is more appealing to acquisitive eyes than one dirty and covered in mud.

Size: 241,038 sq km (81st in world)

Population: 34.8 million (36th in world)

Capital and largest city: Kampala (1.5 million)

Independence Day: 9 October 1962 (from the UK)

World Heritage Sites: 3

Literacy rate: 66.8%

Currency: Ugandan shilling

Population below poverty line: 24.5%

Key exports: coffee, fish and fish products, tea, cotton, flowers, horticultural products

Mobile phones: 16.7 million (52nd in world)

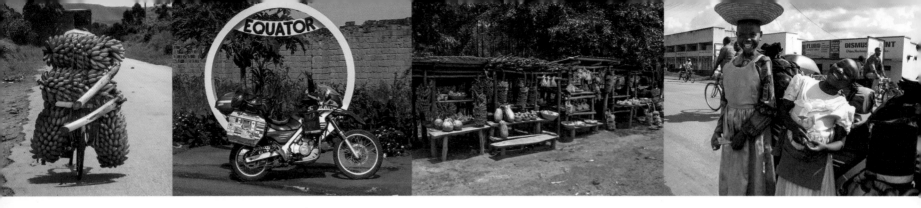

The older officer pulls a couple of bananas out of his pocket, which we devour while talking about African politics. Then, with my paperwork in order, it is time to bid my new uniformed friends goodbye.

For me, perhaps the toughest part of traveling is the goodbyes. Nearly every time I stop, I make new friends. These fleeting relationships never have a chance to evolve. There's no time. Maybe it's the travelers curse, but we must move on. Inside me, though, there's a longing and sense of wonder tugging at me to stay. How much more could I learn, from them and about them?

It's the generosity and sensibility of those locals who slip in and out of my life that thrill me most. Like the two young girls I meet while pulling some Ugandan shillings from the shiny ATM machine in dusty Kabale near the southernmost border. After fending off the usual cadre of street vendors who hawk everything from newspapers, prepaid phone cards, and socks, these two girls, each with a carefully balanced and delicately woven basket filled with fruit atop their heads, approach me. Something about their smiles hints that their motive is inquisitive rather than monetary.

The less shy of the two breaks the ice, asking, "Where are you from?"

"Far, far, away," I tease, "in the United States." Her head is neatly shaved, and beads of sweat make it glisten in the late afternoon sun. So young and innocent, they are barely ten years old.

From South America to Eastern Europe, Africa and the Middle East, seeing more than two people riding a motorcycle always amazes me. I was afraid this sputtering moped or scooter would tire and leave its passengers stranded in the Ugandan countryside.

"Where are you going?" asks the other girl, her eyes white and wide. I am impressed. Both speak with a confident command of English.

"Lake Bunyoni," I answer, pointing westerly.

"We know where that is, of course," she says, her hands on hips, insisting I don't need to point.

"You speak English very well," I reply, showing I am impressed.

We chat about their families, their fruit-selling business, and homework. In the mornings they study English in school. In the afternoons, to pay for books, they sell fruit to locals. Not many tourists pass through here.

"I'm going to be a lawyer," the first girl proudly asserts.

"And I'm going to be president," the other announces.

I look around the grubby town. Beggars roam the streets, which are riddled with piles of rubble from fallen buildings, rebar from abandoned construction projects, and potholes the size of cows. A sooty layer of dust and dirt kicked up by passing trucks coats everything. But these girls are remarkable. In two years of traveling, I've never met young people with so much hope and dreams.

Most children raised in small third-world villages are often lucky enough to travel only to the border of their town. Like their mothers and fathers, they will marry, raise children, and live and

Uganda

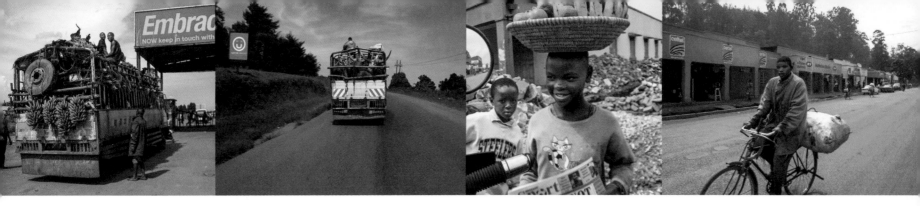

From the southern part of the country to the north and across the equator, everywhere I travel I spot bananas. Tens of thousands of them—full branches hung in roadside shops, bicyclists carrying bunches bigger than their bikes, trucks so overloaded with bananas that they break down under the weight.

work in the same town their entire lives. Yet here in tiny Kabale, Uganda, two girls barely ten years old dream of a brighter future: a lawyer and a president. They strike a resounding chord in my heart. I want to lean over and hug them.

I grab a couple of pieces of fruit from each of their baskets and hand them enough shillings to replenish their inventory for days. "You keep the change and buy books for school," I demand. The inevitable time to say goodbye arrives. "And I'll be back to check up on you, Miss President." They giggle and thank me.

Farther down the street an elderly woman holds out her hand, and as I approach, points to her mouth. I hand her the fruit and make my way to Lake Bunyoni.

The more I travel in tropical and equatorial Uganda, the more I realize how much of the local economy relies on fruit—especially bananas. From the southern part of the country to the north and across the equator, everywhere I travel I spot bananas. Tens

of thousands of them—full branches hung in roadside shops, bicyclists carrying bunches bigger than their bikes, trucks so overloaded with bananas that they break down under the weight. I even spot boys climbing high in the trees, cutting and dropping branches to the ground.

It's no wonder that bananas quench my appetite nearly every day I stay in Uganda. Every time I sit down to eat, breakfast, lunch, and dinner, I am served bananas—fresh or fried. But for dinner? Sure, fried bananas and plantains are a staple of every meal in the tropics. But fresh bananas integrated into a hot dish? Absolutely. When I first dig my spoon into a steaming pot of goat curry with bananas, flavors I've known apart now come together, revealing a new world of taste.

I look down at the Nile River raging below and ask for a second helping. ▬

In the bigger cities of Uganda and elsewhere in Africa, I found the tabloid newspaper headlines entertaining and offering insight into the politics, fears, dreams and hopes of potentially thriving African nations.

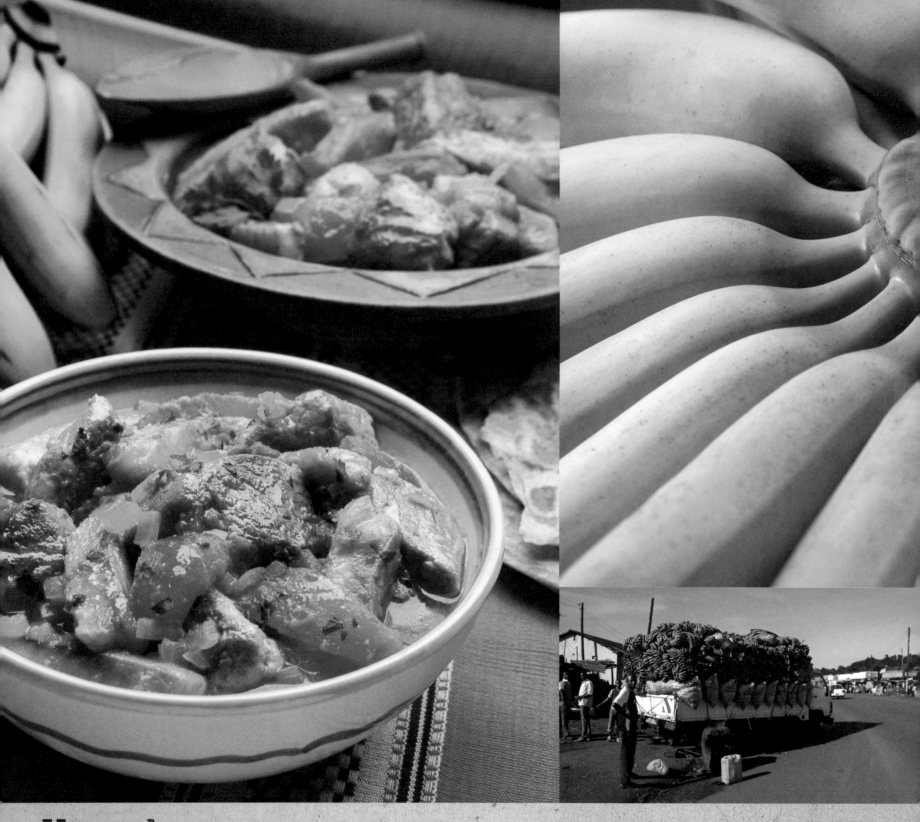

Uganda

I've never seen as many bananas as I saw while traveling through Uganda. They are at stands all along the road, on bicycles, and piled high on trucks, being perhaps the most important crop in Uganda. When I think of bananas, I think of breakfast, dessert, or smoothies. Sitting outside my tent on the banks of the Nile River, I was treated to a dinner of this incredibly new (for me) taste sensation—bananas in a hot curry dish. Though it was then served with lean goat meat, I discovered this recipe works even better with veal. It's often served with leafy greens or other vegetables. I've included a simple cabbage recipe for you to try with this recipe. Experiment and taste the flavors of Uganda by enjoying this simple-to-make traditional dish.

Ugandan Veal Curry with Bananas

Ingredients

Veal Curry

4 tablespoons unsalted butter

1 large onion, finely chopped

1½ tablespoons curry powder

½ teaspoon cumin

2 teaspoons salt

½ teaspoon freshly ground black pepper

1 teaspoon grated fresh ginger

2 pounds veal shoulder chops, cut into 1¼-inch cubes

4 large tomatoes, cut into small wedges

1 cup of water

2 bananas, peeled and cut into 2-inch pieces

Cabbage

1 head Savoy cabbage, quartered, cored, leaves separated and torn into large pieces

1 tablespoon white wine vinegar or white wine

2 tablespoons unsalted butter

2 tablespoons olive oil

Preparation

1. To make the curry, melt the butter in a large heavy bottomed pot over medium-high heat. Then add the onions, curry powder, cumin, 1 teaspoon salt, 1/4 teaspoon pepper, ginger, and veal. Cook over medium heat until the veal is browned, about 10 minutes. Add the tomatoes and water, and simmer for 45 minutes or until veal is tender and cooked to desired doneness.

2. Carefully stir in the bananas and simmer for 10 to 15 minutes longer.

3. Prepare the cabbage by bringing a large pot of salted water to boil over high heat. Add the vinegar or white wine and the cabbage. Cook the cabbage in the boiling liquid until just wilted, 2 to 3 minutes.

4. Drain well and toss in a bowl with the butter and olive oil. Season with salt and pepper to taste. Serve the curry in a shallow bowl over steamed rice, with the cabbage on a separate plate.

From the moment I crossed the border in Uganda, I was reminded of the importance of bananas to this equatorial nation. Perhaps the banana entrepreneurs are too ambitious, overloading their vehicles to the point of failure. But in the food? Bananas shine.

Kenya

OF CONGO

Kampala ★

Kisumu

Congo R

Lake Victoria

Nairobi ★

Chisimayu

Fears, Flags, and New Friends.

A dozen or more Kenyans swarm around me and my motorcycle. I'm not concerned; their smiles are genuine and eyes welcoming. Most are fascinated by the GPS unit mounted to my handlebars. Another rubs his huge thumb over the broken casing of my cracked side-view mirror.

Concerned, he asks, "What happen here?" I tell him of my accident in Tanzania. He shakes his head. "Pikipiki very dangerous," he says, using the Swahili word for motorcycle. The others marvel at all the stickers of country flags that adorn my aluminum panniers, pointing at them and asking, "Where from?" I should be moving on, but I'm impressed, even warmed by their curiosity.

"How come you no have flag of Kenya?" one of the older men asks me. I arrived in Kenya just yesterday and have tended to priorities other than searching for stickers. "I go get you now, one flag," the man says, "you wait." He darts away.

Fuel stops can be entertaining, for both the locals and for me. I'm shocked to think that just a month ago some of these men surrounding me likely participated in brutal and violent ethnic protests that destroyed public and personal property and left hundreds dead.

The December 2007 elections were a setback not only for Kenya but for eastern Africa. For the most part Kenya had been a model of the new and modern Africa: big business, bustling tourism, millions in aid money, a growing economy, and many years of democratic multiparty elections. This year exit polls showed that an opposition candidate, Raila Odinga, had won the presidential election by a significant margin. Yet the incumbent president, Mwai Kibaki, was declared the winner and sworn into office. The opposition cried foul play and took to the streets and the countryside in violent protests targeted against Kikuyu people, the tribe of which Kibaki is a member.

Although I wait politely for my new friend and a Kenyan flag sticker, I ease into questions about the violence in this area.

"Do I have to worry about violence?" I ask one of the men.

Size: 580,367 sq km (49th in world)

Population: 44 million (31st in world)

Capital and largest city: Nairobi (3.4 million)

Independence Day: 12 December 1963 (from the UK)

World Heritage Sites: 6

Literacy rate: 87.4%

Currency: Kenyan shilling

Population below poverty line: 50%

Key exports: tea, horticultural products, coffee, petroleum products, fish

Mobile phones: 28 million (36th in the world)

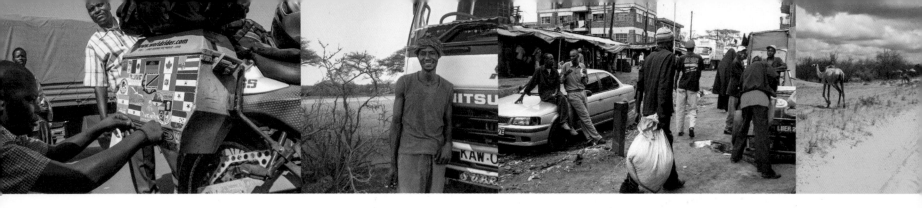

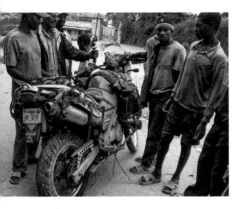

"Why don't you clean dis bike, Mr. Allan?"
I heard this question often after riding the dusty
or muddy back roads of many African countries.
While a clean bike makes it easier to identify
potential mechanical problems, I was less
interested in a keeping a shiny motorcycle
than making new friends.

"You won't have a problem," he replies. Others, nodding, assure the same.

"There's no problem—for today," he continues.

"Does that mean there might be a problem—tomorrow?" I wonder.

"If the government doesn't keep its promise, maybe."

I ask if he would take to the streets if there is more violence.

"If I'm angry I will."

"Did the elections make you angry?"

"I was very angry. Very angry." Several others nod their heads, mumbling sounds of agreement.

The violence was barbaric, tribal, and divided between ethnic groups. Businesses and homes were looted, young girls raped, men stoned and hacked to death on the roads, and bridges destroyed. All told, some 1,300 were killed and more than 200,000 displaced from their homes. Today I'm riding through the wake of it.

"You must have Kenya flag, Mr. Allan." The proud man returns with a sticker of the flag, which features a tribal shield with two spears on top of three thick horizontal stripes—black, red, and green—separated by two thin, white lines. Black represents the majority of the population, green stands for the land, and red for the bloodshed spilled in Kenya's fight for freedom.

"Please, you shall find the best place to put your flag on my bike," I request. He jokingly starts to place it atop the Uganda flag, but finds a clear spot on my panniers, now covered with more than thirty different flags.

On my way to Nairobi I pass through Kisumu, where I see the burned and charred remains of businesses, homes, and even a hospital.

I continue to struggle with the thought that my friendly flag man and the others would have the capacity or will to destroy the community in which they live.

The road to Nakuru in the Rift Valley is a hellish minefield of potholes, until I climb up the eastern escarpment, where the road gets better and the landscape gets greener, I pass Lake Nakuru and ascend to more than 3,000 meters (10,000 feet). The wind is strong, whipping me all over the road.

As the sun makes its slow descent, the lake is like a mirror, shimmering orange and gold in the valley below. Sloping hills, like waves over a misty ocean, roll gently to the horizon, but even the beauty of this placid scene can't take my mind off what I have seen.

The violence has frightened away tourists, leaving hotels and lodges vacant and hurting for business. Yet the traffic in Nairobi is still nauseating. To reset my bearings and take a break from traffic, I stop in the center of town at The Stanley, the oldest and first luxury hotel in the city, where the hotel manager invites me to

Kenya

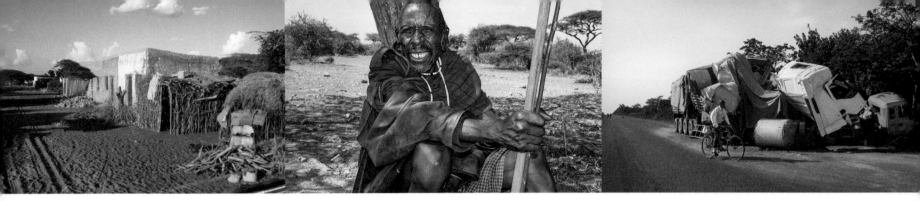

stay at a discount. I'm happy to be in a luxury hotel, likely the last of any modern amenities I'll enjoy until I get to Cairo.

Nairobi is the biggest city I've visited since South Africa; a good place to take care of business. I restock supplies, service my motorcycle, and try to secure visas for Ethiopia and Sudan. Ethiopia is no problem, but the Sudanese Embassy tells me no and to try again in Ethiopia.

I befriend a taxi driver who takes me deep into the slums. We wander the rocky streets, where sacks of coffee, sugar, lime, shoes, fruit, and clothing block traffic and sidewalks. In the alleys between shabby storefront shacks, where aromas of fresh coffee and curried chicken and vegetables delight, I see trash spewed about and smell urine.

This area of Nairobi is home to refugees from Somalia, Ethiopia, Eritrea, the Congo, and elsewhere in Africa. Oddly, for some these slums represent a safe haven and a place to do business. For others it's a better way of life outside the impoverished, food-starved villages of faraway lands.

Days later, on my way to Ethiopia, I pass through desolate and faraway villages. I travel close to the Somali border. The countryside is dry and void and feels as if I'm lost in no man's land.

A truck driver, Abdulah, friendly, tall, and lanky, helps get me on the right track toward Ethiopia. Life moves slowly out here. There are more goats than people, and boys lead dozens of donkeys carrying large yellow containers full with water. For the first time in my life I see a camel outside of a zoo. Along the way, I notice a few cellular phone antenna towers, but no sign of electricity.

In Shantabak, a village not on any map, Abullah leads me into a dark, shaded structure. It is round and made of thatch and dried mud. We sit on tattered fabric covering the dirt floor. A young woman carrying a pitcher of water and a shallow bucket approaches me. She pours water over my hands as I rub them together, washing them, catching the water as it falls into the bucket. It's meal time. Here there are no forks: everyone eats with their hands. Half a dozen men sit on the floor to eat with me. We nod at each other, smile.

The woman sets down several plates in front of us. The boiled goat meat with potatoes, seasoned perfectly, is tender and flavorful and served with rice and chapati, a delicious African flatbread I tear into pieces to scoop up the food and rice. It's so damn tasty, I want to stuff my panniers full of chapati. But there's none left over; it's freshly made for each meal.

Back on the road with a full stomach, I continue the journey to Ethiopia, past more goats, donkeys, and camels. I'm already looking forward to the next chance meeting, the next chance to break bread with new friends.

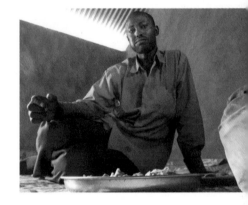

My friend Abdullah shared lunch with me in Shantabak. Lacking chairs, tables, and utensils, this tiny restaurant/home not far from the border of Somalia might have scared other tourists, but to me the boiled goat, potatoes, and chapati bread they served was a highlight of my travels through Kenya.

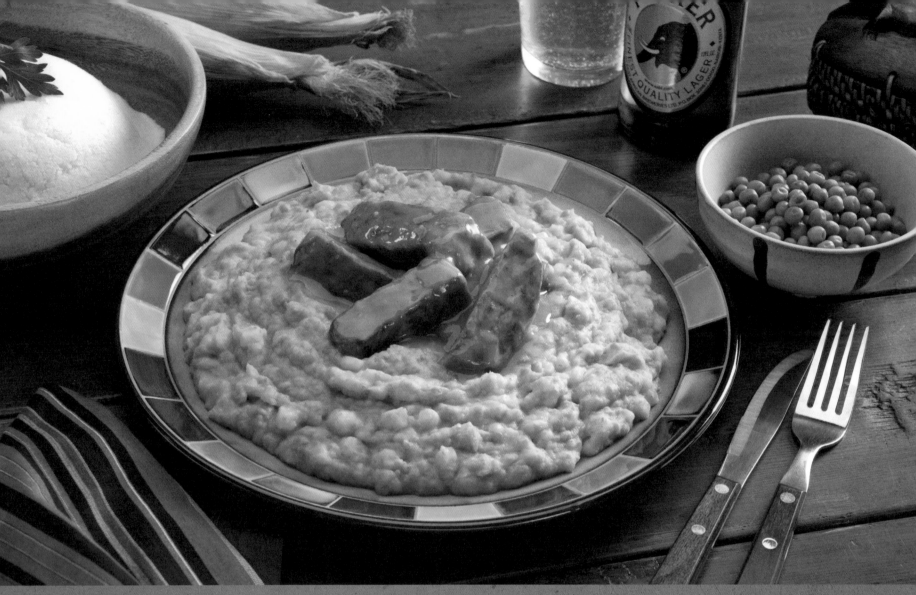

Kenya

I love this hearty dish of steak and irio (mashed potatoes smashed with peas and corn). The rich green color of the potatoes reminds me of the Kenyan flag and of the local people, who eat irio as part of most meals. Here the steak juices make for a flavorful roux that brings this meal together. A group of truck drivers offered me my first taste of nyama na irio when I stopped to ask for directions—a hearty meal that will please anyone who can't refuse a little meat and potatoes now and then.

Nyama Na Irio
Filet Mignon with Potatoes Smashed with Peas and Corn

Ingredients

6 to 7 medium potatoes, russet or white, peeled and cut into 2-inch cubes

2 cups frozen green peas

2 cups corn, preferably fresh off the cob or frozen

5 tablespoons unsalted butter

Salt and freshly ground pepper to taste

1 large onion, cut into ¼-inch thick rings

Cayenne pepper to taste

1 tablespoon white wine vinegar

1 beef bouillon cube

4 cups of boiling water

3 tablespoons olive oil

4 filet mignon steaks (8 to 12 ounces each), about ¾-inch thick

¼ cup all-purpose flour

Dash Worcestershire sauce

½ cup chopped parsley and a few sprigs for garnish

Preparation

1. Place potatoes in a large saucepan and add water to cover. Add a pinch of salt and place over medium-high heat. Bring to a boil, reduce to a simmer, and cook potatoes until almost fork tender, 20 to 25 minutes. Add peas and continue to simmer until potatoes are cooked through and peas are tender, about 10 minutes more. Drain and set aside, reserving the liquid.

2. Meanwhile, in a separate saucepan over medium heat, heat a cup of water with a dash of salt, add the corn, and simmer for a few minutes until tender.

3. Add 3 tablespoons of butter to the still warm potatoes and peas and using a potato masher, blend together to form a pale green slightly chunky mash. Stir in the corn with a little of the warm reserved liquid and season to taste with salt and pepper. Keep warm.

4. In a medium skillet, melt one tablespoon of butter over medium heat and sauté the onions until they begin to brown, about 5 minutes. Add salt and pepper, cayenne to taste, and stir in the vinegar. Crumble the bouillon cube into the pan and add the boiling water. Simmer, stirring occasionally, until the liquid reduces by half, about 15 minutes. With a slotted spoon, remove the onions and puree in a blender or food processor. Return to the sauce and continue to simmer until thickened. Set aside.

5. Season steaks with salt and pepper, heat the olive oil in another skillet over medium-high heat, add steaks, and cook on each side for 3 to 4 minutes for medium rare or to desired doneness. Remove from pan to a cutting board and let rest. Cut steaks into strips, 2 to 3 inches long.

6. Add the remaining tablespoon of butter to the skillet and melt and mix with the steak juices. Stir in a little of the flour, using a whisk or wooden spoon. Sauté over low heat for about a minute while stirring in more flour, enough to make a thick paste or roux. Add the onion sauce from the other skillet and season with salt and pepper and the Worcestershire sauce. While continuously stirring, bring sauce to boil. Add the sliced steak and simmer for 2 to 3 minutes.

7. On heated plates, scoop and spread a generous portion of the potato, pea and corn mash, making a cavity in the middle. Pour steak and sauce into the cavity and drizzle all over with extra sauce to taste. Top with the chopped parsley and garnish with the sprigs before serving.

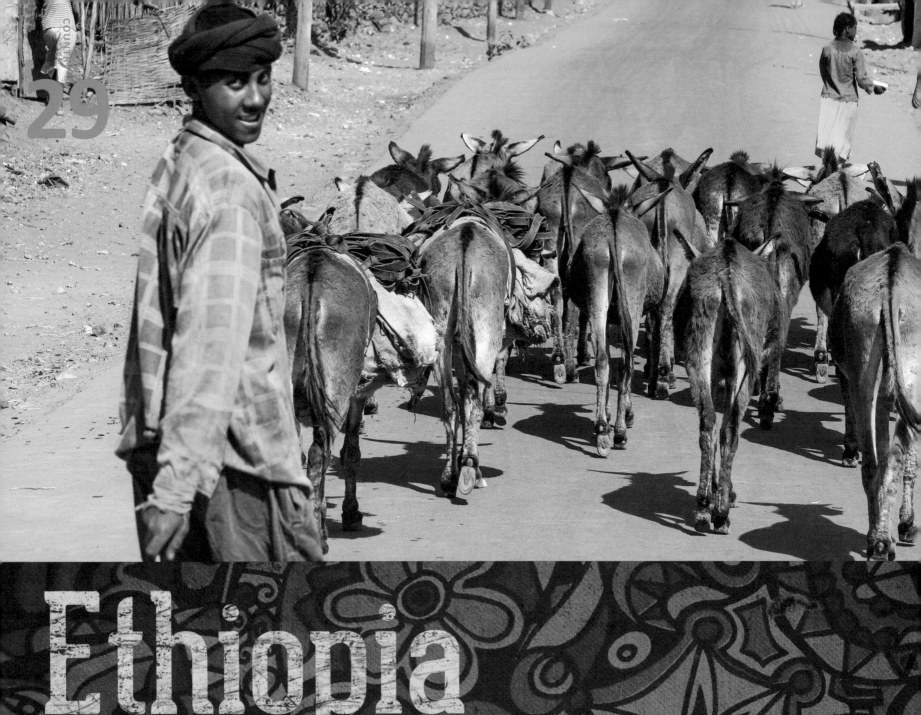

Ethiopia

SUDAN

Dire
Dawa

Berbera

Addis Abbaba

Hargeysa

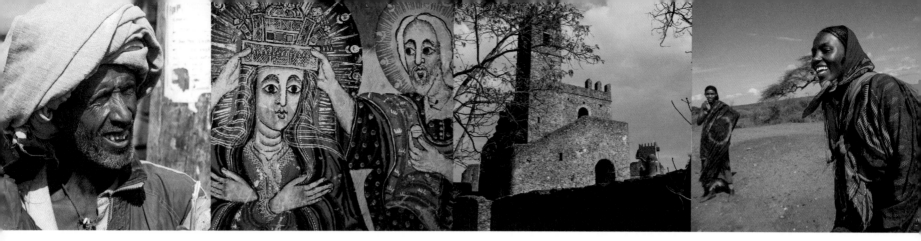

Forever Seduced.

Ethiopia has a unique flavor that is pure, raw, and real, a vibe I've not experienced elsewhere in Africa. I search to understand why and conclude it must be because this country, though occupied briefly by Italian forces during the Second World War, was never really colonized, arguably the only country in Africa that has avoided western imperialism. The country surprises me every day, seducing me with its beauty, its cultural diversity, and the warm affection of its people.

Although Ethiopia has the slowest Internet I've used since the highlands of Peru, that's okay, because it's more fun lingering with the locals than fighting with e-mail or my blog.

Several attractive girls pitch me on a product that is guaranteed to cure all that might ail me and to provide me with good luck and millions of dollars in income. Multilevel marketing, it seems, has made it to this remote Ethiopian outpost.

Over a tasting of local food, including spicy lentils, cabbage, and fiyyel wat (goat stew), complete with the ubiquitous spongy injera, I have a chance to try two different Ethiopian wines and the local brew. The family who run this modest restaurant sprawl a tattered map across the dining table, and we chat about my plans to explore their country.

I head north to Awasa, a city on the shores of Lake Awasa in southern Ethiopia. Along the way, I stop several times to meet the locals, including a twelve-year old girl tending to hundreds of goats. For many miles along the side of the road I notice a deep trench.

Between stretches of arid desert, the narrow road I'm riding passes through dozens of small villages where there are few cars and plenty of locals, a dense mass of humanity, hundreds of people ten to thirty deep, crushed against each other. It takes concentration and patience to navigate through these villages. People, donkeys, goats, and cattle move in chaotic rhythm, blind to motorized traffic.

Size: 1,104,300 sq km (27th in world)

Population: 93.9 million (13th in world)

Capital and largest city: Addis Ababa (2.86 million)

Independence Day: 28 May, 1991 (defeat of Mengistu regime, however it has been independent from colonial power for over 2,000 years)

World Heritage Sites: 9

Literacy rate: 42.7%

Currency: Ethiopian birr

Population below poverty line: 29.2%

Key exports: coffee, khat, leather products, livestock, oilseeds

Mobile phones: 14.1 million (56th in world)

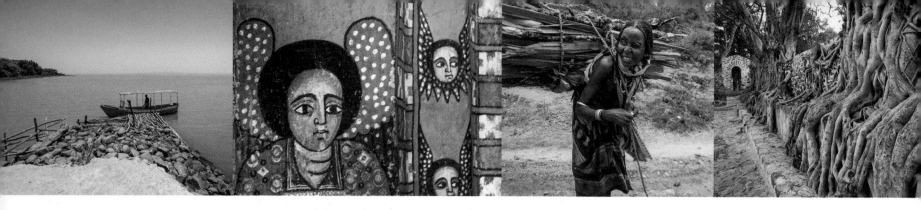

By the time I found a resting place beside Lake Awasa—over two years since leaving California—I had traveled 50,000 miles. Eager to connect with the beautiful women of Ethiopia and to learn their melodic but difficult language, I asked them to document the milestone with Amharic numerals in my journal. They did it happily.

For miles, women carry large and heavy brown belly-shaped ceramic containers tied to their backs. Men push makeshift wheelbarrows, more like carts with no sides: just a flat board atop a tiny steel wheel, usually loaded with fruit, vegetables, or heavy bricks and bags of concrete—hard work.

In one of the crowded towns a huge bus tries to avoid the crush and moves into my lane, forcing me to the edge of the pavement. I throttle down, trying to squeeze through, but there are people and donkeys packed with water, firewood, and clothing. Before I see it, a lone donkey with an empty load trots beside my bike. Its harness smacks into the right grip of my handlebars, shoving it left. I am going so slow it's hard to balance and there's no room to speed up. My bike is pushed into the side of the bus. I crash and slam down onto the pavement.

"Damn donkeys," I think, "You gotta love them—always there when you don't need one."

I admit that I'm smitten by the beauty and eyes of Ethiopian women, especially those working in the kitchen at my guest house. They happily cook me a special meal and help celebrate a significant milestone of my journey. Coming into Awasa I logged my 50,000th mile (80,500 kilometers) since setting off on my journey.

In Addis Ababa, or simply Addis as it's referred to by the locals, I must convince the Sudanese embassy to grant me permission to enter Sudan. I've yet to meet an American who has succeeded in getting a Sudanese visa. I'm taking a big risk. If I fail, I'll be stuck here or forced to turn around.

Because Addis is a maze of one-way streets and a patchwork of contrasting neighborhoods, I opt to travel the city by taxi. Armed with a complete itinerary of Embassy visits, museum probing, market hopping, and people watching, I connect with Debebe Assefa. Neatly dressed and well-groomed, he is proud of his mid-1980s blue-and-white-roofed, 1200cc, Russian-built Lada taxi.

Midday, with grumbling stomachs and parched palates, Debebe takes me to a restaurant rarely visited by foreigners. We agree to share two vegetable dishes because Debebe is fasting. This doesn't mean abstinence from food, rather it's simply abstinence from meat, fat, eggs, and milk. Ethiopian Orthodox Christians obey 250 days fasting every year, including every Wednesday and Friday.

After lunch and before exploring Addis's colorful markets, Debebe takes me to Tomoca, a legendary coffee shop. Ethiopians are as serious about their coffee as they are about fasting.

The sprawling Merkato is the largest market in Africa. If it can't be found here, it's not in Africa—except for a quality rear tire for my motorcycle. Colorful and chaotic, it's more like a neighborhood than a market: even veteran taxi driver Debebe can't tell me where it begins or ends.

Ethiopia

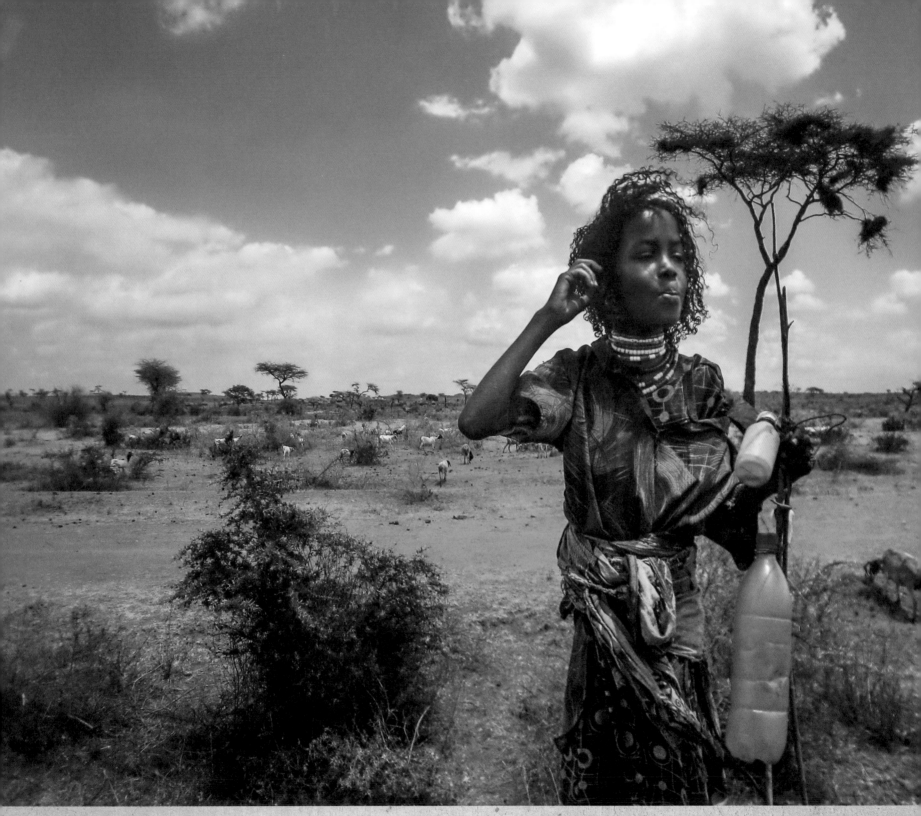

Ethiopia

This journey is no weekend getaway, no two-week hiatus from work. No. This is my job, and it is what I love.

The Sudanese Embassy is madness, and accepts visa applications only three days a week. Dozens of people crowd the entrance and tiny waiting area. Most of the applicants are Muslim women in traditional dress. I go each day, only to be turned away. On my fourth visit, my tenacity pays off. One of the men I befriended earlier recognizes me, waves my passport in the air, and directs me to the cashier. Yes! I'm going to Sudan.

My journey through Ethiopia continues north as I head toward the border with Sudan. I cross the Nile River at the Blue Nile Gorge and visit centuries-old monasteries on the small islands dotting Lake Tana, including Daga Island and the Daga Estifanos monastery, considered one of the holiest in Ethiopia, where no women are allowed to set foot.

In the highlands of northwestern Ethiopia, the Lasta Mountains, at nearly 9,000 feet above sea level, I see perhaps the most spectacular collection of churches and architecture in all of Africa. Considered to be Africa's Petra, Lalibela is a collection of ancient churches more than a thousand years old, all hewn out of red volcanic rock. Carved from the top down, some lie hidden in deep trenches, whereas others stand in open-quarried caves.

The UNESCO World Heritage Site is a dizzying labyrinth of tunnels and dark narrow passageways with creepy crypts, genuine grottos, and galleries that connect all of them.

After Jerusalem was captured by Muslims in 1187, King Lalibela declared this town to be a new Jerusalem. Details of how the churches were constructed are vague, but a hagiography of the king states that the churches were carved with the help of angels.

In Gondar, I wander around, exploring castles and palaces built for emperors. I get lost in age-old markets and once again taste flavors with local people. It's these experiences that truly seduce me and give me the purpose and energy to continue this long and nomadic journey. I am experiencing places I've only dreamed of—and thought I'd never see. Each night, I go to bed with another dream realized. I wake up the next morning and ride on, escaping to somewhere else, where I experience something new all over again.

This journey is no weekend getaway, no two-week hiatus from work. No. This is my job, and it is what I love. I get paid by the smiles on the faces I meet, in the history I learn, and in the faith in humanity that is proven over and over again. 🇪🇹

There are more priests than tourists among the medieval churches of Lalibela, the creation of an Ethiopian king who dreamed of a Christian city—a new Jerusalem his pilgrims could journey to safely. There are 11 churches in total, all hewn from the red rock of the mountains of northern Ethiopia.

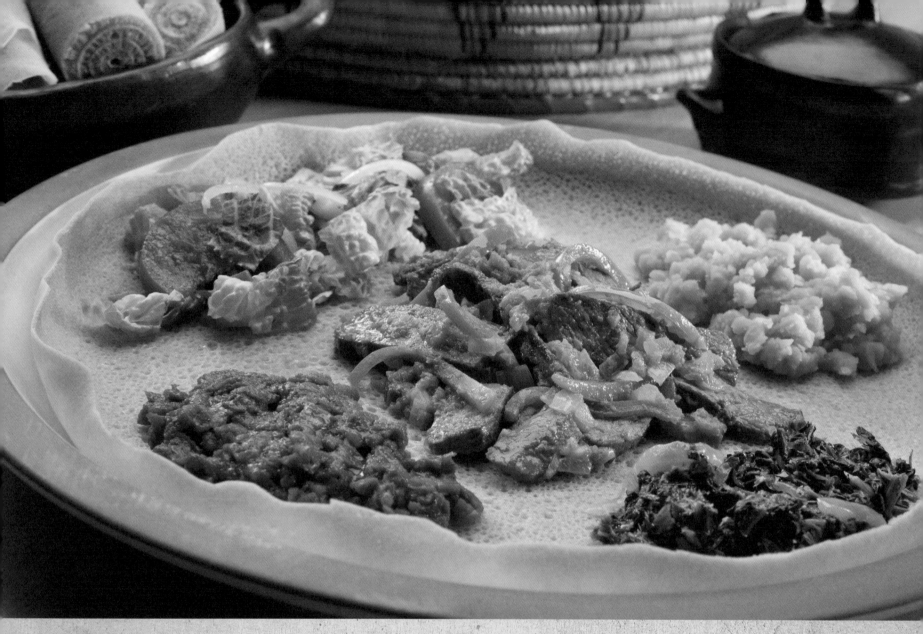

Ethiopia

I was impressed with the diversity of Ethiopian food. I hired a taxi driver while venturing around Addis Ababa, the capital of the country. Over a few days, he shared with me the flavors of the best Ethiopian cuisine and of its coffee. Although there are more vegetarian dishes in Ethiopian cuisine than in perhaps any other country in Africa, I was drawn to the unique flavors of the green pepper sauce that serves as an excellent simmering medium for thinly sliced prime beef. Though normally served with injera, a spongy flatbread made from teff (a grain unique to northeastern Africa) and used to scoop up food to eat with one's hands, I found this dish is just as enjoyable with simple steamed rice.

Zilzil Alecha
Steak Strips Simmered In Spicy Green Pepper Sauce

Ingredients

3 medium green bell peppers

½ cup dry white wine

2 serrano chiles, seeded and finely chopped

½ tablespoon ground turmeric

½ teaspoon ground cardamom

3 garlic cloves, minced

1 to 2-inch piece fresh ginger, peeled and chopped

2 teaspoons salt

¼ teaspoon ground pepper

¼ cup unsalted butter

2 pounds beef strip steak, New York or top sirloin, cut into strips, about 2-3 inches long and ½-inch thick

1 large onion, finely chopped

¼ cup water

Rice for serving, steamed with a dash of turmeric to give it color

Preparation

1. Core, stem, and flatten 2 of the 3 green bell peppers, place skin side up an aluminum foil lined baking sheet, and broil in the oven on high until the skins have blackened, 5 to 10 minutes. Remove from oven, carefully tent and enclose the peppers in the foil, and allow to cool 15 minutes to 1 hour. Peel off the skins, remove any remaining seeds, and roughly chop. Add to a blender or food processor along with the wine, chiles, turmeric, cardamom, garlic, ginger, salt, and pepper. Blend until smooth and set aside.

2. Heat some of the butter in a large deep skillet over high heat, then quickly brown and sear the beef in batches, adding more butter as needed. Remove beef and set aside. Remove excess fat from the skillet.

3. Add onion to skillet and sauté over medium-high heat for 5 minutes. Julienne the remaining green pepper and add to the onion, sautéing for another 5 minutes, until the peppers are softened. Add the green pepper puree and ¼ cup of water and bring to a boil. Add seared beef strips, reduce heat to medium-low, partially cover, and simmer for 5 to 10 minutes or until the beef is cooked to desired doneness.

4. Serve immediately over rice.

It's the pepper sauce that makes this dish so unique. With a combination of green bell peppers and serrano chiles, zilzil alecha can be spicy. You can temper the heat by using an additional bell pepper instead of the chiles—but you'll be missing the true flavor of Ethiopia.

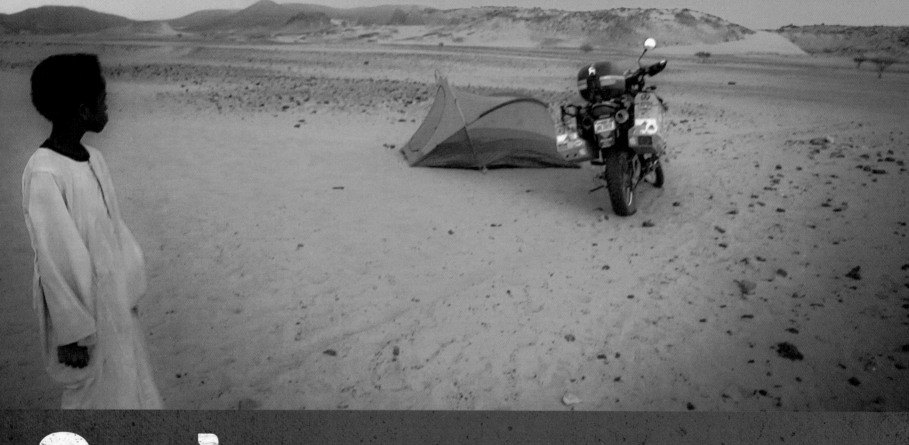

Sudan

CHAD SUDAN Nile ERITREA Al Ghaydan

Khartoum ★ Asmara ★ Sanaa ★ YEMEN

 Al Mukalla

On a One-Week Pass.
Without a sponsor, it's nearly impossible for an American to obtain a visa for Sudan. Eager travelers coming from Egypt or Ethiopia often wait weeks before receiving an answer. For Americans and Britons that answer is always no.

I have no sponsor, but I do have patience, which, combined with compassion and a friendly and professional decorum toward Sudanese officials, ultimately woos them. They give me a visa—with one catch: I must be out of the country exactly seven days after I enter. Don't even think about staying. To ensure I comply, they mandate I check in with Sudanese police within three days of entry.

So that's it, I have exactly one week in Sudan, the largest country in Africa: 1,700 kilometers (1,000 miles) to cross, mostly through blazing Nubian desert, then through immigration and customs and onto a ferry heading to Egypt. Easy enough, except the ferry sails only once a week. Suddenly, I've got a schedule. Timing is critical.

I will have to ride to Wadi Halfa in northern Sudan, where I'll meet the ferry. To maximize the time I have to get there, I must cross the Ethiopia-Sudan border exactly one week before the ferry departure date or be at the whims of the Sudanese justice system—if there is such a thing.

I'm sick, however, with malaria or some other sort of fever. My body shakes so uncontrollably I can't get out of bed. I'm frightened. I don't remember when I stopped taking my malaria tablets, but my symptoms are textbook. I try to sleep. The owners of the guesthouse where I'm staying in Gondar, Ethiopia, are worried about me. So are many of the other guests.

"You mustn't travel across the desert unless you are well," they say, warning me that the road is hard, the landscape desolate, and the journey devoid of towns or even gas stations.

Tomorrow is Thursday, and if I don't leave then, I'll miss the window to get to the ferry on time. Staying longer in Ethiopia is out of the question, though prudence tells me that I should stay at least another day to see if my fever subsides, that maybe I can make it to the ferry in six days.

Size: 1,861,484 sq km (16th in world)

Population: 34.9 million (35th in world)

Capital and largest city: Khartoum (5 million)

Independence Day: 1 January 1956
(from Egypt and the UK)

World Heritage Sites: 2

Literacy rate: 61.1%

Currency: Sudanese pound

Population below poverty line: 46.5%

Key exports: cotton, groundnuts (peanuts), gum arabic, sugar, sesame, livestock

Mobile phones: 25 million (42nd in world)

It didn't take long for the gas station attendant to see I needed rest. He offered me his cot and a slightly chilled beverage, which provided a tinge of relief from the blazing sun. I dozed off for an hour and woke to a full gas tank and smiling Sudanese boys eager to get a rare glimpse of an American.

The next morning I awaken with the birds. I groan. In the mirror I see dark circles and bags defining my red eyes. But I make my decision: Through the harsh lands that lie between Gondar and the border, I head for Sudan.

Before I'm out of town, I stop to fill my tank, two spare fuel bottles, and three bottles of water, just in case.

At first the road isn't bad. There's little traffic, and the few settlements I pass are blips. The landscape changes from green and fertile to gray and semi-arid. Then to sharp rocks and dusty silt. Roadside, I'm greeted by the usual collection of smiling faces and waves, people carrying firewood and water or tending to donkeys packed with sacks of rice, grain, or corn.

An hour later, I ride into a steep, blind, ninety-degree, downhill corner. The road surface is deep, loose gravel. Suddenly, a bus charges uphill on the outside of the turn, in my lane, heading straight for me. If I use my brakes, I'll skid and crash so I downshift, hoping the bus will either stop or move over. It doesn't. There's no room. I can either ride off the cliff, a sheer 100-foot drop, or I can lay my bike down. So I crash into the dirt.

I'm shaking, roughed up, but okay.

Later my motorcycle suit feels like a sauna, thanks to the scorching sun. My boots are hot, as if they're on fire. I'm parched. That's when I realize I've got no water. The spare bottles must've fallen off when I crashed. I panic. The border is still two hours away.

I stop in a small village, but there's no water. I buy and suck down two warm bottles of Coca-Cola, which only make me thirstier.

When I arrive at the border two hours later, I buy a gallon of water, chug what I can, then pour the rest into my boots and over my head. It's soothing. Then I learn the border is closed for the day.

Like many border towns, the Ethiopian outpost of Metema is a dump. Smelly, dusty, and crowded. I still feel ill and now frustrated. I don't want to be here. When I finally get out of my boots, I find my left shin and calf are burned badly, the wound deep red, blistered, and painful.

The border crossing the next day takes hours, but the Sudanese officials invite me into their office, serve me tea, and share a dish of tomatoes and rice. They remind me I must check in with police in three days.

Sudan looks like the Ethiopian desert. I try to make it to Khartoum before nightfall, but the border procedures have taken too long, and I must stop often for water and fuel. In the distance, I see an odd shape—long, winding, and floating—like a mirage. As I get closer I see it is two men leading hundreds of camels alongside the road.

All of the few gas stations are full-serve. One—pumps rusty, parking lot full of holes, grass growing through pavement— looks abandoned.

Inconceivably, it's open. The attendant, worried about spilling fuel on my bike, lets me pump.

Sudan

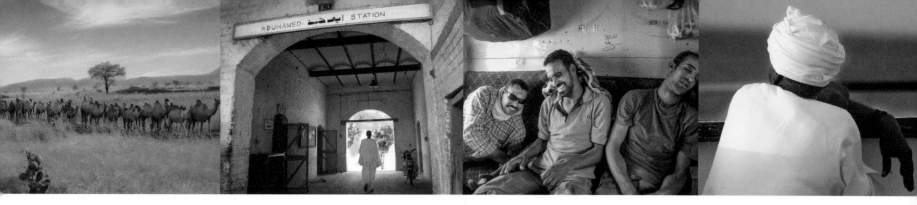

"You very tired, mister," he says.

Inside his office he offers his cot. At first my guard is up. I don't trust him. I shake off the feeling, though, realizing I'm still sick and on edge. I chug a liter of water and collapse. He turns music on his radio. An hour later he wakes me. My bike is still here and nothing is missing. I feel better and move on.

It's a long ride. Later I need more water, food, and shade. A waiter laughs as I pour a whole bottle of cold water over my head. He gives me another and a plate of tamia, chickpea patties like falafel, with flat bread, tomatoes, lettuce, and a cool cucumber sauce. It's refreshing, giving me the energy to move on.

In Khartoum, the capital of Sudan, the Norwegian wife of the owner of the guest house is a nurse. She attends to my burned leg, tells me it's infected and that the heat is dangerous. I must dress the wound daily.

When repacking my bike, I discover one of my spare fuel bottles has a hole, and is empty. I figure the Ethiopian sun boiled the fuel, then pressure built up and split the seams of the bottle. The fuel leaked down into my boot, onto my skin, and, combined with the heat of the engine, burned my leg.

I have already spent two days getting here. I'll need at least three days for my trip to Wadi Halfa. I search the city for travelers headed to Egypt. I find only a group from England who just came from

Egypt and are heading to Cape Town. They tell me it's a long, slow, sandy ride.

Honestly, I'm afraid of the sand, not of falling but because my bike is heavy. If I fall I'll need help to pick it up. If I ride alone, I could get stuck waiting for help. If it takes too long, I will miss the ferry.

There is a train. Like the ferry, it leaves once weekly from Khartoum to Wadi Halfa and makes a few stops along the way. It's my backup plan.

I fall and crash in the sand several times. Thankfully, friendly Nubians always appear out of nowhere to help. I'm still worried, though, that the more north I travel, I may not be so lucky.

So I take the train.

The train is crowded, hot, slow, and breaks down three times—but we make it, arriving the night before the ferry departs.

An Egyptian man befriends me, saying he takes the ferry every month. He takes me to a local restaurant: an open-sided canopy with wood–plank tables, where scoops of curried goat and vegetables arrive with a generous scoop of rice.

Later, as I doze, I reflect on what has been the toughest week of my travels: I made it and am in full compliance with my visa. I won't have to learn what the inside of a Sudanese jail looks like. That small pleasure brightens my memories of the long grueling trek I made to get here. 🇵🇸

The slow, crowded Lake Nasser ferry, from Wadi Halfa at the edge of the Nubian desert to Aswan, had no place to relax save the ship's deck. Here the sun burned during the day and breezy air chilled at night. The locals expected nothing more, and I learned that everything always seemed to work out.

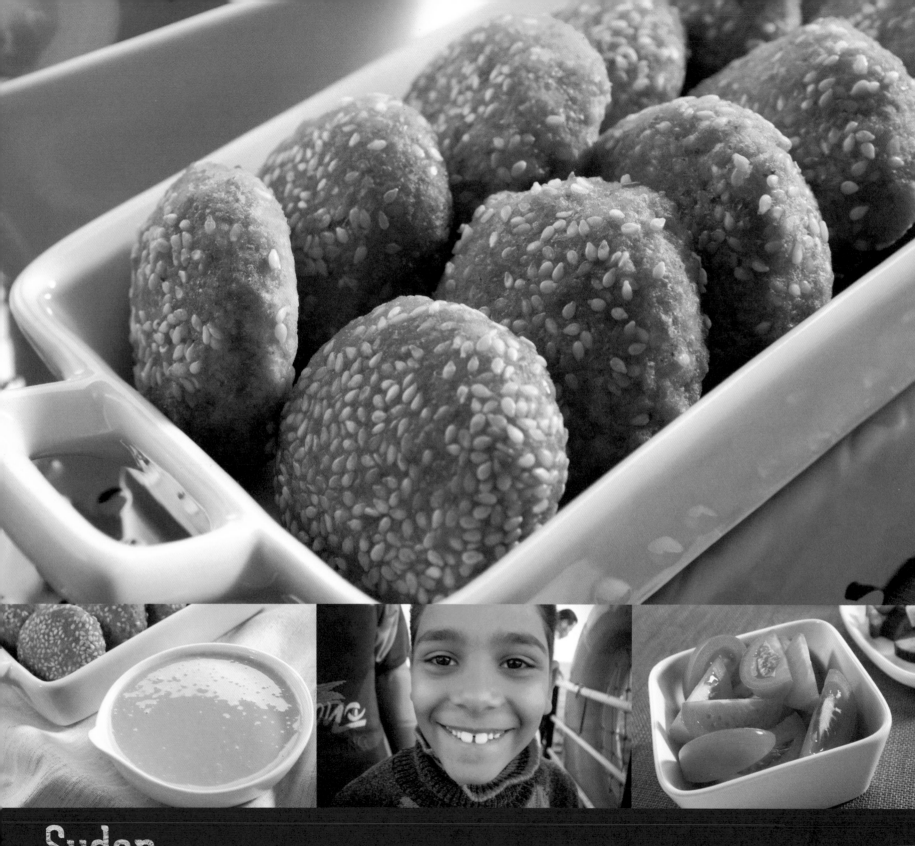

Sudan

From the Ethiopian border to the remote outpost of Wadi Halfa on the banks of Lake Nasser, Sudan amazed me. Just getting into Sudan was a test in patience and bureaucratic nonsense. Alas, I was given only a seven-day transit visa to travel through the largest country in Africa. Happily, the people along the way made my quick trip memorable. Sudanese tamia are like the falafels you find elsewhere in the Middle East, best when made and enjoyed fresh.

Tamia
Sudanese Falafel Pita with Veggies and Tahini

Ingredients

1 15-ounce can garbanzo beans/chickpeas

1½ teaspoons coriander seeds, ground (or ground coriander)

4 cloves garlic

1 medium onion, chopped

1 medium green bell pepper, chopped

¼ cup freshly chopped cilantro

¼ cup fresh lemon juice

4 slices white or whole wheat bread

¼ cup all-purpose flour

1½ tablespoons sesame seeds

Salt and freshly ground pepper

1 teaspoon baking powder

Grapeseed or canola oil, for frying

Chopped romaine lettuce, tomatoes and cucumbers

½ cup tahini or yogurt sauce

Pita or flat bread, warmed for serving

Preparation

1. Rinse and drain the beans and place in a food processor. Add the coriander, garlic, onion, bell pepper, and cilantro and pulse to coarsely grind until there are no whole chickpeas remaining, about 1 to 2 minutes.

2. Pour the lemon juice on a plate and soak each slice of bread in the juice, squeezing the bread to drain excess liquid, then crumble the bread into the food processor with the bean mixture.

3. Pulse again for a minute to combine, add flour and one teaspoon of sesame seeds. Scrape the sides of the processor periodically and push the mixture down. Pulse again until all ingredients are mixed but not quite pureed, about 2 to 3 minutes. Taste and season with salt and pepper. Transfer to a bowl and refrigerate for 10 to 15 minutes.

4. Pour 2 to 3 inches of oil into a deep saucepan or heavy pot and heat to frying temperature, 375 degrees F. Important: If you don't have a thermometer, use the handle of a wooden spoon or a wooden chopstick to test. When it has preheated, dip the handle or chopstick into the oil. If the oil starts steadily bubbling, then the oil is hot enough. If the oil bubbles very vigorously, then the oil is too hot and needs cooling. If no or very few bubbles occur, then the oil isn't hot enough.

5. Remove mixture from the refrigerator and stir in baking powder.

6. Set a baking pan or parchment paper on a work surface. With your hands, take small balls of the mixture and shape into semi-flat patties, about an inch thick and the diameter of a silver dollar (1½ to 2 inches), and place on the pan or paper. Repeat with all the patty mixture.

7. Sprinkle the remaining sesame seeds on the patties and carefully drop one at a time into the oil. Fry in batches for 2 to 3 minutes on each side until lightly browned. Remove and set on paper towels to drain and cool.

8. Cut the warmed pita bread in half, carefully slit each half to make pockets, and put 2 to 3 falafel patties in each. Drizzle with the tahini or yogurt sauce and top with some of the lettuce, tomatoes, and cucumbers. Serve immediately.

Note

The batter should not be too sticky and the patties may seem delicate, but shape them the best you can. When placed into the oil they will bind together. If they won't hold together, you can try adding 2 to 3 tablespoons of flour to the mix. If they still won't hold, add an egg to the mix.

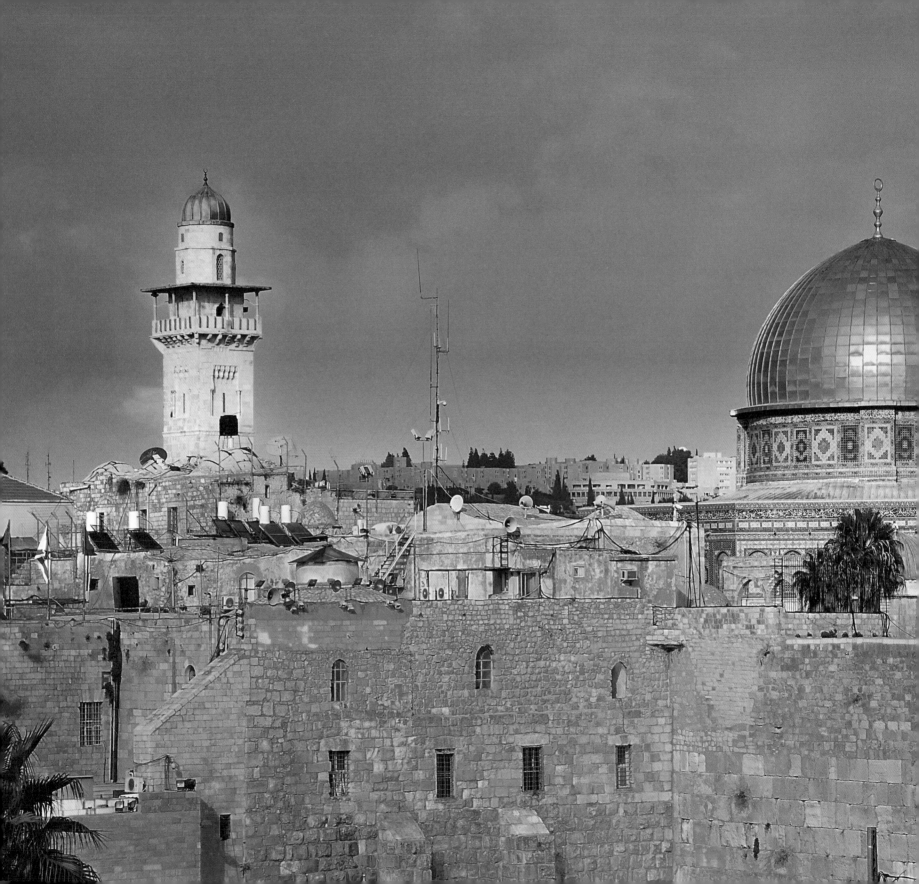

Middle East

> If you reject the food, ignore the customs, fear the religion and avoid the people, you might better stay home.

– James Michener

Egypt

Mut

Al Kharijah

Luxor

Marsa

Red
Sea

Running From the Law.

The golden sands of the Sahara flow to the banks of the Nile in Aswan in southern Egypt, where several small islands dot the river. Cafés serve drinks and tea, as traditional felucca sailboats float downstream along the high cliffs on the opposite bank, where the rock-cut Tombs of the Nobles overlooking this city have protected the dead for millennia.

Thousands of years ago, ships sailed from here to Cairo, transporting the massive granite rock used to build the Great Pyramids. Today cruise ships transport romance-seeking tourists. I take refuge from the cruise ships and sail by felucca to a nearby island, where I meet Amu. At seventy-nine years old, he uses a walking stick.

"My family lost our homeland," he tells me, referring to the flooding that created Lake Nassar and forced the displacement of more than 100,000 Nubians in the early 1960s, when the Aswan High Dam was built.

The desert landscape of this island seems an odd home for herders and farmers. Women congregate at the riverside, where they gather water and wash laundry.

"Would you like to go to a Nubian wedding?" he asks. "Tonight is a special time for Nubian people to celebrate."

He takes me to the home of the groom's family.

"The men will cook today," he tells me. Weddings are the only time Nubian men cook. Large stock pots sit atop wood fires next to sacks of fava beans and flour. Men trim and cut meat, fish, and vegetables.

"I would love to," I tell Amu, "but I don't want to intrude."

"There are five hundred people coming," he says, "I think okay for one more."

Size: 1,001,450 sq km (30th in world)

Population: 85.3 million (15th in world)

Capital and largest city: Cairo (11.2 million)

Independence Day: 28 February 1922

World Heritage Sites: 7

Literacy rate: 72 %

Currency: Egyptian pound

Population below poverty line: 20%

Key exports: cotton, textiles, processed food

Mobile phones: 83.425 million (16th in the world)

Getting my motorcycle into Egypt was no easy task. In most countries I entered, I had to file papers for permits to temporarily import the bike. In Egypt the bureaucracy was overwhelming. The process, which included getting an Egyptian license plate, took more than three days, all while my bike was in quarantine.

Nubian people don't send wedding invitations. This would be considered rude, I'm told. It's the groom's responsibility to visit and invite each of the guests in person.

It wasn't only the many guests at the wedding who were displaced by the creation of the high dam. Two important Egyptian temples, Philae and Abu Simbel, were to be submerged under the waters of Lake Nassar. Thanks to an international rescue effort, they were moved to small islands on the Nile.

The journey to Philae, a UNESCO World Heritage Site also known as the Temple of Isis, is an easy fifteen-minute motorcycle ride to Lake Nassar plus another five minutes by boat to Agilkia Island. Getting to Abu Simbel, perhaps the grandest Egyptian temple, is more difficult. Built by Pharaoh Ramesses II in the 13th century BC as a monument to himself and his wife, Queen Nefereti, the twenty-meter (sixty-five-foot) towering facade of four statues of himself was intended to scare off his Nubian enemies. To reach the new site I must take a three-hour drive in an armed and guarded convoy from Aswan.

Sadly, Egypt has a history of terrorist attacks, which scares off tourists. To create an aura of safety, Egyptian police and military accompany tourists in guarded convoys.

When I leave Aswan for Luxor, I must join another armed convoy. On my way to the convoy starting point I'm stopped by a police officer and ordered to park my bike.

"Where's the convoy," he asks, squelching the noise on his walkie-talkie.

"Yeah! Where's the convoy? I'm looking for it too." My joke goes over his head.

"You wait, wait here for convoy." He chatters in Arabic on the walkie-talkie, then makes a phone call, and after fifteen minutes he tells me to leave. Wow, I think, I can ride freely to Luxor.

The road is narrow, just two lanes, and passes through small towns. Shops and businesses encroach upon the tarmac, which is often congested with donkey carts, pedestrians, and other obstacles. After an hour, I see flashing lights in my rearview: it's a dark-blue police pickup truck with two uniformed officers in the cab and four armed men back in the open bed. I pull over and wave as I let them pass.

Now a white van is behind me, driving less than twenty feet from my rear tire, too close. I flash the rear brake light several times, then turn around and motion them to back off. No reaction. This is the normal way Egyptians drive.

I let him pass, then another van, a motor-coach, and micro-buses as each rides my ass. It's the convoy. They've caught up to me and are dangerously speeding at 120 kilometers per hour (70 mph) on this narrow road. In all, there are twenty minivans, dozens of microbuses, and about thirty motor-coaches. I'm claustrophobic.

To escape, I pass them, but am soon sandwiched between the two vans behind the leading police truck and its flashing lights. I see six white faces in the van following me, western tourists. The Egyptian driver is just six feet behind my taillight. I'm pissed, crane my neck around, lift my visor, and wave, gesturing, "What gives?"

Egypt

No reply. It's time to break free of the convoy.

I jockey to the front, right behind the police vehicle, muster up my confidence, and pass the armed brigade, waving at them. They wave back.

I speed, increasing the buffer zone between me and the convoy. There's not much to see along this stretch of the road, so I focus on arriving safely in Luxor.

Just as I feel freed, I'm stopped at a checkpoint. The convoy is far behind me. Men in crisp white uniforms instruct me to park my motorcycle.

"General says you must wait," one of the officers tells me.

"No, no," I say, "I must go on to Luxor. Very important."

"You must wait," he says again.

"Everyone must wait for general," another officer says.

"I must go," I explain. "I am not part of this convoy."

"No, you wait!" he raises his voice, with a bit of a smirk, his eyes hidden by the shade of his cap.

"Wait for what?"

"You wait!"

"Why?"

"You go talk to general then," he says, shrugging.

Sitting in the shade under the awning of what appears to be an ad-hoc roadside market, miles from any settlement or town, the general points at me with the walkie-talkie in his hand.

"You must wait until I say you can go," he commands.

"Convoy not safe for me. They ride too fast on this road and ride too close to me. I don't want to have accident and be killed in Egypt."

"No. You must wait."

"Not safe for me, please you let me go now," I ask nicely. Then I give in, "Okay, I wait. But for how long?"

"Okay. Good. You wait five minutes."

I walk back and find three officers standing in front of my bike. The entire convoy, more than seventy-five vehicles, is now parked on both sides of the road.

After five minutes, I put on my helmet and get on my bike.

"No. You must wait," an armed officer says, putting his hand on my handlebar.

"I'm not waiting."

"The general did not say everyone could go. We wait for general."

Perhaps equally as impressive as the Pharaohs' commitment to enshrining themselves in massive temples—such as Ramses II here at Abu Simbel near the Sudanese border—was the international effort that moved this temple to higher ground so that it would not be flooded by the waters of Lake Nasser.

Four cops are watching me now. I push the starter button and I point to my watch and say, "I must go. Too dangerous for me to ride in convoy. Too fast. Too close. I go now, general say okay for me." And with that I kick my motorcycle into gear, release the clutch, and pull away.

Each of the young Nubian girls I befriended as I explored the islands dotting the Nile River near Aswan was eager to share her artistic explorations in incredible floral designs, rendered in henna tattoos on her hands and forearms.

"General told me I can go in five minutes," I explain nicely and with a big smile. "Now five minutes finished, and I go." I secure the chin strap on my helmet.

Four cops are watching me now. I push the starter button, point to my watch, and say, "I must go. Too dangerous for me to ride in convoy. Too fast. Too close." I don't know why, but I speak to them in broken English, similar to their own, as if that will help them understand me better. It doesn't seem to work, but I keep at it. "I go now, general say okay for me." And with that I kick my motorcycle into gear, release the clutch, and pull away. The three policemen just stare, dumfounded. I keep an eye on them as they fade from my rearview.

Free at last.

In Luxor, instead of staying on the heavily touristed East Bank, I choose a modest guest house on the more residential West Bank. Not only are there fewer tourists, but it is closer to most of the temples and archaeological sites, which entertain me until I'm ready to move on to Cairo.

The western desert stretches nearly three-million square kilometers (1.8 million miles) to the border of Libya. Mostly barren sand, the Sahara in Egypt is dotted by a number of oases where underground hot and cold springs give birth to fertile ground, teeming with life.

There are no convoys through the Sahara because most tourists aren't interested in the three- or four-day trip. After filling my tank with the cheapest gas in Africa (about one dollar per gallon), I head into the vast Sahara—alone.

The landscape changes as I travel west: rocky plains and colorful buttes, then vast dunes of sand. And amid it all—a farm.

I continue to Dakla and visit its thousand-year-old Muslim village. After checkpoints with new friends serving dates and tea, I roll into Cairo where, rising above the smoggy haze of the city, I see the iconic pyramids of Giza.

I've made it. ▬

Egypt

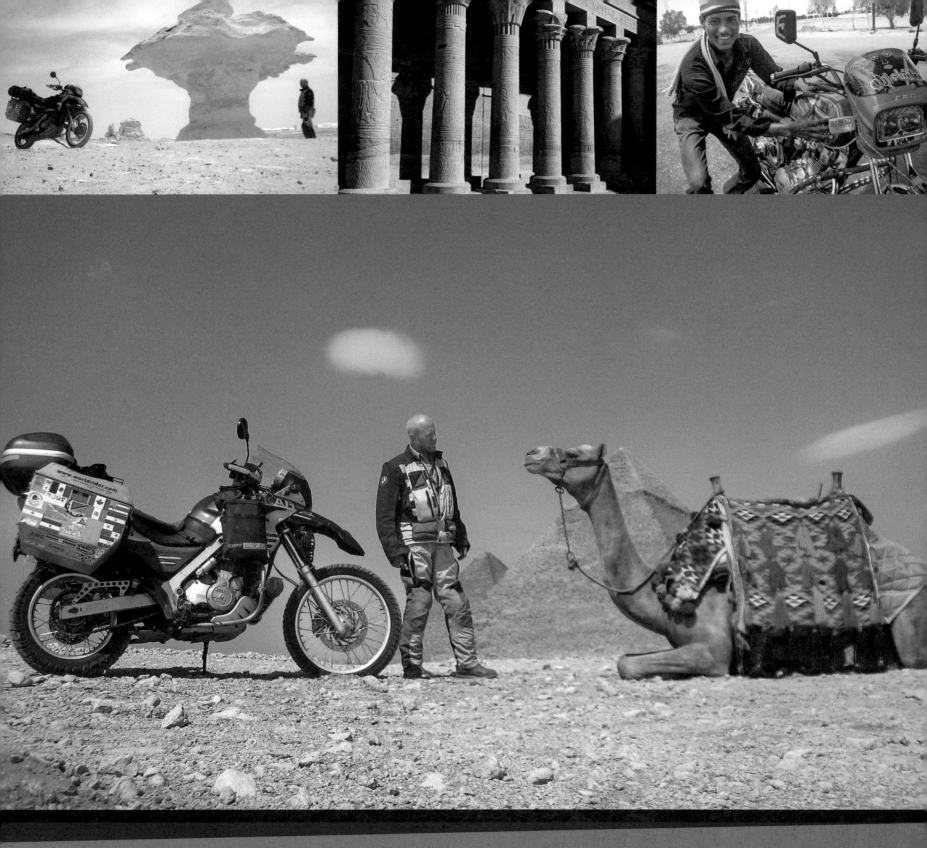

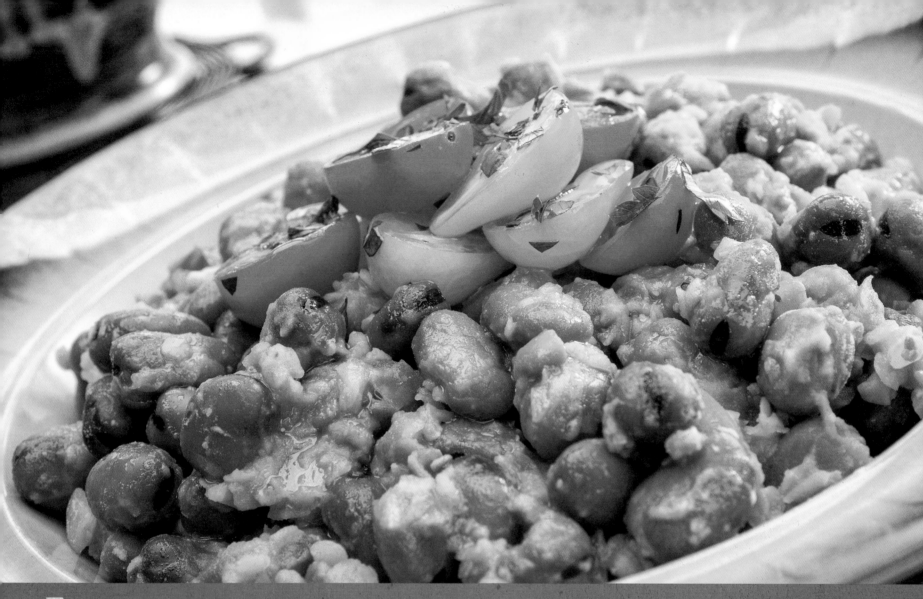

Egypt

As I followed the Nile River from Aswan to Cairo and beyond, I traveled in the shadows of ancient kings and pharaohs, who according to legend, dined on fava beans, the main ingredient of this traditional Egyptian dish. As I rode through the countryside, I passed mile after mile of bean fields. I had to try them when I arrived in Cairo. Always served with pita bread and sometimes with a fried egg on top, ful medames is how most Egyptians start their day—for breakfast, and always with tea. Enjoy it as a main or side dish to any meal.

Ful Medames
Slow-Cooked Fava Beans

Ingredients

1 pound fava beans, dried and peeled

½ cup red lentils (optional)

½ large onion, chopped

6 cloves garlic, crushed

1 teaspoon cumin

2 tablespoons lemon juice

Salt to taste

Olive oil or melted butter for garnish

Green onions, chopped, for garnish

Fried or hard-boiled egg and pita to serve

Preparation

1. Soak the fava beans in water overnight or for 8 to 12 hours.

2. Drain the beans and place in a large saucepan with red lentils, onion, garlic, and cumin. Add enough water to cover ingredients by 2 inches. Bring to a boil, reduce heat to low, and simmer for 1 hour or until beans are tender, occasionally skimming any foam or skins that float to the top.

3. Remove from heat, drain, and mash lightly with a potato masher or the back of a spoon. Stir in the lemon juice and salt to taste.

4. Place the beans in a serving bowl and garnish with a drizzle of olive oil or melted butter and chopped green onions. Serve with fried or sliced hard-boiled egg on top and with pita bread.

Variation

If you don't have the time to soak the beans, you can try canned beans (drain and rinse), but there's no comparison with the fresh.

As I traveled north from Ethiopia, middle eastern cuisine slowly appeared. Thicker than Mexican tortillas and the chapati of Eastern Africa, Egyptian flatbread, or pita, is made from fresh dough, usually cooked on rocks heated by wood fires. I loved this bread fresh and hot, tearing off small pieces to eat with fresh salads, hummus, and more.

Jordan

Wisdom is a Stone's Throw Away. Wow! Things sure change after a short

cruise across the Gulf of Aqaba, in the Red Sea. For the first time in more than six months, I see the golden arches and smell burgers and fries. The McDonald's sits on the main square, with a view of the sea and a tony yacht club, and is surrounded by outdoor shopping malls and resort hotels. This is the Middle East?

Am I lost? I think I'm in Aqaba, Jordan. To be sure I know where I am, I look for a road map. There is no shortage of bookstores, called libraries here, but there are no maps. Except for a few tourist guidebooks, all the books are in Arabic. Interestingly, I am unable to find an Arabic translation of *Seven Pillars of Wisdom*, by T.E. Lawrence.

If not for Lawrence and the support of the British and French governments during the 1916–1918 Arab Revolt, Aqaba would likely look a lot different today. Lawrence, a British Navy officer, convinced the Arabs to align their actions with the British World War I strategy for toppling the Ottoman Empire with the help of an Arab rebellion.

In July 1917, Lawrence led a few hundred Bedouin nomads 600 miles by camel and by foot to Aqaba, where they took Ottoman forces by surprise and seized control of the city. With access to its port, the British navy could then deliver supplies to the region by ship, making the battle a key turning point in the revolt.

With additional supplies, money, and troops, Lawrence and his Arab forces continued the offensive, ultimately marching victoriously into Damascus in the fall of 1918. His successes earned him international fame as Lawrence of Arabia, and after the war he wrote *Seven Pillars of Wisdom*, an autobiography that describes his Arab Revolt experiences in vivid detail.

Size: 89,342 sq km (112th in world)

Population: 6.5 million (104th in world)

Capital and largest city: Amman (1.1 million)

Independence Day: 25 May 1946 (from League of Nations mandate under British administration)

World Heritage Sites: 4

Literacy rate: 92.6%

Currency: Jordanian dinar

Population below poverty line: 14.2%

Key exports: fertilizers, potash, phosphates, vegetables

Mobile phones: 7.5 million (93rd in world)

For me, the trip from Aqaba to Wadi Rum is much easier. The road is smooth and paved, winding through historic Muslim villages and ancient forts. Thousands of years ago this road had been a major trade route from Egypt to Damascus, as well as for traders from Arabia carrying frankincense and other spices. Today on the road I see Mercedes limousines and tattered buses while along the roadside and in the distant desert, many Bedouin travel by camel. They look peaceful, calm, and comfortable, thanks to the slow, rhythmic gait of the animal.

Riding through Jordan on a motorcycle, I find it's hard not to think of Lawrence of Arabia, not only because of his impact and the history here, but because Lawrence was also a motorcyclist. Today I retrace his route not by camel but by motorcycle, something Lawrence never had the chance to do. Sadly, Lawrence fatally crashed his British-built Brough Superior SS100 in England in 1935, just two months after retiring from military service.

In Wadi Rum, the largest valley in Jordan, I see more Bedouins on camels and ride through the dusty roads of their village, made up of goat hair tents, concrete homes, and a handful of shops.

This is the Valley of the Moon. Cut into sandstone cliffs, surrounded by mountains, and sculpted by the wind, it is set among purple, blue, ochre, and orange rock formations, many towering more than a hundred feet. One massive formation with distinct conical features is called the Seven Pillars of Wisdom.

As I ride through the desolate landscapes of this young country, I find the people friendly and helpful and the women beautiful.

I take the King's Highway, which is the world's oldest continuously used trade route, to the prehistoric city of Petra. Unknown to the western world until the early 1800s, Petra sits strategically on this route, sandwiched between the Red Sea and the Dead Sea, at the crossroads between Arabia, Egypt, and Syria.

Designated a UNESCO World Heritage Site, Petra is described as "a rose-red city half as old as time," in a prize-winning poem by John William Burgon. It is instantly recognizable by most westerners as a set for Steven Spielberg's *Indiana Jones*, or more recently, *Transformers*.

The road leading to Petra is lined with hotels, tourist shops, and restaurants squeezed close together. I look for a hotel offering a safe place for my motorcycle. After riding up and down the road a couple of times, I see a man trying to capture my attention by waving a scarf. He's not hawking anything, but is a motorcyclist and the manager of a hotel who promises me secure parking and arranges my room. Behind the reception counter is a photograph of a man and a woman on a motorcycle, a Harley-Davidson.

"Who's that?" I ask.

"That's King Hussein and Queen Noor. He liked motorcycles very much," he tells me, adding, "So do I. King Hussein was best for our country and for Middle East." Hussein became the second Middle

Like Machu Pichu in Peru, Petra is an impressive work of ancient stone masonry that eluded Western historians for centuries. I walked through a narrow cleft in the sandstone rock called the Siq, until it opened to reveal the impressive treasury "building" hewn out of solid rock.

Jordan

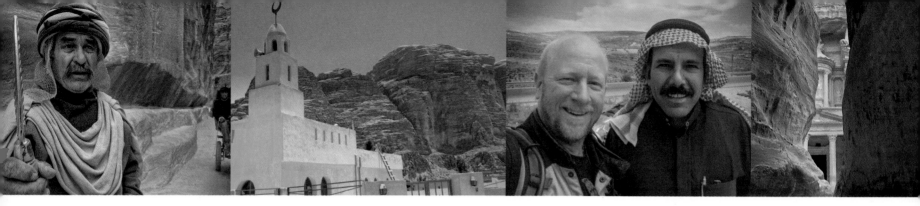

Eastern leader to recognize Israel and dramatically improved the lives of Jordanians with infrastructure improvements that brought water and electricity to most of the population. He was born in 1935, the year Lawrence of Arabia was killed, and died in 1999.

After several more days discovering Petra, I continue my journey north, taking a road off the beaten track, which carves through rocky hills, winds around scenic buttes, and rises and dips with the contour of the land. I crest one whoop-de-whoop, roller-coaster-like hill after another.

Over the course of a mile, I spot several clusters of friendly locals, school boys, walking on the side of the road. Many wave as I pass, but then I feel a sharp thud through my thick jacket as something strikes me. It takes a minute before I grasp what happened. Am I shot?

I slam on the brakes of my trusty BMW, putting the antilock system to test. The school kids flee. I'm not bleeding. The weapon? A small stone about three inches in diameter and an inch thick. It bounced off my jacket and nestled itself securely on my bike.

I quickly release the clutch, pop a small wheelie, and turn around, speeding after the kids. I jump my bike off the tarmac onto the dirt, climbing a rocky hill. The kids are dashing off in many directions. I rev the engine and continue after them with fervor. Then I stop and shout at the top of my lungs, "Get back here now!"

I'm very visible and audible to people living in the houses that dot the landscape. A man wearing a typical red-checkered Bedouin

headdress with a black rope waves me down. Standing behind him is a young boy. Not one of the evil doers.

"What is the problem?" he asks. I explain what happened. His name is Attayak, and he is apologetic for those boys in his neighborhood. He tells me he knows the boys, they are friends of his son. He promises me he will speak to the boys and to the school teacher, and scold them for the danger they could cause to drivers.

Then he invites me into his home for tea. We sit on the floor on cushions that line the perimeter of the room. A single window provides light, only an Arabic calendar graces the walls. There's a knock on the door, and Attayak returns with a tray and serves the tea. We speak of the upcoming presidential election in the US, as well as the late King Hussein and life in Jordan.

After an hour, he gives me directions. We exchange hugs and a few photographs and, as I ride on, passing signs pointing to the borders of Saudi Arabia, Iraq, and Syria, I realize that Attayak and I shared more than a cup of tea. Though I was filled with anger for the violent act committed by those children, I was quickly calmed by the simple gesture and local ritual of tea and conversation while seated on the floor of a Bedouin home. And that it should be so simple, here in the tension-filled Middle East! I wonder, if people could take a moment and curb their anger over a cup of tea, would they learn about each other and discover what makes us all the same, that we all share the primordial human need for connection?

As I was motoring my way along the ancient Jordanian highway, some kids decided to make me a target of their stone-throwing game (and here's the evidence). I made them the target of a chase of fear, until I made my own Mid-east peace accord over tea and a hug with a local bedouin.

219

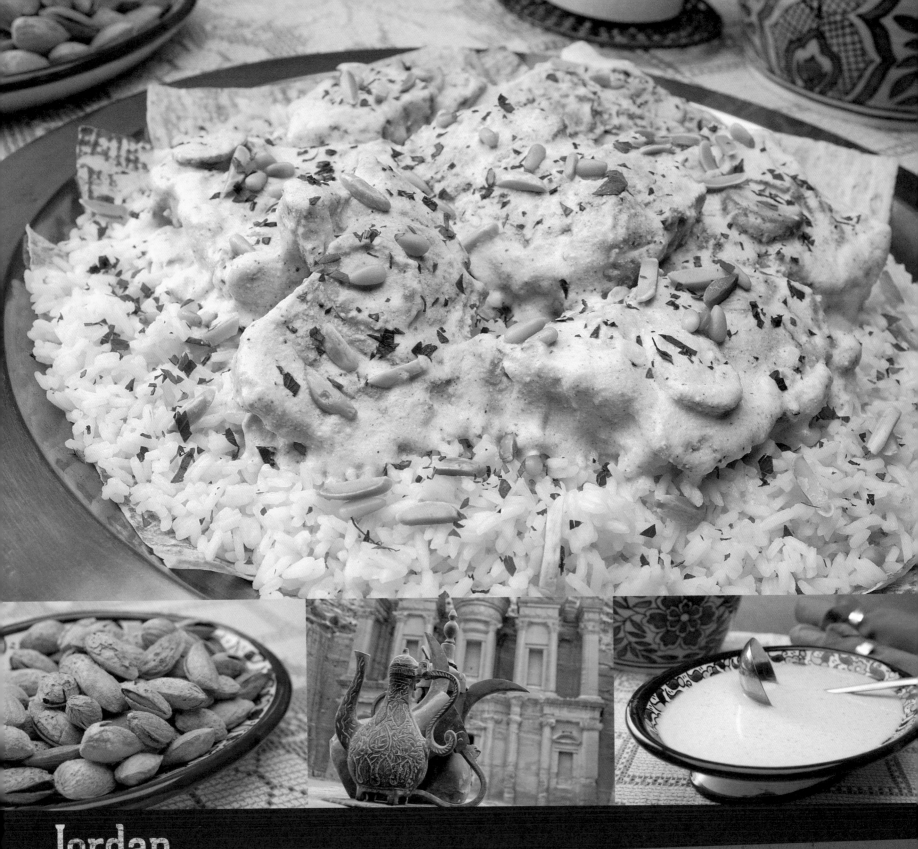

Jordan

From Aqaba on the Red Sea to al-Salt, Petra, Amman, and the borders of Saudi Arabia and Syria, the Jordanian people are passionate about food, especially mansaf. Served on special occasions such as weddings, births, and holidays, or to honored guests, it's a traditional Bedouin dish served on a large platter and shared by many. No forks are needed. Enjoy it in the Bedoin tradition of eating together from the platter with your right hand. This is the perfect meal to share among friends while telling stories of travel, adventure, and family.

Mansaf
Herbed Lamb Simmered In Yogurt Sauce With Almonds

Ingredients

8 cups plain low-fat yogurt

2 teaspoons all-purpose flour

Pinch saffron threads

½ teaspoon ground cinnamon

1 teaspoon salt plus more to taste

1 large egg white

¼ cup olive oil

2 pounds lamb, preferably on the bone, such as leg or shanks, cut into chunks

6 garlic cloves, chopped

1 large yellow onion, chopped

2 bay leaves

1 cinnamon stick

1 tablespoon ground cumin

1 tablespoon ground coriander

1 tablespoon garlic powder

½ teaspoon ground cardamom

½ teaspoon ground cloves

1 teaspoon ground black pepper

1 cup blanched whole almonds

½ cup pine nuts

3 cups steamed long grain rice

½ cup chopped Italian parsley

1 lime, cut into wedges

Pita bread, warmed for serving

Preparation

1. In a blender or food processor, puree yogurt, flour, saffron, cinnamon, 1 teaspoon of salt, and egg white until smooth and consistent (you may have to do this in batches) and set aside.

2. In a large, slightly deep skillet or heavy duty pot, heat oil over medium heat, add lamb, and cook for 10 minutes to brown. Add garlic and sauté for 1 minute more. Add enough water to cover the lamb by 2 inches. Add onion, bay leaves, cinnamon stick, and a dash of salt. Cover and simmer on medium-low heat for about an hour, until meat is tender and breaks apart easily with a fork.

3. While the meat simmers, in a small bowl create spice mixture by combining cumin, coriander, garlic powder, cardamom, ground cloves, and a teaspoon of fresh ground pepper and set aside.

4. Pour yogurt into a large stock pot and heat over medium-high heat. Continuously stir the sauce with a large wooden spoon in one direction. If you reverse direction the yogurt will curdle. As the sauce begins to bubble, add spice mixture and continuously stir the sauce in the same direction until the yogurt mixture just begins to boil, then remove from heat.

5. Remove lamb from skillet and set on a plate. Strain lamb broth and slowly add 2 to 3 cups of broth to yogurt mixture. Add lamb and stir constantly, in the same direction, while bringing the mixture to boil, then remove from heat.

6. In a small skillet over medium heat, lightly toast the almonds and pine nuts.

7. Spread the rice in a thick layer over a large platter, sprinkle half of the almonds and pine nuts on top. Place lamb on the rice and nuts and ladle 1 to 2 cups of the yogurt sauce over the meat and rice. Reserve the remaining sauce in a serving bowl. Garnish with the chopped parsley and lime wedges and serve with warm pita or flatbread.

Variation

Though this is traditionally cooked with lamb, if you don't eat lamb you may substitute chicken or pork.

Israel

Ashdod

Jerusalem

JERUSALEM

Ashqelon

Bethlehem

Madaba

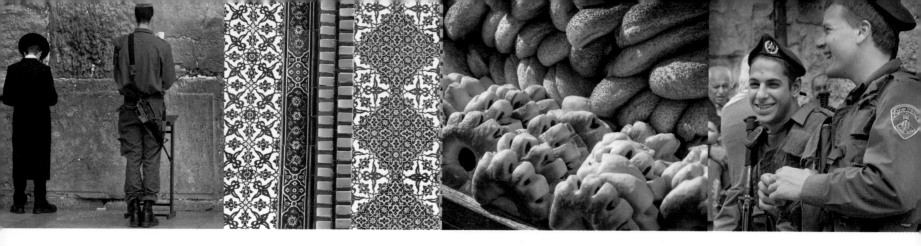

Inside and Outside the Walls.

Flanking the Dead Sea, I ride the King's Highway to a tiny Jordanian outpost nestled within the banks of the Jordan River at the King Hussein Bridge and the Israeli border. Also known as the Allenby Bridge, it is the only entry and exit border for Palestinians traveling in and out of the West Bank. I plan to enter Israel by crossing this bridge, to explore the Old Town of Jerusalem, and then to return to Jordan to travel north into Syria. A good plan, but there are complications.

Like every country I've visited, Israel requires a valid passport, which will be stamped upon admission. Problem is, Syria won't admit anyone with an Israel stamp. For travelers heading to Syria, some Israeli border officials can be persuaded to stamp a loose piece of paper, which can be inserted into the passport and discarded upon exiting. This workaround, however, is problematic for overland travelers.

When I return to Jordan, crossing back over this bridge, I will get another Jordanian entry stamp in my passport. If Syrian officials find a Jordanian entry stamp from either of the two borders leading from Israel, they'll refuse me entry. Using a second passport might help, but Jordanian officials will certainly question and refuse to issue an exit stamp in a passport that has no entrance stamp. Besides, even if I could explain the rationale for two passports, I would have another challenge: my motorcycle and the Carnet de Passage.

Like a passport, my carnet is legal-sized book of papers documenting the origin and ownership of my motorcycle, allowing me to temporarily import the vehicle, and providing a record of all the countries it has entered and exited. It's protection for governments from lost duty or tax. Before departing on this journey, I secured a Carnet de Passage by making an indemnity deposit, which will be refunded once I provide proof that the motorcycle entered and exited each country and is back in the US. Some countries don't require carnets, but having one can simplify border crossings. The Syrian government requires a carnet. So does Israel.

Size: 20,770 sq km (154th in world)

Population: 7.7 million (97th in world)

Capital: Jerusalem (768,000)

Largest city: Tel Aviv-Yafo (3.2 million)

Independence Day: 14 May 1948 (from League of Nations mandate under British administration)

World Heritage Sites: 7

Literacy rate: 97.1%

Currency: new Israeli shekel

Population below poverty line: 23.6 %

Key exports: citrus, vegetables, cotton, beef, poultry, dairy products

Mobile phones: 9.2 million (80th in world)

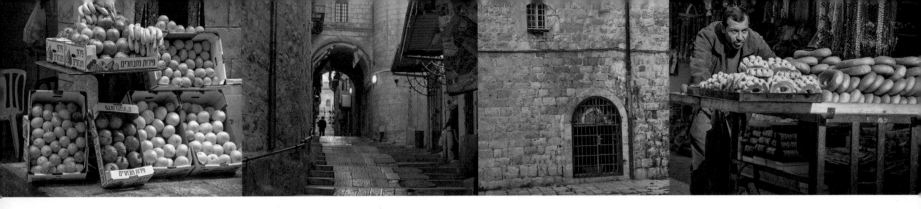

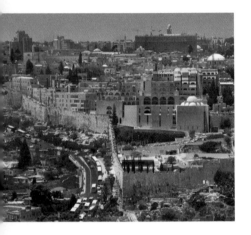

I found two walls in Israel, the one pictured here, surrounding Jerusalem's Old City, was built by the Turks some 400 years ago. The other was built by the Israeli government just a few years ago to separate Israel from Bethlehem in the West Bank.

So, if I show up at the Syrian border with a carnet stamped at either a Jordan or Israel border, I won't be able to visit Syria.

Unless I want to skip visiting Syria, I must give up on the notion of riding in Israel—this time. I decide to enter Israel and the West Bank on foot and try my own hand at Middle Eastern diplomacy: to persuade Jordanian officials to hold off from stamping my passport by promising them I'll exit Jordan through Syria. I need to convince the Israelis, too.

Before I begin my journey to the holy lands, I find a local Jordanian who agrees to watch my motorcycle, which I park in his yard.

I receive more hassle and interrogation from the Israelis than the Jordanians. Still, they both agree with my plan.

So, though I'm now in Israel, my bike is in Jordan. A part of me is missing.

Shalom.

In Jerusalem, I run into President Bush for the second time during my journey. The first time was in Tanzania, several months before, during his campaign to show U.S. commitment to African growth and development and the largest international health initiative in history to fight HIV/AIDS. Today (May 14, 2008), President Bush is in Jerusalem to join Israelis in celebrating the sixtieth anniversary of its statehood.

As I wander through the Old City of Jerusalem, I think of the ghosts haunting this city, those who walked, prayed, and fought on these

cobblestone walkways for the last three-thousand years. It's impossible to grasp what's happened here: endless turmoil and conflict over control of these streets, always plaguing the possibility of peace. Even now, with President Bush in Israel, blood spills on the streets of West Beirut, just a few hundred miles away in Lebanon, as Iranian-backed Hezbollah reignite the Lebanese Sunni–Shiite conflict, seizing control of a large part of the city and leaving many dead.

The Old City hasn't been part of Israel for all its sixty years of statehood. During the Arab-Israeli War, East Jerusalem and the Old City were captured and annexed by Jordan, only to be taken and annexed by Israel some twenty years later during the 1967 Six-Day War. Shortly after, Israel declared all of Jerusalem its capital.

Sixty years is not even a point in time considering Jerusalem is one of the oldest cities in the world. Over the millennia, blood has stained these streets as this city changed hands more than twenty times. Just in the last thousand years, the city has been besieged by the Romans, Byzantines, and Muslims. The Crusaders pushed out the Muslims, who were pushed out by the Egyptian Ayyubids, who were then overthrown by the Egyptian Mamluks. The Ottoman Turks then conquered the Mamluks, taking Jerusalem and rebuilding the city and constructing the walls that still surround it today. For more than 400 years, it was part of the Ottoman Empire, until the Turks surrendered at the end of World War I, and it became a mandate of the British Empire—until sixty years ago today.

Today, the leader of the Free World and his motorcade of unmarked black cars and vans with dark-tinted windows are escorted with

Israel

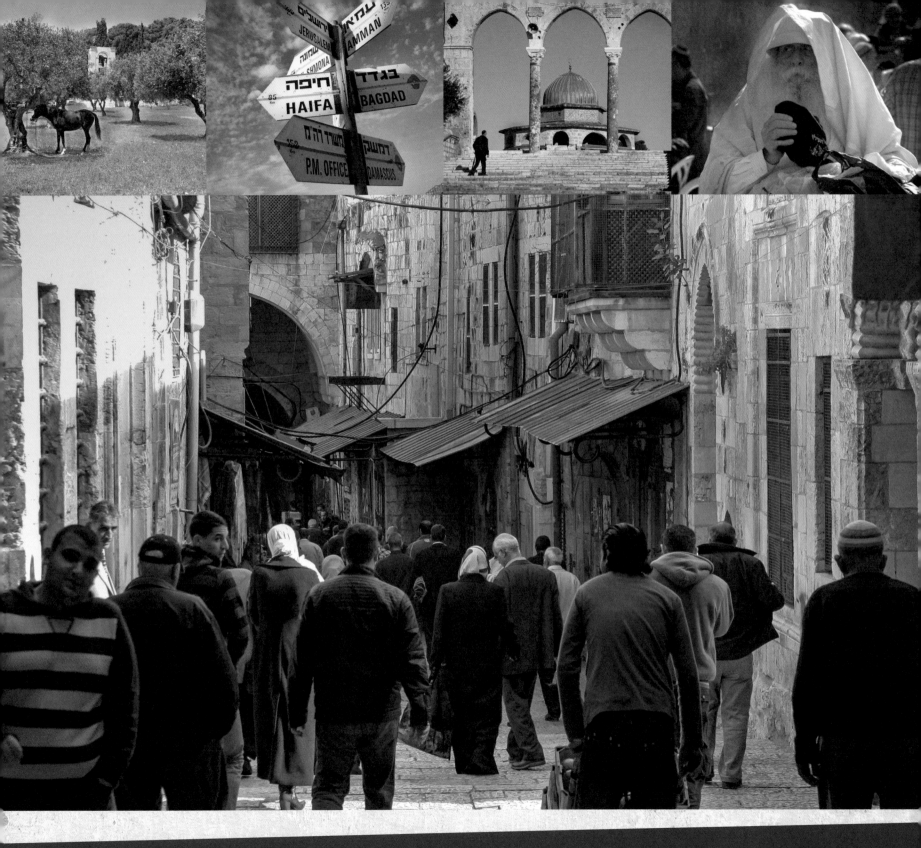

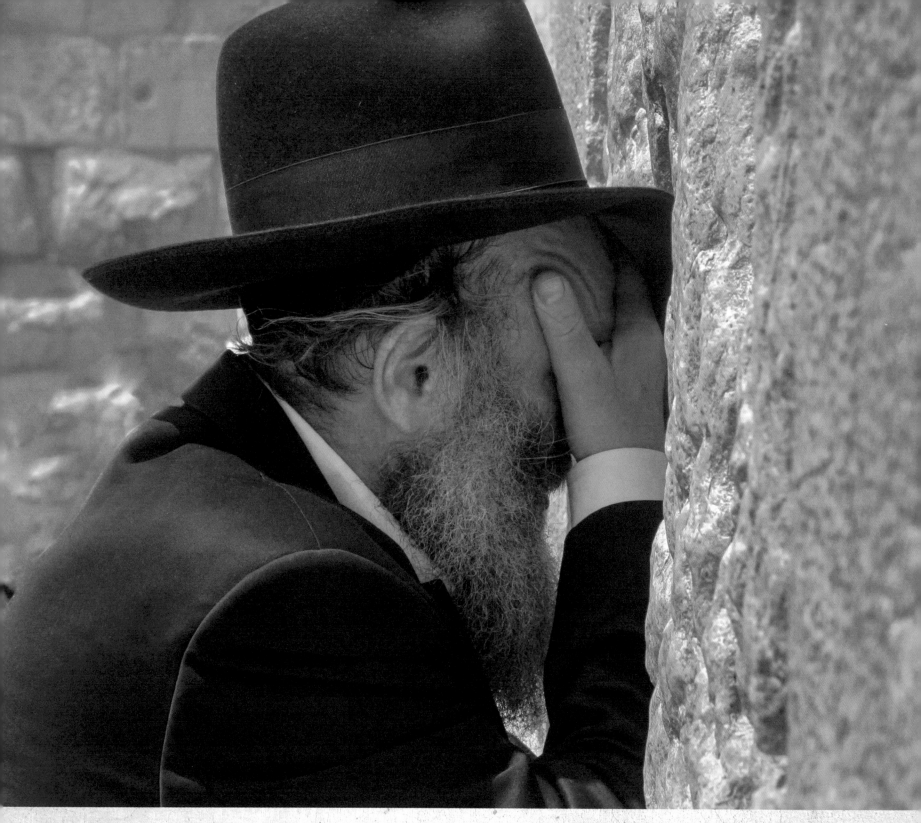

Israel

flagrant displays of lights, loud sirens, artillery, and hovering helicopters—all courtesy of the Israeli police and military.

Taking refuge from the chaos, I explore the Old City, climbing the Turkish-built wall that surrounds it. The Old City is divided into four uneven quarters: Christian, Muslim, Jewish, and Armenian. Staring in the face of history, at the birthplace of the world's three major monotheistic religions, I can't help but think Jerusalem belongs to everyone.

In the Jewish quarter, armed Israeli police direct me through a metal detector and inspect my bags. I don a paper *yarmulke* (skull cap) and approach the Western Wall (19 BCE), the only remaining feature of the Jewish Second Temple, considered by the Jews to be their most sacred site. Here, Jewish worshippers pray as they face the wall, many bobbing their heads and swaying their bodies. Some kiss the wall and stuff prayers written on small pieces of paper into its cracks.

Just above the wall is the Temple Mount, considered sacred not only by Jews but also by Muslims. Here stands the most dominating structure of the Old City skyline: the golden Dome of the Rock (691 CE), a shrine built over the rock from which the Islamic Prophet Muhammad is said to have ascended into heaven. I wander across the courtyard. Inside the Al-Aqsa Mosque, Muslims bow toward Mecca while firmly pressing their foreheads onto the precious carpet covering the floor.

In the Christian quarter, where Jesus is said to have been crucified and buried, stands the Church of the Holy Sepulchre. Christians kiss the stone representing the one his dead body was placed upon. They light candles and pray over the tomb in which it is said he was resurrected.

Walking over cobblestones worn smooth by thousands of years of Jews, Christians, and Muslims, I'm able to get to each of these sites in minutes. Today thousands of worshippers of different faiths still work and live in the same place, side-by-side, eating the same food, walking the same paths, and sharing an understanding of the violent history that reverberates off the walls of this city. Even though their beliefs differ, in their eyes and faces I see them as the same: humans ripe for connection. When I offer my smile, they smile back.

It's business as usual in the colorful Muslim quarter: merchants pushing wooden carts stacked with spices, fruit, beans, and clothing. Hunger has overtaken my appetite for learning and history, so I head outside the Damascus gate, where dozens of vendors cook and serve the best street food in the city. The kebabs smell delicious, but I grab a glass of freshly squeezed pomegranate juice and a *schwarma* made with freshly sliced lamb and french fries in a toasted flatbread, folded and drenched in yoghurt sauce. Sitting on the steps nearby a woman wearing a *hijab* (head scarf) is sharing a plate with her young son. A few teenage boys wearing yarmulkes devour a plate of french fries, and an elderly tourist wearing a New York Yankees baseball cap to shield his sunburned face is served tea from a vendor carrying a large, odd-shaped golden pot on his back.

It's all here. Everyone's here. In Old City Jerusalem. 🇮🇱

I wandered around old Jerusalem for hours almost daily, exploring each of the ancient city's four quarters. All over, locals sold fresh-squeezed pomegranate juice, morning harvests of vegetables and fruit, homemade hummus, and an odd variety of savory and sweet treats that kept me wondering, "Exactly what is this?"

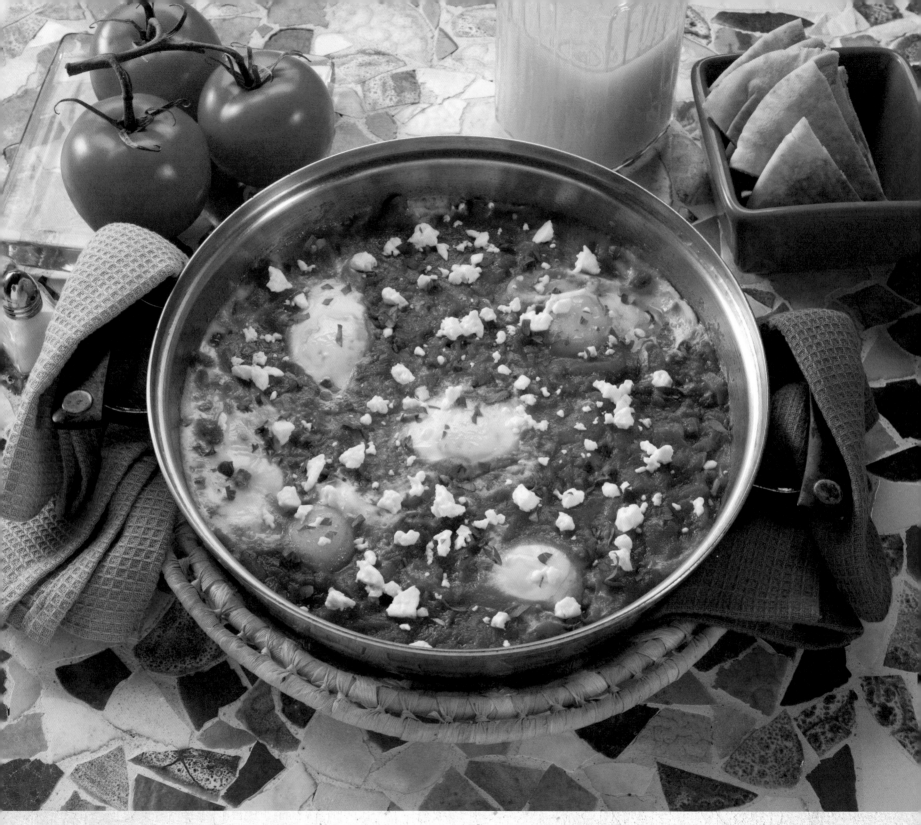

Israel

From the old city of Jerusalem to the cosmopolitan cities of Haifa and Tel-Aviv, everyone in Israel loves shakshuka. Historians say it originated from Morocco, in North Africa, but to me it feels a lot like a Middle Eastern version of huevos rancheros, only better. No matter its origin, most people agree that this delicious dish of eggs poached in spicy tomato sauce is the world's best cure for a hangover. While that may be true (I tested this one morning in the old city), shakshuka is great for breakfast, lunch, or a late-night snack. Although it may be on the menus of most restaurants in Israel, the best preparation is usually at home and made by Grandma, or by you with help from friends and family in your own kitchen.

Shakshuka
Eggs Poached in a Spicy Tomato Sauce

Ingredients

¼ cup olive oil

1 small yellow onion, chopped

6 garlic cloves, minced

½ red bell pepper, cored, seeded, and diced

4 jalapeño chile peppers, stemmed, seeded, and chopped finely

2 pounds fresh tomatoes, cut into quarters, or 1 28-ounce can diced tomatoes

2 tablespoons tomato paste

1 teaspoon ground cumin

Pinch ground caraway seeds (optional)

1 tablespoon paprika

Pinch cayenne pepper

2 teaspoons salt, or to taste

6 large eggs

½ cup crumbled feta cheese

1 tablespoon chopped parsley, for garnish

Pita bread, warmed for serving

Preparation

1. Heat olive oil in a deep large skillet or sauce pan over medium heat. Add chopped onion and sauté for 4 to 5 minutes, until softened. Add garlic and sauté for another 1 to 2 minutes.

2. Stir in bell pepper and jalapeños and sauté over medium heat for 5 minutes, until softened. Add tomatoes and tomato paste, stirring well to combine. Add cumin, caraway, if using, paprika, and cayenne and stir well. Simmer over medium heat until sauce begins to reduce. Season to taste with salt.

3. With the back of a spoon, create 6 shallow indentations in the sauce. Crack each egg directly into an indentation, being careful not to break the yolks. Be sure to space the eggs evenly, placing one egg in the center of the mixture.

4. Cover the pan, reduce the heat slightly, and allow the mixture to simmer for 10 to 15 minutes, or until the eggs are cooked and the sauce has thickened, checking occasionally for sticking.

5. Sprinkle with the feta and garnish with the parsley.

6. Serve from the pan with the warm pita bread.

The bright red color of this dish will light up any table. Use the freshest and juiciest tomatoes when in season, otherwise feel free to use a can of diced or crushed tomatoes.

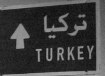

تركيا
↑ TURKEY

باب الهوى
↑ BAB ALHAWA

Syria

CYPRUS SYRIA

Beirut ★ **Damascus** •Bakhtaran
LEBANON ★

ranean Sea **Baghdad** ★

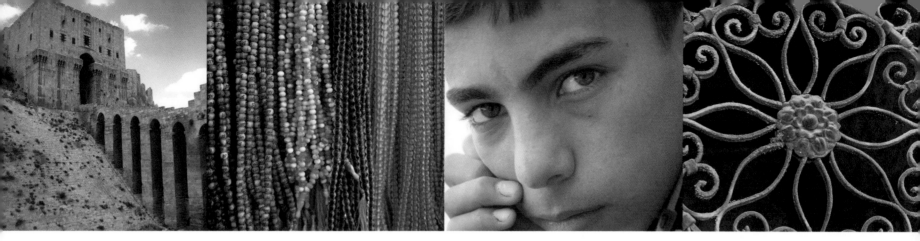

The Unlikely Reality.
"You'll never get into Syria," many travelers warned as I rode north through Africa. American citizens, they explained, cannot secure a Syrian visa at land borders. "Can this be true?" I wonder as I finally draw near. After more than two years and fifty border crossings, I haven't been turned away—yet.

According to the Syrian ministry of tourism website, tourists must obtain visas from the "Syrian embassy or consulate in the original country of the tourist or his place of residence." It further states that "visas are granted at the border, for only the subjects of foreign countries that have no diplomatic representation in Syria." This is a problem. Even if I'd secured a visa in the United States two years prior, it would have expired by now. And after the paper shuffling and rubber-stamping torture I endured both getting into and out of Egypt, my border-crossing confidence has waned. What if I am turned away? I'll have to retrace hundreds of miles, endure further bureaucratic minutiae, and likely deplete the most important pills in my first-aid kit: for headaches.

I decide to go anyway. If they refuse me I'll be angry, I'm sure, but I'll deal with it. Somehow.

The border between Jordan and Syria is a mass of confusion. The roadside is lined with cars and buses and cargo trucks billowing dirty diesel smoke and kicking up dust as they rumble by. Bedouins, Iraqis, and Iranian women in black *hijabs* stream in and out of the small immigration building. The Saudi men impress me most—wearing traditional *thwabs,* long white robes neatly pressed and spotless, with a *ghutra* resting delicately on their heads, also white and pristine. How do so many of them keep them dirt free? With beat-up boots, oil-stained pants, and a jacket that I should have washed weeks ago in Cairo, I wonder if this American might be too dirty to be allowed entrance into Syria.

Size: 185,180 sq km (89th in world)

Population: 22.5 million (53rd in world)

Capital: Damascus (2.5 million)

Largest city: Aleppo (3 million)

Independence Day: 17 April 1946 (from League of Nations mandate under French administration)

World Heritage Sites: 6

Literacy rate: 79. 6%

Currency: Syrian pound

Population below poverty line: 11.9 %

Key exports: wheat, cotton, fruits and vegetables, livestock, meat

Mobile phones: 13. 1 million (59th in world)

Surprisingly, the Syrian Muslims in this temple were happy to let me take photos as they prayed and sang. Following Islamic tradition, Muslims pray five times daily, part of a necessary spiritual diet. The act, during which they seek guidance and forgiveness, serves as a reminder of God and the opportunities He offers.

Though I have three invitations to the homes of Saudis by the time I reach the window, nobody even hints I am waiting in the wrong line. I wonder if some strange force in the barren desert of Wadi Rum made me invisible to Syrian officials because it takes a ruckus to get the tall, dark-skinned man with a fresh, pink scar on his cheek to acknowledge me. When he does, he simply glances at my passport, pushes it back under the glass, mumbles something in Arabic, and walks away.

"Huh?" I think.

I clear my throat. Then call out to him several times, trying to catch his attention. He just stands there, only a few feet away, with his back to me. The echoing sound my key makes as I rap it on the window turns everyone's eyes at me except his. This is the wrong thing to do. With nary any effort he cranes his neck in my direction, glares, and points to an adjacent window. As if I were a dog, he motions with his hand to wait.

I never stop smiling. Perhaps naively, I believe I can do anything if I use a lot of patience, a good attitude, and a little luck. I've made it this far. However, when the only English-speaking official hands me a card with the phone number of the Syrian embassy in Washington D.C., I realize I'd have a better shot at winning the lottery than getting into Syria.

But I refuse to give up. I wait. My motorcycle always attracts attention and new friends, so I bide my time, sharing stories, practicing Arabic, and eating dates with curious local travelers. After I watch the gruff man with the scar drive away, I stand in line again and try further persuasive techniques with the next shift. And the next.

Maybe it is my endless smile, easy attitude, desperate pleas, unnerving patience, or stubborn refusal to leave. Or maybe I am just lucky. But they finally give me a glimmer of hope. "We will ask Damascus," a tall, lanky younger man says. In total it takes twenty-four hours—camping at that border, practicing my Arabic, and telling stories—until Syrian immigration grants visas for me and my motorcycle.

Even so, with my visa in hand and motorcycle documentation in order, the uniformed guards at the border checkpoint will not lift the gate and let me in. Ordered to park my bike aside so others can pass, the uniformed guard instructs me to wait for the chief inspector. Dressed in my motorcycle suit, I feel beads of sweat dripping down my forehead, my heart pounding, and uncertainty shrouding my brain. "What now?" I think.

The heavy, stomping boots of three guards sound like they're marching a prisoner to the gallows. Dozens of keys rattle against their thighs. They stride down a concrete path littered with loose gravel and bordered by green shrubbery and large rocks painted white. The man in the middle carries a silver tray, its mirror finish reflecting the sun so brightly I have to squint to see. Resting on it are three small glasses, a silver sugar bowl, and three miniature spoons.

"Please, Mr. Allan, before you go we would like to share a glass of *shai* (tea) with you," the chief inspector says, smiling and pouring tea into the glasses.

Syria

"Shukran," I say, politely offering a thank-you in Arabic as I spoon sugar into my *shai.* I'd imagined different circumstances, where the chief inspector, broad-shouldered with bright-silver hair, bushy eyebrows, and a day-old stubble shadowing the harsh features of his face, could be intimidating. But here, as we sit together on a bench and sip *shai* at the dusty border between Jordan and Syria, his eyes and subtle smile are inviting and his curiosity authentic as he questions me about my travels, my family, and life in America. Using a stick, he sketches a rough map of Syria in the dirt between his boots and shares with me some off-the-beaten-track places in his country I shouldn't miss.

In some ways it's akin to grabbing a beer among friends, but it seems that everywhere I travel in the Arab world, no matter my destination, new friends everywhere convince me there's always time for a glass of *shai.*

At a gas station a few hours outside Damascus, the owner invites me into his office, where he and two friends sit around a large, circular platter set atop a rusting metal desk. On the platter, brightly colored vegetables seasoned with flakes of mint and parsley present a stark contrast to the drab, windowless back room of this service station.

"Sit. Sit. You sit," Ahmed orders. "You have *shai* with us first. Damascus waits for you." He places a small silver tray with a tea-filled glass and a small sugar bowl in front of me. Across the table, Mohammed and Yousif, each with a fork in his hand, digs into the salad. Tearing a piece of pita and offering me a fork, Ahmed

demands again, "Eat. Eat. You need energy to ride motorcycle far way to Damascus city."

The first forkful tastes clean and fresh. A delicate balance of mint combined with cool cucumber, juicy tomato, and delicate feta unfolds a flavor sensation I would expect to find at a fine restaurant but never behind the oil-stained, greasy door and pungent petroleum aromas of a rundown gas station in the middle of nowhere Syria. I want another. Yes! I sip my *shai* and look at Yousif, Ahmed, and Mohammad, each sporting a wide grin, eyes focused on me. Though I feel I am onstage, I am too hungry to care.

"Eat, eat, you need good food for energy," Ahmed says, forming his hand into a scoop and gesturing toward his mouth. "Eat, my American friend."

Yousif and Mohammed avert their gaze to Ahmed, proud of their friend who can speak English. I reach over the platter and scoop more salad and pita.

"This is delicious," I say, and I indulge in more of the tasty salad. Ahmed translates for his friends. Yousif smiles and gently moves the platter closer to me. He nods and waves his hand over the food.

When I try to pay for the tank of gas, Ahmed refuses my money. "No. No. No," he bellows. "My gift to you, my American friend."

I will offend him if I do not accept. So I quietly let it go and head to Damascus.

Shukran, Ahmed. *Shukran,* Syria. 🇸🇾

The souks of Damascus and Aleppo were magnets to me and the lens of my camera. In Aleppo I got lost in the patchwork maze of aisles, merchants, and low-hung tapestries. Like others, the butchers seem to practice their trade in questionably hygienic environments, yet I never was sick in Syria or anywhere else in the middle east.

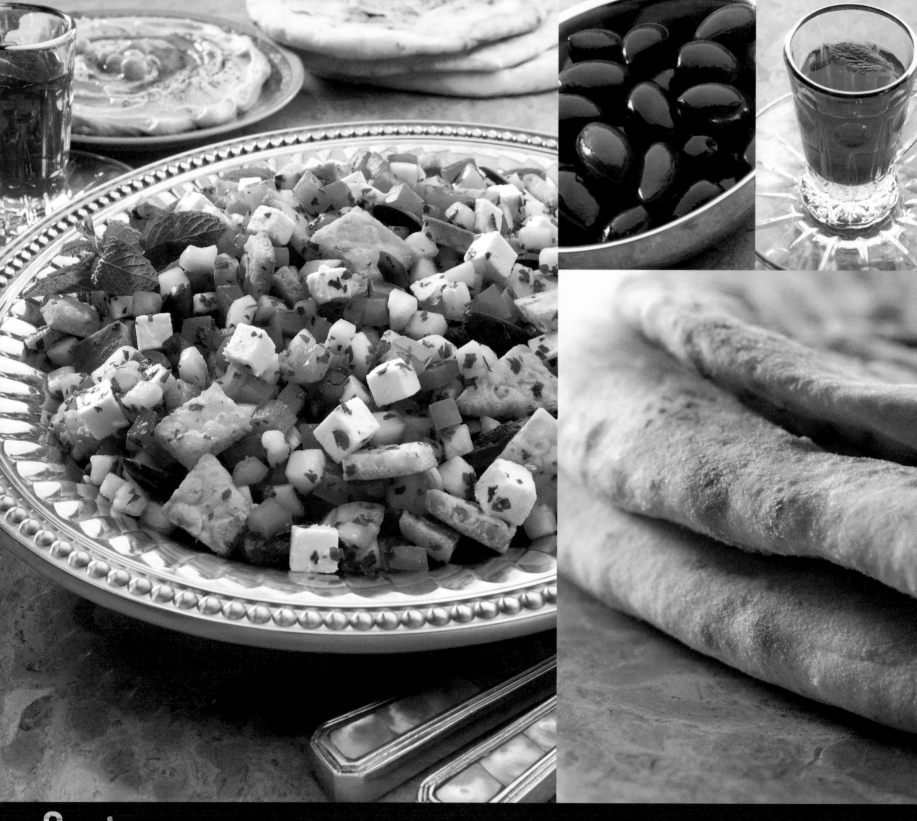

Syria

There are many versions of this fresh salad found throughout the Middle East. But it was in a greasy gas station in the middle of Syria, across from the farm where the ingredients were grown, that I truly discovered the magic of this crisp staple salad—local ingredients and fresh mint. It's important to prepare this with the highest quality olive oil in order to truly enjoy the fresh flavors of this dish. Serve this colorful dish on a large flat platter and, instead of individual plates, simply dig your forks in together and share.

Fattoush
Crisp Salad with Fresh Herbs and Pita Strips

Ingredients

½ English cucumber, peeled, seeded (if necessary), and cut into ¼-inch dice

2 large pitas (preferably pocketless, Mediterranean-style), cut into ¾-inch square pieces

¼ cup extra virgin olive oil, premium quality

1 tablespoon fresh lemon juice, or to taste

3 garlic cloves, minced

Salt and pepper to taste

½ medium red bell pepper, cored, seeded, and cut into ¼-inch dice

1 vine-ripened tomato, seeded and finely chopped

¼ cup green onions, finely chopped

2 tablespoons stemmed and finely chopped flat-leaf parsley

1 tablespoon stemmed and finely chopped cilantro

3 tablespoons stemmed and finely chopped mint leaves (save a few sprigs for garnish)

Hearts of romaine, hand torn, rinsed and spun dry, for garnish

¼ cup crumbled feta cheese, preferably from sheep's milk (optional)

⅛ cup pitted Kalamata olives (optional)

Preparation

1. Preheat the oven to 325 degrees F.

2. Place the diced cucumber into a strainer, sprinkle with salt and allow to drain for 15 minutes.

3. Meanwhile place the pita pieces on a cookie sheet and bake them in the oven until crisp and golden brown, about 20 minutes, shaking the pan 2 or 3 times as they toast. Remove from oven and allow to cool slightly.

4. Make the dressing by whisking together the olive oil, lemon juice, garlic, and salt and pepper in a large mixing bowl.

5. Continue whisking until the dressing is emulsified, then stir in the bell pepper, tomato, green onions, parsley, cilantro, mint, pita strips, and cucumber. Season to taste with more salt and pepper and toss well to coat.

6. Gently toss in feta and olives, if using, and transfer to a large platter garnished with the romaine and the mint sprigs. Serve immediately.

Olive trees have been growing and the people have been making olive oil in Syria as far back as 2400 BC. The secret to the best fattoush salad is the quality and freshness of the olive oil. Like wine, the best print the date of harvest on the label, and olive oil should be consumed within a year.

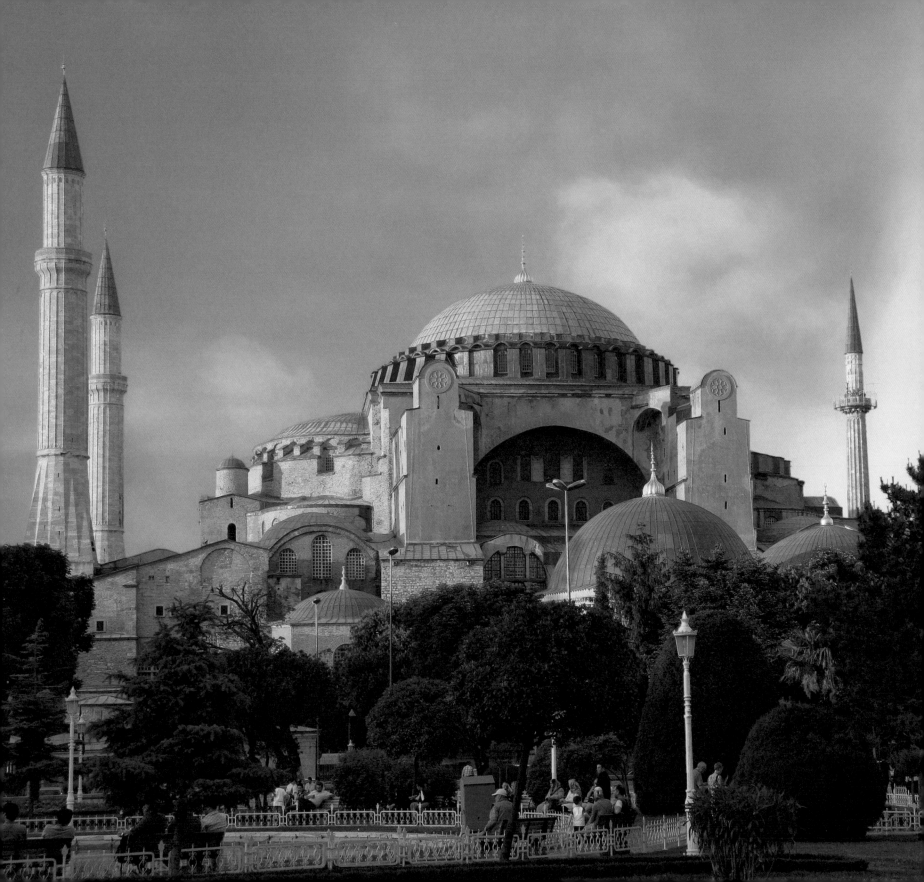

Asia | Europe

> Men go abroad to wonder at the heights of mountains, at the huge waves of the sea, at the long courses of the rivers, at the vast compass of the ocean, at the circular motions of the stars, and they pass by themselves without wondering.

– Saint Augustine of Hippo

Turkey

Manisa
Afyon
Elazig
Mus
Izmir
Tuz Golu
Kayseri
Van
Tatvan
ferry
Nehri
Malatya
Nigde
Diyarbakir
Batman
Kurtalan
Menderes
Zab

Sign Language.

I know where I am going. I just don't know how to get there. My GPS shows no roads. And though the directional signs are large and easy to read, they confuse me. I do not recognize the name of a single town or city. The first person I ask for help, a farmer in dirty overalls loading grain onto the back of his rusting tractor, seems excited and unleashes a barrage of words and passionate, if not guttural, expressions. But other than his enthusiasm, I do not understand him. I try talking to a young boy riding his bicycle, but I scare him, and he darts away through a field of tall corn. I pull up alongside a large truck, waving my hand and pointing my finger to the side of the road, hoping he'll pull over. The driver is friendly enough, smiles and waves back, but doesn't get it.

Size: 783,562 sq km (37th in world)

Population: 80.7 million (17th in world)

Capital: Ankara (3.9 million)

Largest city: Instanbul (10.4 million)

Independence Day: 29 October 1923 (successor state to the Ottoman Empire)

World Heritage Sites: 11

Literacy rate: 87.4%

Currency: Turkish lira

Population below poverty line: 16.9%

Key exports: foodstuffs, apparel, textiles

Mobile phones: 65.3 million (19th in world)

From Jordan to the Syrian and Turkish borders I've checked every bookstore, gas station, and tourist information kiosk I've come across. A road map of Turkey has eluded me. Usually my first day in a new country is filled with excitement, new discoveries, and curiosity. With the sun waning and the temperature dropping, my first day in Turkey is filled with anxiety.

I follow my compass, heading northeast, my best guess about the direction to Cappadocia. I pass through many small villages and miles of farmland, but the only signs of commerce are feed stores and small, single-pump gas stations. Whether on motorcycle or horse, traveling this part of southern Turkey there is at least no risk of running out of fuel.

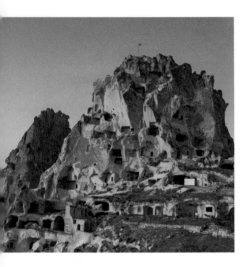

Whether you spell it Cappadocia, Capadocia, or Kapadokya, this historical site is also the name of the people who inhabited the region nearly 2,000 years ago. Here in Goreme, rock from volcanic eruptions has eroded into caves, pillars, and spires like minarets. Legend has it the locals took to the caves for homes and created vast underground cities.

Soon I'm being chased by two boys riding a noisy Russian-made scooter. They dart onto the road from a dusty cornfield. In the rearview I see them giggling and waving their hands. I'm sure I've surprised them when I stop. We are many languages apart, but together share the thrill of riding on two wheels. I do my best sign language to see if they can find me a map. I point to a small map in a guidebook, and then unfolded a map of Syria, shrugging my shoulders while lifting the palms of my hands. Seems my game of pantomime works. They wave me to follow, leading me through a maze of streets to a small bookstore. About the size of bathroom, the dimly lit place is crammed with books, leaving barely enough room for the proprietor, his chair, and his tea. The boys proudly stand by me in the doorway as the owner waves around his shop, pointing out books and handing me his favorite titles.

But I do not need a book. I need a map. So, I show him my map of Syria. He flashes a nicotine-stained smile and hands me a world atlas. With lots of practice under my belt, I begin another performance of pantomime-accented sign language and other nonverbal attempts at communication. They produce no map. Maybe I've lost my touch here in Turkey. I follow the boys again on another chase through the streets and alley of the biggest town I've seen in this country so far. We hop over a sidewalk and turn down a street where large signs that certainly need no translation clearly advise DO NOT ENTER. Yes, I am going the wrong way down a one-way street. Great! My first day in Turkey, I'm committing punishable traffic violations. "How will I explain this to a police officer?" I wonder.

We pull in front of a stationary and copy store just as the owner closes and locks the door. The boys handle the communication and plead my case while feverishly pointing at me and my motorcycle. It works. He not only has one map, he has four options. He shoves one into my still-gloved hand, and when I pull out my wallet he waves his hand back and forth and shakes his head. He rummages through a cluttered box on the floor, pulls out a dog-eared English-Turkish dictionary, and shoves that into my hand, too. Then he leads me through a door in the back of his shop where, lifting a protective tarp, he proudly unveils a shiny Honda dirt bike and gestures me to straddle the machine.

I thumb through the dictionary before bidding farewell and confidently say, *"Sağ olun."* Thank you.

For the next month, that map and dictionary guide me through the back roads of Turkey, taking me into Asia and finally Europe where, crossing the Bosphorus Bridge at sunset, I gaze in awe at the striking shapes of the mosques and palaces of Istanbul silhouetted against a fiery orange glow. For a moment I forget I am riding. So high over the water, I feel like I am flying into the exotic city, not on a motorcycle, but atop some modern magic carpet. 🇹🇷

Turkey

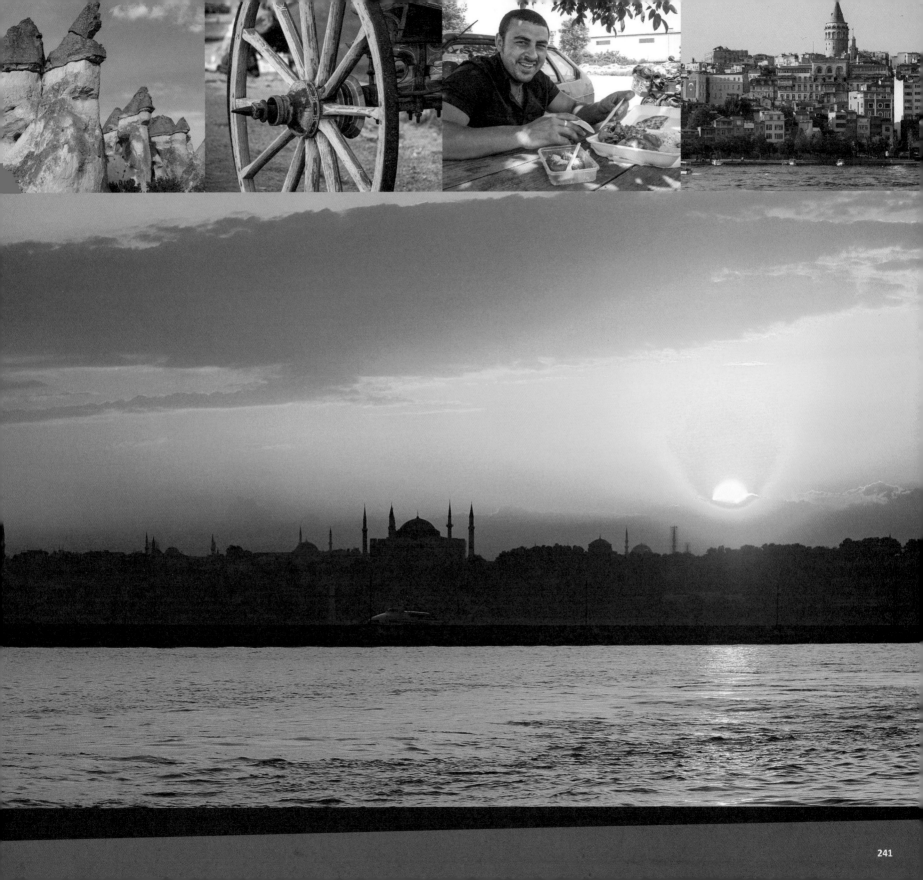

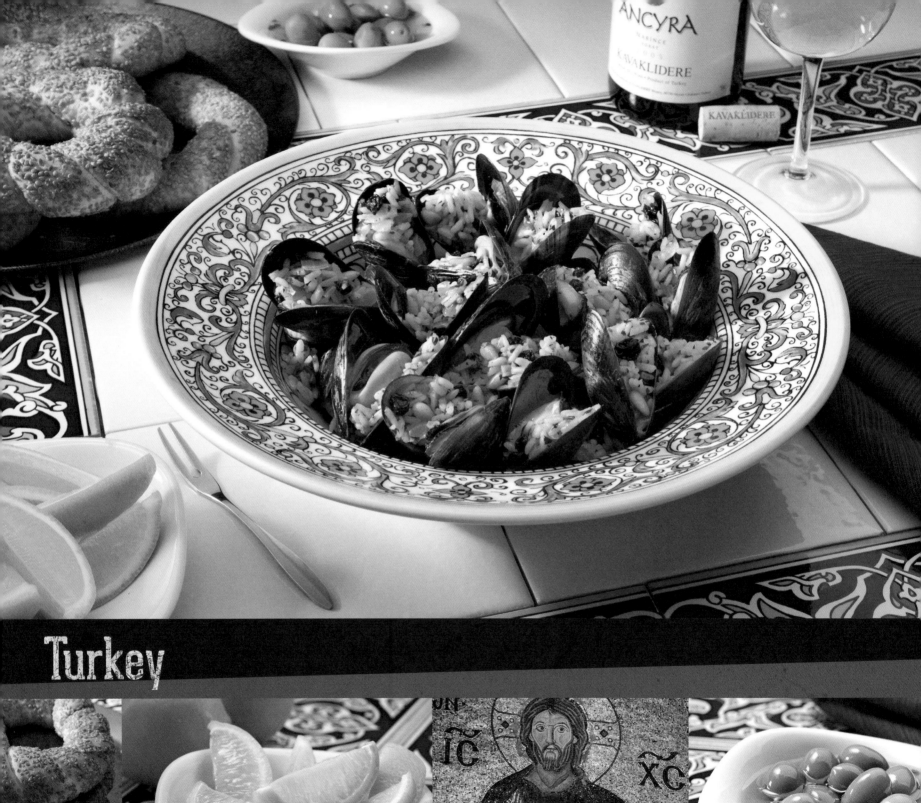

Turkey

Street food. It's no secret that the true flavors of any country or region are usually found on the carts of street vendors—on the busy streets of a bustling city or the dusty roads in small towns. Strategically situated between the Black Sea and the Marmara Sea, for thousands of years Istanbul has been an important trade stop between Europe and Asia. Weary traders and travelers alike looked no further than the seas surrounding this magical place to tame their appetites. For me, the taste of Turkey and Istanbul comes from Midye Domasi, the freshest mussels stuffed with spiced rice and pine nuts and sprinkled with lemon juice.

Midye Dolmasi
Stuffed Mussels

Ingredients

24 fresh mussels

½ cup short grain or arborio rice

¼ cup olive oil

2 medium onions, finely chopped

2 garlic cloves, finely chopped

¼ cup pine nuts

1 large vine-ripened tomato, grated

¼ cup black currants

1 teaspoon ground allspice

¼ teaspoon ground cinnamon

Sea salt to taste

1 cup boiling water

Freshly ground black pepper, to taste

¼ cup finely chopped Italian parsley

Lemon wedges to serve

Preparation

1. Clean the mussels by soaking them in cold water for about twenty minutes, while scrubbing them with a firm brush. Remove the beards with a dry towel.

2. Carefully open the live mussels so as not to break the shells. To make this easier, soak them in a large bowl of lukewarm water so that the shells open a little. Over a bowl, take each mussel by the pointed end and carefully insert a sharp knife between the shells along the flat edge and cut through the mussel toward the rounded end, where it is attached at the top. Carefully pry the shells open just slightly, collecting the juices in the bowl, and allowing the mussels to stay in the shell. Set aside.

3. In a large bowl, rinse the rice well under cold running water while massaging it with your fingers to loosen the starch. Drain the milky water and repeat until the water is clear. Let the rice sit in cold water for about 5 minutes and rinse once more. Set aside to drain.

4. In a saucepan, heat the olive oil over medium-low heat and cook the onions, garlic, and pine nuts for about 10 minutes, or until the pine nuts turn a light golden brown and the onion has softened. Stir in the rice, tomato, currants, allspice, and cinnamon and cook for 2 to 3 minutes. Lightly season with salt and pepper, then add enough boiling water to just cover the rice. Bring the mixture to a boil while stirring, then cover with a tight lid. Reduce the heat to low and simmer for 15 minutes or until the liquid has been absorbed and the rice is tender. Place rice mixture in a bowl and stir in the fresh parsley.

5. Strain the water reserved from the mussels and pour 2 cups into a large saucepan. Place a colander in the pan. Spoon herbed rice mixture into each mussel, then squeeze closed and clean off the excess with a towel. Gently stack the mussels in the colander, using a plate as a weight to keep the mussels closed while they cook. Cover the pan and bring to a boil, then lower the heat and simmer for 20 minutes.

6. Let the mussels cool and serve at room temperature or chilled with the lemon. To devour this delicacy, simply tear the top shell off the mussel, squeeze lemon juice on it, and use the shell to spoon into your mouth. Yummy!

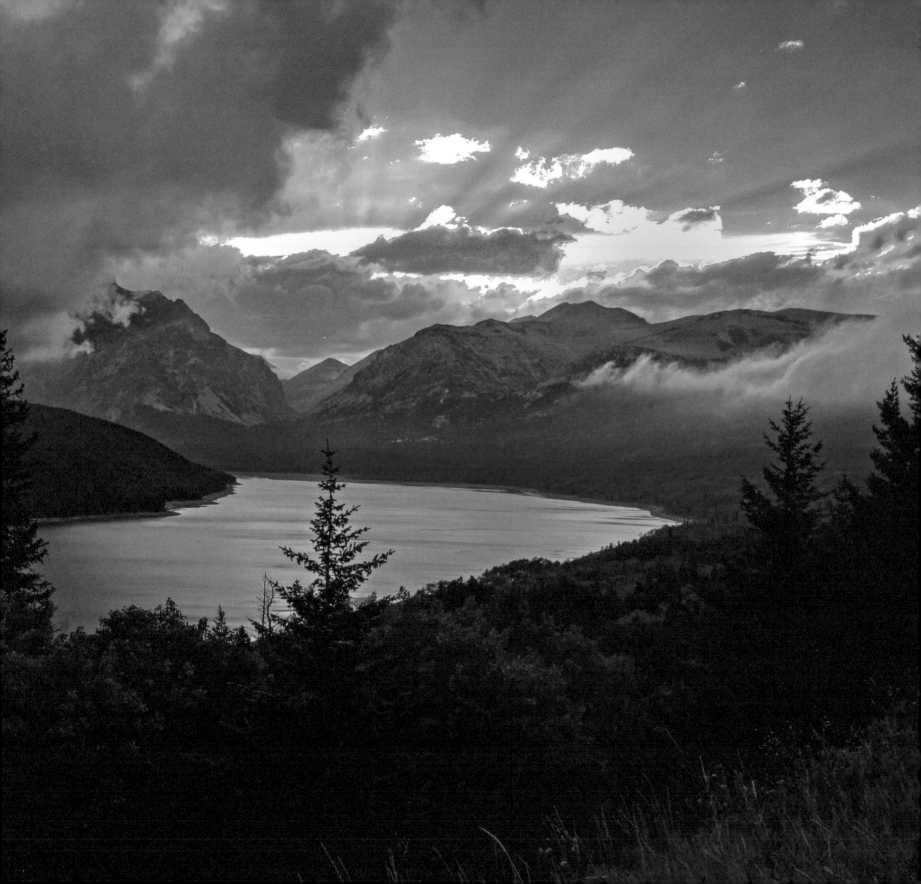

Coming Home

No one realizes how beautiful it is to travel until he comes home and rests his head on his old, familiar pillow.

— Lin Yutang

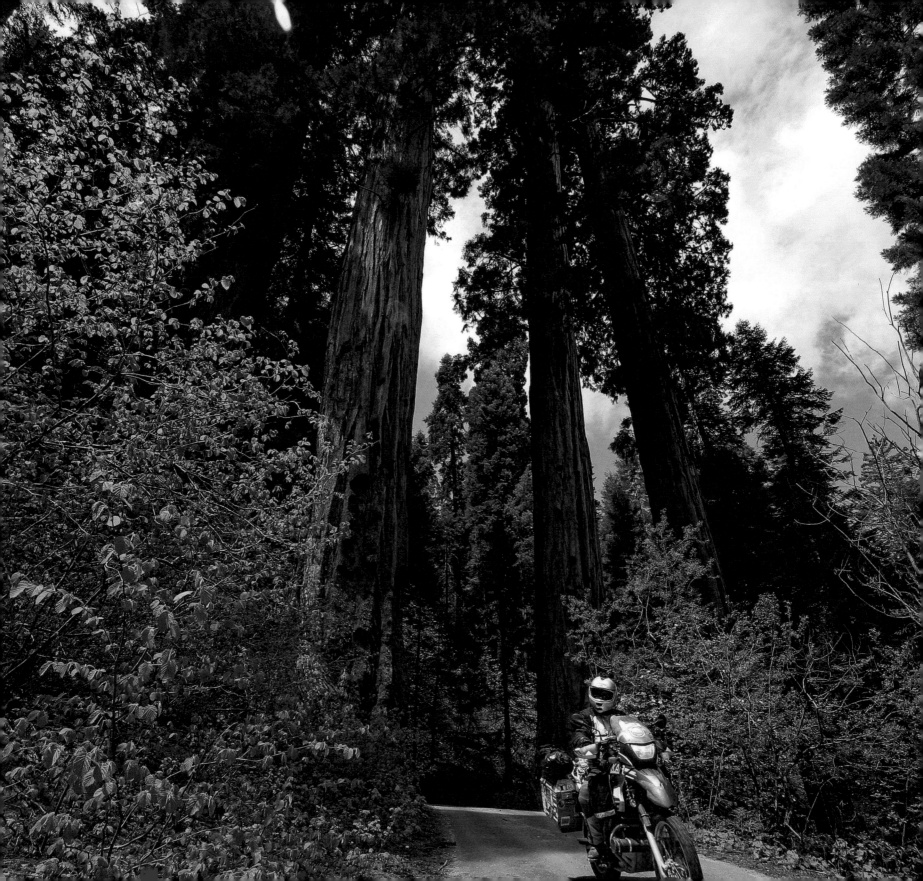

When is it time to go home? When is something finished?

I stare at the unmistakable skyline of Istanbul. I'm in Asia but, looking over the Bosphorus strait, I see Europe. For the past three years I've explored a good part of our world, and the more I experience and learn, the more I realize I've yet to experience and learn. That's true whether I'm traveling the world on a motorcycle, or at home among family and friends.

I've made many new friends over these past years, some in places so remote that I wonder if I'll ever see them again. Others follow my blog or Facebook page or continue to connect with me via email and text messages. Just yesterday, the taxi driver I befriended in Kenya texted, "Are you ok, where you now?" I feel lucky. Still, there are more friends down the road.

There are no strangers in this world, only friends I haven't met.

For the last few months, I've been trying to get a visa for Iran. United States citizens can get an Iranian visa if they are part of an organized tour, but solo travelers, especially one on a motorcycle, cannot. I've overcome immense obstacles over the last three years, so many that I believe that I can do most anything, especially with the will, passion, and patience to do so. I was sure I could get into Iran. Yet I have failed. This hurts.

Last week I met a German couple, on a motorcycle, who had just returned from three weeks of traveling through Iran. A few days later I shared tea with a British man, a backpacker, who also has been in Iran. Like other experienced travelers I've met, the Germans and the Brit shared the same emotion about Iran. Both expressed that it was one of the best, if not the best, places they'd ever traveled in.

Often people ask me, "Where's the best place you've been?" It's impossible for me to answer. Yet when pressed about what makes Iran the best, both the German couple and the Brit agree that it's "the people." I believe them, and I'm hopeful that, someday soon, I can find out for myself.

Now, after some three years of travel, I've come to another fork in the road. It's painful, but I decide it's time for me and my motorcycle to return home. Some will ask, "Are you finished?" No. There is more in this life for me to experience. Whether adage or cliché, it's true: Life is a journey, and we all are travelers. I will continue to learn, explore, and share, and there will be more adventures—more time with family and friends and more meals shared. And I will get to Iran.

I arrange to ship my motorcycle by boat from the Port of Derince, here in Istanbul, to the Port of Baltimore, in Maryland. My bike will travel with its panniers and top box stuffed with most of my riding

on a cross-continental ride through the back roads of the United States, the last leg of my WorldRider journey.

Not so fast.

In the warehouse I find my bike in sad shape. It's haphazardly strapped to an undersized pallet, precipitously leaning over, nearly on its side. The battery is dead because the shippers left the key on. A port mechanic offers a jump start, but the battery is shot, won't hold a charge.

It's worse than I realized: I've been ripped off, too. My tank panniers have been sliced with a knife, and the locks on my aluminum side

This is not the homecoming I expected.

gear and bike essentials. My camera, computer gear, and clothes are packed in a large duffel, which I'll carry on the plane. It will take me about eleven hours to fly to Washington D.C., and a month for my bike to float across the Atlantic.

I get to Baltimore a week after my bike was unloaded off the ship. It takes a couple hours of paperwork and waiting before the shipper will release it. We are nearly finished, when a U.S. customs agent asks to verify the vehicle identification number (VIN), directing me to bring the bike to the customs inspection building.

That's easy, I think, I'll ride it there. My boots, helmet, and riding suit are packed on the bike. I will clear customs and ride to Virginia to spend time with my brother and his family. Then I will embark

panniers pried off. The thieves didn't take everything, but they did take everything I need to continue my journey: my riding suit, helmet, gloves, and most of my tools and camping gear. I won't ride my motorcycle without a helmet. I'm flushed and shaking. Not angry; astonished. Disappointed.

In three years on the road, I've never been ripped off, robbed, or vandalized. Okay, I was pick-pocketed on the Buenos Aires *Subte* (subway), but not on my motorcycle. In Turkey, I saw my bike loaded on the ship, intact and secure. Here, in my own country, I'm violated. This is not the homecoming I expected.

It will cost more than $2,000 to replace these things. Fortunately, followers of my blog rally and send me $700 in donations. My

friends, Andy at Aerostich, Tommy at Held USA, and Al at Jesse Luggage, send replacement gear for free or at discount.

In Virginia, I'm amazed at how much my nieces, Anna (nine) and Emily (twelve), have grown. For the next week, my brother Jon arranges for many friends to meet for food and conversation, either cooking and barbecuing or going out. One night at a casual restaurant in Georgetown, I'm surprised when the waitress serving us recognizes me.

"Do you ride a motorcycle?" she asks. "Were you in Brazil?"

I never thought I'd see her again, especially in a Washington restaurant. We met at a guest lodge on a small island in Brazil. I was traveling north to the Amazon; she and a friend were volunteering for an aid organization in Salvador. I'm astounded again by these small-world coincidences, and I wonder, is this just another coincidence, or is it a part of a larger fabric, made of threads of incidents, independent and seemingly random?

I pack my motorcycle and ride to New York City, where I connect with my best friend Tim, who two years ago met me in Argentina and Chile. After many meals and reunions with friends in the Big Apple, I begin my solo journey home, back to California. I ride only back roads, usually two lanes. They're much slower to travel than highways or interstates, with stop signs, traffic lights, and many small towns. What's the hurry? I ask myself.

Somewhere along the Blue Ridge Parkway in North Carolina, while packing up my tent, my mobile phone rings. It's Fidelity Investments, about a margin call. They must sell my few remaining investments to pay back money I borrowed when I leveraged my

stocks to help finance this trip. I'm nearly broke, as are so many others, with the country plunging into recession. With no other choice, I'll have to max out my credit card to get across the country.

At a scenic overlook, I rest and stare into the distance and wonder what's next. That's when I remind myself of the people I met along this journey who had nothing, yet lived happily, with joy, and were always friendly, open, and willing to share what little they did have.

A guy on a motorcycle pulls up. Still engrossed in thought, I'm not as quick to engage as I am normally. He walks around my bike, uttering expressions of disbelief.

"Did you go to all those countries on this?" he asks, referring to the country flags on my panniers.

Like so many before him, he asks to take my picture with my bike. Tall, with a soft southern accent, from the waist up he's pure motorcyclist, wearing a black biker jacket, sporty motorcycle gloves, and a modern helmet. From the waist down, he looks as if he might've hopped off a horse instead of a motorcycle, wearing blue jeans and cowboy boots.

Beneath neatly trimmed hair he beams an easy smile. The seat of his motorcycle is piled high with a nest of duffel bags and camping gear, so much a load that it would make any donkey or camel I'd seen in Africa jealous. In his late thirties, Cliff is on a weeklong vacation from his job as a maintenance supervisor for a large resort casino. He tells me it's his first motorcycle camping trip.

He's intensely enthusiastic, and his eyes sparkle when he shares his discoveries and tells stories from his journey. In less than a week

At Liberty State Park in New Jersey, the park police let me ride my motorcycle onto the pedestrian-only sidewalk so I could take photos of my bike against the backdrop of the Statue of Liberty and Ellis Island, historical icons of our nation's freedom, openness, and opportunity.

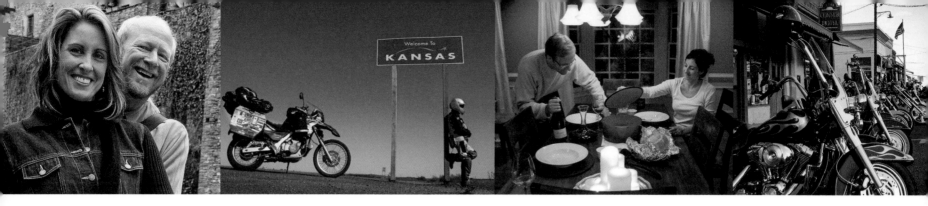

and only a few hundred miles from his home, Cliff has connected with people, immersed himself in new experiences, and renewed his sense of wonder and curiosity. I see in all this proof that even small steps outside the comfort zone can dramatically open one's mind, improve one's tolerance, and expand one's worldview.

We share a few beers over tasty Thai food in downtown Asheville. The next morning we bid each other farewell, promising to connect again in the future.

I take my time riding to California. Along the way I make new friends and delve into the history of the United States, stopping at several Civil War battle sites and riding the Natchez Trace Parkway through Tennessee and Mississippi. In Tennessee, I cross the path of Lewis and Clark, as I did three years ago in Oregon and Idaho, and I realize I've come full circle.

I take in pop-culture history, too, exploring the roots of American music, from the Grand Ole Opry in Nashville to Graceland in Memphis, the home of the King, and then across Highway 61, The Blues Highway.

In the Arkansas Ozarks, my friends Sean and Laurene, owners of a motorcycle accessory company, put me up in their beautiful home on Beaver Lake. Sean wakes me for an incredible early morning ride in the mist while we watch patches of fog wisp over the lake, rising slowly and then mysteriously floating away like ghosts.

In Kansas, a state without a national park, I go out of my way to ride the Wetlands and Wildlife National Scenic Byway and through the Quivira National Refuge, to see a part of Kansas most interstate travelers never experience. I ride through miles and miles and miles of straight roads, most ending at a T-junction, as if the roads were drawn on an old Etch-A-Sketch. They zig-zag at right angles through fields of wheat, soybeans, and sunflowers. The riding isn't challenging or fun, but it's a marvel to watch the synchronized movements of flocking red-winged blackbirds.

On a long lonely stretch of a Kansas back road, I see a slow vehicle moving toward me. It looks like a carriage. As I get closer I realize it's a horse and buggy, and I exchange waves with the driver, a man wearing a tall top hat, cuddled up against a dog in the front seat. I'm in Yoder, Kansas, an Amish community and home, I'm told, to the Parade of Quilts. It occurs to me that here, in my own country, there are people who choose to live a simpler way of life, not unlike so many I encountered in the Third World who have no choice.

Here the gas stations have no credit card slots, and the pumps don't automatically shut off. Pump first, pay later. I pump, but as my mind wanders, the gas overflows onto my boot. There's no question: I'm not from around these parts.

When I finally cross into California, on what's left of the old Route 66, and make my way to the Pacific Ocean, I have an odd, unsettled feeling. I have arrived home with more questions than answers, more unknowns than certainties, and I realize the journey is far from over.

You are never lost, you've simply come to another fork. It's up to you to choose what to do with it.

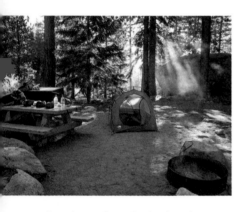

From the grandest national parks to the smallest state recreation areas and parks, on my journey home I rediscovered our nation's forests, rivers, lakes and deserts and was reminded how lucky we are to have such great park systems and services. Here I make camp in the Sierra Nevada mountains of California.

This has been a quest to discover truths about our world. It has also been a search to find myself. I believed that the only way I could find myself was to first get lost. A long time ago, I set off on this journey alone, to do just that. However, I quickly learned that I am never alone. Someone always finds me, and that's when we connect, learn, and share truths.

Perhaps what I looked for, and what I found, was here all along: tables surrounded by family and good friends and even strangers I've yet to meet—all accompanied by laughter, stories, and good food prepared with a dose of passion and an abundance of heart and soul.

You are never lost, you've simply come to another fork. It's up to you to choose what to do with it. After all, what may seem like a fork in the road, two people going their separate ways, may in time appear to be something else. When I parted ways with the woman I'd met on the Brazilian island, it seemed like a fork in the road until I looked up to find her serving me in a D.C. eatery.

Or when I sought refuge in a remote gas station from the chilling winds of Patagonia, and there—with a plate full of *empanadas,* as though waiting for me to arrive—sat Adrian, a teacher and motorcyclist I'd befriended earlier.

Or when, at the bottom of the world, in Tierra Fuego, a guy found me lost and roaming the streets, looking for a place to stay, and invited me into his home. It was not just anybody, it was Pepe, a guy I'd met more than a year earlier at the top of the world, the Arctic Ocean in Alaska.

Or when, on the other side of the world, in South Africa, I ran into an Aussie couple I'd met in Mexico two years earlier.

Or when, in Malawi, I lost my irreplaceable black Moleskine book, but months later heard from a young woman there who had met the guy who found my book and made the effort to find me and return it. Even more, we learned that we share the same birthday. Today we're good friends on Facebook.

Or when, in Rwanda, I received an email from Zambia about the spare tire that had flown off the back of my bike there, two months and four countries earlier. I'd searched for hours in the Zambian bush but never found it. A friendly Zambian did find it, and arranged to ship it to me in Cairo.

Coincidence, or another thread? Are the forks in the road truly forks? Or are they warp and woof, at once separate but mysteriously interwoven into a tapestry—in a design I can't always see at first but am destined to discover further on down the road?

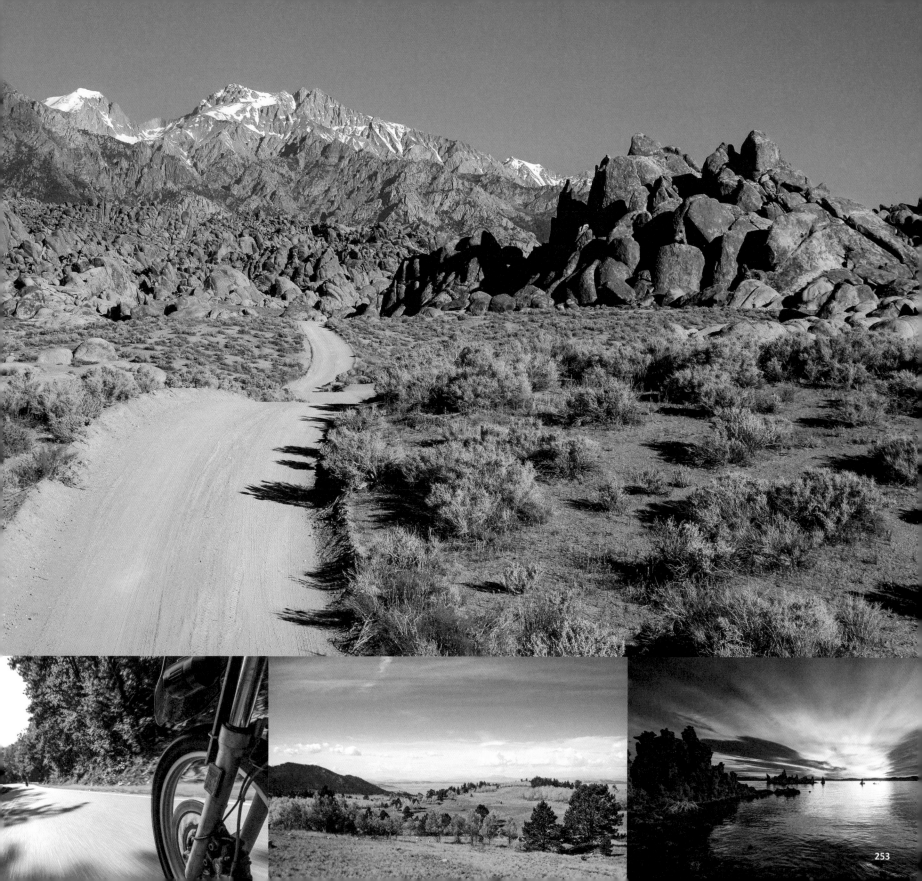

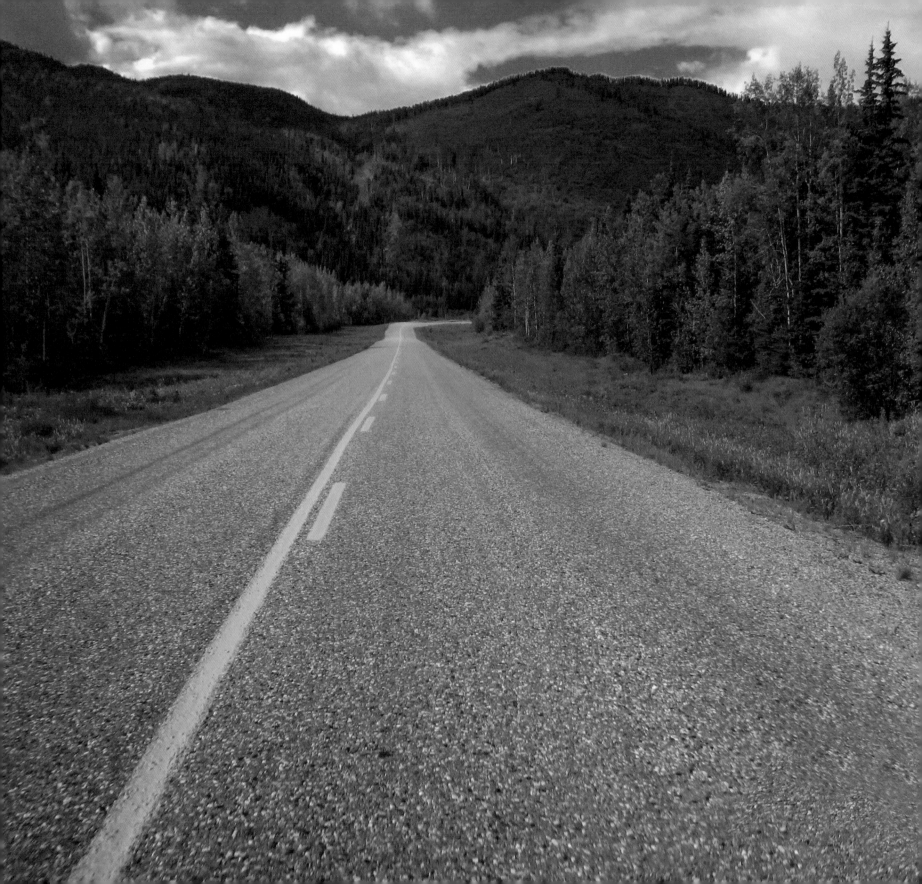

Two roads diverged
in a wood, and I—
I took the one less
traveled by,
And that has made
all the difference.

– Robert Frost

Acknowledgements

Writing, producing, and finally publishing FORKS has been a journey that has taken me nearly the same amount of time to complete than did my journey around the world. I could never have completed either of these journeys without the help, support, and confidence of so many people—people who believed in me.

Though my time away created anxiety, worry, and distance for my family, I am grateful for the help, support and love from my brother, Jonathan, his wife, Maria, and my beautiful nieces, Emily and Anna. Thank you Jonathan for your ideas, creativity, and confidence. Thanks to all of you for sticking with me around the world and at home through the nearly four years I've been working on this book. I love you.

From the day I decided to travel the world and throughout the long days and evenings of producing FORKS, Michael Paff, the immensely talented designer of this book, the WorldRider logo and website, and so much more, has been there—generously supporting my dream and encouraging me to pursuit my vision and passion. Thank you Michael for making me look good and putting up with me and my endless curiosity and questions. You make dreams come true.

The idea for this book was born over a Brazilian moqueca and Syrian fattoush salad when my friends Bonnie and Doug Toth suggested I include recipes and stories—like a cookbook. Furthermore, this book would never have been produced if not for Bonnie's design, production, and coordination skills. Thank you Bonnie and Doug for your friendship and for your creativity, support, and for pushing me to finish this book. I'd be lost without you.

Of the many ways these journeys have enhanced my life, perhaps the most important is the many new friends I made. From the strangers turned friends along the road, to those who followed my blog and emailed me notes of support, accolades, and encouragement. One friend who, after I shared my frustration in persuading traditional publishers to see my vision for this book and support it financially, persuaded me to listen to my gut and follow my intuition to publish FORKS on my own. Thank you Robb and Tara Rill for your friendship, confidence, and the financial support that launched this project.

FORKS is more than a book about travel, food, and culture; it's about the choices we make and decisions we must live with—like those I made in choosing this fork or that fork along the roads of my life. So many people have supported and encouraged me to follow these roads. My lifelong friend Tim Amos, who, over the years, not only inspired me to dig deeper into my appreciation of art, history, architecture, culture, and photography, but also has been a travel buddy for years and met me while I traveled through Chile and Argentina. Thank you Mr. Amos for being the essential creative sounding board on my many projects and for pushing me to think deeper, encouraging me to publish this book and supporting my career as a professional speaker.

Every creative project needs a team, and the team that helped produce FORKS could likely fill a theatre. From feedback to photography, production, editing, coordination, and more, I couldn't have pulled this off without my dream team. Thank you Curt and Martha Van Inwegan or your time, the creative atmosphere at Casa de Las Vistas, and for introducing me to your daughter Bettina Chavez and Digital Photo Finish, who helped edit and prepare the photos in this book for publishing.

Thanks to the passionate perfectionism of Jim Porter and the team at James Porter Photography, including Erika Stout, and food stylist Lisa Meredith for making the sets and the food look so good.

To Nick Paff, who working alongside his father, Michael, helped layout this book and review thousands of my photos, looking for those that would best enhance my stories and the pages of this book. To Bryan and Michelle Roe, for endless brainstorming, idea generation and recipe testing.

With so many photographs in this book, and the many photographs of me that I could not possibly have taken, I thank, Tim Amos, Andy Tiegs, Ronnie Borregeiro, Jonathan Karl, and the dozens of travelers and locals all over the world who offered to take my photo and allow me to use it on my website and in this book. Not only for taking the great photos of me in Peru and Bolivia, I thank my friend Jeremiah St. Ours, you calmly managed the crisis of my broken leg and continue to be for me a mentor, inspiration and a creative sage.

So many others deserve thanks. John Angus for serving as my stateside logistics and support manager while I traveled the world, sourcing and shipping replacement parts and supplies for three years. Charlie Read for your critical and creative eye, David Hatfield for your amazing photo and video skills, Stephanie Cipriani for support in coordinating recipe testers.

Thank you to the best editors in the business, Jim Powell and Dean Whitlock, for challenging and focusing me and my writing and to Sharon Martin for your keen eye. Without your collaboration and dedication to this project, it might have taken another three years to complete. To PJ Dempsey for reviewing recipes.

Thank you for believing and helping Michael Yacavone, Ken Hauck, Brian Brown, Q-Man Johnson, Paul Hunter, Cecilia deWolf, Carla King, Amar Dhillon, Greg Kiernan, Wendi Fisher, and Priscilla Shanks.

Thanks to those businesses that provided props and assistance with recipes and ingredients, including Bazaar del Mundo and Awash Ethiopian Restaurant & Market in San Diego, Moqueca Restaurant in Oxnard, California, and Francois Louw at Potjiepotusa.com.

Thank you for cooking, tasting, and testing the recipes in this book: Aaron Hand, Alicia Thompson, Amanda Thorin, Anne Holtz, Charlie Read, Debbie Carter, Gary Dawson, Jen Rine, Julanne Bullard, Kristen Kennedy, Laura Woolpert, Linda Shearer, Lisa Ecker, Liza Kraft, Marcia Ward, Shelley Steele, and Sofia Reino.

I am grateful for the companies that recognized the enormity of my journey that provided me with the essential support and products that kept me going for three years. I'm especially thankful for the quick response and friendships I've made with the owners and employees of these fine companies: thank you Adam Ziegelman, Al Jesse, Andy Goldfine, Jeff Scully, Kyle Copeland, Laurene Franklin, Mark Hutchins, Pierre Vaillancourt, Steve Peyton, Sukoshi Fahey, Tommy and Elissa Kincaid, Rob Brooks and William Plam. And to the companies Adventure Motorcycle Equipment, Aerostich, Airhawk, AKG Acoustics, Avon Tyres, Caberg Helmets, Eagle Creek, Held USA, Jesse Luggage Systems, Lonely Planet, Map Resources, Oakley, Ortlieb USA, PIAA, Platinum Associates, Touratech USA, Westone, and Works Performance Products.

Thank you for donating to my pre-trip auction or the gasoline PayPal fund on my website: Bill Harlan & Harlan Estate, BackRoom Wines, KoolFog, Meadowood Resort Napa Valley, Plantagenent Funding, Platinum Associates, Timber Inn, The Wine Cellar Club, A.T. Gyuris, Aaron Hand, Alex Mathews, Audrey & Howard Shaff, Barbara & Bill Sharp, Bob Burgess, Bolivar Ramos, Bonna Burtt-Greenberg, Glenn Heitsmith, Greg Hoxsie, Jeff Levine, Jeffrey Eltringham, Joanne Foley, Kenneth Shames, Kent Clayton, Keven Ellison, Kim Mihaleas, Korye Logan, Louise Joy, Michael Timmins, Norm Denton, Ray Sanford, Rex Gelert, Robb Rill, Robert Brenner, Roland Yamamoto, Sal & Mary Ann Catalano, Salvador Carlucci, Sangaroon Yangchana & Nick Morell, Teri Sawyer, Chuck Bruno, The Kerby Family, Tim Kuehn, Uncle Ronnie, and Wenda Arcala.

For those who I may have missed, the hundreds of people I met along these journeys, and to the people in this book and all over the world, I thank you for the inspiration and constant reminder of the beauty of people and humanity.

Peace.

My bike: modifications, maintenance, and statistics

2005 BMW F650GS Dakar

Though I'd owned a 2001 BMW F650GS, it was the standard GS model and not the Dakar. One thing that was a critical factor in the decision to sell my trusty 2001 BMW steed and switch to the more modern 2005 model, was the size of the front wheel. The Dakar version of the BMW F650GS uses a 21" front wheel while the standard F650 uses a 19". Perhaps you might think that 3 inches wouldn't make a big difference. But it does. In rough terrain, where the front wheel would pound over rocks, boulders, or wash-boarded dirt on poorly maintained paved roads littered with potholes, those extra three inches soften the blow and could make the difference between a rough bump and a bent wheel rim.

So in March 2005, I sold my F650 and worked with the great team at BMW of Santa Cruz County and bought the 2005 Dakar. The 2005 was the first year that BMW's fuel-injected F-series included twin spark plugs. The 650cc powerplant is a single cylinder engine built by Rotax and modified by BMW specifically for this bike. The extra spark plug not only helps the single cylinder engine run smoother, it also makes for more efficient combustion, ensuring that there's no unspent fuel in the cylinder chamber.

I went through a painstaking process to determine the smartest, lightest and most cost-effective modifications and accessories with which to outfit my motorcycle. This list is in no particular order, but in my opinion represents the best selection of accessories available at the time, offering the best combination of protection, comfort and security for an around the world motorcycle journey.

Modifications and Factory Options

Fuel-injection (BMW factory standard)

Anti lock brakes (BMW factory option)

Heated hand grips (BMW factory option)

GPS – Garmin GPSMAP 276C

Locking and shock-mount GPS bracket – Touratech

Engine protection bars – Hepco Becker

Fork protection blades – Touratech USA

Sidestand extension – Jesse Sidestand Xtender

Sidestand foot enlargement plate – Wunderlich

Folding gear shift lever – Wunderlich

Master brake cylinder guard – Wunderlich

Center stand – Touratech

Fork springs, heavy duty – Touratech

Headlight protection – Ventura Light-Guard

Brake light – pulsing LED

Wider foot pegs – Touratech

Front fender extender – BMW (plastic and for pre-2001 F650 models) Purchased and fitted in Cape Town, though I wish I had it earlier in my trip as it keeps mud, dust and water from flying off the front tire and into my face.

Riding lights – PIAA 510 (changed to HID Cross Country in USA)

Locking throttle grip – Throttlemeister Cruise Control

Seat customization – Saddlemen

Seat cushion – AirHawk

Rear shock – Works Performance Ultra Sport HD Rear Shock

Exhaust – Adventure Pipe Exhaust System with Stash Tube (false pipe for storing spare parts)

Chain guard – Touratech

Luggage/panniers – Odyssey Bags by Jesse Luggage

Luggage straps, adjustable – Rok Straps

Top luggage case (BMW factory option)

Tank panniers – Aerostich

Waterproof duffel bags –Ortlieb RackPack Dry Duffels (2 small, strapped to Jesse panniers)

Tool carrier, a 3" PVC tube strapped with hose clamps to engine protection bars

Map case – CycoActive Crossbar Mapcase

Statistics and Maintenance for My Three Year Journey

Miles traveled: 62,329

Fuel consumed: 4225.2 liters (1,116.2 gallons)

Borders crossed: 55

Photos taken: 52,077

Tires changed: 13, front, 9 rear; only one flat

Chains replaced: 6

Sprockets replaced: 6 sets, front and rear

Brakes replaced: 3 sets, front and rear

Bearings replaced: 1 steering head, 1 rear wheel

Cables replaced: 1 clutch

Oil & Filter Changes: 16

Gas filters replaced: 2

Shocks replaced: 2, rear

Fork seals replaced: 6

My packing list

Often I'm asked what does someone take along on a multiyear around-the-world motorcycle adventure. Though this list was much longer when I started, I learned that what you think you might need is never what you really need. Still, I managed to get all this gear on a single motorcycle with luggage and storage modifications I made to my 2005 BMW F650GS Dakar.

Riding Gear

Motorcycle jacket and pants – BMW Rallye2 two-piece suit with zip-in Goretex liner
Helmet – Caberg Justissimo flip-up
BMW ComforTemp jacket and underwear
Motorcycle gloves, 3 pairs – Held USA (light, medium, winter)
Heated vest – BMW
Earplugs – Westone
Glove liners – REI
Hydration backpack – Camelback
Convertible silk scarf – Buff
Waterproof socks, 1 pair – SealSkinz

Clothing

Long underwear, base layer, 1 set – Patagonia Capilene 1
Long pants, 2 sets convertible – ExOfficio
Long sleeve shirts, 2 convertible – ExOfficio
Rain jacket – Marmot
Shoes – Oakley SI Assault
Sandals – Keen Newport H2
Sunglasses – Oakley
Short pants/swimsuit
Short sleeve button down shirt, 2 – Royal Robbins
Sock Liners, 2 pairs – REI
Socks, 5 pairs – SmartWool
T-Shirts, (2) – miscellaneous
Underwear, 5 pair – ExOfficio

Camping Gear

Camp Towels – 2, small and large
Camp stove & fuel bottle – MSR WhisperLite
Clothesline
Sleeping bag – Mountain Hardwear
Camp mattress – Insul Mat
Mattress/sleeping bag liner – Cocoon silk
Cookware set & utensils
Folding campstool
Mosquito net
Tent – NorthFace Tadpole 23 with footprint
Headlamp – Petzl
Pillow, compressible – Thermarest

Documents

Drivers license and passport, – 10 copies each
Motorcycle title and vehicle registration – 10 copies each
Carnet de Passage
Emergency evacuation insurance card – MedJet Assist
Immunization records
Yellow fever immunization card
Medication prescriptions

Technology

Apple MacBook Pro 15"
Batteries – AA, AAA
Adapter – BMW Accessory socket to female cigarette lighter
Cables – ethernet, Firewire, USB, GPS sync & charging
DC-AC converter
iPod
Bluetooth mouse – Kensington
In-ear headphones – Westone MH-1 audiophile
CD/DVD disks – software blanks
PC card to compact flash adapter
100 GB hard disk drive and cable
USB thumb drives (2)

Personal Hygiene & Health

Advil
Antibiotic (Levoquin)
Transderm (motion sickness)
Water purification tablets
Baby powder
Chapstick
Dental floss
Deodorant
Toiletry bag with mirror – Eagle Creek Wallaby
Face cleanser
First aid kit
Hand sanitizer
Imodium
Lotion
Mefloquine (Larium malaria pills)
Pepcid AC
Pepto Bismol tablets
Glasses – readers
Red yeast rice
Shampoo
Shave Cream (tube)
Toothbrush and toothpaste
Vicodin
Handy wipes – Action Wipes
Syringes and needles

Writing & Reading

Pens and Sharpie
Manuals – BMW riders and maintenance
Guide books – Lonely Planet
Maps
Moleskin journal
Spanish dictionary
Spare dummy wallet

Photography & Video

Battery chargers for cameras
Camera DSLR – Canon 20D
Camera point-and-shoot – Canon Powershot Series (3 models over 3 years)
Camera video – Canon HD
Compact flash and SD Cards
DVC video tapes
Lenses – 17-85mm, 10-22mm, 70-300mm
Manuals for cameras
Tripod and head – Gitzo
Wireless microphone – AKG

Spare Parts

Brake pads – front & rear
Chain tensioners
Fork seals
Fuel filter
Fuses
Hose clamps (2)
Levers – brake and clutch
Misc nuts & Bolts
Oil filter kits (2)
Side-stand safety switch
Tire tube 17"
Waterpump impeller

Maintenance Tools & Other Supplies

18 Gauge Wire (10 ft)
Airhawk seat cushion
Aquaseal
Bike cover – Aerostich
Electricians black tape
BMW F650GS service manual – digital
Cable lock – for bike, helmet and jacket
Chainlube
Digital multimeter
Dry bag patch repair kit
Duct tape
Eagle Creek Pac-It sacks and bags (sm & med)
Fuel Bottles – 2 1.5L Sigg
JB Weld
Jumper cables
Latex gloves (6 pairs)
Leatherman WAVE pocket tool
Motorcycle grease
Plumbers Goop
ROK Strap (spare)
Screwdriver kit
Siphon hose
Socket kit metric, Torx, hex
Spare zipper pulls
Tie down straps
Tire irons – Aerostich Titanium
Tire pressure gauge
Tire tube patch kit
Valve stem remover
ViceGrips
WD-40
Wrenches
Zip ties
Ziploc bags

Index

Index

About the Author

ALLAN KARL is a world traveler, adventurer, photographer, author, entrepreneur, and inspirational keynote speaker. With an insatiable passion for travel, culture, people, and food, he has explored more than 60 countries, photographing, writing, and blogging about them along the way.

Allan's quest for adventure—and culture, cuisine and connection—has led him to the most remote places on the planet. He sailed the Flores Sea in search of the prehistoric Komodo Dragon, climbed the most active volcano in Indonesia, swam in the Arctic Ocean, trekked the jungles of Central America searching for the elusive quetzal, and competed as a team member in the toughest motorsport race in the world, The Dakar.

Allan inspires people to step out of their comfort zone and pursue dreams, overcome obstacles, face their fears and embrace change, and smile—especially in the face of adversity. And he knows how. Allan spent nearly three years riding around the world alone on a motorcycle. Along the way he was marched into the Colombian jungle at gunpoint, crushed his leg in the middle of nowhere in Bolivia, and had to beg the governments of Syria and Sudan to let him across their borders. (Eventually they gave in.)

Allan is principal of WorldRider Productions, where he focuses on speaking, publishing, coaching, and creating content that brings to life his stories and experiences around the world—demonstrating again and again how the discoveries he has made and the lessons learned can help all of us lead more rewarding lives.

A dynamic and inspiring professional speaker, Allan shares his message with captivating storytelling and award-winning photography that touch themes of adventure, personal growth, creativity, innovation, tolerance, environment, effective communication, travel as education, and the importance of following dreams and pursuing passions.

Allan is also a marketing strategist for clearcloud, a digital marketing and branding consultancy located in Southern California.

Allan grew up in Connecticut but now lives 3000 miles away, in Leucadia, California.

www.allankarl.com | www.worldrider.com | www.forksthebook.com

WorldRider Productions

PO Box 232356

Leucadia, California 92023-2356

forks@worldrider.com